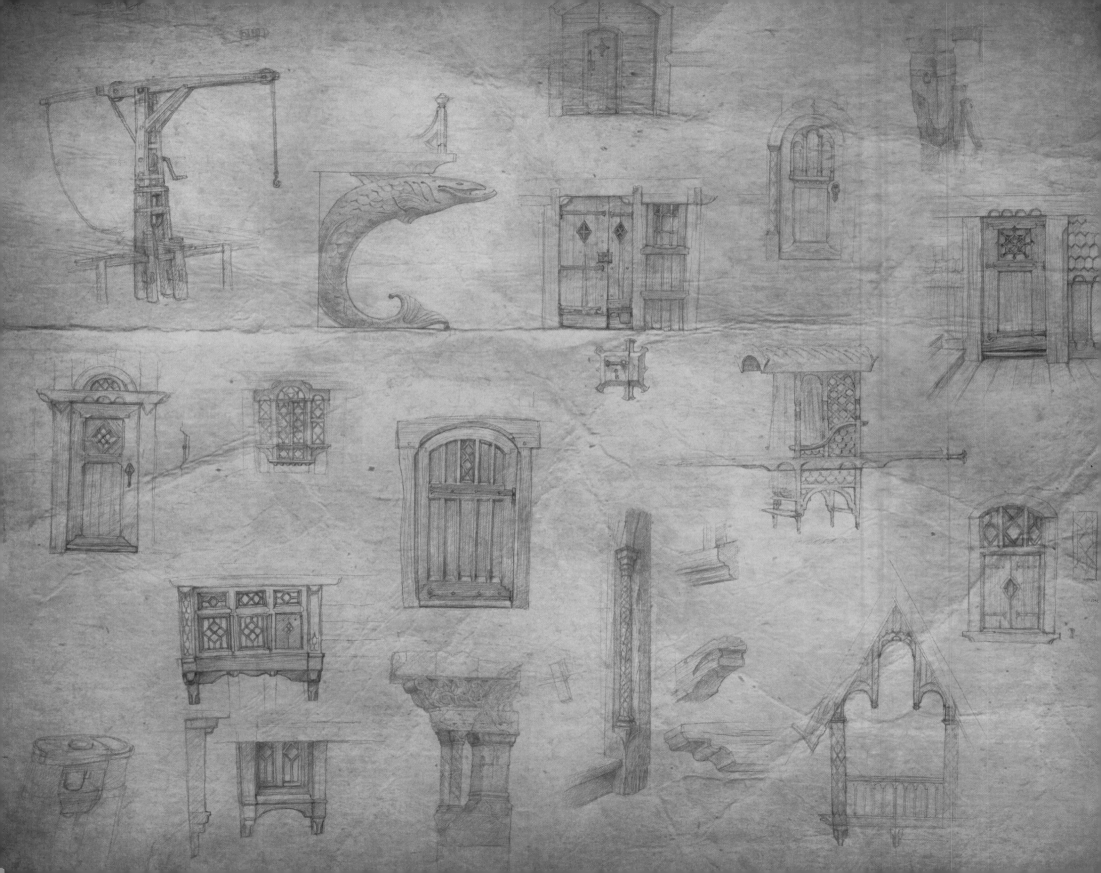

# THE HOBBIT™

## THE DESOLATION OF SMAUG

### CHRONICLES ✦ ART & DESIGN

Published in 2013 by:
Harper Design
*An Imprint of* HarperCollins*Publishers*
10 East 53rd Street
New York, NY 10022
Tel (212) 207-7000
harperdesign@harpercollins.com
www.harpercollins.com

Library of Congress Control Number: 2013949055

ISBN: 978-0-06-226569-2

Printed in China, 2013

Cover design by Monique Hamon
Back cover art by John Howe
Spine art by John Howe

Other publications from Weta include:

*The Hobbit: An Unexpected Journey Chronicles: Creatures & Characters*
*The Hobbit: An Unexpected Journey Chronicles: Art & Design*
*The Art of the Adventures of Tintin*
*The Art of District 9*
*Weta, The Collector's Guide*
*The Crafting of Narnia: The Art, Creatures, and Weapons from Weta Workshop*
*The World of Kong: A Natural History of Skull Island*

Visit the Weta Workshop website for news, online shop, and much more
at www.wetaNZ.com.

*The Hobbit: An Unexpected Journey*
*Chronicles: Art & Design*

*The Hobbit: An Unexpected Journey*
*Chronicles: Creatures & Characters*

**COMING SOON**
*The Hobbit: The Desolation of Smaug*
*Chronicles: Cloaks & Daggers*

# THE HOBBIT™

## THE DESOLATION OF SMAUG

CHRONICLES ✦ ART & DESIGN

INTRODUCTION BY ALAN LEE

FOREWORD BY RA VINCENT
WRITTEN BY DANIEL FALCONER

HARPER DESIGN
An Imprint of HarperCollinsPublishers

www.wetaNZ.com

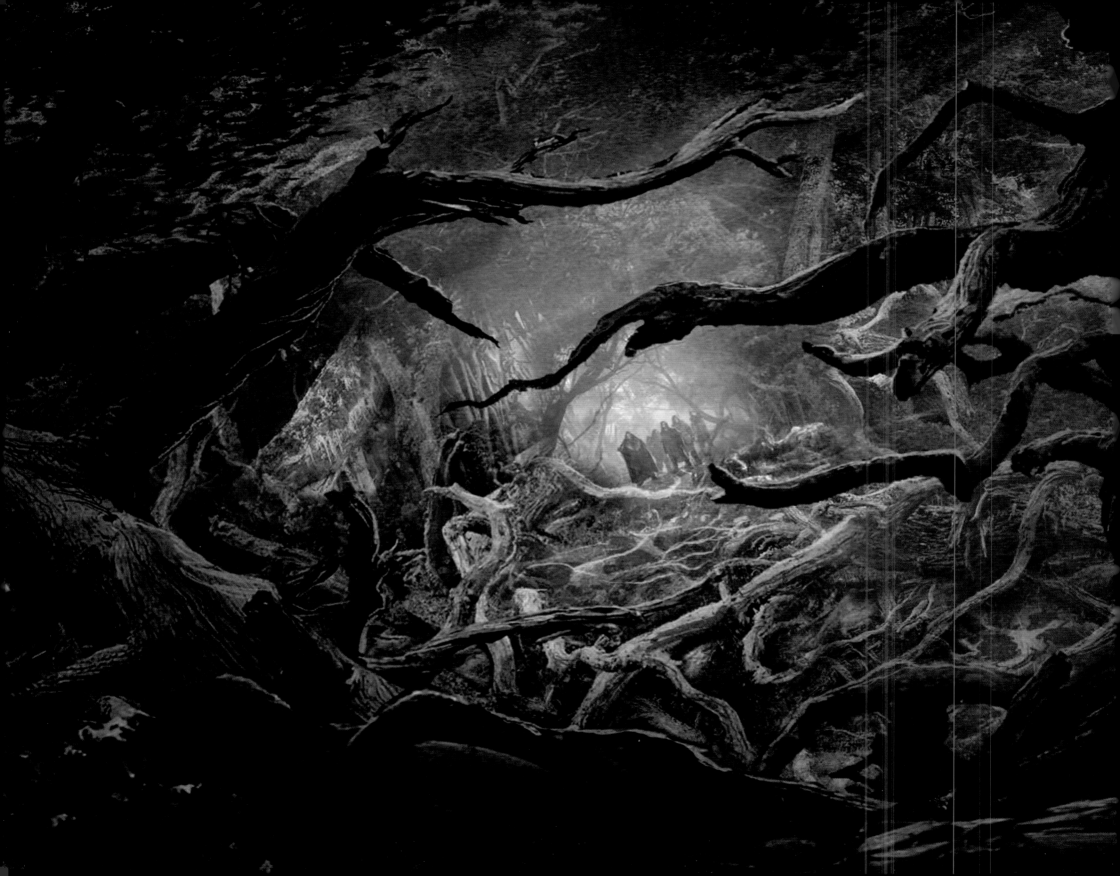

# CONTENTS

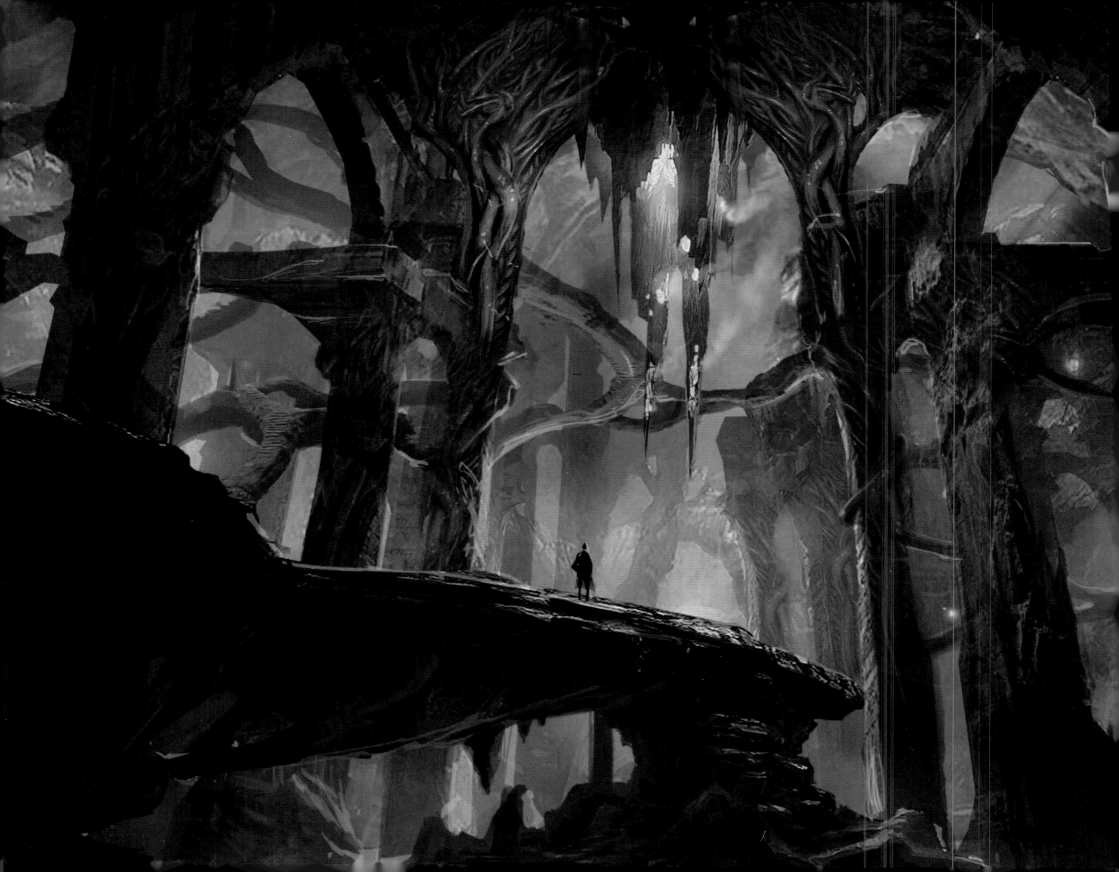

# Acknowledgements

As Bilbo Baggins and his Dwarf companions journey ever deeper across Wilderland on their Quest to reach the Lonely Mountain, they travel through an ever-changing landscape peopled by unique inhabitants, hitherto-unseen on screen. Such a rich world demanded extensive and thoughtful conceptual development. The teams at 3Foot7 and Wetas Digital and Workshop produced literally thousands of drawings and models in the course of this multi-year exercise. No single book could ever hope to comprehensively gather all that was produced, but it has been our endeavour to provide as rich and as detailed a record of this journey as possible, told through insightful commentary by the artists themselves.

A book of this sort can only happen through the goodwill and generosity of said artists, as well as all those who helped shape and protect their vision. It is therefore with the deepest sincerity that I wish to take a moment to express my appreciation for the many people who have made it possible.

Peter Jackson, Fran Walsh and Philippa Boyens have been our guides in Middle-earth, permitting me creative freedom to explore and chart its countless nooks and crannies in undreamed-of detail, for which I am deeply grateful. I have so enjoyed running around in their world, and have done so with the aid of a wonderful team. Thanks to Weta Publishing's fabulous Kate Jorgensen and Monique Hamon, the most delightfully good-natured and patient colleagues any author could hope to work alongside, and to Chris Smith, David Brawn, Terence Caven, Charles Light and the team at HarperCollins*Publishers* UK whose experience, perspective and support we have relied upon most heavily in this series.

I am deeply thankful to our allies at 3Foot7, Judy Alley and Melissa Booth, for their tireless support, advice and thoughtfulness. I can't imagine trying to work on such a project without the assistance we have enjoyed from 3Foot7. Sincere thanks also to Wingnut Films' Matt Dravitzki and Amanda Walker, and to Alan Lee and Ra Vincent for their respective Introduction and Foreword, produced for us in the midst of trying to meet the weighty demands of pick-up filming on *The Hobbit: The Desolation of Smaug* and *There and Back Again.*

We at Weta Publishing have been blessed with supportive and enthusiastic champions at Warner Bros. among whom Jill Benscoter, Susannah Scott, Elaine Piechowski, Victoria Selover and Melanie Swartz are owed special acknowledgement. Many other people across all the related companies associated with *The Hobbit* have also assisted us in gaining access to both personnel and assets in the course of the creation of the Chronicles series and key individuals are named in full in the credits section at the back of this book.

Within Weta Workshop I have enjoyed unparalleled trust and freedom to craft these books thanks to Richard Taylor, Tania Rodger and Tim Launder. I appreciate the confidence each of these key people within Weta has shown in our team and for championing our initiative beyond the company walls.

In any project there must come times when deadlines bite and weekends and evenings away from work tend to become luxuries eschewed. At these times an author leans heavily on their family and I could not wish for more support in this regard. Thanks to my dear wife, Catherine, and daughters Anushke and Bree for being so understanding when I am absent in mind or body.

Finally, as this book is all about celebrating ideas, let me acknowledge the minds behind those ideas, the artists without whom I would have no stories to tell or art to show. Thanks to everyone who took time away from their demanding work to share their insights and stories with me, for their trust and for sorting through mountains of artwork to choose favourites. I hope you can be proud of the result, as presented. Not everyone who worked on the film has work in this final edit of the book. Inevitably, due to the limits of page count, some things cannot be included, and to those artists I express my gratitude for their understanding.

What I hope we have achieved with this Chronicle is a deep and rich volume that offers a peek through the window into the creative reservoir that has nurtured the visual development of *The Hobbit: The Desolation of Smaug*. This isn't everything and we have much, much more to share in the course of this book series, but for now I hope every reader, be they new to Middle-earth or a long-time resident, will be inspired by the tales, ideas and artistry shared herein.

Thanks everyone.

**Daniel Falconer**

# FOREWORD

As a creative industry the film business depends upon the harnessed talents of many inspired dreamers and arts practitioners. The design offices and workshops of *The Hobbit* are especially well populated with these gifted artists, whose skills and experience have been essential in helping to deliver Peter Jackson's vision as director.

In an adventure this enormous, everything must go through the same process: from the tiniest piece of decoration on a costume or hand prop to the details of every vast city. They all start off at the same conceptual beginning, then through practical design and creation phases before their considered and deliberate delivery to the film set.

Working on this project alongside some of my design and film-making heroes has truly surpassed my expectations. I've also had the pleasure of working with contractors from a huge range of disciplines. I can't think of another job in which a person might get to work with a painter, sculptor, glass-blower, potter, saddler, cutler, jeweller, calligrapher, boat-builder, wheelwright, tinker, farrier, book-binder

and weaver – the list is as long and varied as the world we helped create and the passion that each has for their craft has enhanced Peter's cinematic adaptation of Middle-earth to a previously undreamt of degree of sophistication and detail. The world of *The Hobbit* looks real thanks in no small part to their combined talents.

The making of *The Hobbit* has also helped revitalize the arts and crafts of many of New Zealand's small artisan businesses and confirmed that, although we may be a tiny group of islands in the Pacific, our product can be global.

This beautifully collated book of images and stories about the design of the second film celebrates a little of what these people achieved. I hope that it inspires creative urges in its readers to dream big.

**Ra Vincent,**
**Set Decorator**

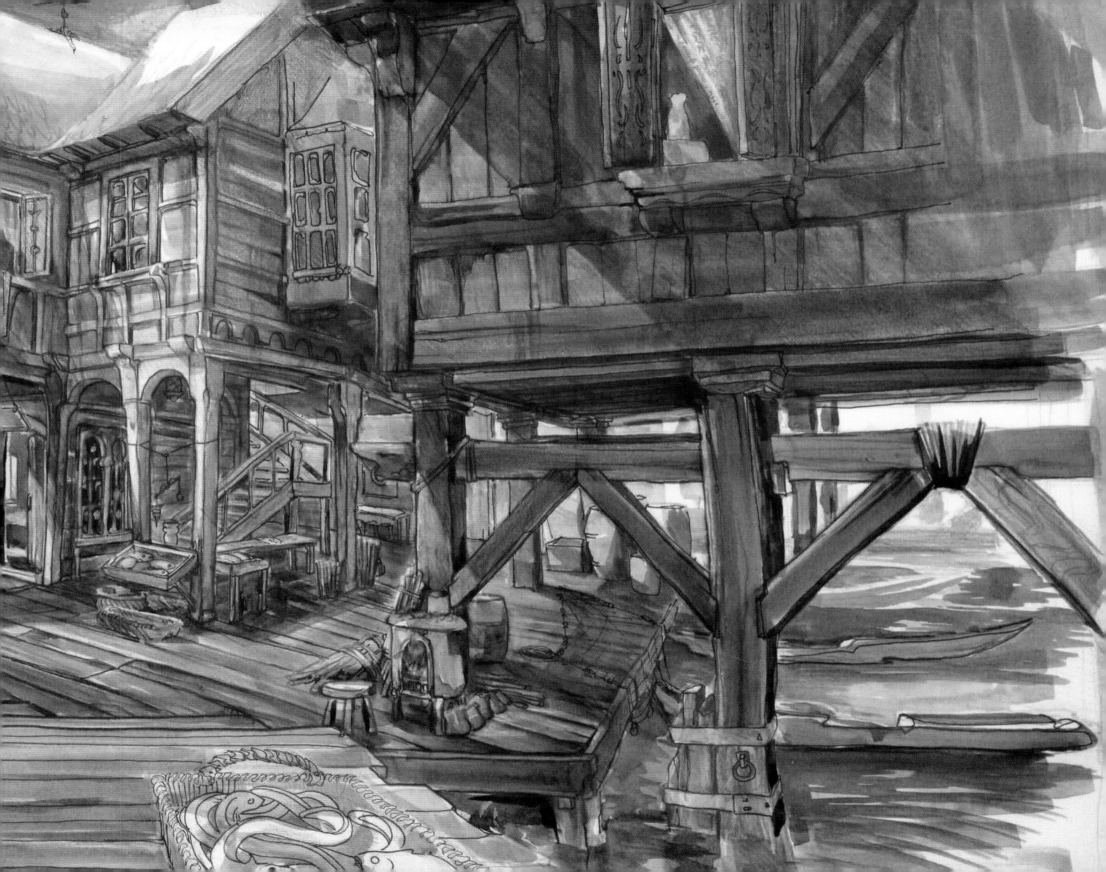

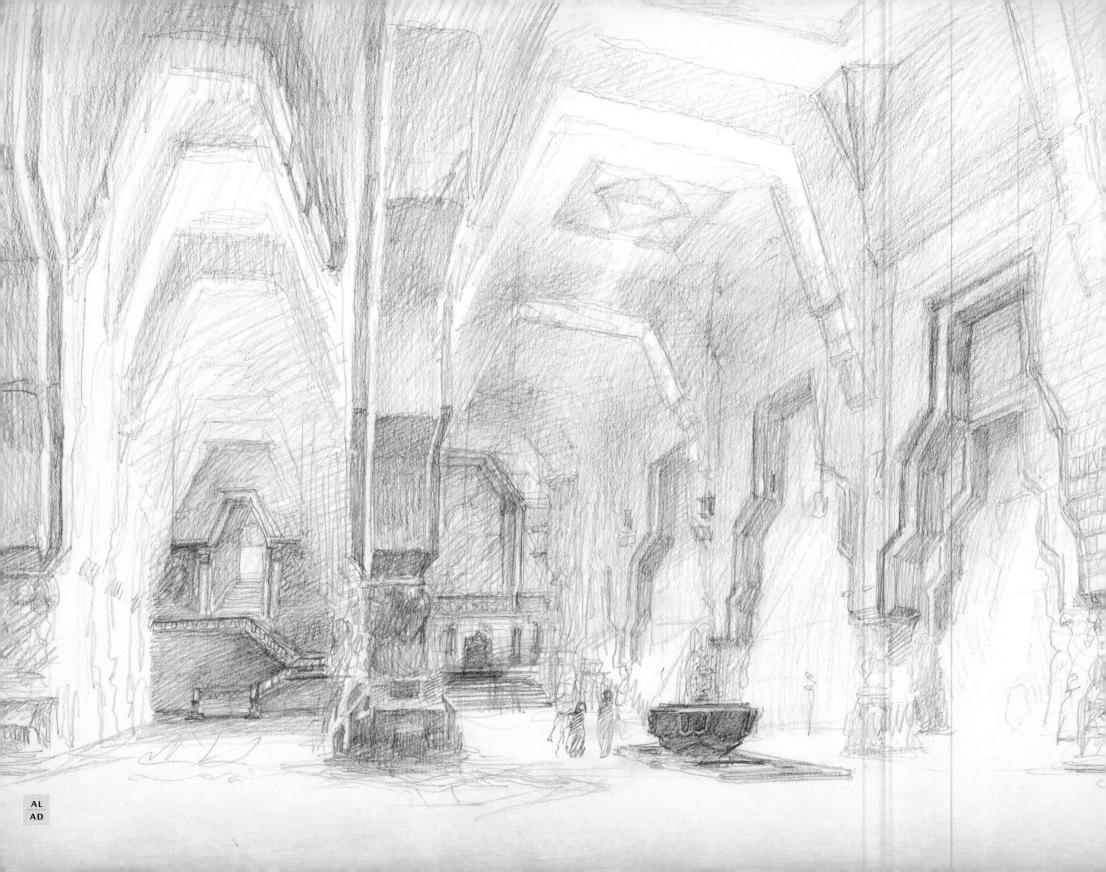

# INTRODUCTION

At the end of *The Hobbit: An Unexpected Journey* we left our gallant Company of thirteen Dwarves, a Wizard and one hobbit at the Carrock, safely delivered from both frying pan and fire, and a deadly attack by Azog and his Hunter Orcs, looking across a vast landscape with a tantalizing glimpse of the Lonely Mountain on the far horizon. This was followed by an even more tantalizing glimpse of Smaug, basking in his hoard of treasure, a foreboding hint of what was to come.

Staring east with Thorin and Bilbo we found ourselves looking at an expanse of Middle-earth that we hadn't visited before in *The Lord of the Rings* trilogy, with all the opportunities that presented for our design teams – vast, uncharted territory for us to explore.

As always, the first points of reference as we began imagining what lay ahead were the texts, both Tolkien's beautiful story and the films' scripts, which were constantly developing, shifting in emphasis and incorporating fresh ideas, a process that continues through shooting, post-production and editing.

The writers have been very generous in the wealth of ideas, environments, creatures and characters they have given us to work with, rich material for us to visualize. Tolkien thoughtfully provided another ancient, atmospheric forest – formerly Greenwood the Great, but now overgrown, decaying and full of perils, and known as 'Mirkwood'. And then there were the creatures and strange archetypal characters that live in it or on its borders: Beorn, the Werebear, the Wizard Radagast the Brown, Wood-elves, huge spiders and the Necromancer now inhabiting the ruined fortress of Dol Guldur.

Beyond the eastern border of Mirkwood lay the Long Lake and Lake-town, a rare human settlement in these distant and dangerous lands, within sight of the Lonely Mountain and the barren lands around it known as 'The Desolation of Smaug'.

There, beyond the ruined city of Dale, lies Erebor, lost kingdom of the Dwarves, with its occupant, the last and most fearsome Dragon in Middle-earth.

There were so many new areas for us to explore, offering the designers and fabricators in the Art Department, Costume and Make-up Departments, Weta Workshop and Weta Digital wonderful opportunities to stretch their imaginations, as well as test their skills with the added challenges brought about by the use of 3D and the higher resolution of 48 frames per second. As you will see, these challenges have been met with great energy, ingenuity and vision. By the time this book goes to print, most of us will have been working on *The Hobbit* film trilogy for four or five years, and yet it seems that there are still new things to design every day. The physical sets, props and costumes need to be replicated as computer models, and expanded upon as the wonderful cast, extras and stunt performers are joined by hordes of computer-generated characters and creatures in their carefully crafted digital environments.

What you will find in this book is a relatively small selection from the huge body of work that has gone into the visualization and production of *The Hobbit: The Desolation of Smaug*, but I think it conveys the flavour of excitement and ideas that have been, and continue to be, shared by all of us who are fortunate enough to work on these films.

**Alan Lee,**
**Concept Art Director**

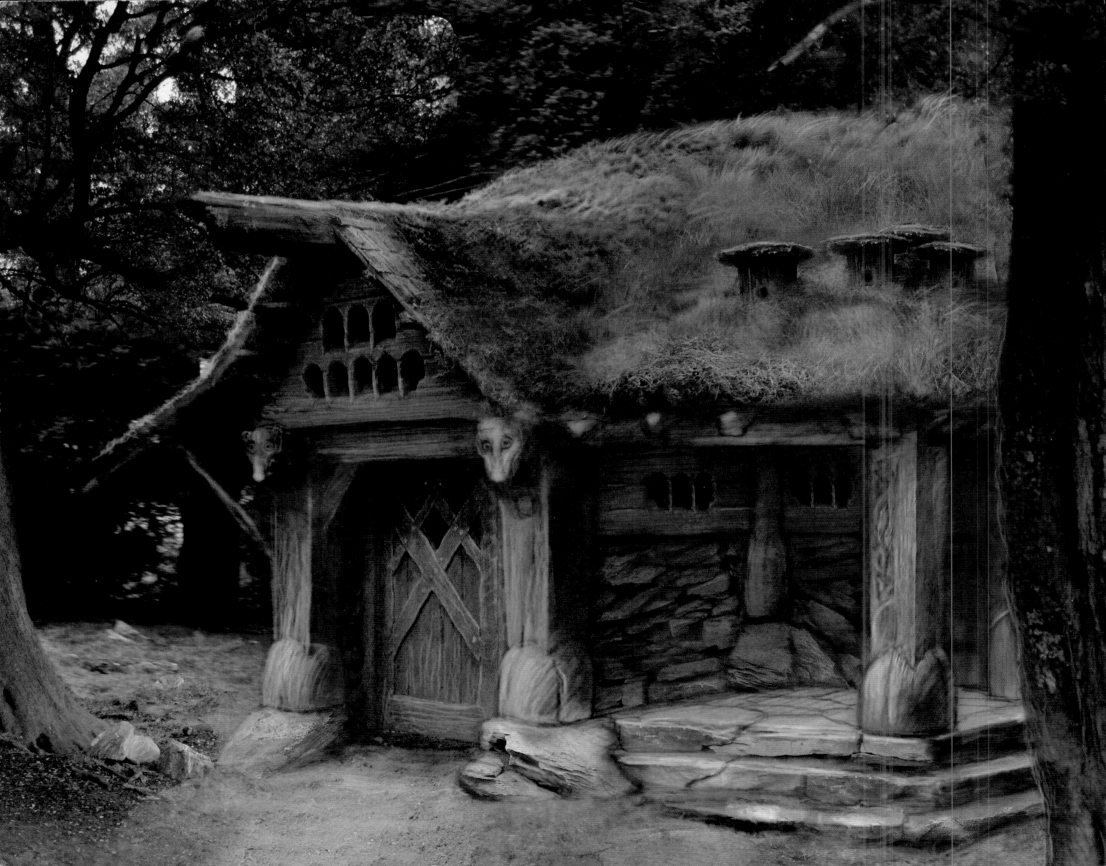

# QUEER LODGINGS

## HOUSE GUESTS OF BEORN THE SKIN-CHANGER

At the beginning of the second installment of *The Hobbit* the Dwarves and Bilbo make with all speed for the hedge-walled holding of Beorn. An enemy of Wargs and Orcs, Beorn should be a friend to the bedraggled Company, but the grim hermit is mysterious enough to keep everyone on their guard. Even the usually confident Gandalf does not let down his guard when they seek shelter in Beorn's unusual home, with its leering carved visages and indoor stabling. Beorn is no ordinary man, but a skin-changer, an ancient giant who is loyal to none but himself and the animals in his care, and who is none too trusting of Dwarves or wayward travellers who stray into his lands and home.

The visuals of Beorn's idyllic property were achieved as a combination of studio set and two locations with some digital enhancements. Being of abnormally large proportions, Beorn's home was built to an impressive scale, with towering doorways, lofty table surfaces and windows far above average eye height. Walking into the oversized set imposed a perspective on the visitor normally appreciated only by a toddler.

Unaccustomed to having house guests, the host's home is comfortable, but not necessarily welcoming. Its unique style would offer the Art Department's carvers ample opportunity to show off their impressive skills, filled as it was with intricately carved surfaces and features, the work of an obsessive craftsman.

Meanwhile, Beorn himself presented a double design challenge. Given that the actor Mikael Persbrandt would appear in the form of man and bear, he required dual forms for his costume, make-up and hair designs.

JH
AD

# BEORN

## BEAR CREATURE DESIGNS

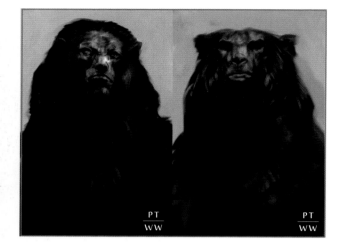

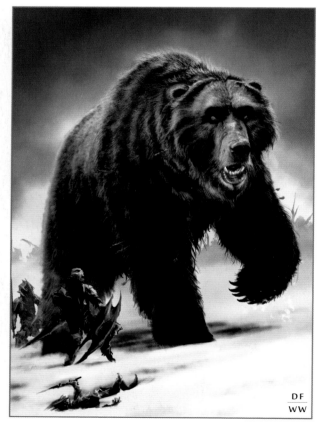

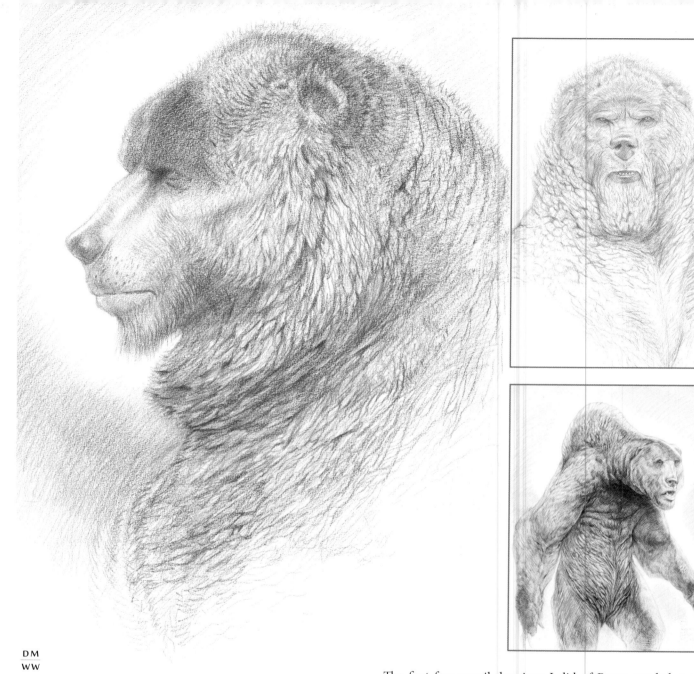

To me, Beorn was not a monster like an Orc or Troll. He was the personification of nature at its most majestic and savage, so my first concept depicted him as a huge silver-tinged bear, terrifying and unpredictable, but nonetheless noble and beautiful in the way a great big grizzly or Kodiak bear is.

**Daniel Falconer, Weta Workshop Designer**

The first few pencil drawings I did of Beorn tended more towards noble, anthropomorphic bears, which looked brooding, majestic and thoughtful in repose, but had the capacity to be terrifying when angered. Most predatory mammals look downright 'cuddle-adorable' when not scaring down prey, so it was a challenge to make Beorn look sufficiently intimidating in a neutral expression.

**David Meng, Weta Workshop Designer**

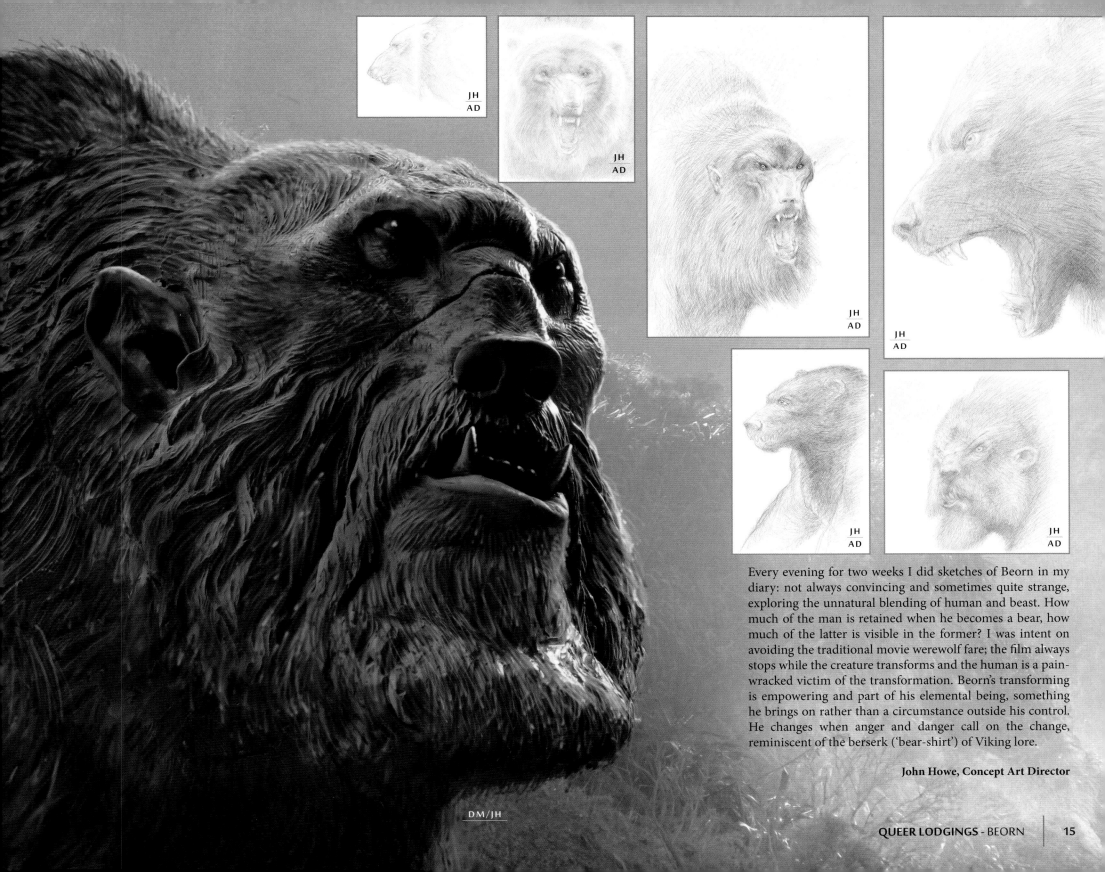

Every evening for two weeks I did sketches of Beorn in my diary: not always convincing and sometimes quite strange, exploring the unnatural blending of human and beast. How much of the man is retained when he becomes a bear, how much of the latter is visible in the former? I was intent on avoiding the traditional movie werewolf fare; the film always stops while the creature transforms and the human is a pain-wracked victim of the transformation. Beorn's transforming is empowering and part of his elemental being, something he brings on rather than a circumstance outside his control. He changes when anger and danger call on the change, reminiscent of the berserk ('bear-shirt') of Viking lore.

**John Howe, Concept Art Director**

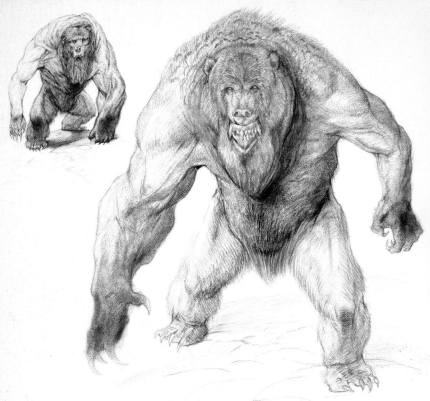

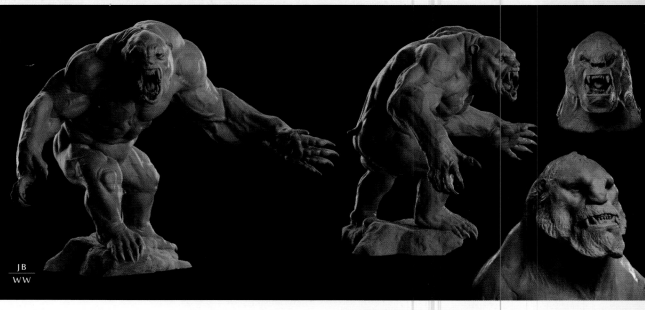

Peter was keen to explore extremes, so for a while our brief was to make Beorn a monstrous, asymmetrical figure, which was fun to draw. It was great to give him a wiry little arm on one side, and a massive tree trunk of a limb on the other. It was also important for us to really play around with proportions, to avoid anything that too closely resembled the human form.

**David Meng, Weta Workshop Designer**

We had all produced earlier conceptual pieces to resolve what Beorn might look like. Gus Hunter and Nick Keller had done some illustrations that Peter had liked (*bottom*). Jamie Beswarick and I were then asked to work up some maquettes, physically (*above*) and digitally (*below, right*). We explored anatomical possibilities, showing Beorn standing on two legs, on all fours or walking like a primate. I also looked at the face, combining the fierce nature of the bear with the character he is when in human form.

**Andrew Baker, Weta Workshop Designer**

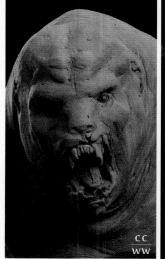

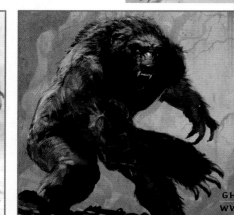

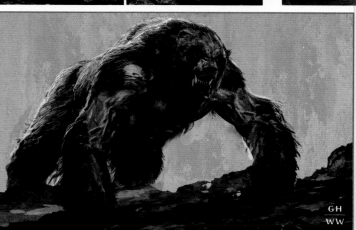

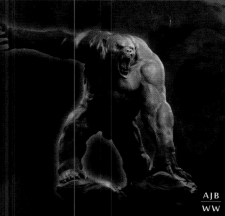

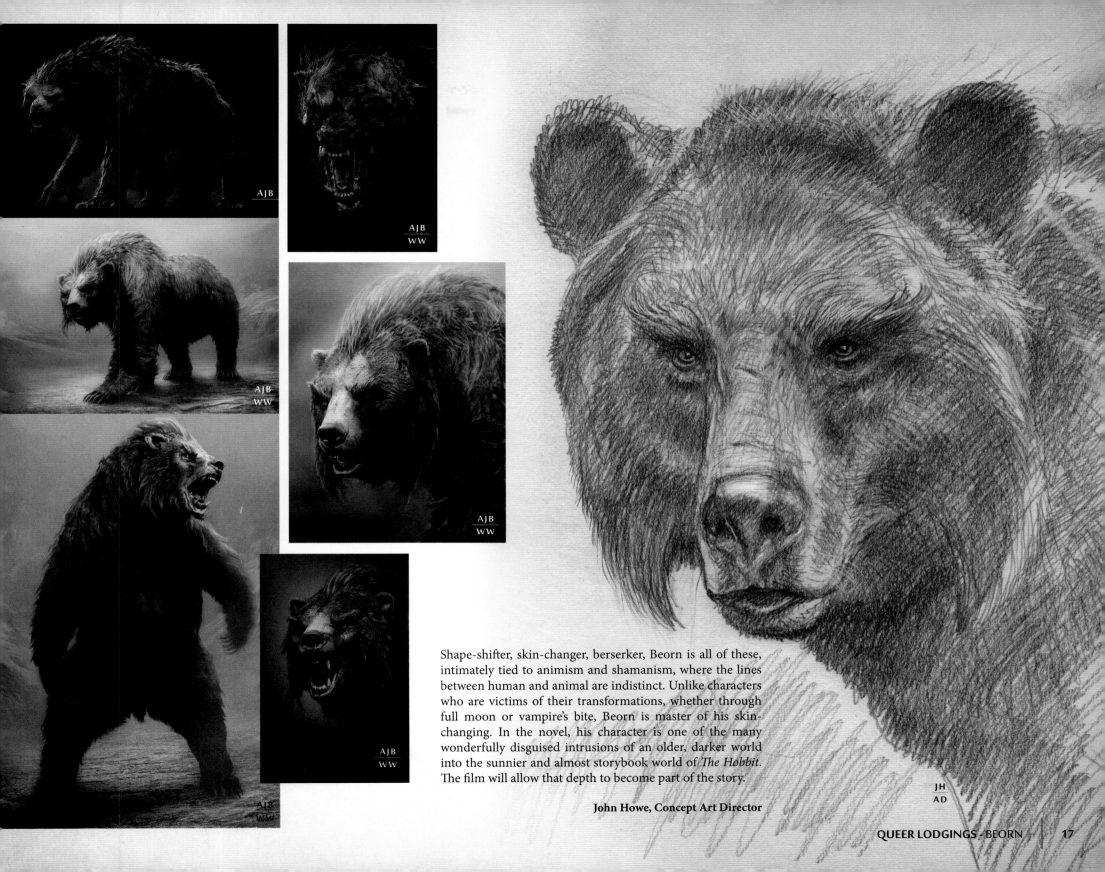

Shape-shifter, skin-changer, berserker, Beorn is all of these, intimately tied to animism and shamanism, where the lines between human and animal are indistinct. Unlike characters who are victims of their transformations, whether through full moon or vampire's bite, Beorn is master of his skin-changing. In the novel, his character is one of the many wonderfully disguised intrusions of an older, darker world into the sunnier and almost storybook world of *The Hobbit*. The film will allow that depth to become part of the story.

**John Howe, Concept Art Director**

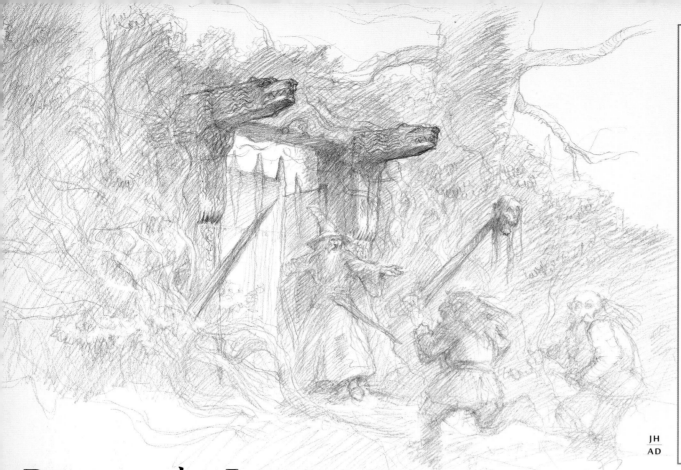

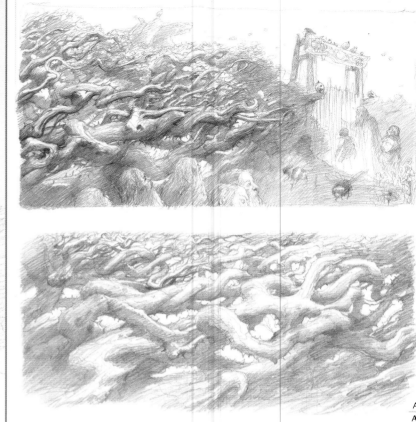

# BEORN'S LANDS

In J.R.R. Tolkien's book, Beorn's home is described as having a thorn hedge. There are beehives and giant bees, giant cows and oversized goats and pigs. The idea was that this was a slightly enchanted place. Step through the gate and you have entered another world where everything exists at a slightly different scale, a lovely fairytale feeling.

**Alan Lee, Concept Art Director**

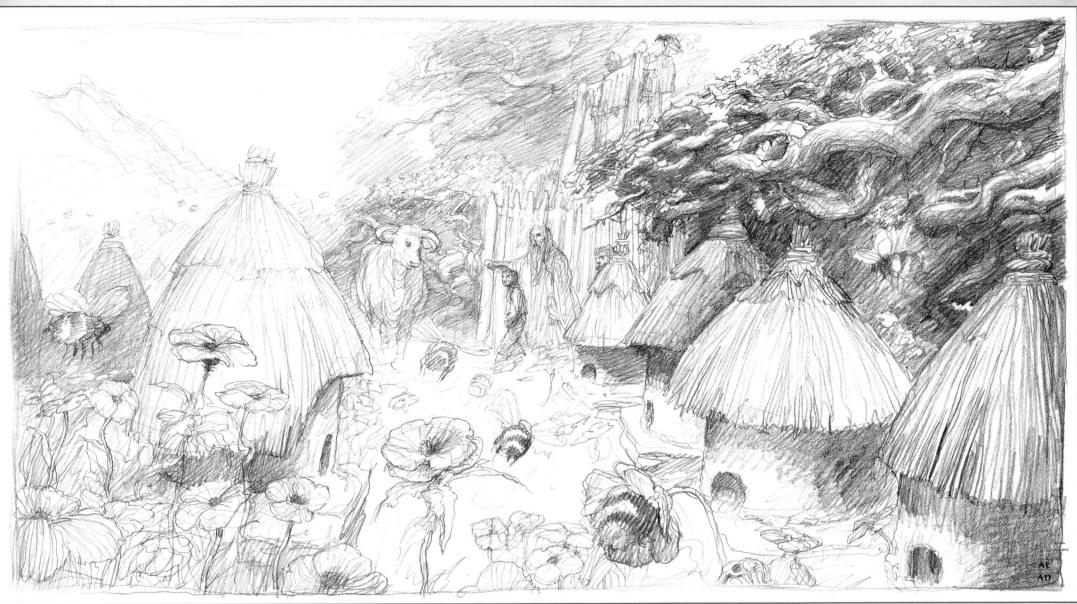

Beorn's thorn hedge surrounds his home like an impenetrable wall. It is so thickly interwoven and tangled that the Orcs and their Warg allies can't get through it without alerting the master of the realm to their intrusion, and few would dare. What the Dwarves find when they seek shelter inside is a world out of proportion to anything they are used to. Beorn is huge, towering over Gandalf, and his entire home has been built to suit his great size, literally dwarfing his guests.

**Dan Hennah, Production Designer**

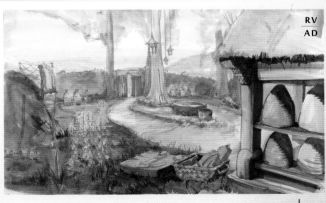

# BEORN'S HOME

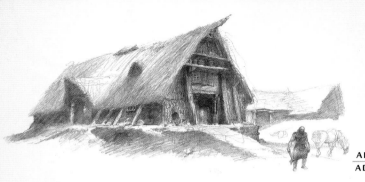

Peter wasn't sold on portraying Beorn's house exactly the way Tolkien describes, which is very much a traditional wooden longhouse, inspired largely by Hrothgar's great hall Heorot, from the *Beowulf* saga. We had seen something like that with Edoras, so it seemed unwise to make a bed-sit version of the Meduseld for Beorn to call his home.

**John Howe, Concept Art Director**

Some early designs for Beorn's home had it built into the side of a hill so that part of the interior would feel as if it was a cave. Others included trees growing into the end of the hall.

**Alan Lee, Concept Art Director**

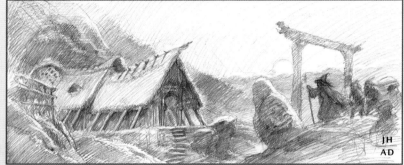

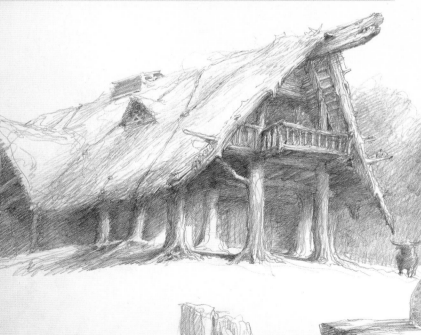

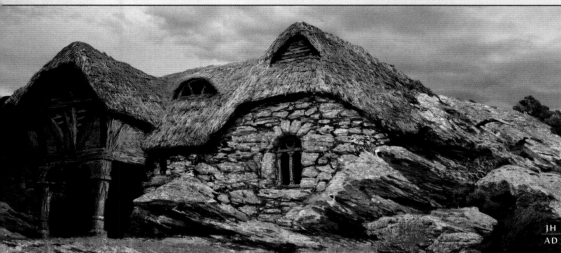

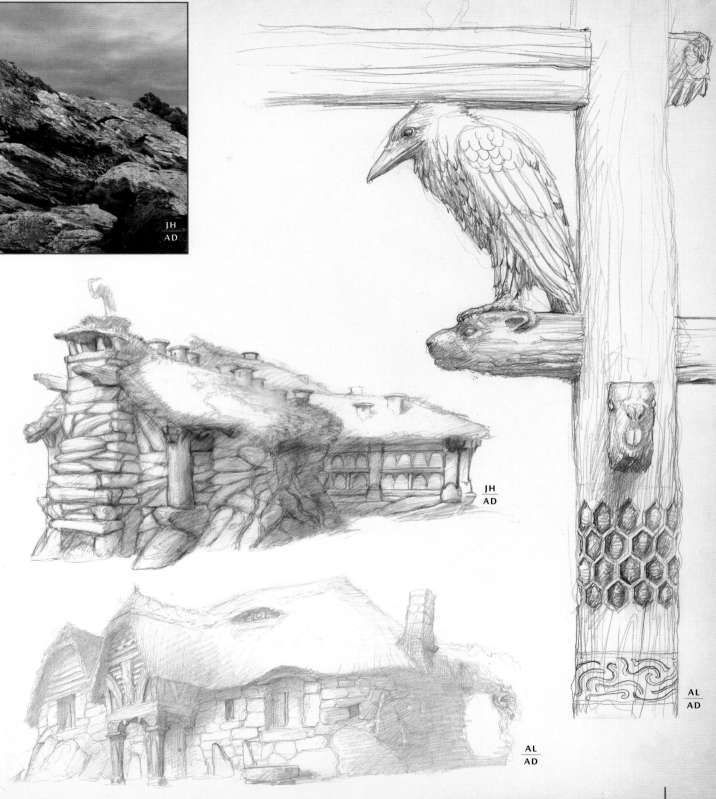

We searched other avenues, designing and redesigning the house half a dozen times until coming to the idea that his home could be built mostly out of rough stone and squared logs set in posts, but with the windows and doors cut straight through the horizontal timber.

If asked to describe Beorn's home as we finally realized it, I would say it was a Haida longhouse built by Vikings on a marae, with stables attached, like a 19th-century farmhouse from the Bernese Oberland.

Its style is predominantly inspired by Norwegian stave churches, Russian wooden architecture and Viking carving. Every sculpted detail is different; I did literally a hundred sketches (or at least it certainly felt like it). Several of the sculptors were Maori, or with a firsthand knowledge of traditional Maori carving. They automatically and naturally brought a touch of their heritage to the set. The result was enchanting. I used to go hang around just to watch them work; I must have made quite a nuisance of myself.

**John Howe, Concept Art Director**

Beorn has been living in this place for a long time, so his house has become rooted in the landscape, just like he has. With a turf roof and huge stones that he has quarried, it almost feels underground, though it's not, and over the years he has richly carved it with imagery from his own history and knowledge.

**Dan Hennah, Production Designer**

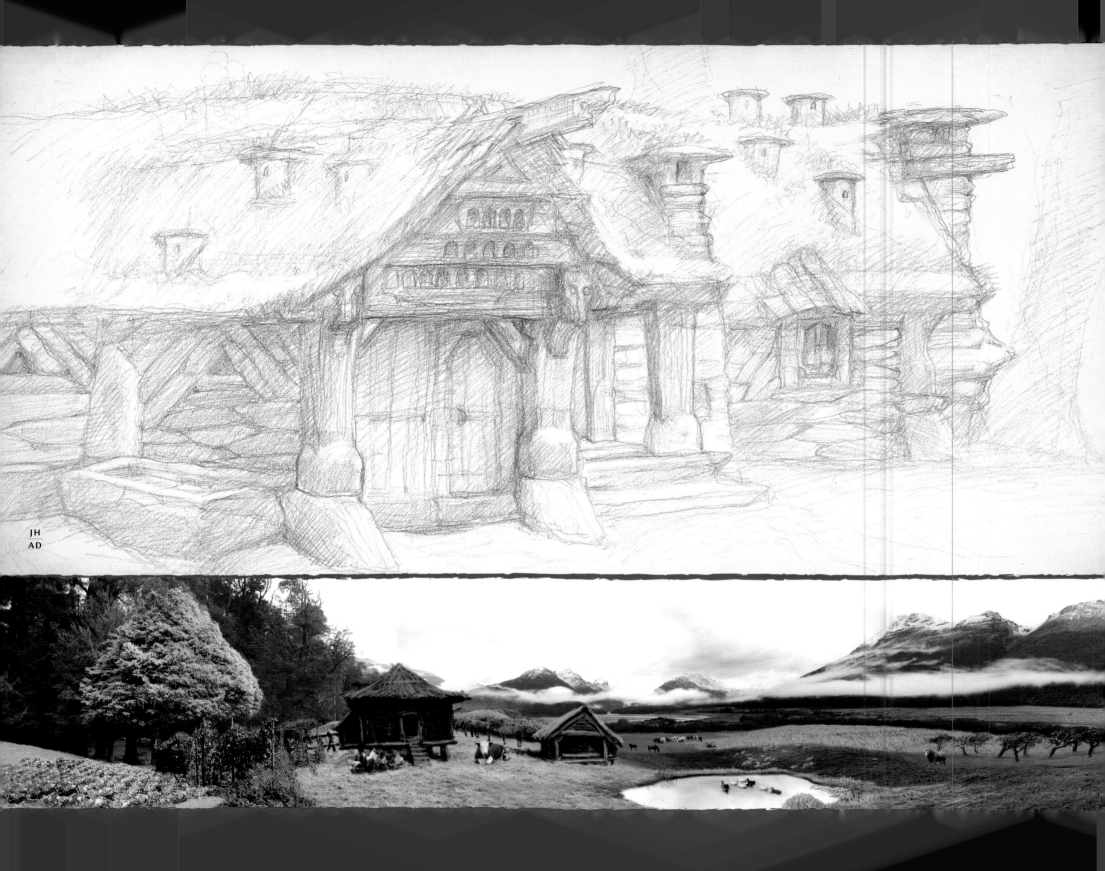

JH
AD

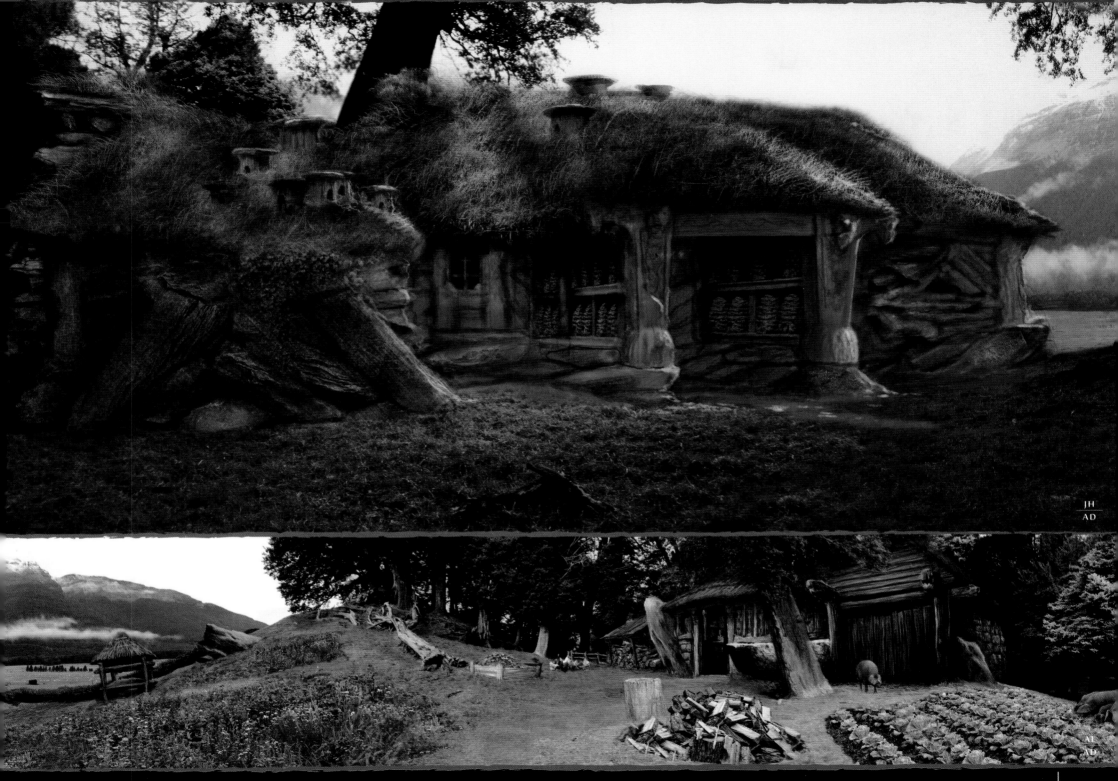

In our design process we use conceptual models, usually built at around 1/16th scale *(below)*. They offer Peter a very effective visualization tool in planning his shots and determining his exact needs, but they also help us resolve how we will build our practical sets within budget and figure out what elements might end up being computer generated.

**Dan Hennah, Production Designer**

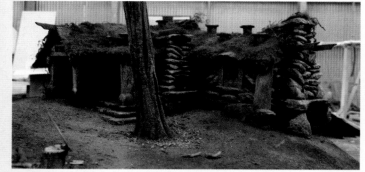

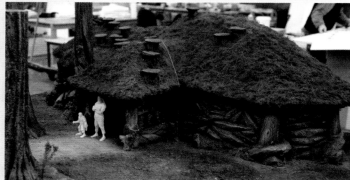

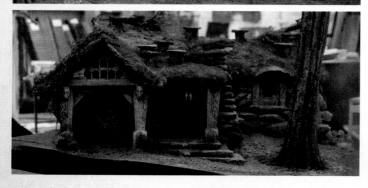

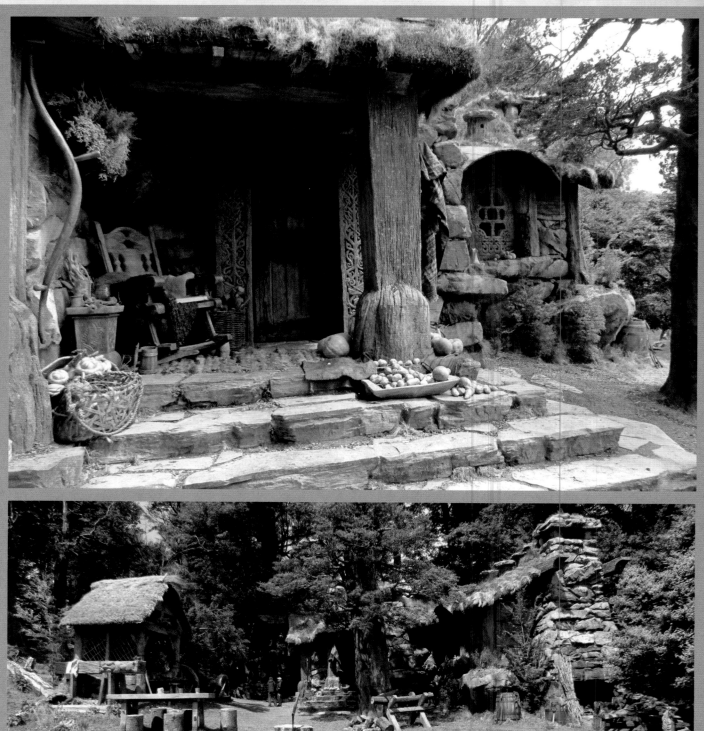

*Above: The final complete and dressed exterior and interior sets of Beorn's home.*

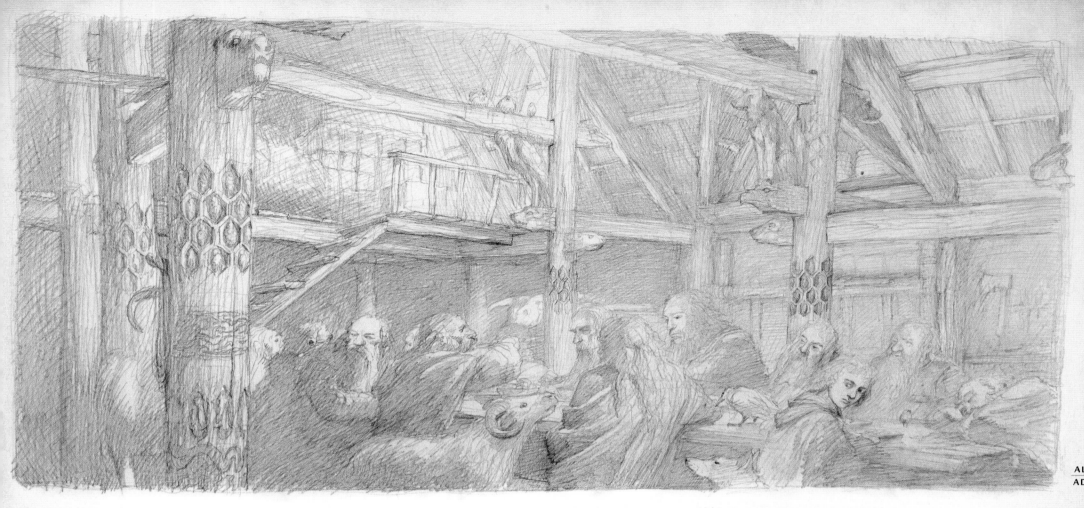

AL
AD

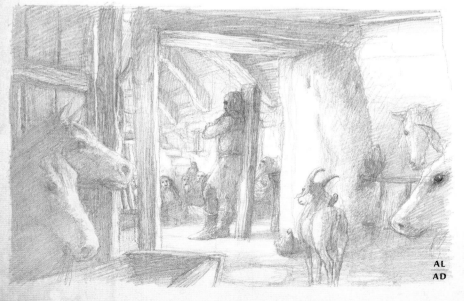

AL
AD

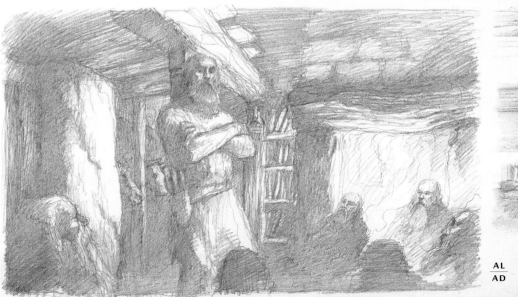

AL
AD

JH
AD

**QUEER LODGINGS - BEORN'S HOME** | 25

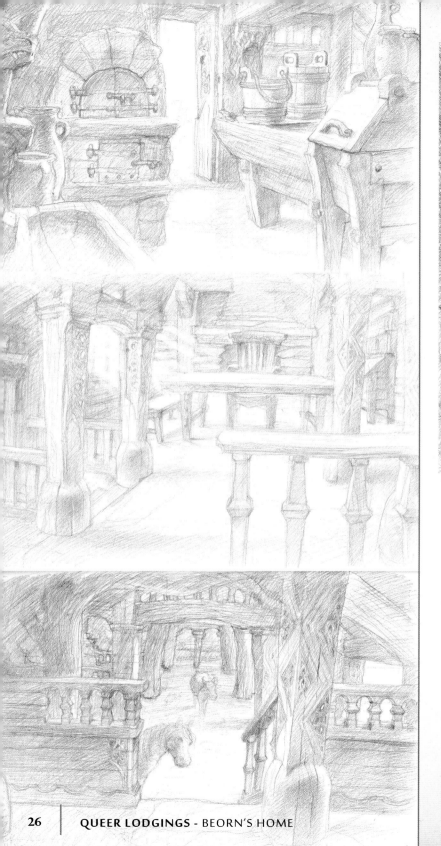

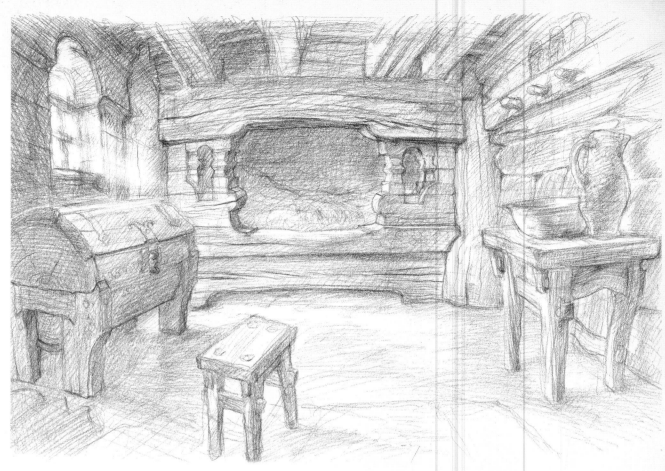

The colours inside Beorn's home are warm, but we stayed with yellows rather than reds, going with the honey theme.

**Dan Hennah, Production Designer**

Beorn's bed is not dissimilar to a cave – walls of stone with the opening carved through the beams of the house.

**John Howe, Concept Art Director**

JH
AD

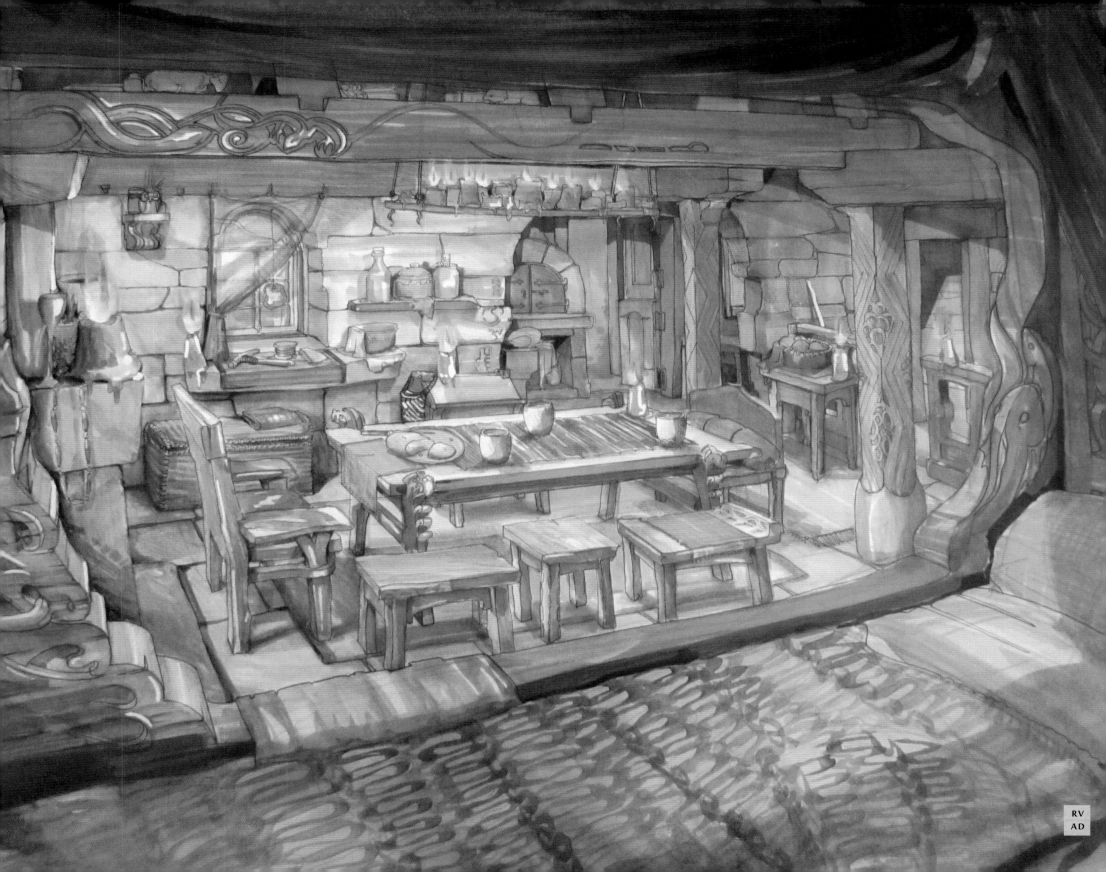

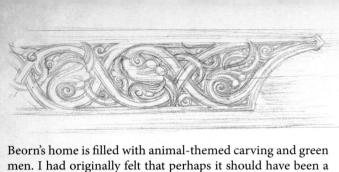

Beorn's home is filled with animal-themed carving and green men. I had originally felt that perhaps it should have been a little more primitive, but it really turned out well and looks like it has been done by a being with a lot of time on his hands and an obsessive character, which fits Beorn.

**Alan Lee, Concept Art Director**

In a sense Beorn's carvings represent him filling the inside with the outside, reinforcing through his musings his connection with nature and his place as the last of his kind – his only companions now are animals. I very much see his carving as improvisation, without planning, he simply starts in one place and carves until the space is full, ignoring the joints between the beams. The doorways have been carved through the logs, rather than traditionally framed and lintelled.

**John Howe, Concept Art Director**

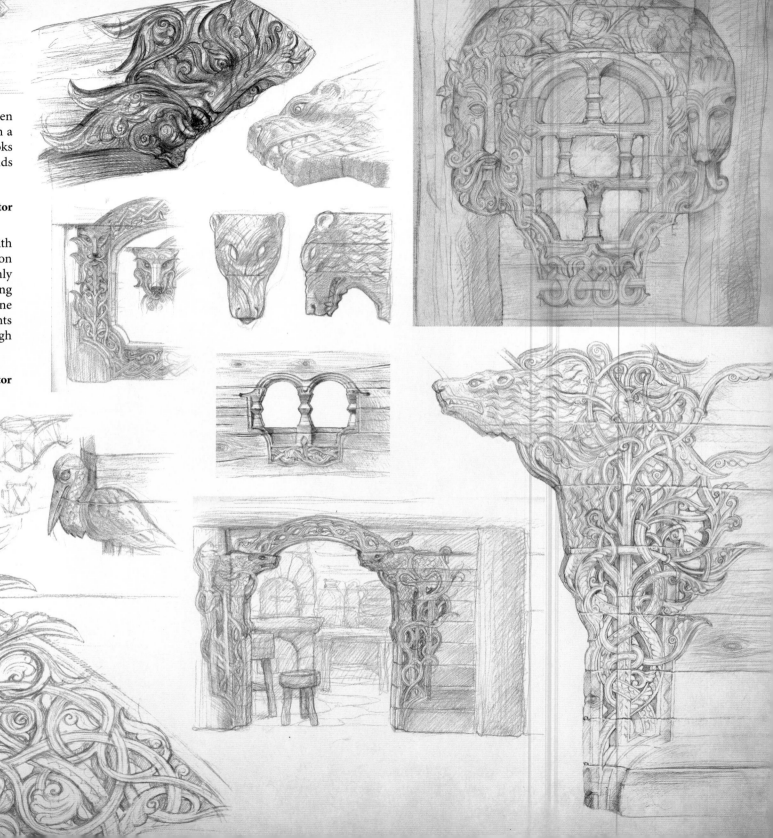

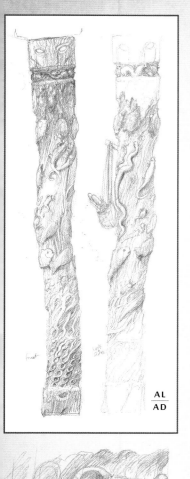

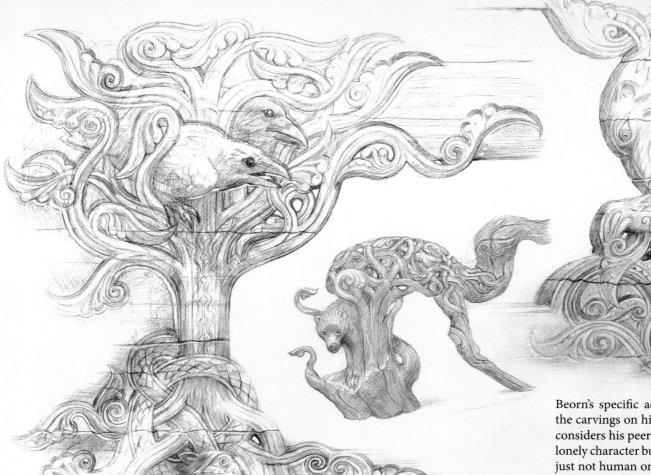

Beorn's specific aesthetic is written in his furnishings and the carvings on his walls. He pays homage to the animals he considers his peers and friends. It is easy to think of him as a lonely character but in truth he is surrounded by companions, just not human ones. We used Beorn's skill as a craftsman to help give a domestic touch as well as the animal qualities. He carves effigies, but he also carves beautiful, functional furniture, and he can weave and knit. These are necessary skills and seeing his handiwork around his house helped temper the animal elements such as his indoor stables, with a human touch.

**Ra Vincent, Set Decorator**

Beorn's hall diverged from the author's precise description, but the carved detailing within is filled with references to the northern European mythology from which Tolkien so dearly loved. Yggdrasil, Nidhoggr, Huginn and Muninn all appear, and the Green Man is an equally constant theme. Carvings echoing Beorn's shape-shifting nature decorate the windows. It was the best way I could find to stay true to the spirit of Tolkien while freely interpreting his description.

**John Howe, Concept Art Director**

# BEORN

## MAKE-UP, HAIR & COSTUME

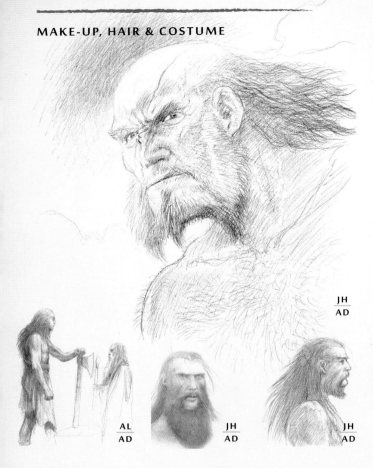

JH / AD

AL / AD          JH / AD          JH / AD

Peter was quite keen that Beorn should appear as something other than just a big human or someone who lived wild up in the mountains. He wanted an element of something animal-like in Beorn because he is a skin-changer. Peter came up with the notion of horse hair, which has some practical issues associated with it from a wig-making perspective that we figured out, but it gave us a unique texture and look. We decided to give him a ridge of hair that would extend all the way down his back when he is shirtless to suggest something more animalistic in him.

Once again, the final design was something that was defined in the make-up chair, using artwork as a starting point, but moving beyond it as you can only do when you are working with real hair and have Peter, Fran and Philippa there in person, reacting to it.

**Peter King, Make-up and Hair Designer**

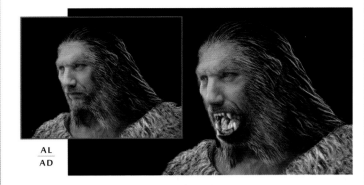

AL / AD

My contribution to Beorn was a design in which I added a little nose-piece which Peter liked. It was a subtle prosthetic which gave him a little bit of an animal look without pushing it too far.

**Alan Lee, Concept Art Director**

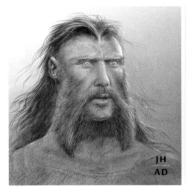

JH / AD

PK / DF
MD / WW

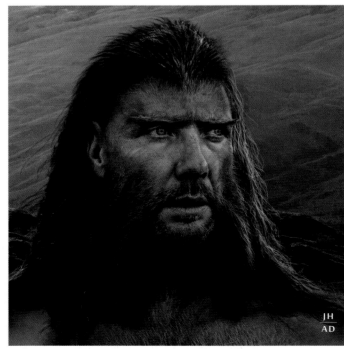

JH / AD

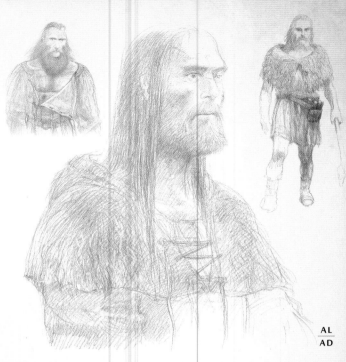

AL / AD

Beorn's hair became a mane that grew down his back, adding to his animal element without making him beast-like. His garments are simple and rough, with folk motifs meant to echo the culture of the Beornings.

**John Howe, Concept Art Director**

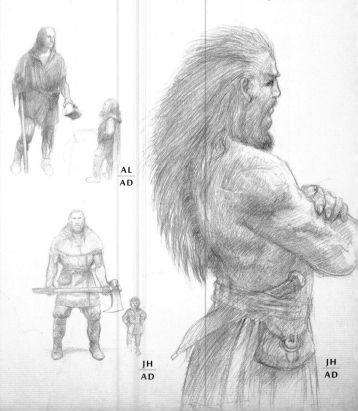

AL / AD

JH / AD          JH / AD

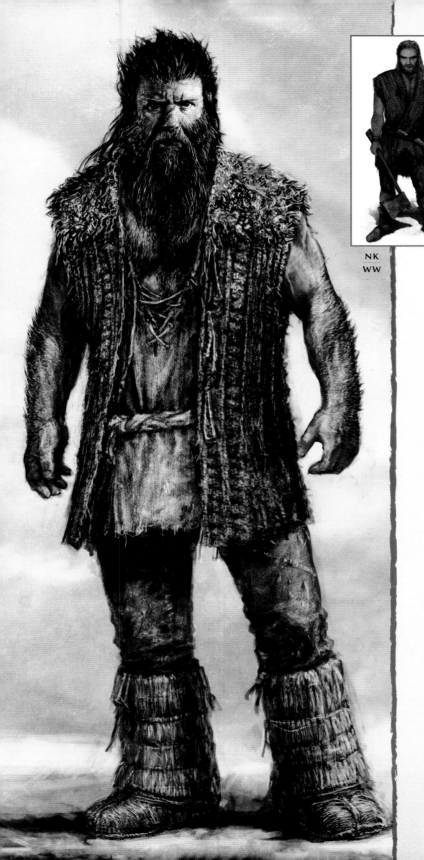

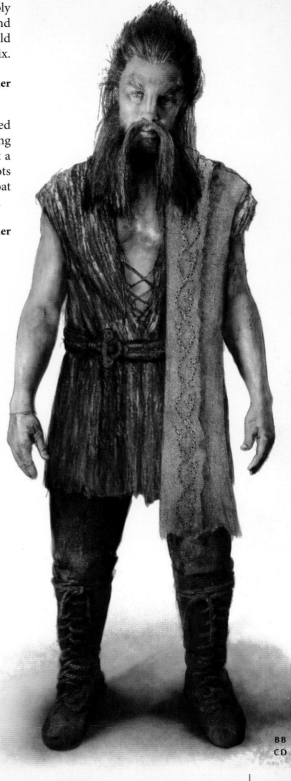

Beorn is a huge, hulking character, so there should probably be a simplicity to his garments, but it is a fine line to find because he is not unsophisticated. He isn't just a crazy wild man living in the woods, so we had to find just the right mix.

**Nick Keller, Weta Workshop Designer**

Beorn would go through many permutations as we tried to find exactly the right look for him. Because his clothing couldn't use animal skins or fur, we had instead looked at a heavy linen for his shirt and silk for his trousers. His boots could be canvas rather than leather and we had a waistcoat that was a bonded fabric, textured to look like beaten bark.

**Ann Maskrey, Costume Designer**

The challenge of Beorn's costume was to portray a sense of culture whilst still remaining rustic, earthy and masculine. A friend to all animals and a strict vegetarian, Beorn would only use natural materials gathered without the need for the sacrifice of animal life. We wanted to make sure what he wore looked like something he would have made himself, so we wove together linen from flax and wool, presumably from his goats and sheep, threaded between a network of twines to create a unique, homespun feel. We gave him a kind of wrap with a decorative motif *(right and below right)*, suggesting a certain level of sophistication. We experimented with samples of stitching and felting to find a design that was integrated into fabric more like a texture rather than applied on top.

**Bob Buck, Costume Designer**

NK
WW

AM
CD

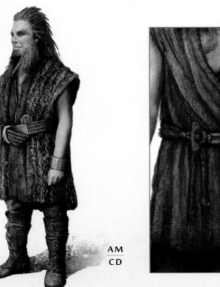

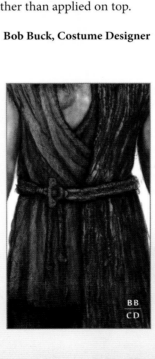

AM
CD

BB
CD

BB
CD

# BEORN'S PROPS

*Above: Beorn's chair, table and other props in situ on set.*

Beorn was nearly twice the size of a Dwarf, so we had to scale everything of his by a factor of 1.86. His table sat at my shoulder height and the top was six inches thick. Beorn's things were all conceived to be something he could craft using the set of tools that he had, and be practical. Unlike the Dwarves or Elves, the forms are simple, but he would then sit down in his idle time and whittle the most beautiful carved decoration into them.

**Nick Weir, Prop Master**

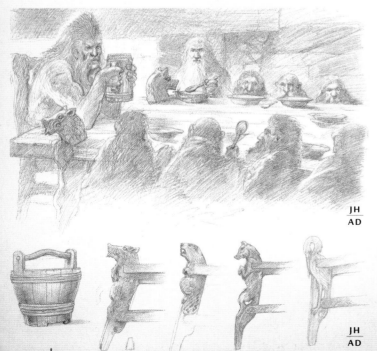

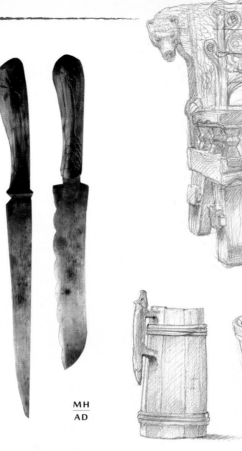

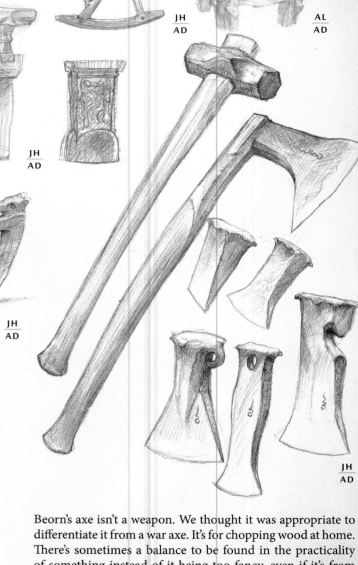

Beorn takes no meat and has beehives and gardens, but as he is a grudging host it's not at all certain that he will be friendly toward the Dwarves. Even Gandalf is unsure of how they will be received. The gate in the hedge, through which Gandalf ushers them in some haste, is surmounted by spikes and framed by the profiles of leering beasts. Once inside, the Dwarves are … dwarfed. They can barely get their elbows over the edge of the table and the drinking jugs are as big as small barrels. Beorn's great wooden chair is carved with snarling bears. His bed is set into the wall, like a bear's den. Everywhere there are carved faces of creatures baring their teeth at the Dwarves. You could outstay your welcome here and it might very quickly become decidedly unpleasant. Beorn isn't accustomed to being a host, so while there are places for his animals, there is nothing to accommodate other guests – especially in such numbers, and unexpected.

**John Howe, Concept Art Director**

Beorn's axe isn't a weapon. We thought it was appropriate to differentiate it from a war axe. It's for chopping wood at home. There's sometimes a balance to be found in the practicality of something instead of it being too fancy, even if it's from Middle-earth, so we made a simple, really good practical axe. The actor, Mikael Persbrandt, used it on location in Paradise to chop wood, which it did very effectively.

**Nick Weir, Prop Master**

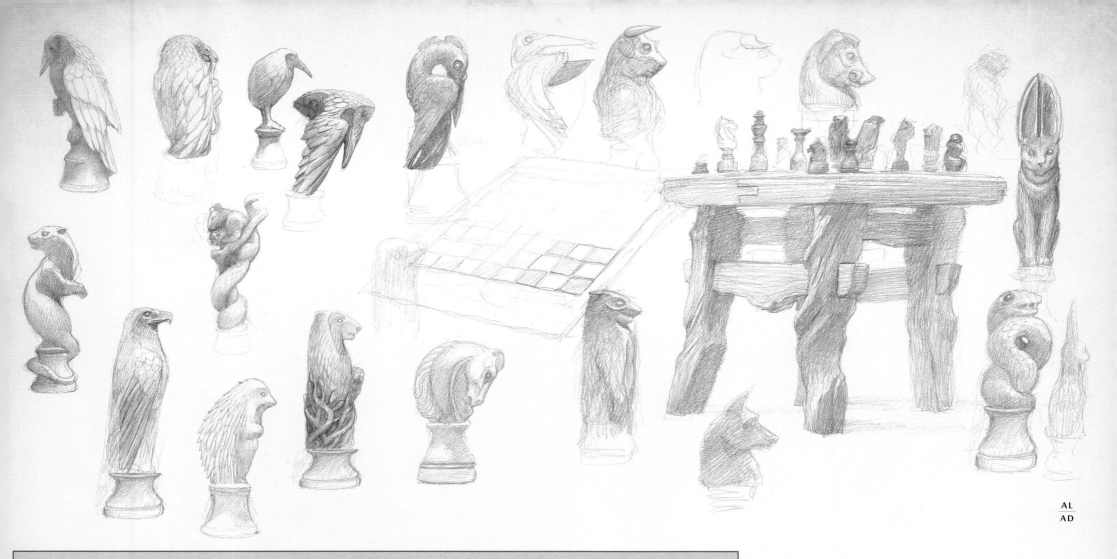

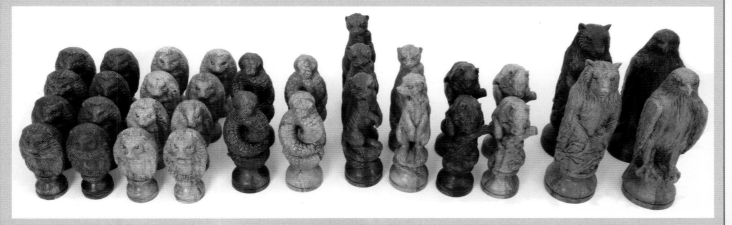

The idea behind Beorn's carved wooden chess set, quite apart from the simple charm of having something so delightful and personal in his home, was to have an artefact that Bilbo could bring home with him as a souvenir, and indeed one of the pieces can be seen in a chest in Bag End. Because of Beorn's identification with the animal kingdom it felt appropriate that all the pieces would take the form of different animals: a bear, an eagle, a hedgehog, a squirrel, snake and others. The squirrel was a bishop, the hedgehog a pawn. The sculptors did a beautiful job of making them and they received a beautiful close-up in the film, which was very gratifying.

**Alan Lee, Concept Art Director**

*Above: The full complement of final chess piece props created for Beorn's home.*

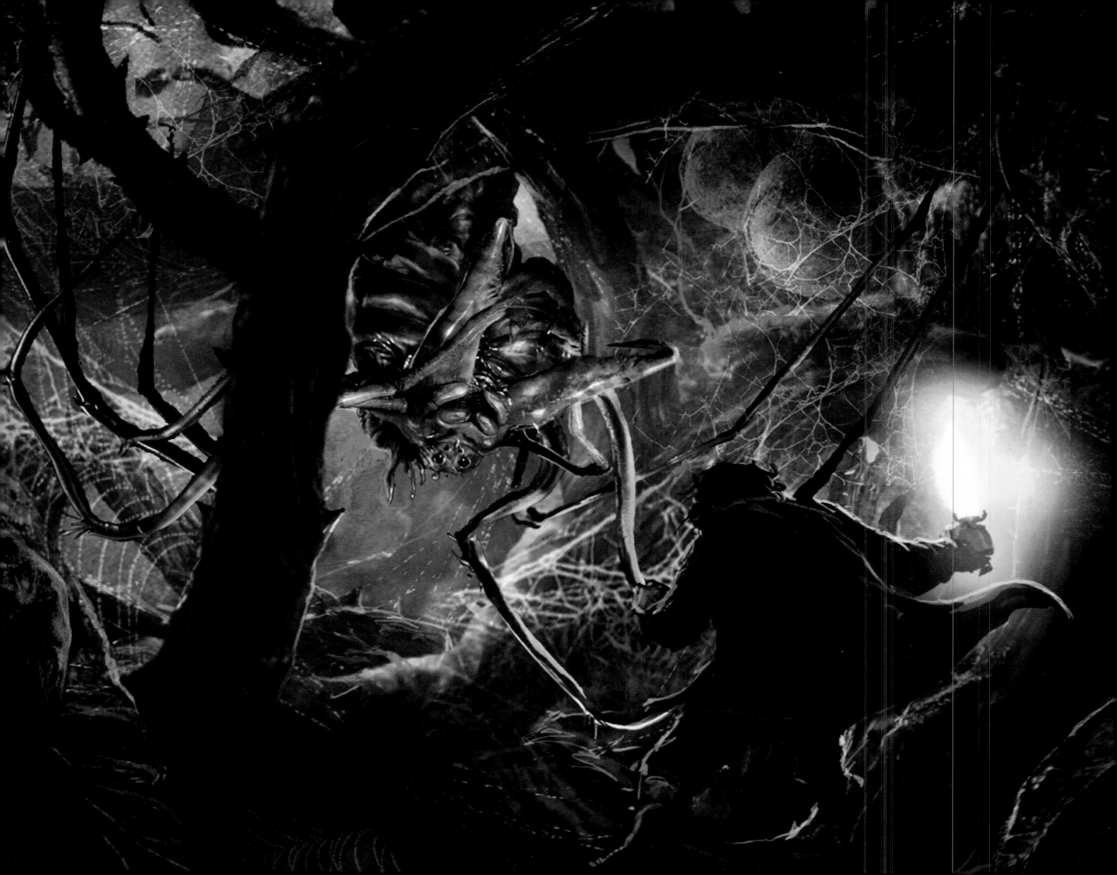

# FLIES & SPIDERS

## LOST IN THE FOREST OF MIRKWOOD

Plunging into the gloom, the Dwarves and Bilbo attempt to pass through Mirkwood, an ancient, sprawling forest that stands between them and the Lonely Mountain. Mirkwood, however, is well named, and it isn't long before the Company begins to succumb to the unrelenting oppression of this seemingly endless swathe of rot, thorns, fungi and darkness. There is a sickness spreading through the forest and it soon takes hold of the Dwarves.

Furthermore, Mirkwood is crawling with life, much of it unfriendly, and before long spiders come sniffing at the strange new prey that has blundered into their midst.

Spooky forests are always fun to imagine, but Mirkwood needed its own character and it would be a misstep to simply repeat the twisted, mossy trees of Fangorn. Through the many concepts that were created, decay, thorns and toadstools would become a theme, along with claustrophobic webs and dripping goo. As the Dwarves journeyed deeper into the forest its character would change, becoming even more bizarre and unsettling with the introduction of strange colours and fungi run mad.

The spiders themselves also went through many iterations as their design was honed, from heavily camouflaged, thorny creatures through translucent variations and some that recalled Shelob quite closely, eventually moving through black widows and wolf spiders toward something quite unique and terrifying.

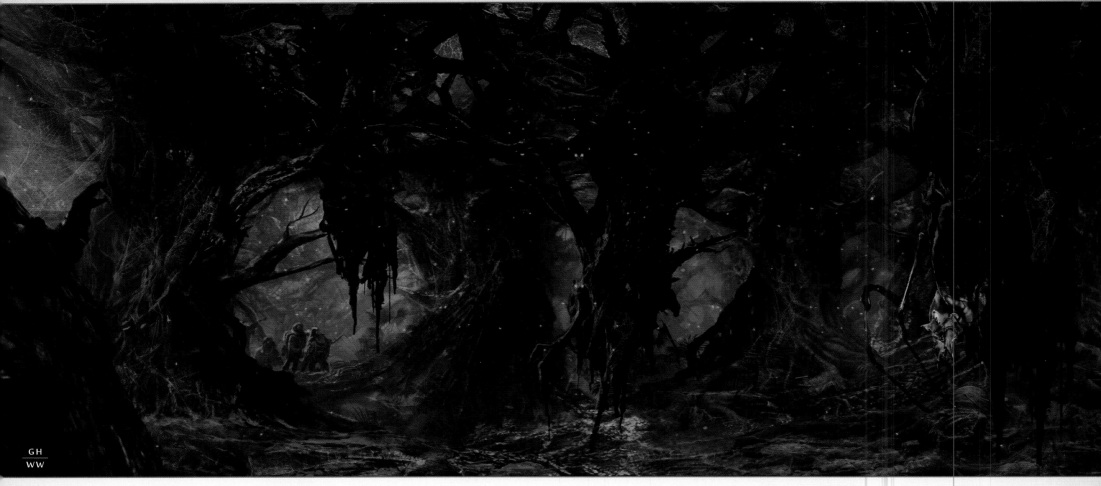

GH
WW

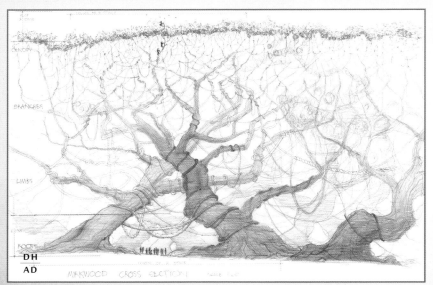

DH
AD

# MIRKWOOD

**BENEATH THE CANOPY**

Tolkien established Mirkwood as an ancient forest. To sell that impression we needed larger than life trees with huge branches. In our story we go from forest floor to canopy, so it was important for us to know how that would work – if the diameter of a trunk at ground level is three metres, then what size is it halfway up and how big are the branches there? How much foliage is there in the middle levels or is it all just at the very top where there's sunlight?

**Dan Hennah, Production Designer**

JH
AD

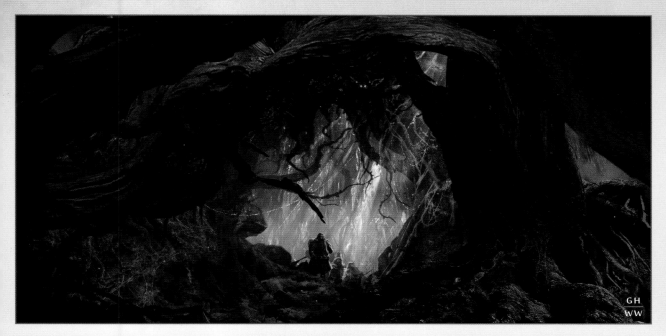

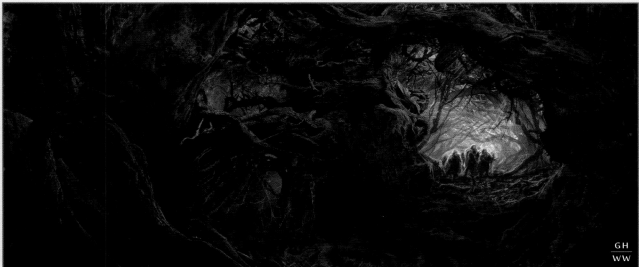

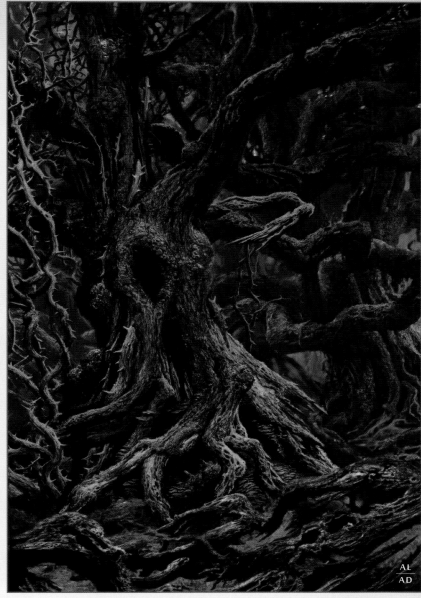

The idea behind the early Mirkwood forest concepts I worked up was of decay and rot taken to an extreme. Paul Tobin had the idea that some of the trees might be so rotten that the bottom of their trunks have completely fallen away and they hang suspended by their intertwined branches and cobwebs *(opposite, top)*. The spiders could live up in the branch maze, run up and down inside these hollow trunks, pop out and attack people.

**Gus Hunter, Weta Workshop Designer**

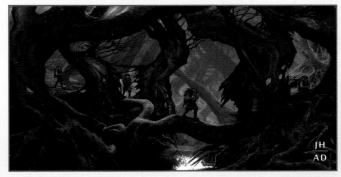

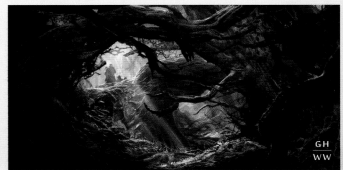

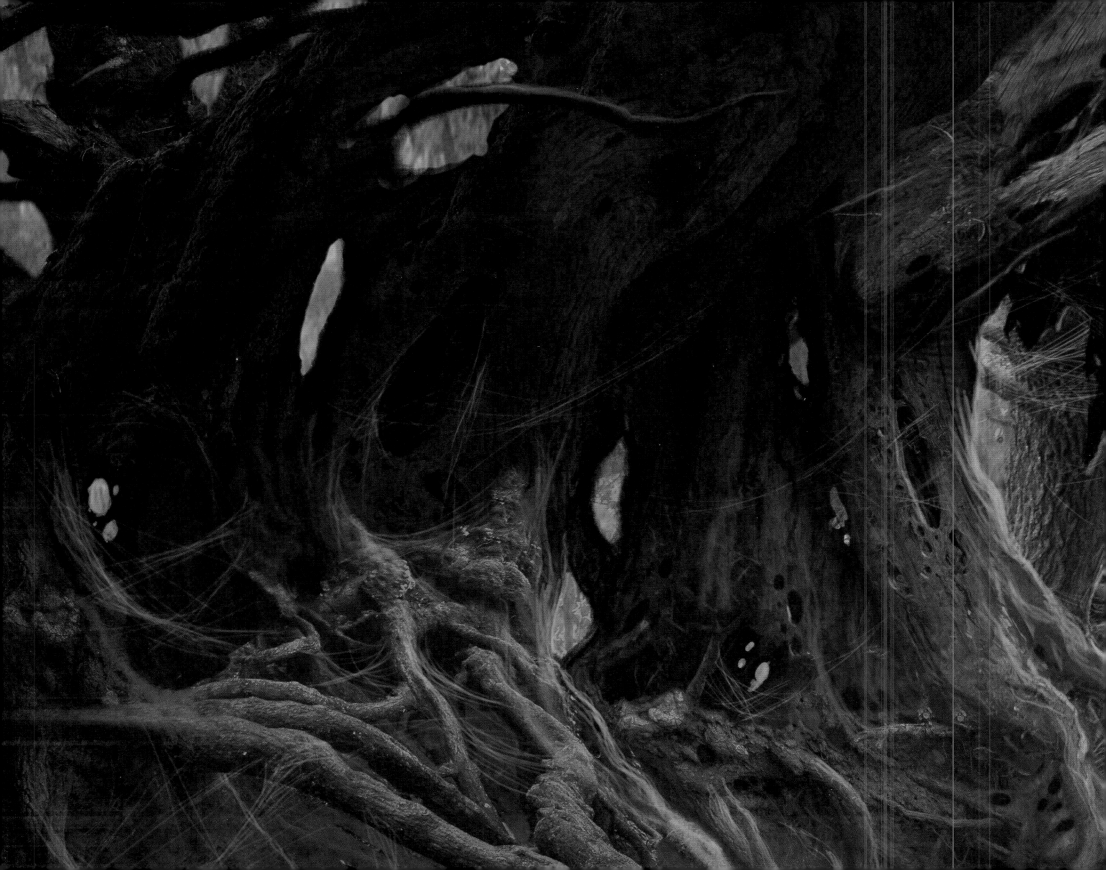

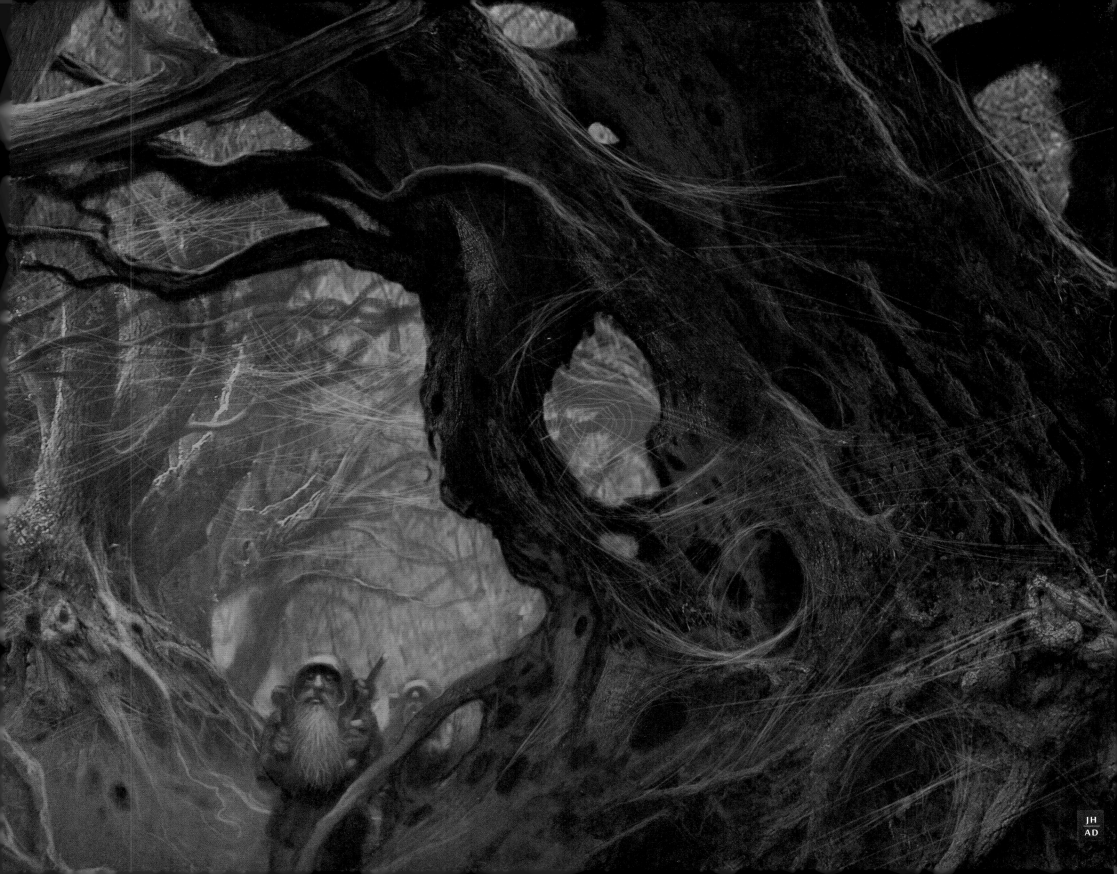

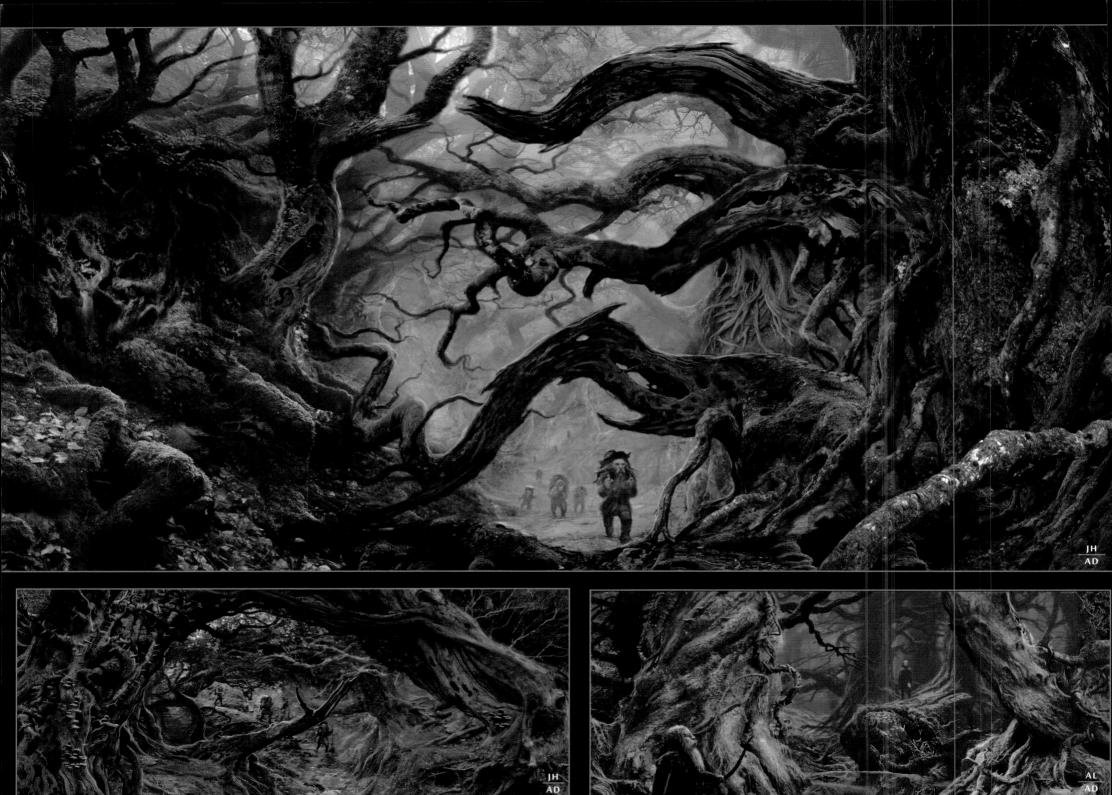

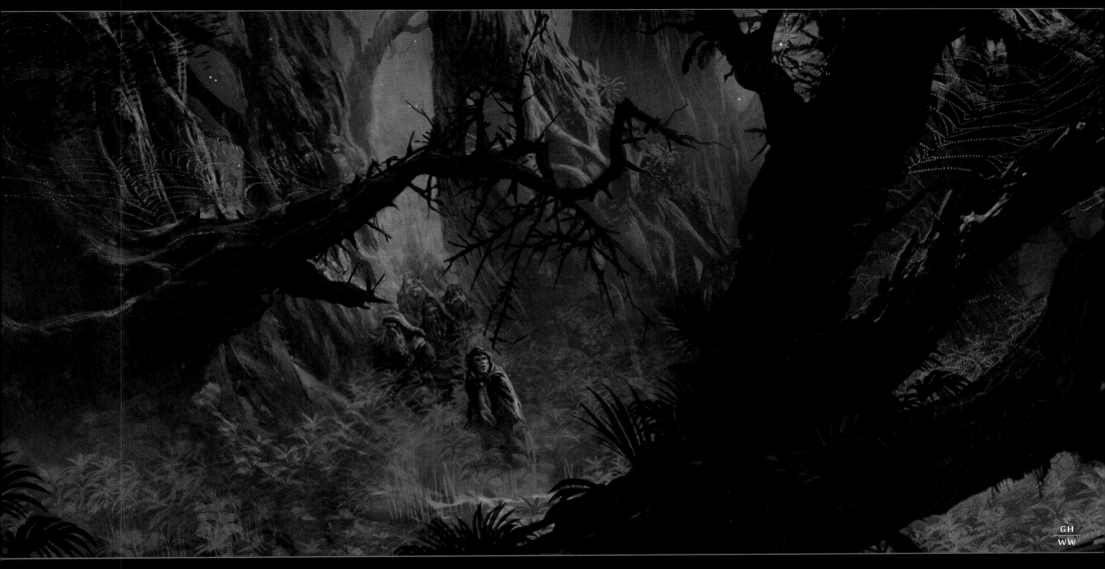

Being a diseased forest, we have a lot of strangling vines and fungi that are eating the trees. The tree bases are rotting. There's a lot of algae growth on the bark creating different colours, as well as mosses, lichens and poisonous-looking stuff.

The light in the forest is either moonlight or heavily filtered sunlight. It is very blue and green in the concept artwork, but in amongst that palette are little bits of colour, as seen in certain pieces. We decided to develop this. Sickly, brightly-coloured growths in forests often suggest poison and the atmosphere in Mirkwood is thick with disorienting fungal spores that fog the mind. To illustrate the effect on the Dwarves we decided to make everything slightly psychedelic.

Interestingly, in our 3D and 48 frames per second shooting process we have found that colour is eaten by the camera, desaturating the image, so we could go to town with our colours on the set and yet have them appear surprisingly subtle once shot.

**Dan Hennah, Production Designer**

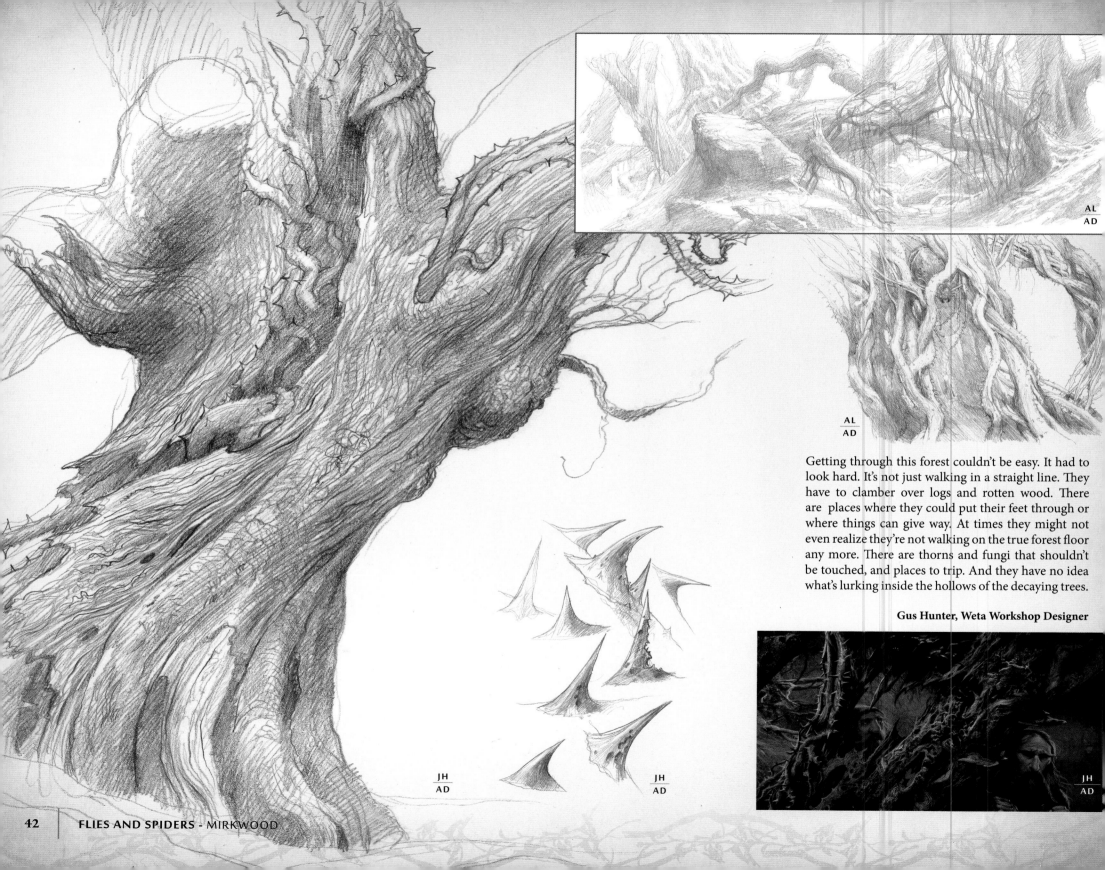

AL
AD

AL
AD

Getting through this forest couldn't be easy. It had to look hard. It's not just walking in a straight line. They have to clamber over logs and rotten wood. There are places where they could put their feet through or where things can give way. At times they might not even realize they're not walking on the true forest floor any more. There are thorns and fungi that shouldn't be touched, and places to trip. And they have no idea what's lurking inside the hollows of the decaying trees.

**Gus Hunter, Weta Workshop Designer**

JH
AD

JH
AD

JH
AD

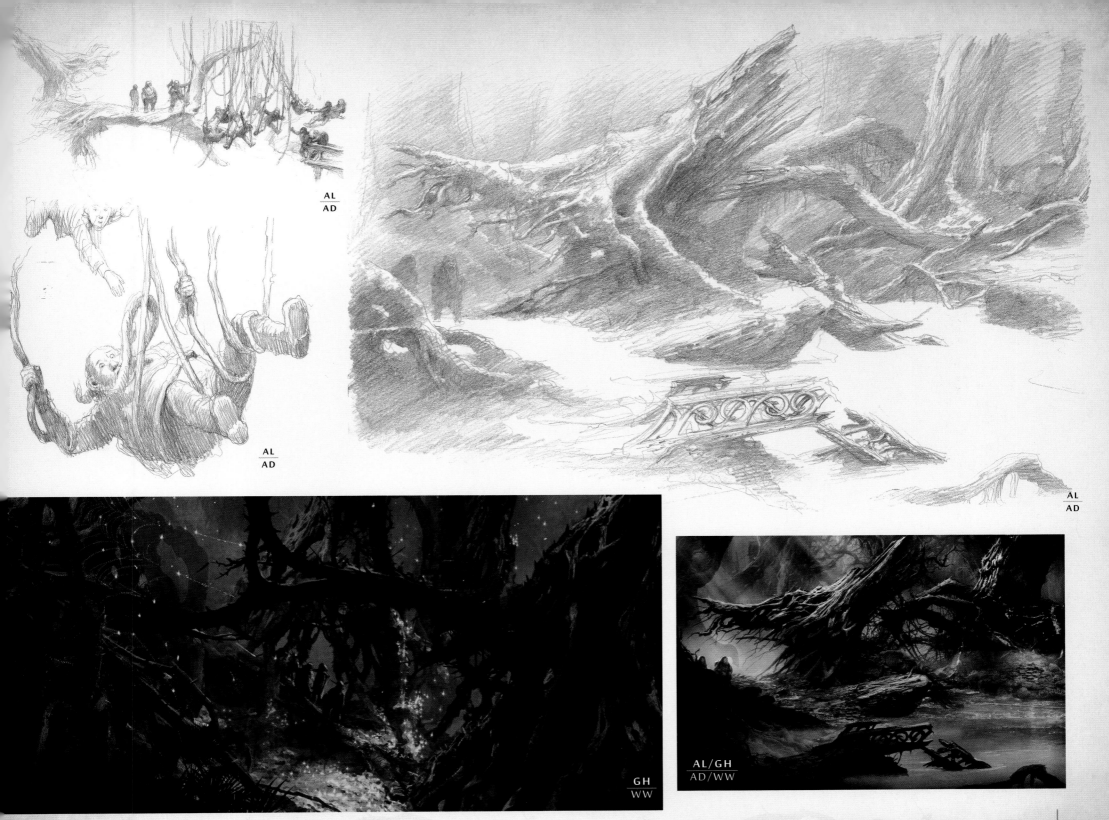

AL
AD

AL
AD

AL
AD

GH
WW

AL/GH
AD/WW

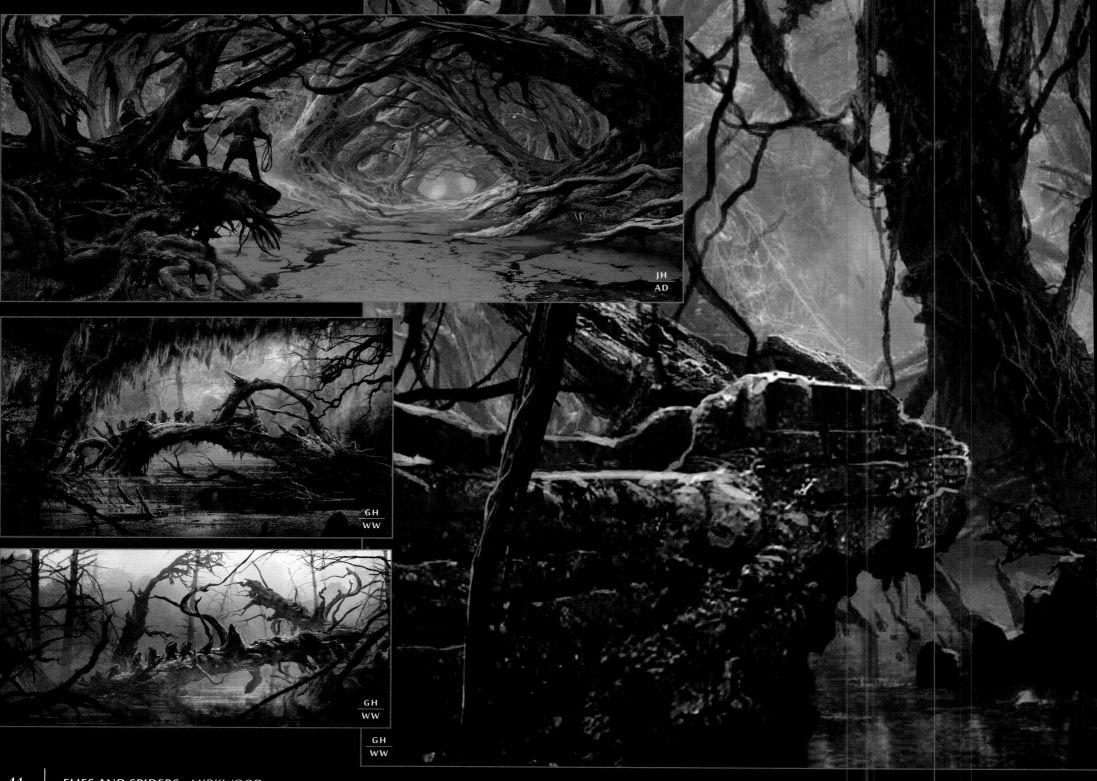

JH
AD

GH
WW

GH
WW

GH
WW

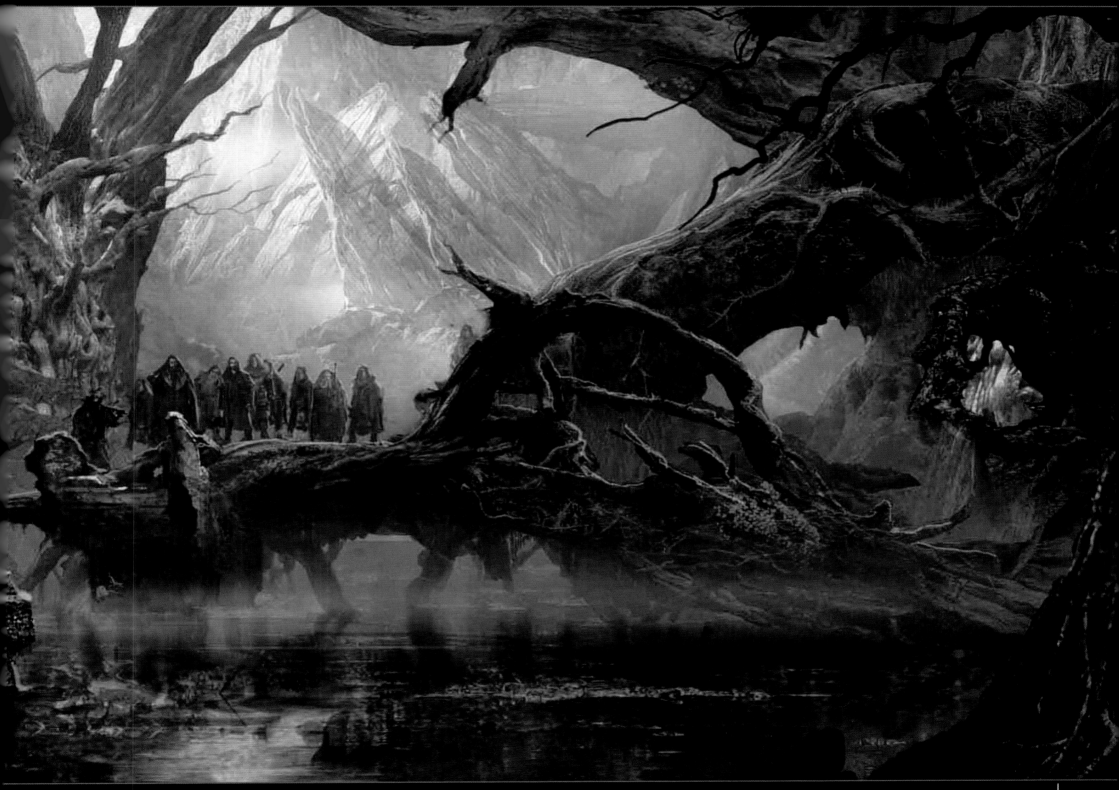

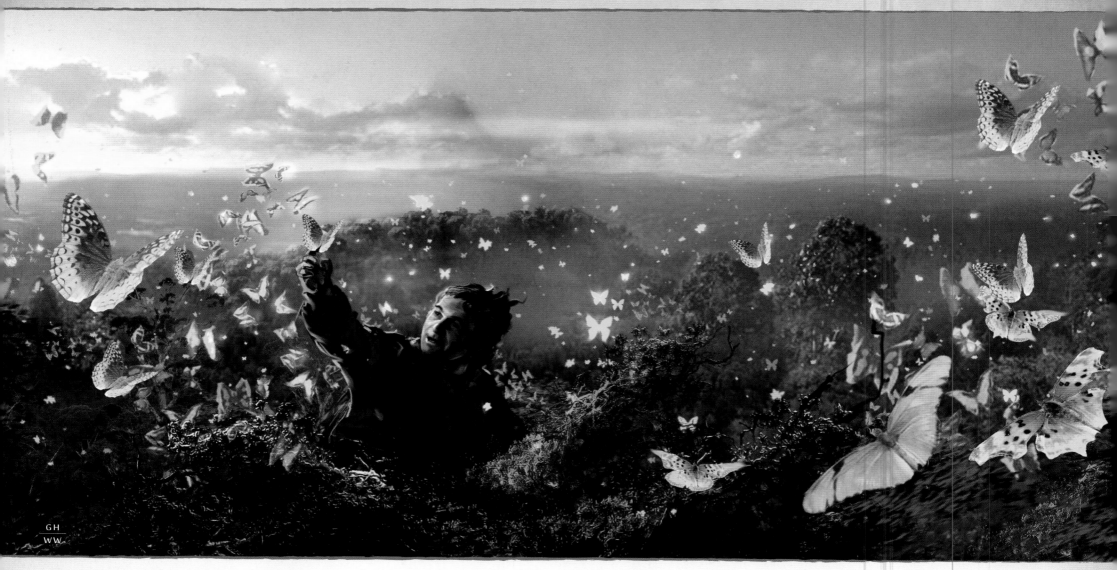

# MIRKWOOD CANOPY

Bilbo climbs up to see if he can see the edge of the forest. We had established that he would pop out of the canopy into early autumn so our foliage is turning. Tolkien also established that the air above the forest is breezy and full of butterflies, which is a lovely contrast to the dark, heavy, dangerous environment where all the Dwarves are arguing with each other, lost and miserable. The challenge for us was to ensure that these two quite opposing environments would work believably together, one being over while the other is under this dense canopy of leaves.

**Dan Hennah, Production Designer**

AL
AD

# COCOONS

The image, so beautifully described in the book, of all the Dwarves wrapped in spider web and hanging in the centre of the spiders nest, was a real pleasure to work on, and a challenge to film! Fortunately the Art Department had some prior experience with spiders with their work on Shelob in *The Return of the King* and had found a formula for creating large webs. I thought one of the Dwarves might be sharing his cocoon with a nursery of baby spiders.

**Alan Lee, Concept Art Director**

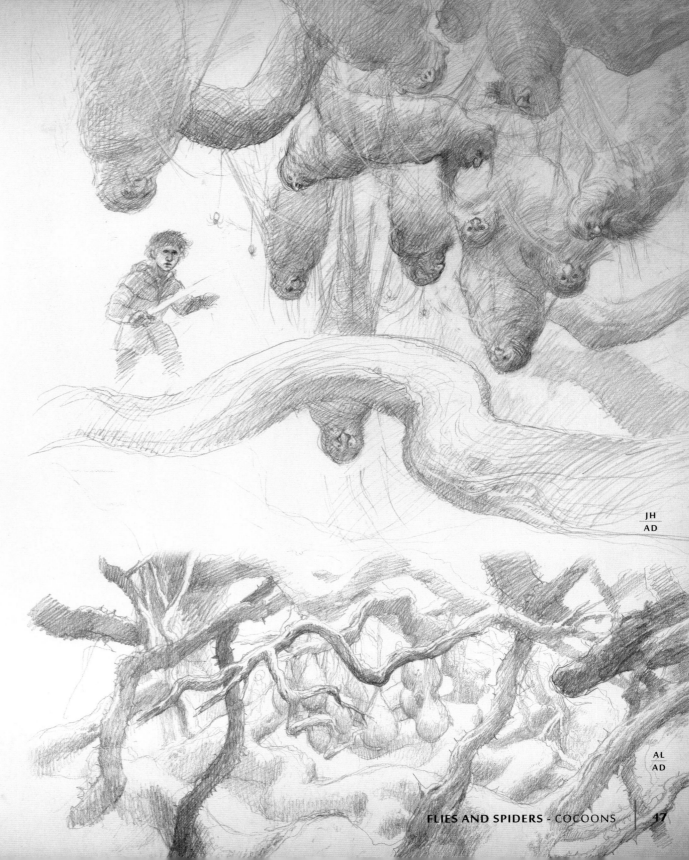

# SPIDERS

We had established Shelob for *The Lord of the Rings*, but Peter felt Mirkwood's spiders needed to have their own unique look. Though smaller, they could be even more disturbing and creepy, hiding in the maze of twisting trees and rotted-out limbs and trunks to snatch out and grab their prey.

**Richard Taylor,**
**Weta Workshop Design & Special Effects Supervisor**

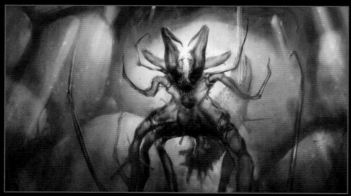

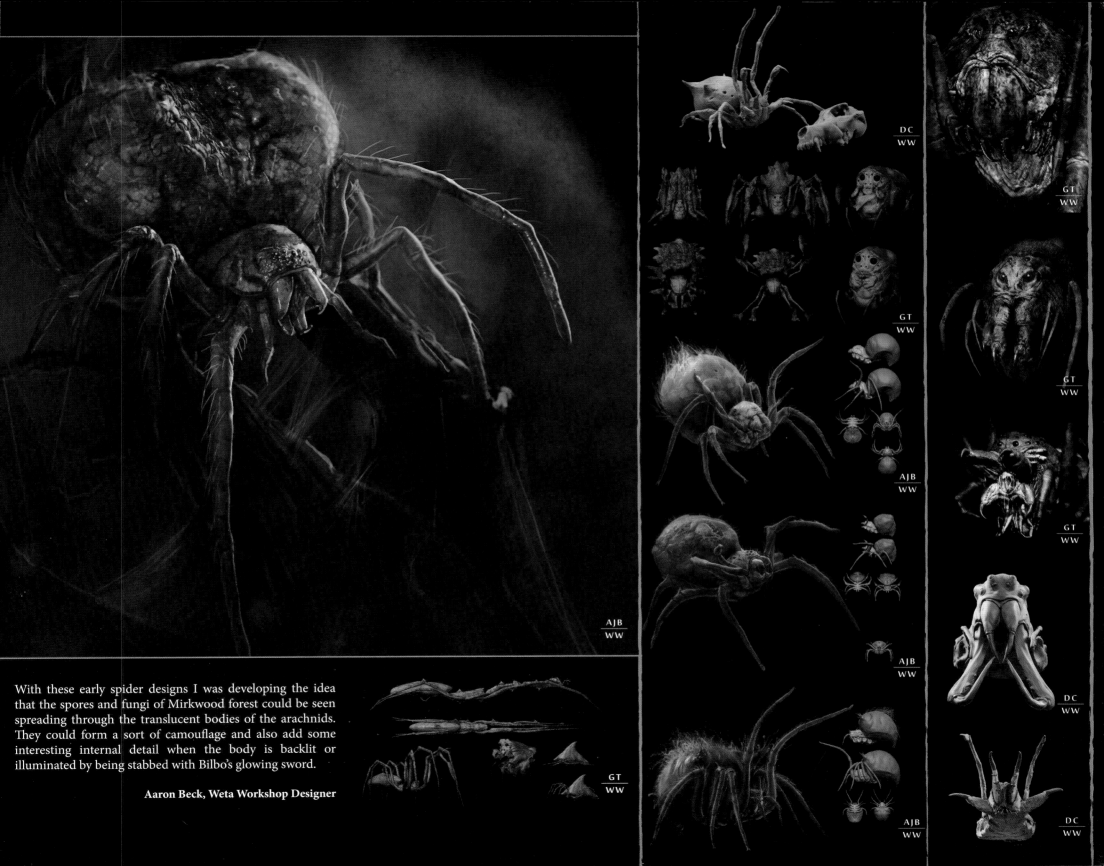

With these early spider designs I was developing the idea that the spores and fungi of Mirkwood forest could be seen spreading through the translucent bodies of the arachnids. They could form a sort of camouflage and also add some interesting internal detail when the body is backlit or illuminated by being stabbed with Bilbo's glowing sword.

**Aaron Beck, Weta Workshop Designer**

AJB / WW

GT / WW

DC / WW

GT / WW

GT / WW

GT / WW

GT / WW

AJB / WW

AJB / WW

DC / WW

AJB / WW

DC / WW

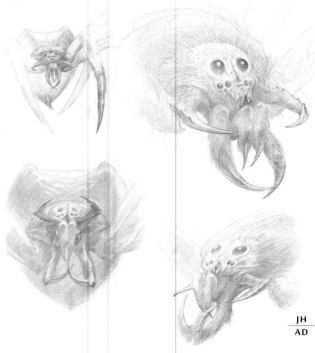

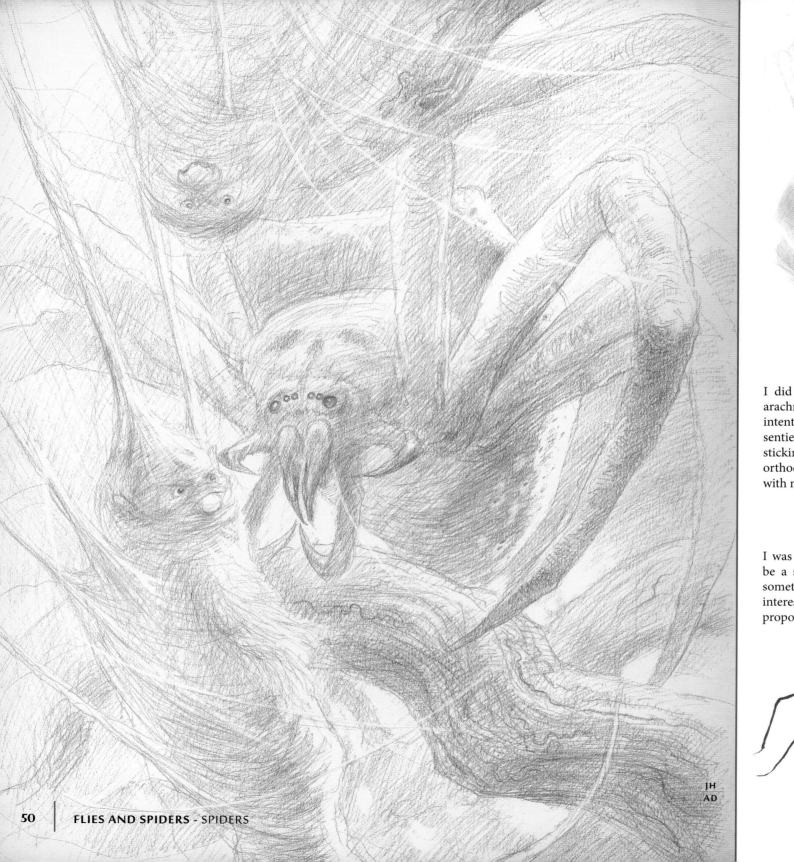

I did many drawings of the Mirkwood spiders although arachnid anatomy is hardly a familiar subject. I was more intent on giving them intent – the purpose that goes with sentience, since Tolkien's spiders can talk – than necessarily sticking to what makes real spiders tick. Despite their orthodox number of legs, they perhaps have more in common with mantises or beetles than spiders.

**John Howe, Concept Art Director**

I was looking for a design idea for the spiders that would be a strong contrast to Shelob and thought that perhaps something based on long-jawed spiders might offer a really interesting and fresh look. I gave the concept wasp-like proportions, very slender and creepy.

**Daniel Cockersell, Weta Workshop Sculptor**

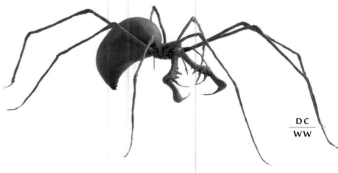

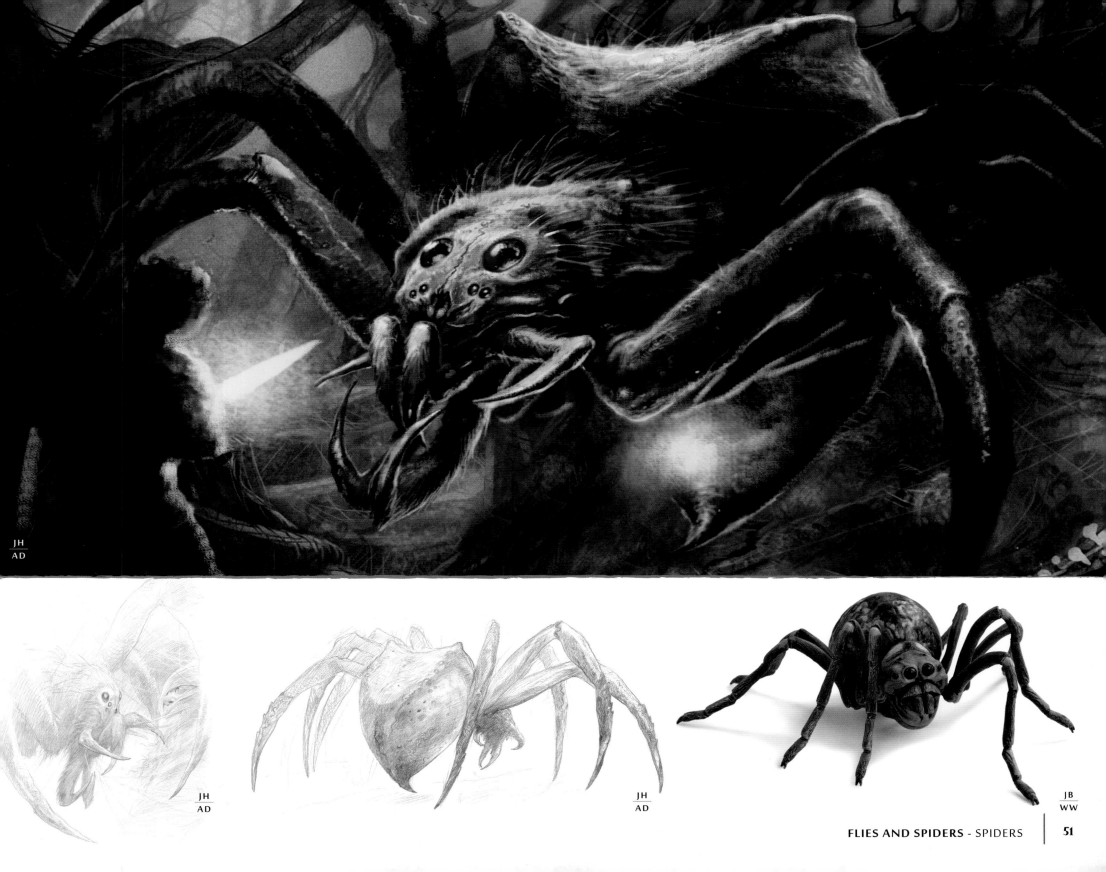

JH
AD

JH
AD

JH
AD

JB
WW

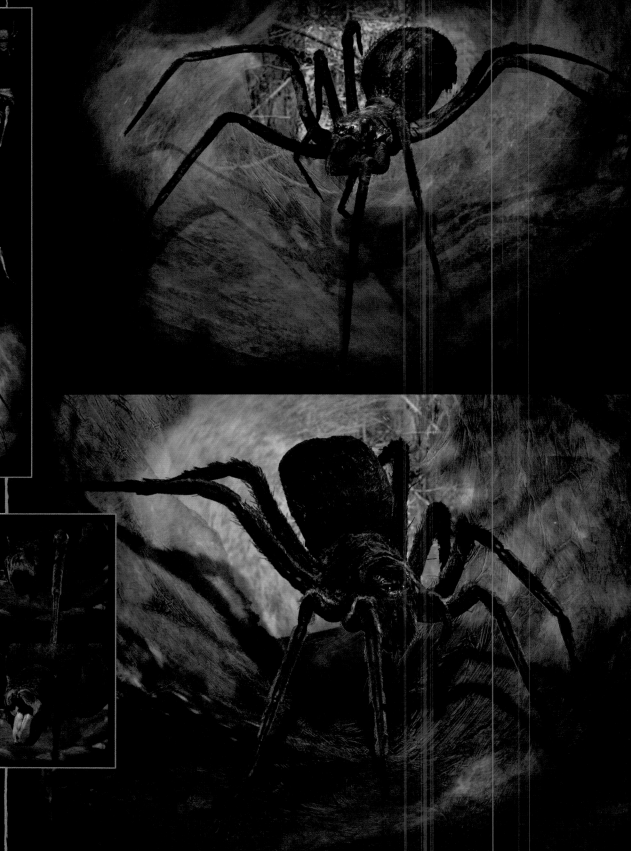

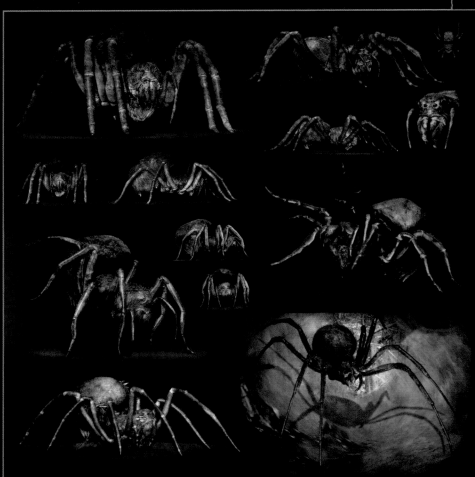

Towards the end our main leads for spiders were black widows and wolf spiders, which gave us some pretty nasty looking results. Both of those directions came straight from Peter. There was also discussion about a projecting beak shape to the mandibles.

**Greg Tozer, Weta Workshop Designer**

GT
WW

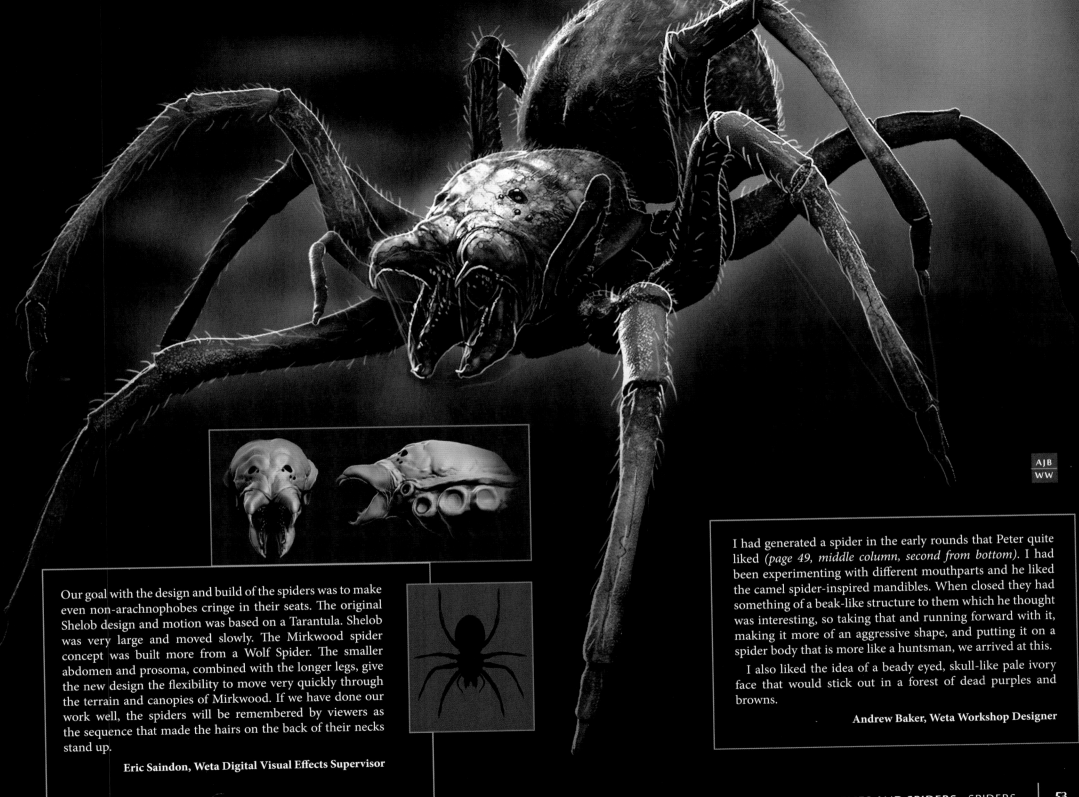

Our goal with the design and build of the spiders was to make even non-arachnophobes cringe in their seats. The original Shelob design and motion was based on a Tarantula. Shelob was very large and moved slowly. The Mirkwood spider concept was built more from a Wolf Spider. The smaller abdomen and prosoma, combined with the longer legs, give the new design the flexibility to move very quickly through the terrain and canopies of Mirkwood. If we have done our work well, the spiders will be remembered by viewers as the sequence that made the hairs on the back of their necks stand up.

**Eric Saindon, Weta Digital Visual Effects Supervisor**

I had generated a spider in the early rounds that Peter quite liked *(page 49, middle column, second from bottom)*. I had been experimenting with different mouthparts and he liked the camel spider-inspired mandibles. When closed they had something of a beak-like structure to them which he thought was interesting, so taking that and running forward with it, making it more of an aggressive shape, and putting it on a spider body that is more like a huntsman, we arrived at this.

I also liked the idea of a beady eyed, skull-like pale ivory face that would stick out in a forest of dead purples and browns.

**Andrew Baker, Weta Workshop Designer**

AJB
WW

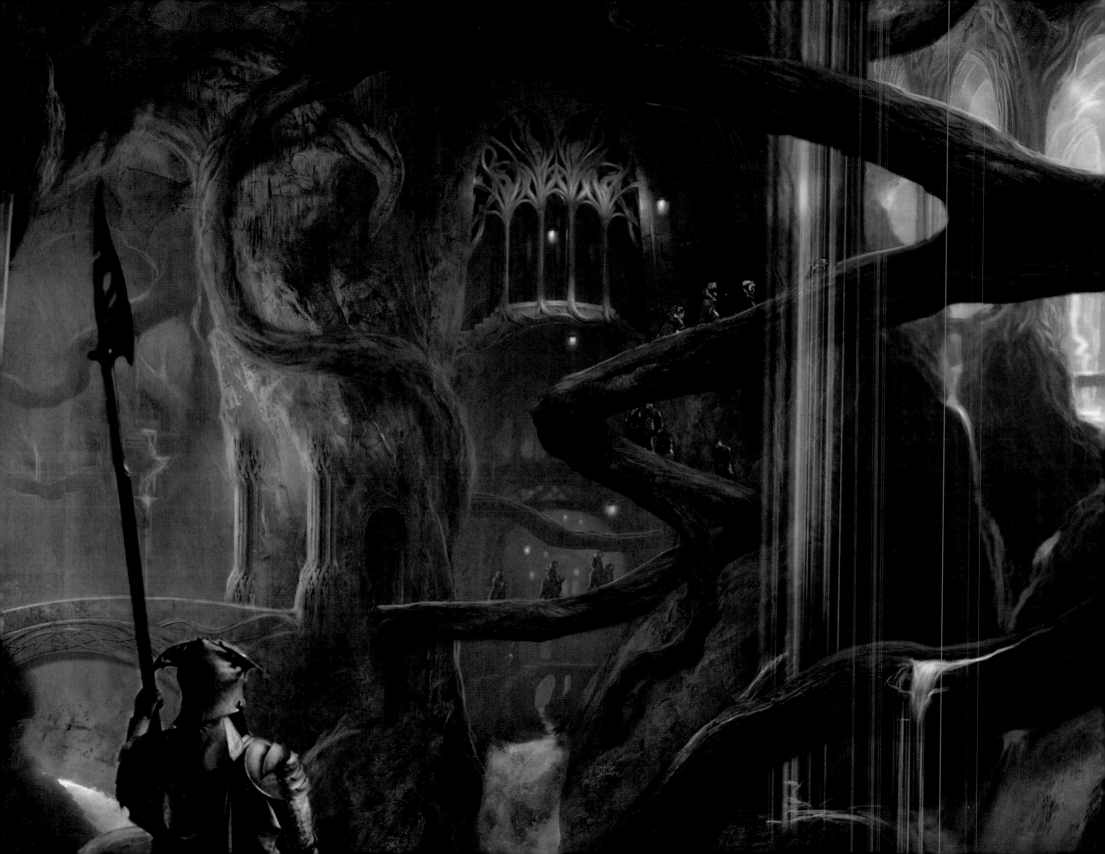

# THE WOODLAND REALM

## THE ELVES OF MIRKWOOD

Throughout *The Lord of the Rings* and even in *The Hobbit* audiences have grown accustomed to Elves as benevolent, if lofty allies to the travellers and their quests. In Mirkwood we meet a new group of Elves who are not invested in the broader themes of Middle-earth and are driven by their own provincial agendas and the whims of the king, Thranduil.

When the Dwarves are found stumbling in the forest it is not shelter they are given. Dwelling in a vast palace of caverns carved from the living rock beneath the forest, their Woodland Elf hosts instead capture, interrogate and eventually imprison the Company when the explanations for their trespassing fail to impress King Thranduil. Thorin in particular earns the Elven-king's cold attention, for there is little love lost between their families since the days of Erebor's fall.

Being underground and at war with the changing forest above them, the Woodland Elves' realm is a very different civilization to any audiences have yet seen in the saga, though it still carries many of the familiar Elven themes such as elegantly stylized natural forms and a stately airiness, created by the film's Art Department.

The Elves themselves have a new look as befits their pricklier nature. We meet new characters such as King Thranduil and Tauriel, and enjoy the welcome return of Legolas, though this time as someone less sympathetic to the Quest and sporting a new appearance.

The Elven design challenge was among the more daunting ones this time around, as it was necessary to complement what had been established, but also diverge from it and find an equally successful new look. This process would take shape through close collaboration and probably some friendly competition between the Costume Department and Weta Workshop.

# MIRKWOOD ELF HUNTERS

## COSTUME

The once-beautiful Greenwood has become Mirkwood, a dangerous and unpleasant place. While the Elves hold the evil at bay in the Woodland Realm, their garments reflect the spiky and perilous nature of the forest. The distinction between armour, clothing and camouflage is blurred, outlines unclear, akin to the dappled sunlight seen in a dark wood. These Elves are shadow figures, swift, invisible and deadly, far wilder and more dangerous than the stately immortals of Rivendell. Rather than aloof and serene, they are edgy and almost predatory. Nonetheless their garments are incredibly detailed and elegant, a tight-fitting melange of metal, cloth and leather.

**John Howe, Concept Art Director**

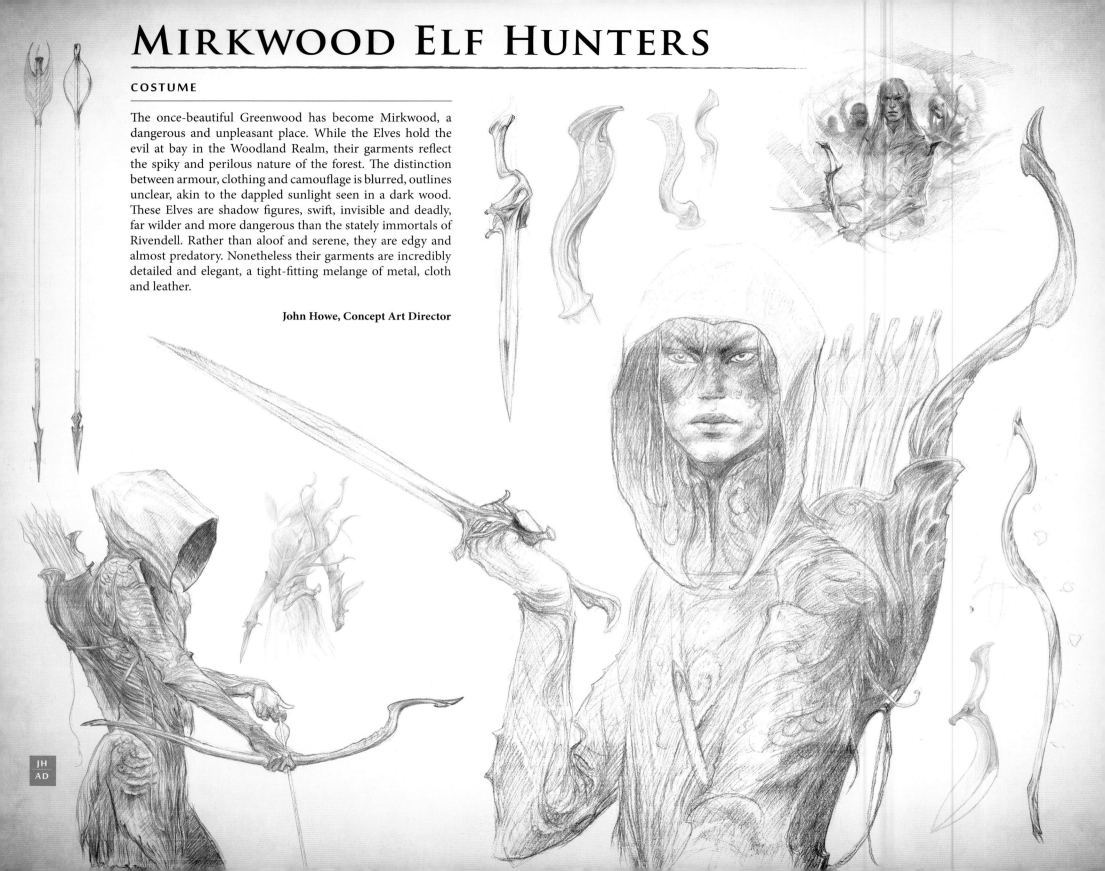

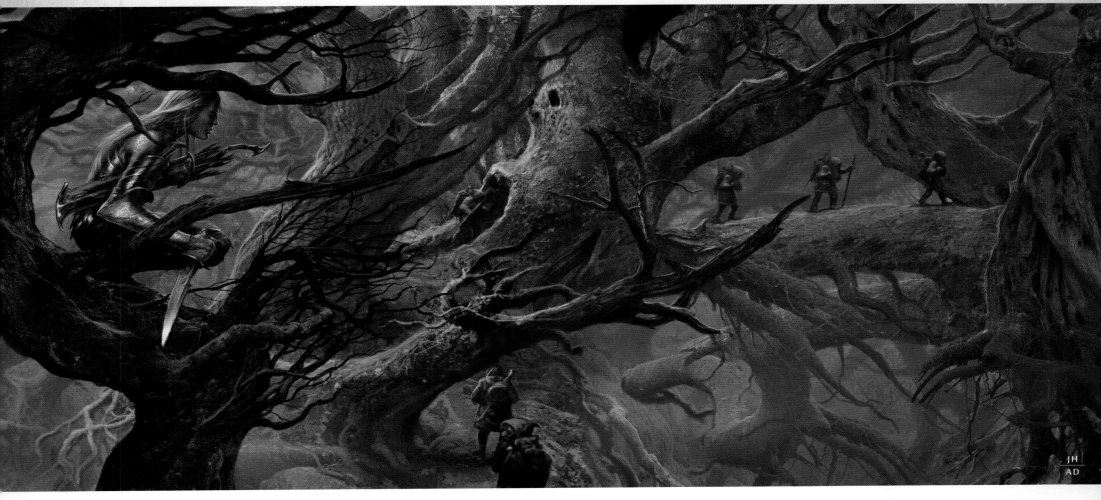

There is an asymmetry to the Elven hunters that espouses swift attack and lethal defence. Even their bow designs were asymmetrical, while their knives have reverse grips, held back against the wrists, barbed arrows and twice-recurved swords. These forms exist to develop a whole fighting style for these Elves that would be both flowing and jagged, like a deadly dance.

**John Howe, Concept Art Director**

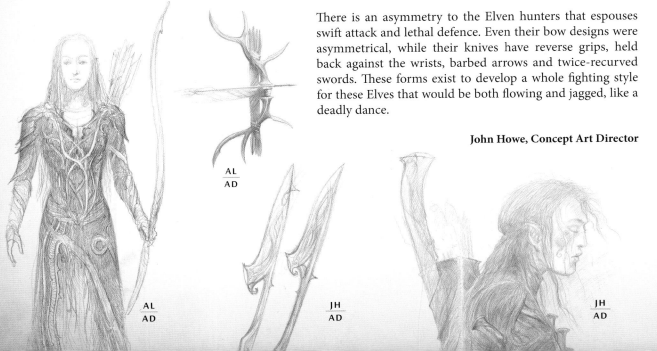

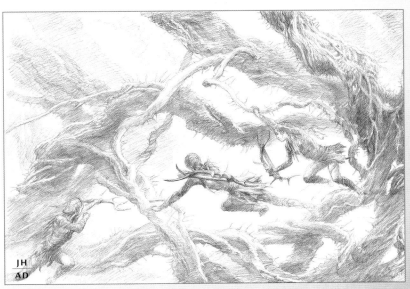

AL
AD

AL
AD

JH
AD

JH
AD

JH
AD

**THE WOODLAND REALM** - MIRKWOOD ELF HUNTERS | **57**

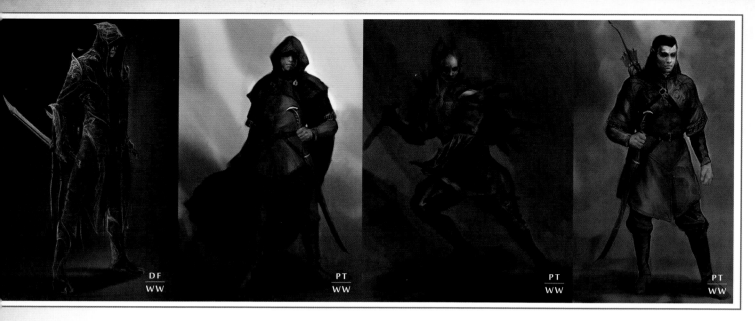

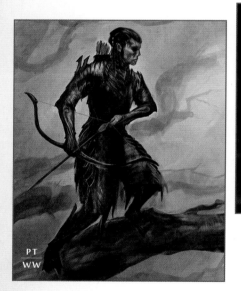

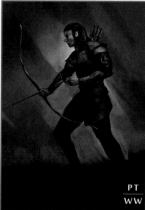

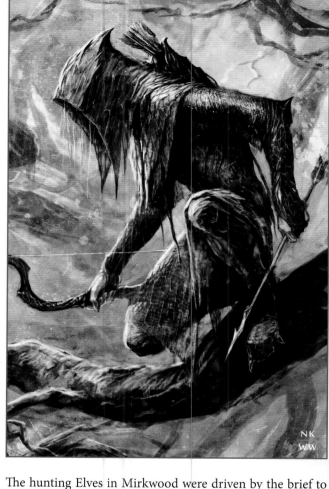

The Elven hunters were to be incredibly agile and lethal and potentially have a number of weapons. A lot of the early designs were trying to be respectful of Legolas's costume from the earlier films so we weren't necessarily starting with something completely different to what had gone before. I think Peter was less concerned with that and more concerned with coming up with something that was really great and memorable, so the conservative approach gave way to a pursuit of something more exotic, unexpected and dangerous-looking.

**Paul Tobin, Weta Workshop Designer**

The hunting Elves in Mirkwood were driven by the brief to make them look dangerous with a ninja assassin quality. We went through a very extensive design phase but kept coming back to a particular drawing that Peter really liked (above). The issue was that while it looked great as an illustration, finding costume elements that replicated what we had in the painting and would look equally as good when they moved was really difficult. We played with multiple layers and some innovative materials including fine chain with translucency, or running rivulets of very fine chain down fabrics like veins in a leaf. The Costume Department and Weta Workshop's costume specialists all worked on it, but I think we might have been chasing an impossible brief. We were looking for a fabric that would hold its shape one minute, looking fabulous in a static pose, but behave like liquid in the next.

**Nick Keller, Weta Workshop Designer**

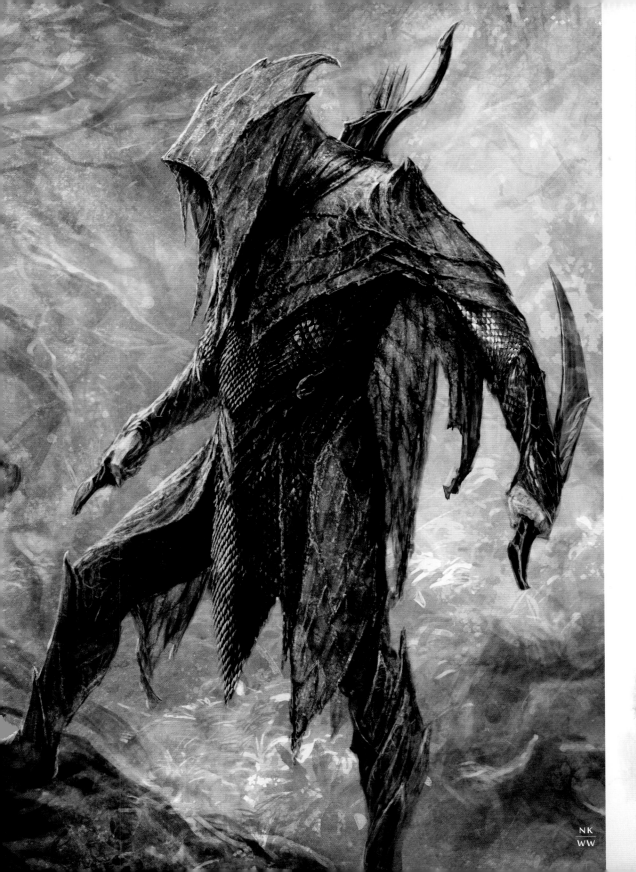

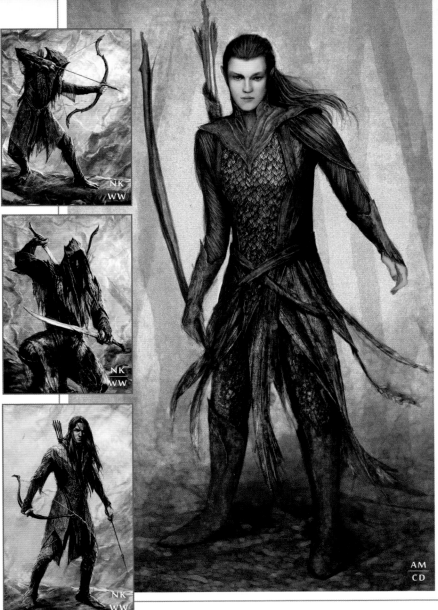

The main challenge with these Elves was that they had to look light and swift and yet strong, without being encumbered by armour. The way round this was to use strong-looking components of textured and plain leather and incorporate some metal gauze and leaf mail, along with laser-cut leather leaves in a kind of corset or body protector, which was a little different on each Elf. The variation also made it easier to get them to work on both men and women.

**Ann Maskrey, Costume Designer**

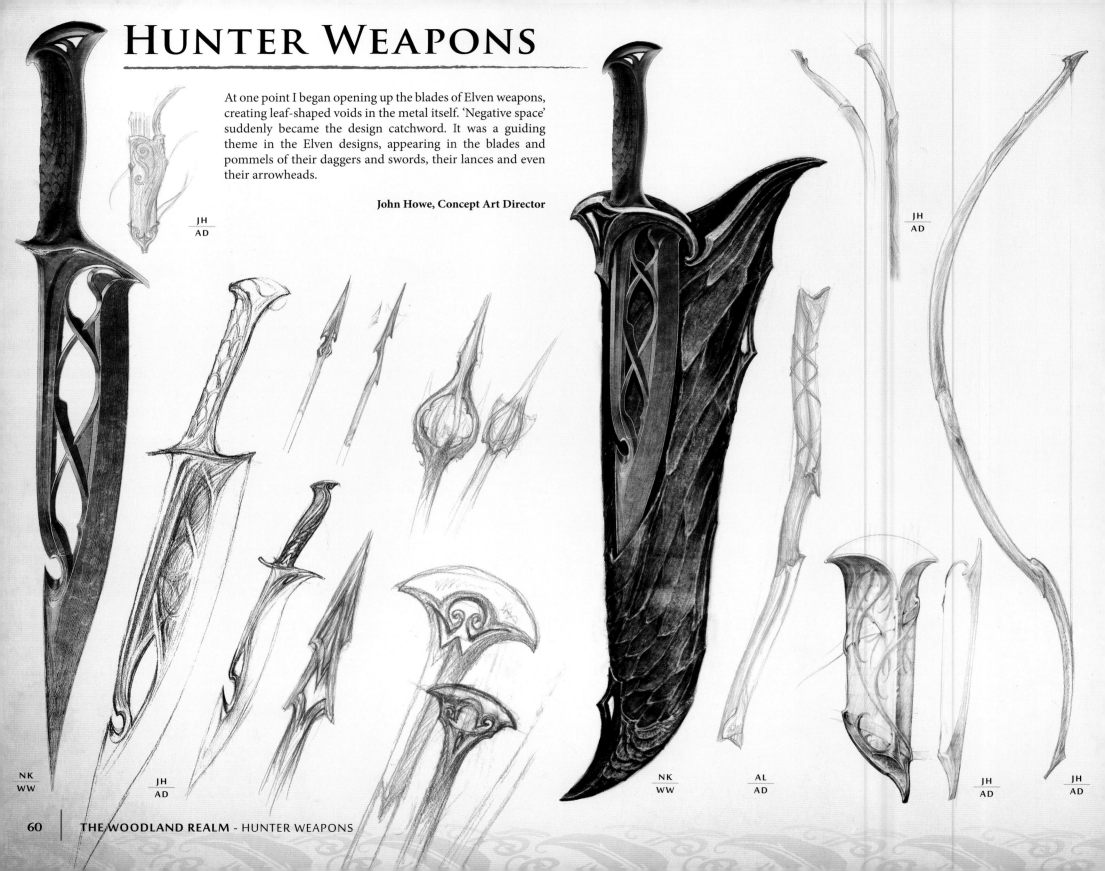

# HUNTER WEAPONS

At one point I began opening up the blades of Elven weapons, creating leaf-shaped voids in the metal itself. 'Negative space' suddenly became the design catchword. It was a guiding theme in the Elven designs, appearing in the blades and pommels of their daggers and swords, their lances and even their arrowheads.

**John Howe, Concept Art Director**

JH
AD

JH
AD

NK
WW

JH
AD

NK
WW

AL
AD

JH
AD

JH
AD

# TAURIEL

## COSTUME DEVELOPMENT

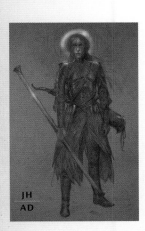

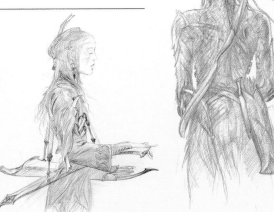

JH
AD

JH
AD

Birds crop up a lot in Tolkien, especially in *The Hobbit*. At one point we were exploring a bird theme with Tauriel as we searched for a motif for her. She was a bit of a silent killer at that point and it referenced that aspect of her character. John Howe did some incredible designs that included weapons secreted all over her, but over time she evolved from assassin to huntress and we pushed into exploring some costume ideas that were more akin to Legolas, or with some fine gold armour components woven among leathers or suedes.

Ultimately she moved away from all that when Nick Keller found a really strong lead for her involving fine scale mail *(overleaf, far right)*.

**Paul Tobin, Weta Workshop Designer**

In every film there is one culture or one challenge that tests you above all else. In *The Hobbit* it has been the Elves of Mirkwood. We were challenged to find a piece of design that achieved what the director sought for these characters and was achievable as a practical costume.

To that end, we produced numerous drawings for Tauriel and the Mirkwood Elf hunters and explored many different materials in our mock-ups. Part of the challenge was complementing *The Lord of the Rings*' Elves while creating something which stood independently and represented a progression. There was some great art that came out of the process and some amazing materials that we found and developed.

**Richard Taylor,**

**Weta Workshop Design & Special Effects Supervisor**

The creation of my costumes was a legendary process. I have lost count of the number of fittings I went through and the hours of standing, arms outstretched, being jabbed with needles and prodded with fingers. It was a seemingly neverending process. Why? Tauriel was one of two featured female characters, the only one that was unique to *The Hobbit* movies, and she had to be just right. It is difficult with strong female characters to strike the correct balance between feminine and lethal, delicate and strong. Tauriel had to embody the grace of Galadriel and Arwen, while representing the fighting stealth and power of Legolas and Elrond.

**Evangeline Lilly, Actress, Tauriel**

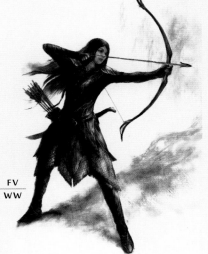

FV
WW

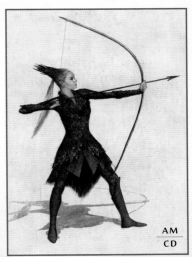

AM
CD

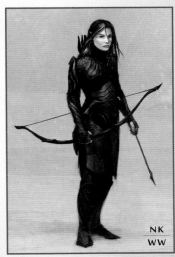

NK
WW

PT
WW

Tauriel's look was challenging to nail down, but we had a lot of fun on the way. I never tire of drawing beautiful Elves. As an Art Noveau fan, I continually teetered at the brink of making her too fey, allowing her design to slip into high fantasy. *The Hobbit* is more whimsical in style than its sequel, but Tauriel could not look like Tinkerbell.

We all tended to keep throwing layers at her, too, which cost you nothing in a drawing because you can lie without knowing it, but in reality each one adds more bulk to your actress and that is generally something to avoid.

I thought her hair could be a defining feature so a number of my concepts involved creating a strong contrast between the brilliant auburn of her locks and the ash of her cloak, maybe having her hair fall down the inside of her cloak so you would see flashes of it when she moved.

**Daniel Falconer, Weta Workshop Designer**

Tauriel's design was closely linked to the progression of the hunting Elves as it became clear she was going to be their leader. We had been all over the place with possible looks and eventually felt like we were getting somewhere when the idea of a fine scale mail was introduced. There were a couple of illustrations I did that were very positively received by Peter, Fran and Philippa *(facing page, left and overleaf, left)*. Both involved scale mail as the dominant costume element.

When Eve Gilliland joined our specialty costume department, having made some amazing real metal scale mail costumes for the World of Wearable Arts competition and show, Richard Taylor, who is a judge for the event, was so impressed that he said they'd have made the Lothlórien Elves' scale using her technique if they had seen it, so we set about trying to incorporate it for Tauriel, painted in interesting mottled greens and gold.

**Nick Keller, Weta Workshop Designer**

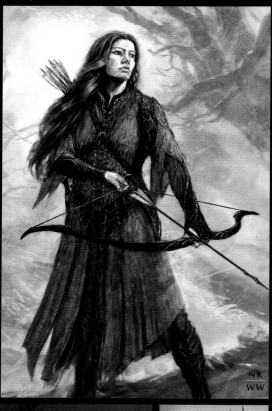

NK
WW

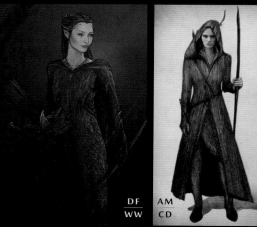

DF
WW

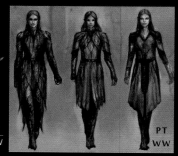

AM
CD

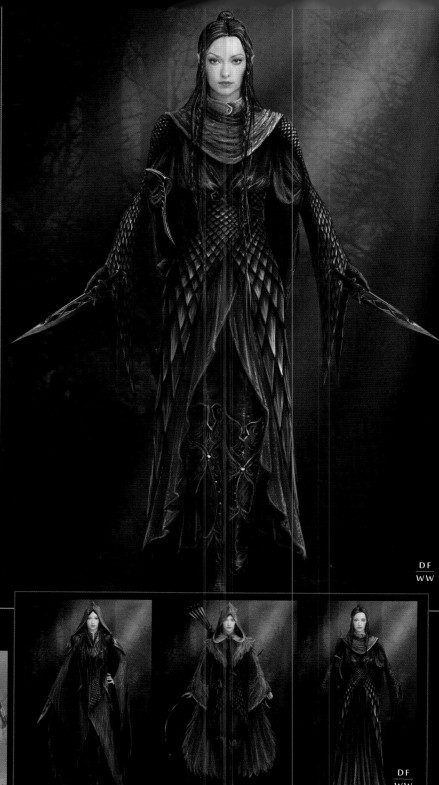

DF
WW

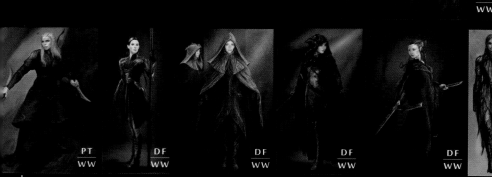

PT
WW

DF
WW

DF
WW

DF
WW

DF
WW

PT
WW

DF
WW

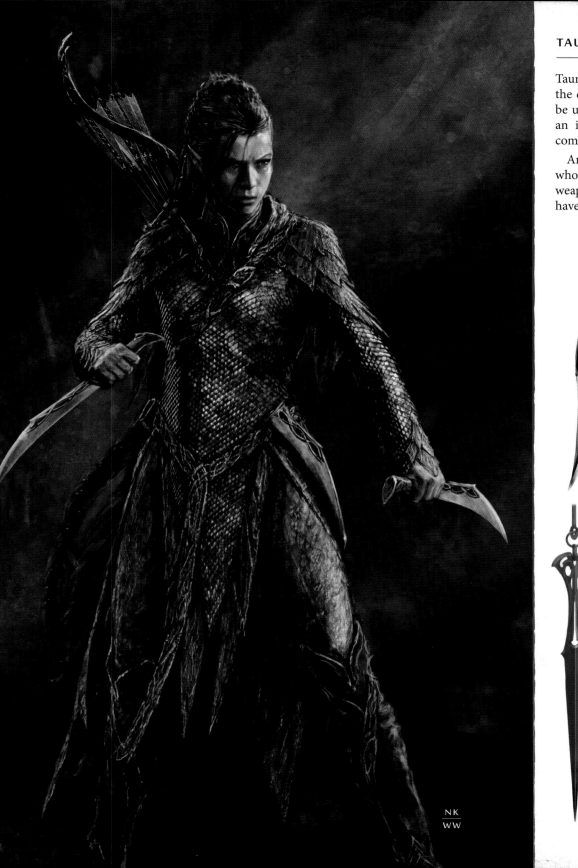

## TAURIEL'S WEAPONS

Tauriel's daggers started out with Thranduil but Peter chose the design for her. They have a thorn-like shape and could be used with a reverse grip, which I thought might suggest an interesting fighting style that would differ from and complement Legolas's dual dagger technique.

Another idea that I drew came from the Stunt Co-ordinator who suggested pursuing a whip-chain idea. It's a very Asian weapon but could be quite cool and I imagined she might have worn it in her hair *(below, left)*.

**Paul Tobin, Weta Workshop Designer**

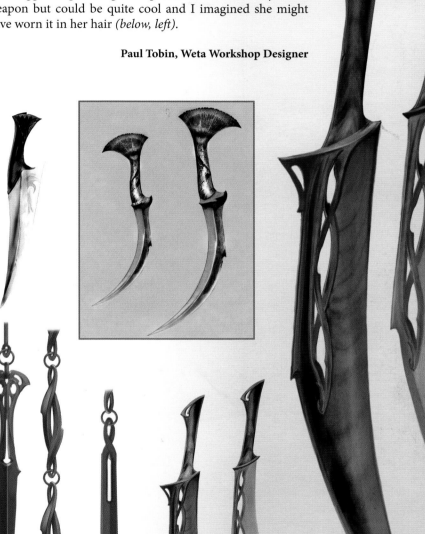

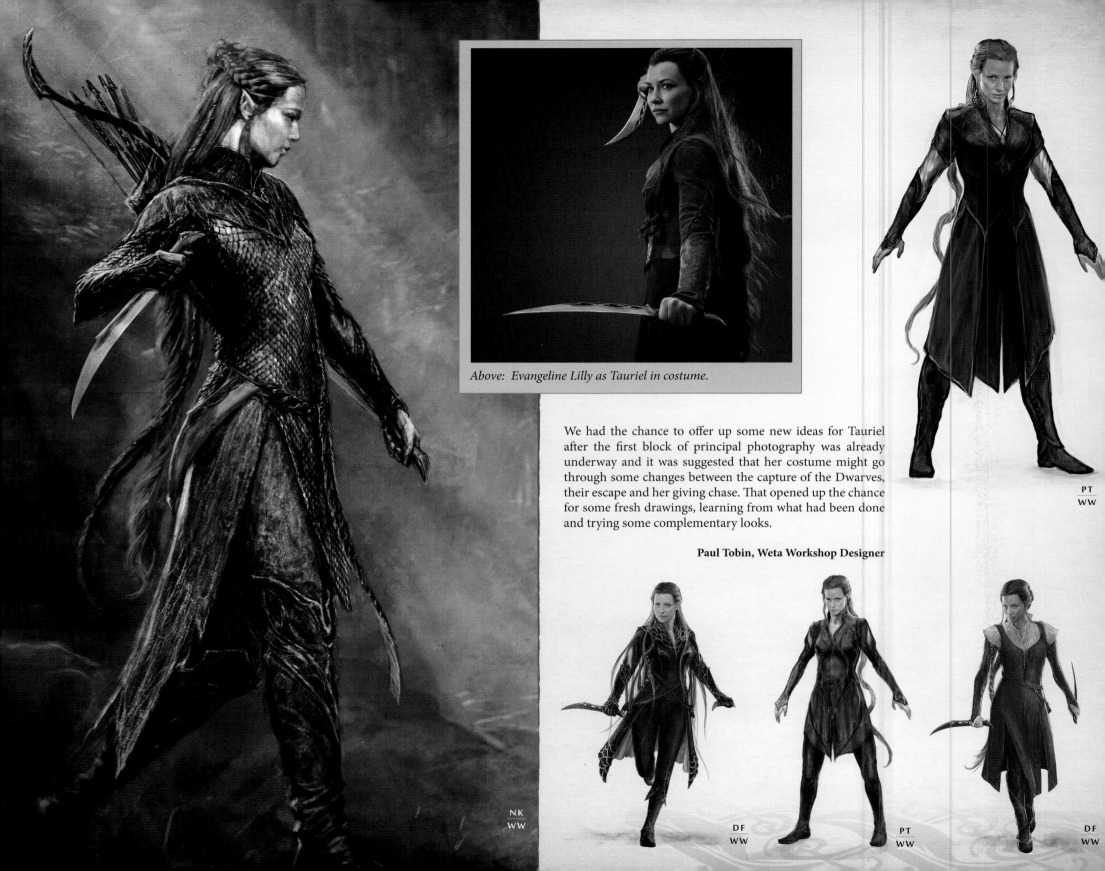

*Above: Evangeline Lilly as Tauriel in costume.*

We had the chance to offer up some new ideas for Tauriel after the first block of principal photography was already underway and it was suggested that her costume might go through some changes between the capture of the Dwarves, their escape and her giving chase. That opened up the chance for some fresh drawings, learning from what had been done and trying some complementary looks.

**Paul Tobin, Weta Workshop Designer**

PT
WW

NK
WW

DF
WW

PT
WW

DF
WW

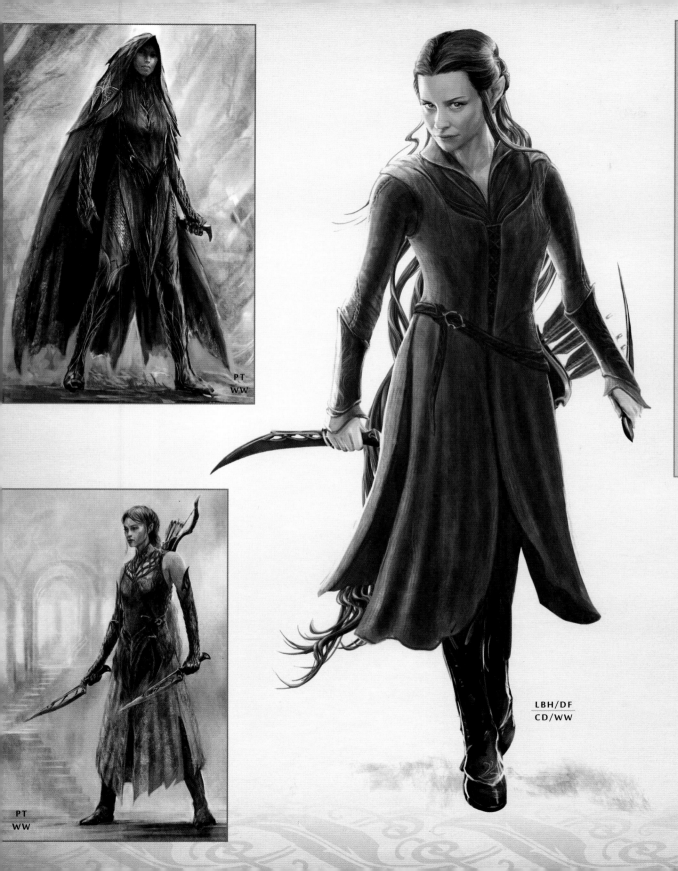

PT
WW

LBH/DF
CD/WW

PT
WW

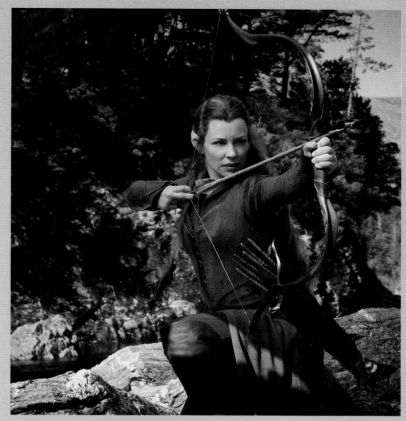

*Above: Evangeline Lilly as Tauriel in costume.*

Peter, Fran and Philippa wanted to see an evolution in Legolas and Tauriel's looks, something of a travelling look for when they left Mirkwood to follow the Dwarves. We needed athletic designs that allowed them to move unencumbered through the forest and be combat ready at any moment.

Tauriel had been shot in an earlier costume for some scenes so my brief was to create something that had layers and could have more than one transitional form.

The filmmakers were looking for a sense of continuity with Arwen's riding costume in *The Fellowship of the Ring*, which provided a terrific starting point. I designed a feminine, practical and sleeveless long hoodie! It was worn over a leather cuirass, fitted leather pants and boots. She looked terrific.

**Lesley Burkes-Harding,**
**Costume Designer, Legolas and Tauriel**

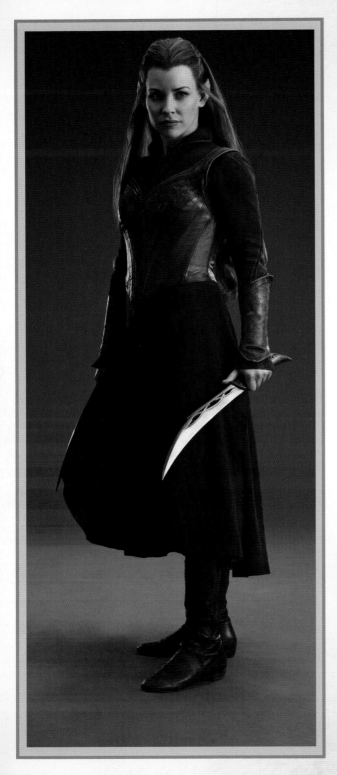

Tauriel has a scene with Kili in the cells, a moment in which we witness the enmity between these estranged races soften a bit between a young Elf and a young Dwarf. Reflecting what the scene is about, we removed a layer. In theory this would be what she wore beneath her hood and corset. For practical reasons her jacket and skirt had been a two part costume, but we made it a single piece dress just for this scene, the idea being she doesn't change her costume every time she leaves the stage, but rather that she has layers she wears in different combinations.

**Bob Buck, Costume Designer**

My favourite version of Tauriel's costume was the one I wore in the 'romantic' cell scene with Kili, the young Dwarf. Comfort and freedom of movement are paramount to my feelings about any article of clothing. Even on the red carpet I want to feel like I'm in my pyjamas, and this costume was the only time in the entire story I was not wearing my leather chest guard. Being armour, the guard was somewhat uncomfortable and could restrict movement – particularly difficult in any and all action sequences! Compared to the Dwarves, though, all of my costumes were a breeze!

**Evangeline Lilly, Actress, Tauriel**

Tauriel is a warrior and a very active character, but it was important that we not bury her femininity, so opening up her collar and giving her a simple and elegant pendant for the scene in which she talks with Kili made sense. Elves revere starlight, so I included the shape of a star held in the gentle embrace of some barbs. There's a little danger there, because they are sharp, but beauty as well, very much like her. It's a little token of her being an Elf maiden, even if she is one that can kick your butt.

**Bob Buck, Costume Designer**

# LEGOLAS

## COSTUME

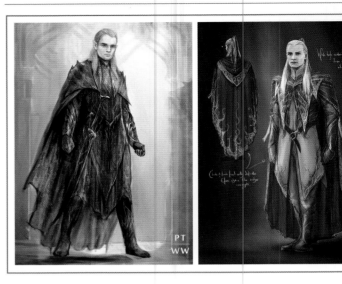

Legolas went through a number of transformations, starting with some early concepts that tied into the bold autumnal colouring I was pitching for the Elves early on, through a phase when we were trying to reference the costume he wore in *The Lord of the Rings*, eventually to somewhere quite new and different. Finding a balance between something light and unencumbered and something that looked tough and armoured was challenging.

**Paul Tobin, Weta Workshop Designer**

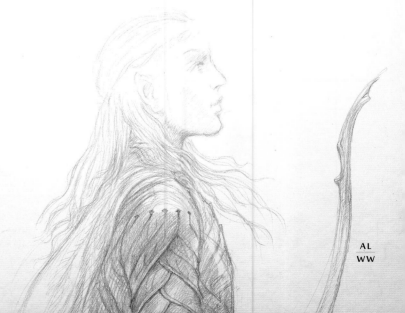

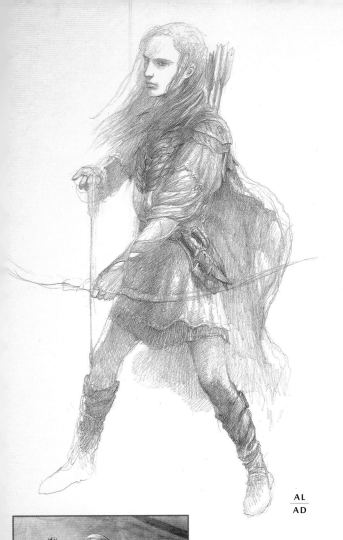

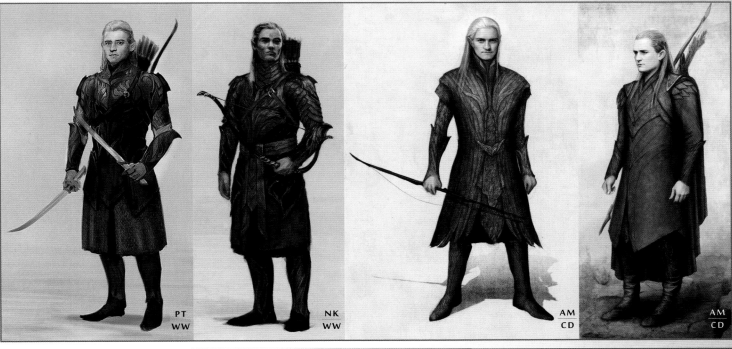

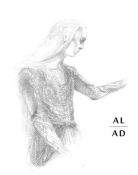

AL
AD

AL
AD

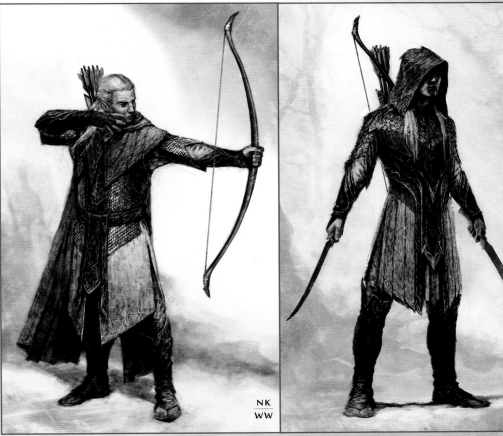

Legolas's costume for *The Hobbit* had to have echoes of what went before, though it became more elaborate. It is similar in cut and colour but more complicated. Physically, the actor is different, squarer across the shoulders, so this ended up changing what we could do with the costume.

**Ann Maskrey, Costume Designer**

We were vigorously seeking a comfortable level of armour versus light fabrics. Legolas had to be able to move as freely and lightly as we had seen him do before, but we also wanted to give him some armour that would make him look tough and strong. We were told he was going to be the captain of the guards, so he had to look impressive.

**Paul Tobin, Weta Workshop Designer**

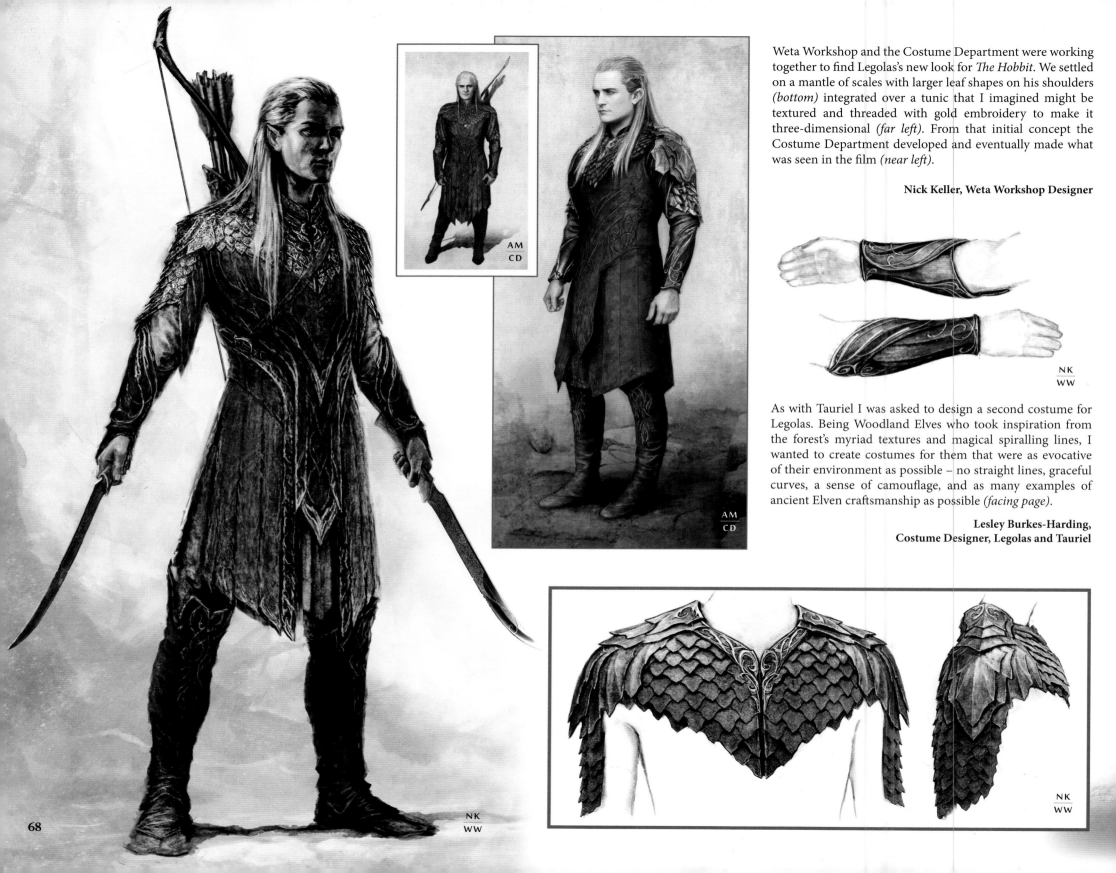

Weta Workshop and the Costume Department were working together to find Legolas's new look for *The Hobbit*. We settled on a mantle of scales with larger leaf shapes on his shoulders *(bottom)* integrated over a tunic that I imagined might be textured and threaded with gold embroidery to make it three-dimensional *(far left)*. From that initial concept the Costume Department developed and eventually made what was seen in the film *(near left)*.

**Nick Keller, Weta Workshop Designer**

As with Tauriel I was asked to design a second costume for Legolas. Being Woodland Elves who took inspiration from the forest's myriad textures and magical spiralling lines, I wanted to create costumes for them that were as evocative of their environment as possible – no straight lines, graceful curves, a sense of camouflage, and as many examples of ancient Elven craftsmanship as possible *(facing page)*.

**Lesley Burkes-Harding,**
**Costume Designer, Legolas and Tauriel**

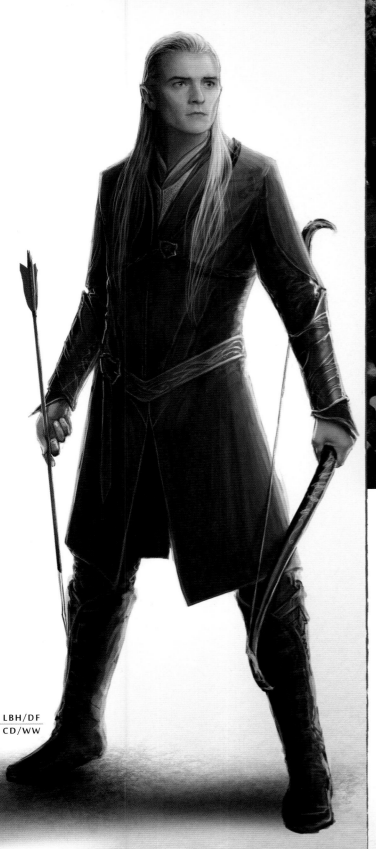

LBH/DF
CD/WW

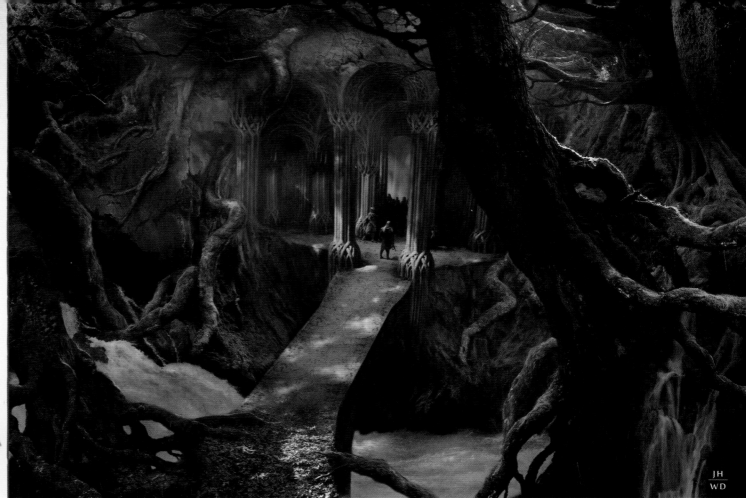

JH
WD

# THRANDUIL'S HALLS

### ENVIRONMENT DESIGN

Beneath the surface the Elves of Mirkwood have carved their home out of the limestone and, unlike the Goblin caves, it's beautiful. It's a natural cave system but they have gone in and carved the stalactites into tree shapes. It's an extension of the forest they once loved above. While the character of the forest has been changed by the evil leeching from Dol Guldur it has been Thranduil's policy to shut himself away in his kingdom, outlasting the troubles of the world. It might be a good strategy for an immortal being, except he doesn't yet understand that even the Elves will be affected by what is quietly growing in strength in the south.

**Dan Hennah, Production Designer**

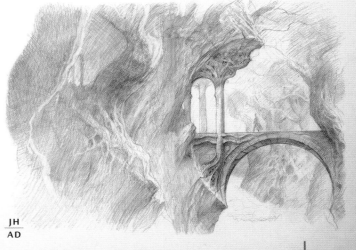

JH
AD

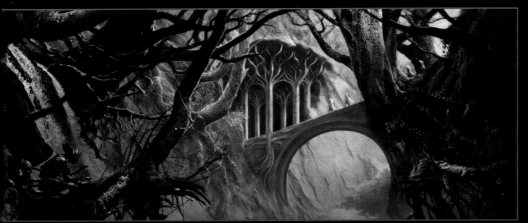

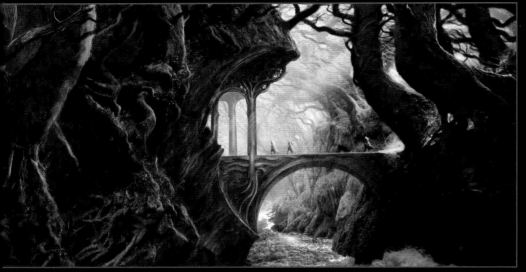

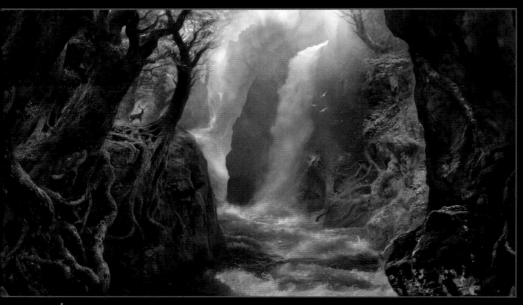

JH
WD

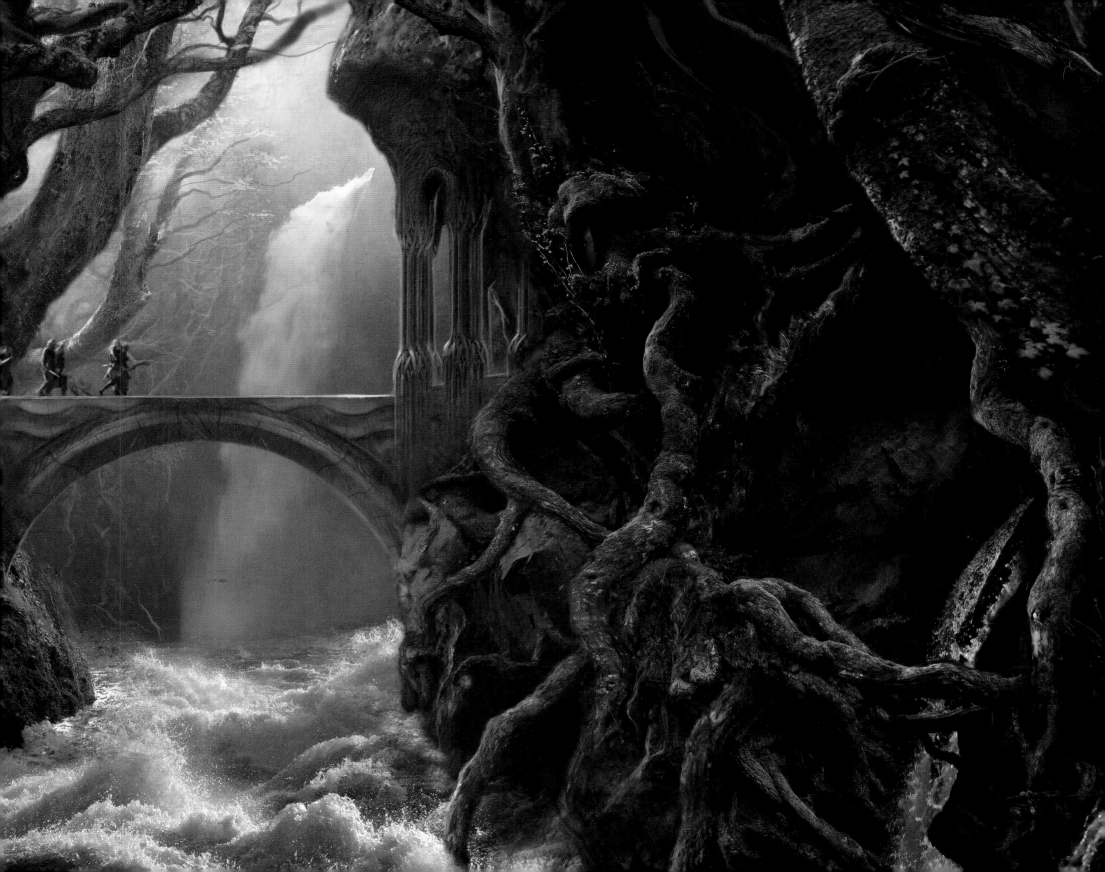

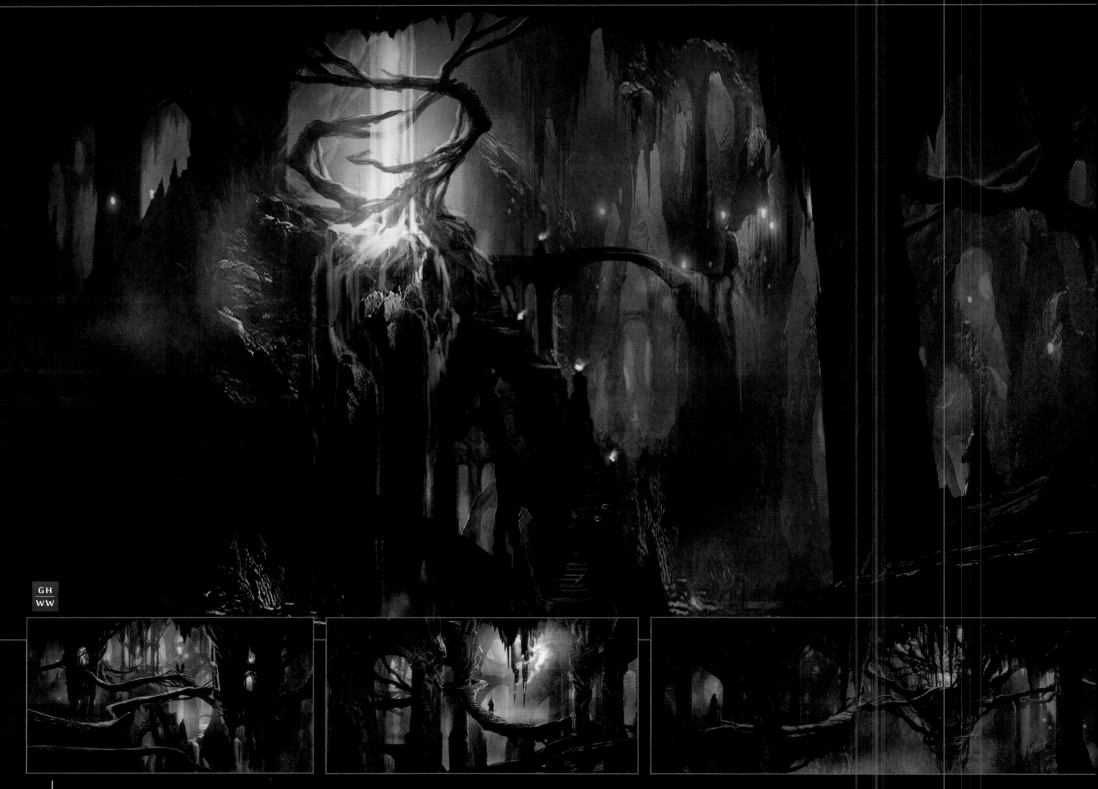

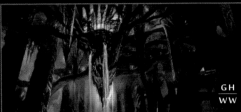
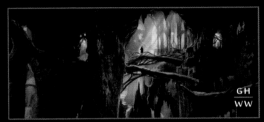
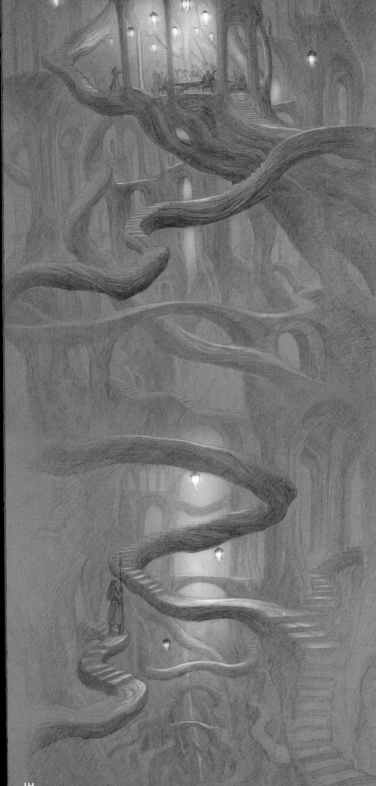

Descending into the underground Elven kingdom, Peter wanted to see an environment with a lot of depth. He wanted to look through layers of pillars and big winding roots, creating a really big space. Imagining what might light this place, in addition to torches, I thought there would maybe be stalactites filled with pockets of oil that the Elves would light. That could be quite beautiful, especially with a misty atmosphere created by waterfalls and reflections in water.

The throne room would be the centrepiece of the kingdom, with passages and networks of root walkways winding towards it. There would be waterfalls and streams as the water cascades down through hollow roots. It would be an enchanting place.

**Gus Hunter, Weta Workshop Designer**

Being new to Weta at the time, I was very nervous when I started these paintings *(top)*. I wanted to achieve the drama of Gus Hunter's amazing paintings, but with my own language – different colours, different moods. There are no bad ideas, just ideas that haven't found the circumstances to suit them, so we explore. I'm a big fan of Tolkien's world, so I built a vision of Middle-earth in my mind with the colours that surround me as an artist. I tried to express those ideas while following the guidelines that Gus had established as the lead environment artist.

**Eduardo Pena, Weta Workshop Designer**

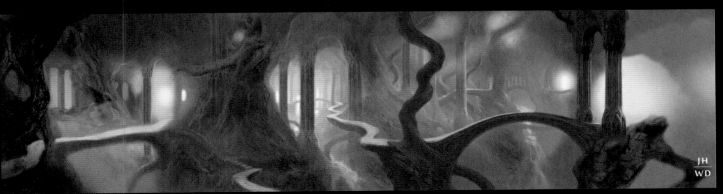

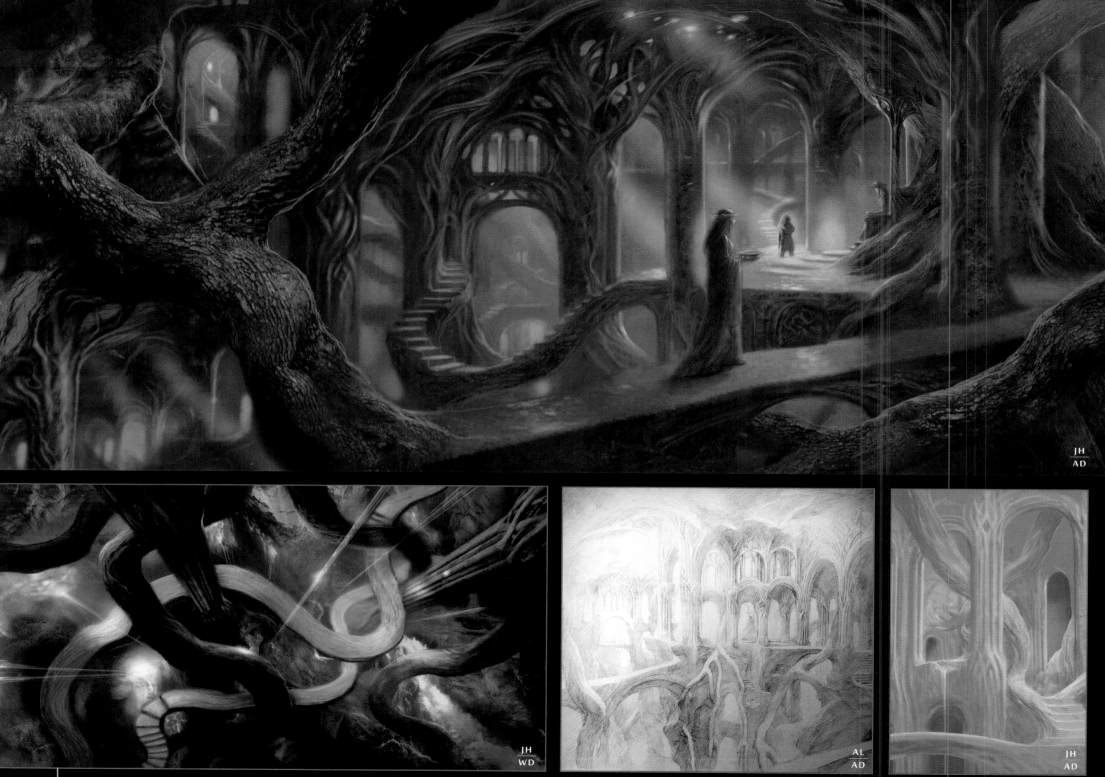

**THE WOODLAND REALM** - THRANDUIL'S HALLS

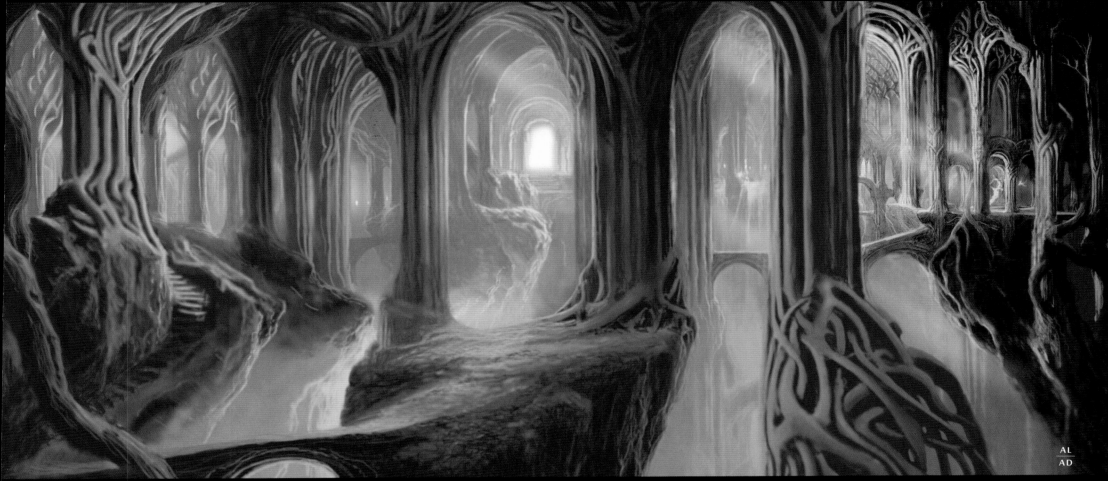

## LIGHTING

Amid their carved tree pillars the Elves have created beautiful brass fixing oil lamps with hollowed out amber, casting a warm light. And there are seams of amber in everything. It's all still very Art Nouveau, as is the pervading Elven aesthetic, even though they're underground.

**Dan Hennah, Production Designer**

The lighting in the caverns is evocative of sunlight piercing a leafy canopy. It's a kind of petrified woodland environment and all the decorative tracery is based on trees, limbs and leaves, with animals in there as well. The backlit amber was something of a theme for Mirkwood during a lot of the developmental drawings.

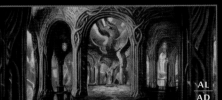
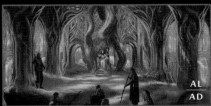

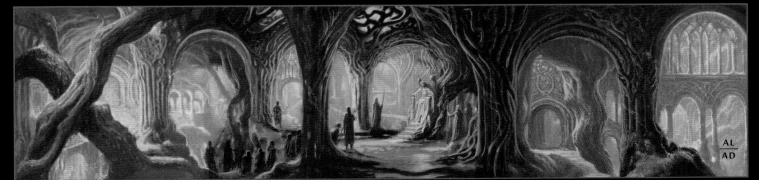

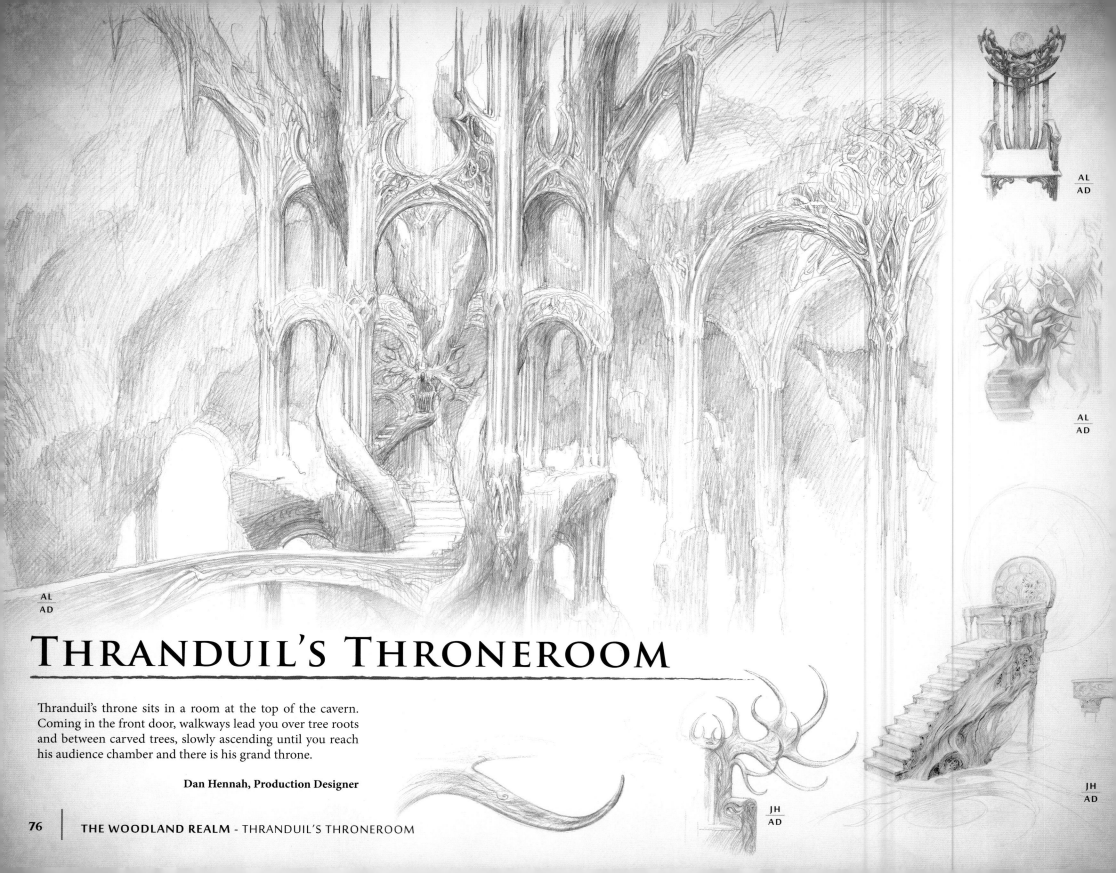

AL
AD

AL
AD

AL
AD

AL
AD

# THRANDUIL'S THRONEROOM

Thranduil's throne sits in a room at the top of the cavern.
Coming in the front door, walkways lead you over tree roots
and between carved trees, slowly ascending until you reach
his audience chamber and there is his grand throne.

**Dan Hennah, Production Designer**

JH
AD

JH
AD

We created countless concepts, trying to fix on a style and colour, but Peter's feedback brought us to the idea that Thranduil's throne room was really part of a much larger area and that he would always be looking off into great distances. The antlers on Thranduil's throne were something that I had introduced as a modest element, but which took flight in John's concepts. That is often the case in the way we work together. They are huge and very dramatic, creating a powerful shape framing Thranduil on his seat.

**Alan Lee, Concept Art Director**

The work Alan and I do isn't complete once the sets have been built and shot. We are also involved after the shoot, taking raw film plates and extrapolating elements that fill the green screen voids and often explode the scale of a given environment by orders of magnitude, far beyond what would have been practical to built and film. Thranduil's throne room, for example, was quite a small set comprising the elevated root throne, antlers and steps down to a platform. Everything else was to be realized digitally, so it was our role to go back and revisit that environment, expanding it into a grand and breathtaking space of waterfalls, twisting root walkways and carved rock pillars *(colour art, previous page)*.

**John Howe, Concept Art Director**

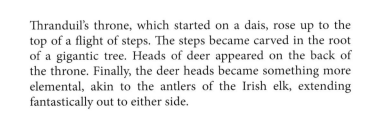

Thranduil's throne, which started on a dais, rose up to the top of a flight of steps. The steps became carved in the root of a gigantic tree. Heads of deer appeared on the back of the throne. Finally, the deer heads became something more elemental, akin to the antlers of the Irish elk, extending fantastically out to either side.

**John Howe, Concept Art Director**

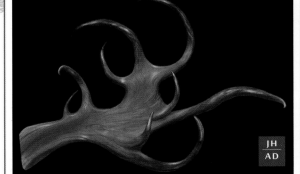

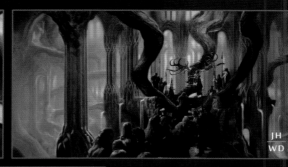

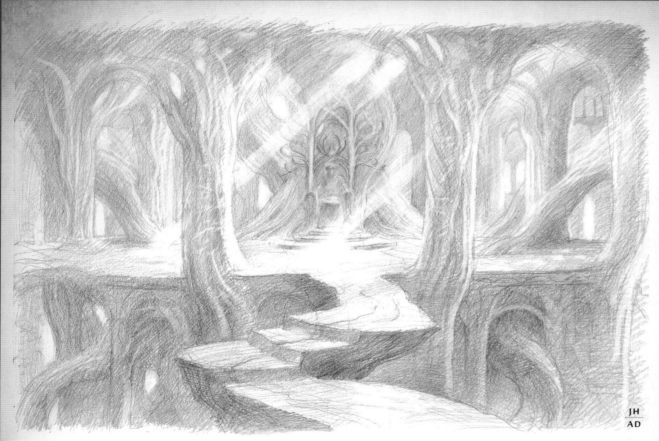

During preproduction John and I design environments and come up with concepts *(above)* which Dan Hennah and the Art Department team eventually turn into sets. Once the shoot is finished our task changes slightly and it becomes our job to go back in and work over photographic plates, painting in concepts for what will eventually be digitally extended *(all other images this spread)*. It's actually a very enjoyable process and allows us to be involved all the way through, influencing what Weta Digital creates for each shot.

**Alan Lee, Concept Art Director**

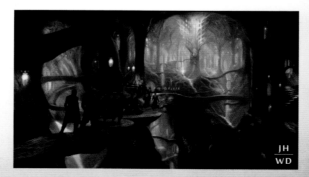

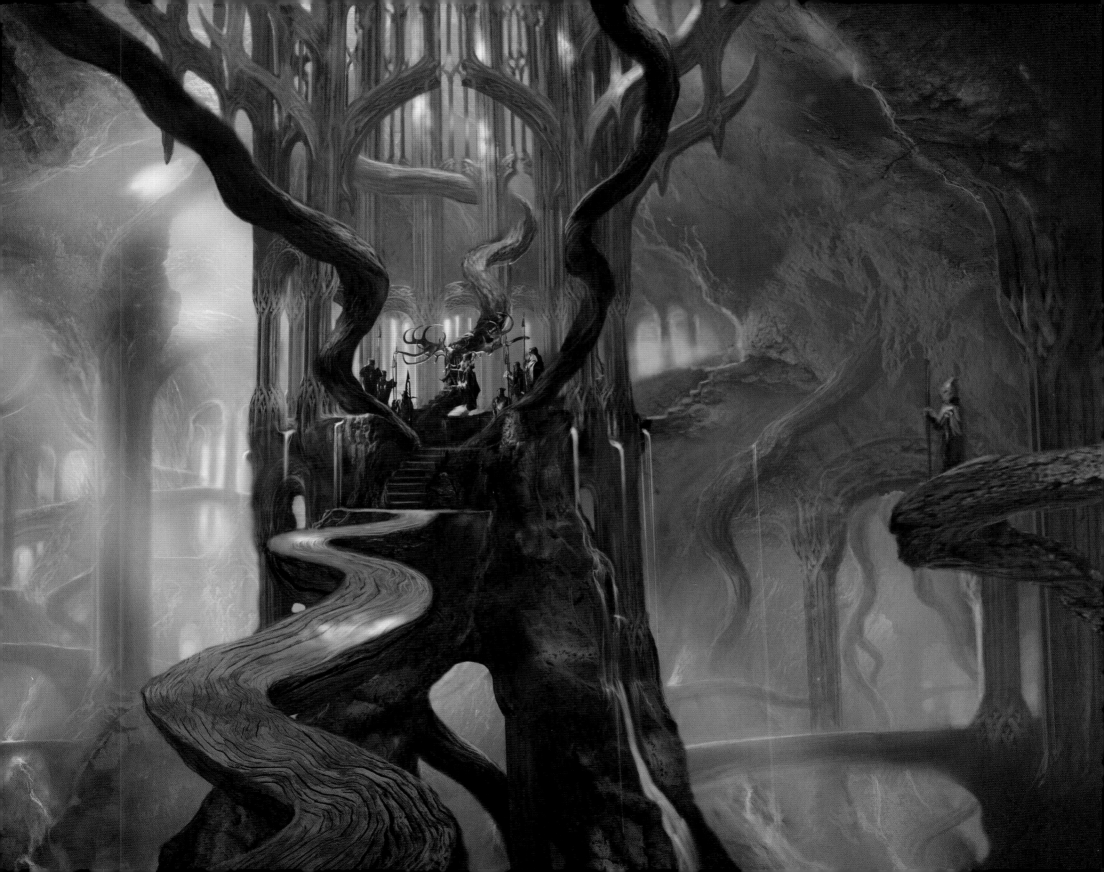

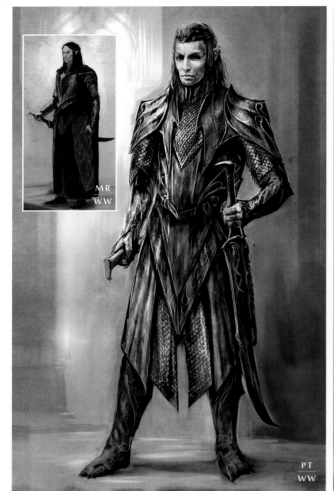

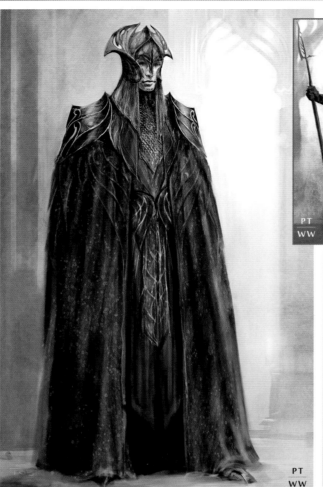

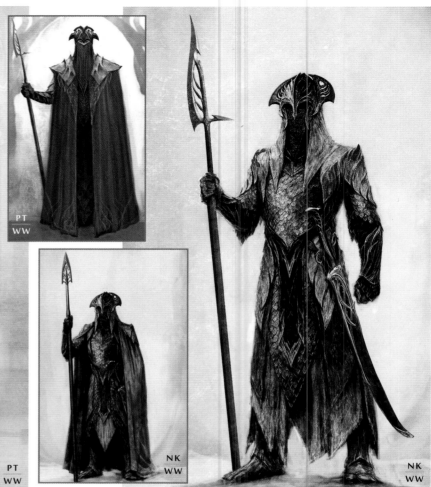

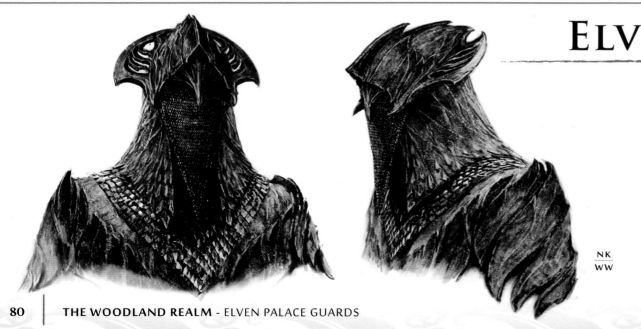

# Elven Palace Guards

## COSTUME DESIGN

As the designs evolved we settled into a green colour scheme, gradually becoming desaturated by the time we reached the final look of the palace guards. I was pleased to see the fan shapes in the helmet kept re-emerging because they gave such a striking shape to the head.

The notion of masking the palace guards also stuck. I thought it would look intimidating when the Dwarves first come in. Until now Elves have always been friendly, but these guys are indifferent and superior. They're dangerous, so masking them makes them unreadable and more imposing.

**Paul Tobin, Weta Workshop Designer**

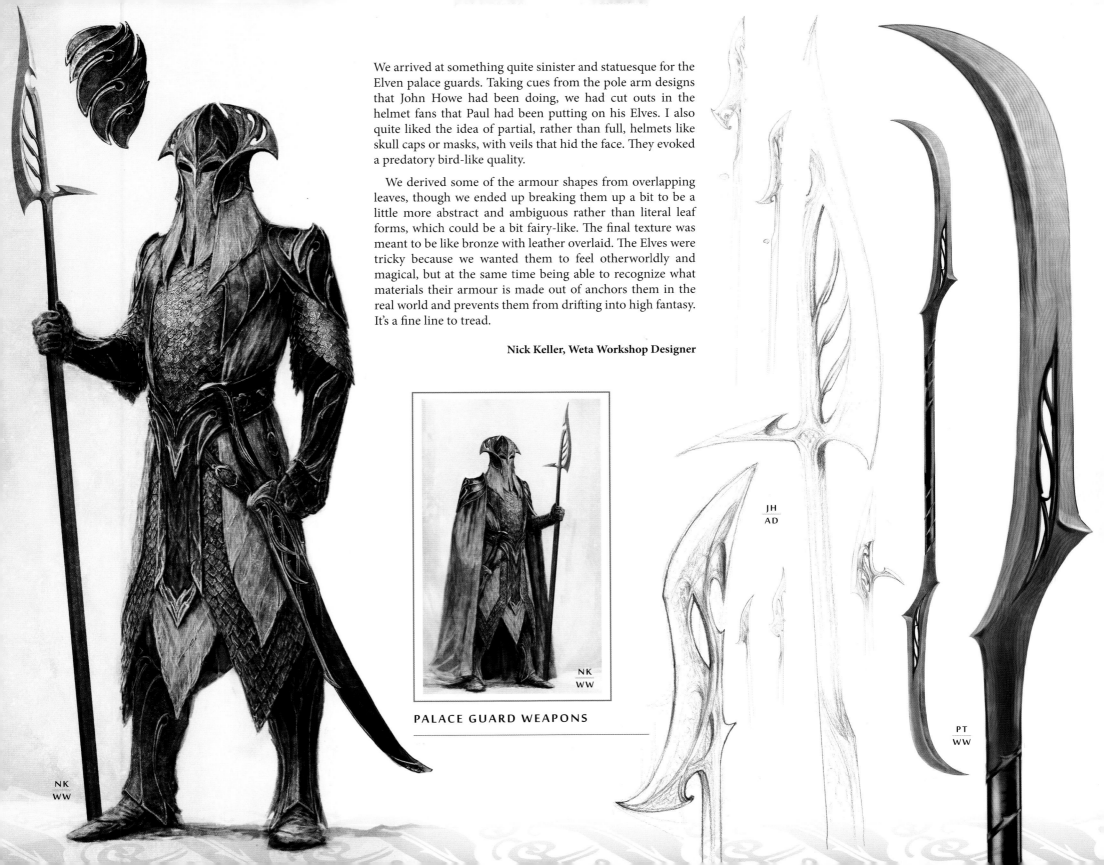

We arrived at something quite sinister and statuesque for the Elven palace guards. Taking cues from the pole arm designs that John Howe had been doing, we had cut outs in the helmet fans that Paul had been putting on his Elves. I also quite liked the idea of partial, rather than full, helmets like skull caps or masks, with veils that hid the face. They evoked a predatory bird-like quality.

We derived some of the armour shapes from overlapping leaves, though we ended up breaking them up a bit to be a little more abstract and ambiguous rather than literal leaf forms, which could be a bit fairy-like. The final texture was meant to be like bronze with leather overlaid. The Elves were tricky because we wanted them to feel otherworldly and magical, but at the same time being able to recognize what materials their armour is made out of anchors them in the real world and prevents them from drifting into high fantasy. It's a fine line to tread.

**Nick Keller, Weta Workshop Designer**

## PALACE GUARD WEAPONS

NK
WW

JH
AD

PT
WW

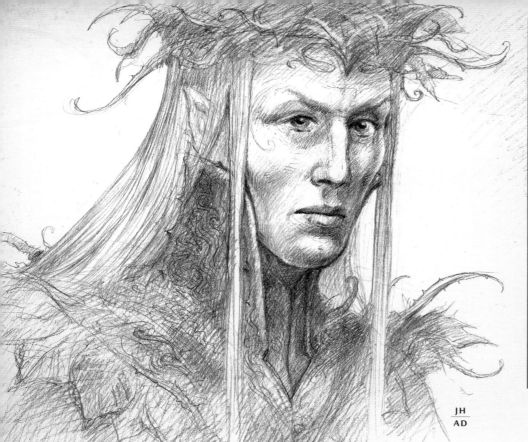

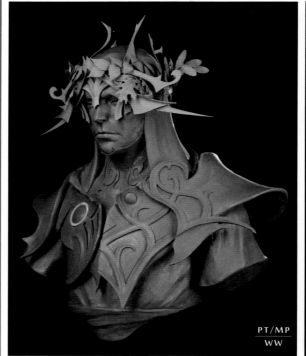

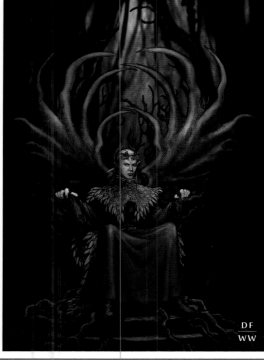

# THRANDUIL

## COSTUME DESIGN

All the Elven designs are inspired by nature, but unlike the Rivendell Elves, the Elves of the Woodland Realm are closer to nature itself, their art is less refined and filtered and stylized. These are the Elves who do not seek out the Undying Lands, but retreat into Middle-earth itself as their magic and power fade. This was the premise of their reintegration with nature, leafy, spiky and a bit dangerous, a step on the path away from sophistication to something very much closer to nature. There are the remains of the Elven elegance we know, with high collars, slim silhouettes and crowns, but it is all growing back into the forest again, into something wilder and less predictable. They are fading into the land, going underground, becoming the *Daione Sidhe* of legend.

**John Howe, Concept Art Director**

Thranduil was one of the first subjects I explored. His arrogance and grandeur are a complete contrast to Elrond, who is more understated. I took inspiration from the book descriptions, giving him a crown with elderberries and oak leaves that was very elaborate. I imagined he might hold his staff horizontally the first time we meet him. There's something unfriendly about holding it that way *(facing page, left)*.

His armour would be all ceremonial, with finely crafted wooden shoulder-pieces to give him a strong silhouette. As we went along the grandeur was less part of his character and he became more of a puritan with an austere look.

**Paul Tobin, Weta Workshop Designer**

It's funny to look back on some of the earliest work you did on a project when so little was defined. Thranduil was among the first things I drew. While he moved so far from my first drawing *(above, right)*, there must have been some synchronicity at work because I gave him a tree-root throne with great antlers and he ended up sitting on one in the movie years later.

**Daniel Falconer, Weta Workshop Designer**

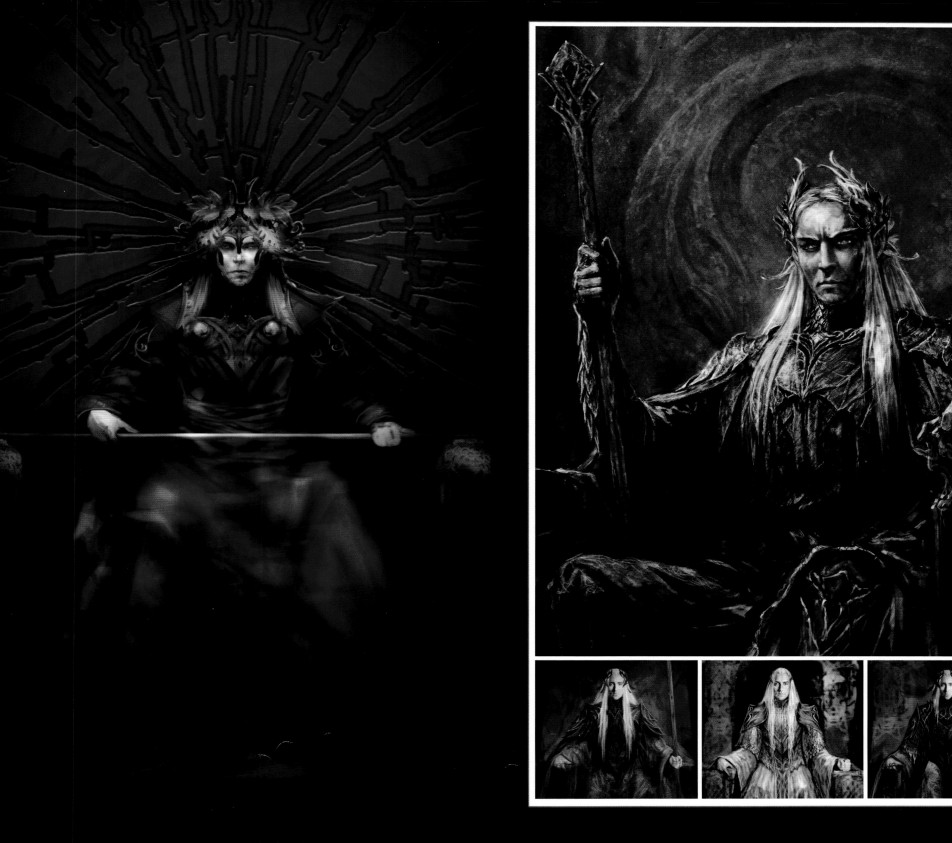

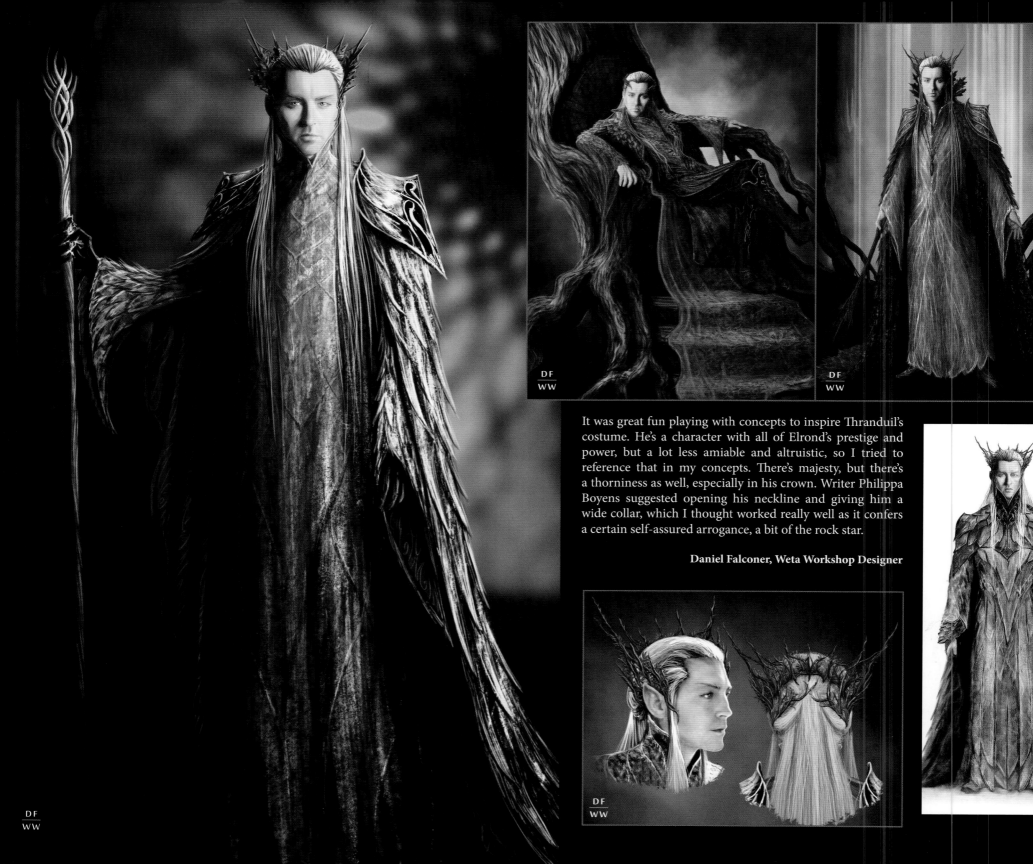

It was great fun playing with concepts to inspire Thranduil's costume. He's a character with all of Elrond's prestige and power, but a lot less amiable and altruistic, so I tried to reference that in my concepts. There's majesty, but there's a thorniness as well, especially in his crown. Writer Philippa Boyens suggested opening his neckline and giving him a wide collar, which I thought worked really well as it confers a certain self-assured arrogance, a bit of the rock star.

**Daniel Falconer, Weta Workshop Designer**

DF / WW

DF / WW

DF / WW

PT / WW

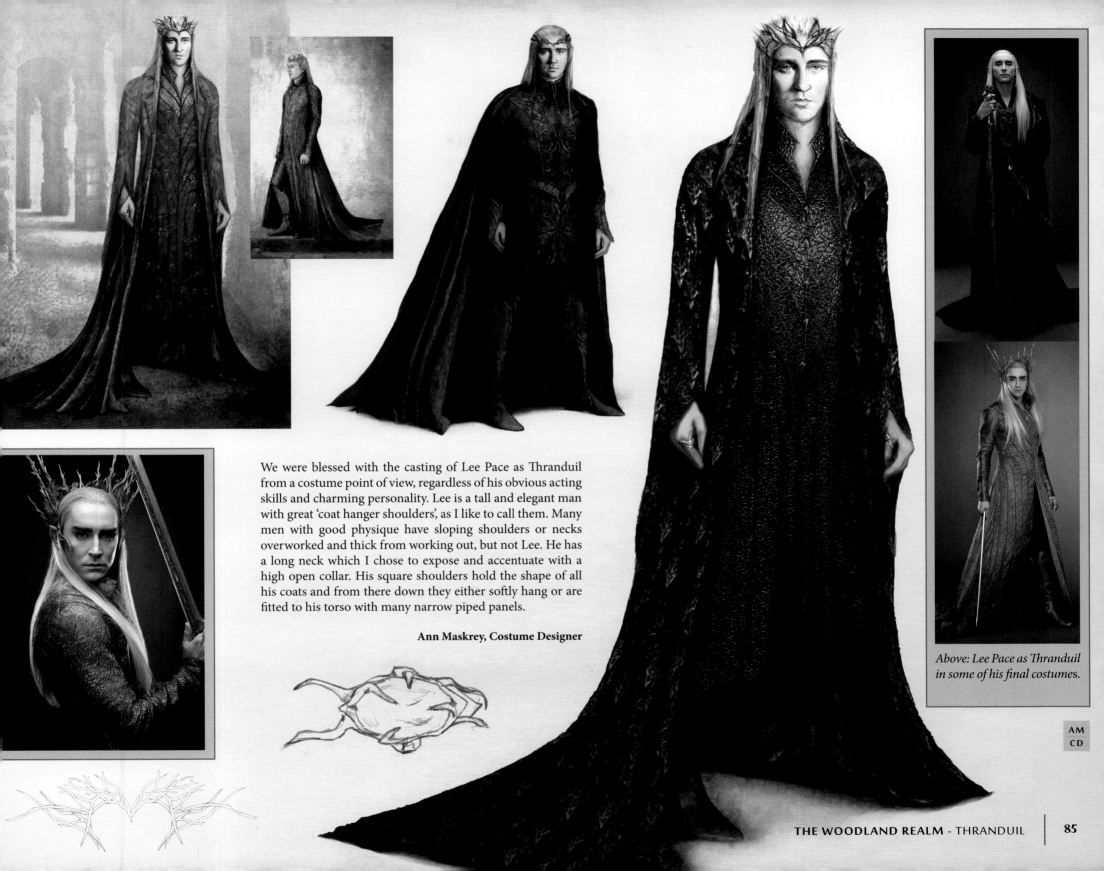

We were blessed with the casting of Lee Pace as Thranduil from a costume point of view, regardless of his obvious acting skills and charming personality. Lee is a tall and elegant man with great 'coat hanger shoulders', as I like to call them. Many men with good physique have sloping shoulders or necks overworked and thick from working out, but not Lee. He has a long neck which I chose to expose and accentuate with a high open collar. His square shoulders hold the shape of all his coats and from there down they either softly hang or are fitted to his torso with many narrow piped panels.

**Ann Maskrey, Costume Designer**

*Above: Lee Pace as Thranduil in some of his final costumes.*

AM
CD

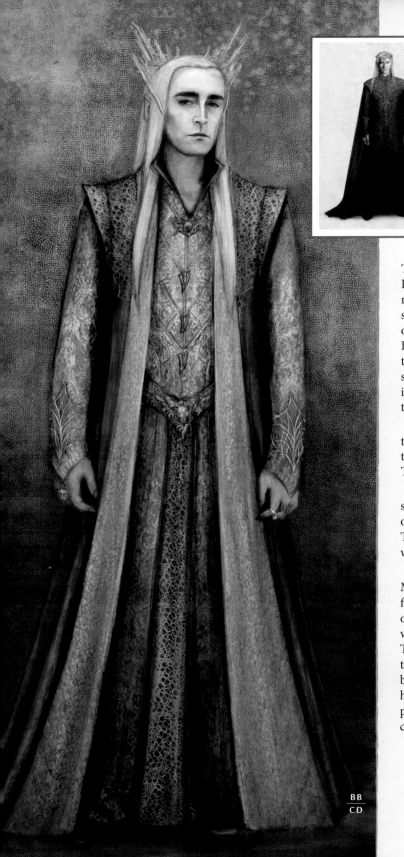

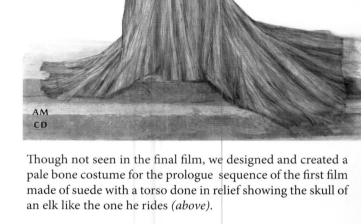

Thranduil needed a costume for his visit to Erebor and Philippa Boyens left us with the words starlight and moonlight to consider. To me that suggested a pewter silver shimmer or perhaps some slightly grey-mauve tones, but overall, a coolness, which is Thranduil through and through. I wanted to achieve an iridescent quality in the garment and to continue those long, lean lines of his hair down his costume so that hair and clothing became almost one – icy, simple and iconic *(left)*. He has long lines that accentuate his leanness, tapering to points in his sleeves, collar and shoulders.

The crown that had been made was very spiky and I wanted to ensure that that feeling of sharpness carried through into the costume as well. That barbed beauty is such a part of Thranduil's character.

The colour and texture of the costume were evocative of silver birch, but the overall effect we were looking for was one of coldness, of winter. Other scenes in which we saw Thranduil in Mirkwood had an autumnal palette, but this was a different time and, in my mind, a different season.

We found a fabric that had a certain intertwining quality. Mirkwood is a dense, bewildering and unforgiving place, full of twisting vines and tangled branches, with thorny organic forms. Combined with elegant brocade fabrics, that we cut up and put back together, this felt very appropriate to Thranduil. Breaking them up and recombining them made them feel more abstract, angular and organic, almost like bark. We took his robes completely to the ground because he is a king and these are his lordly garments. Given he is paying an official state visit to Erebor when we see him in this costume I think he would be in his full regalia.

**Bob Buck, Costume Designer**

Though not seen in the final film, we designed and created a pale bone costume for the prologue sequence of the first film made of suede with a torso done in relief showing the skull of an elk like the one he rides *(above)*.

**Ann Maskrey, Costume Designer**

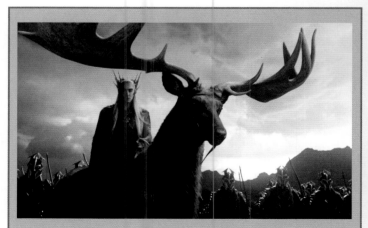

*Above: Lee Pace as Thranduil in a still from* The Hobbit: An Unexpected Journey.

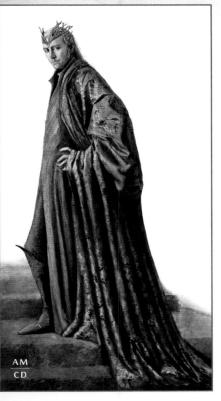

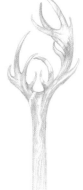

## THRANDUIL'S STAFF

As with everything to do with Thranduil, the design of his staff included thorn and stag-horn elements. Compared to the imagery in Rivendell there was more vigour in the Woodland Realm, with shapes that were stronger and slightly more ambiguous. It was beautiful, Elven design, but with an element of threat to it as well.

**Alan Lee, Concept Art Director**

## THRANDUIL'S SWORD

Thranduil's sword was a lucky first strike. Paul Tobin and I offered a handful of concepts and Peter picked one straight out. I liked the conceptual purity of an entire sword that was crafted from a single piece of metal, handle and all, a severity and simplicity that befit Thranduil. Cut-throughs and filigree wove like vines along the handle, offering grip, and subtracting weight from the blade itself. Weta Workshop Swordsmith Peter Lyon's finished prop was an exceptional piece of work.

**Daniel Falconer, Weta Workshop Designer**

# PALACE STAFF

The Elven palace servants wore scrunched leg wraps of leather over simple slippers. I kept them in the colours of wines and wine-bottles, which I thought would look good on the set. Executive Producer Zane Weiner quipped one day that, in his dark velvet wrap coat, Galion the butler looked like Hugh Hefner!

**Ann Maskrey, Costume Designer**

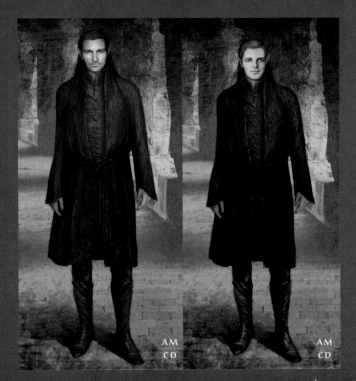

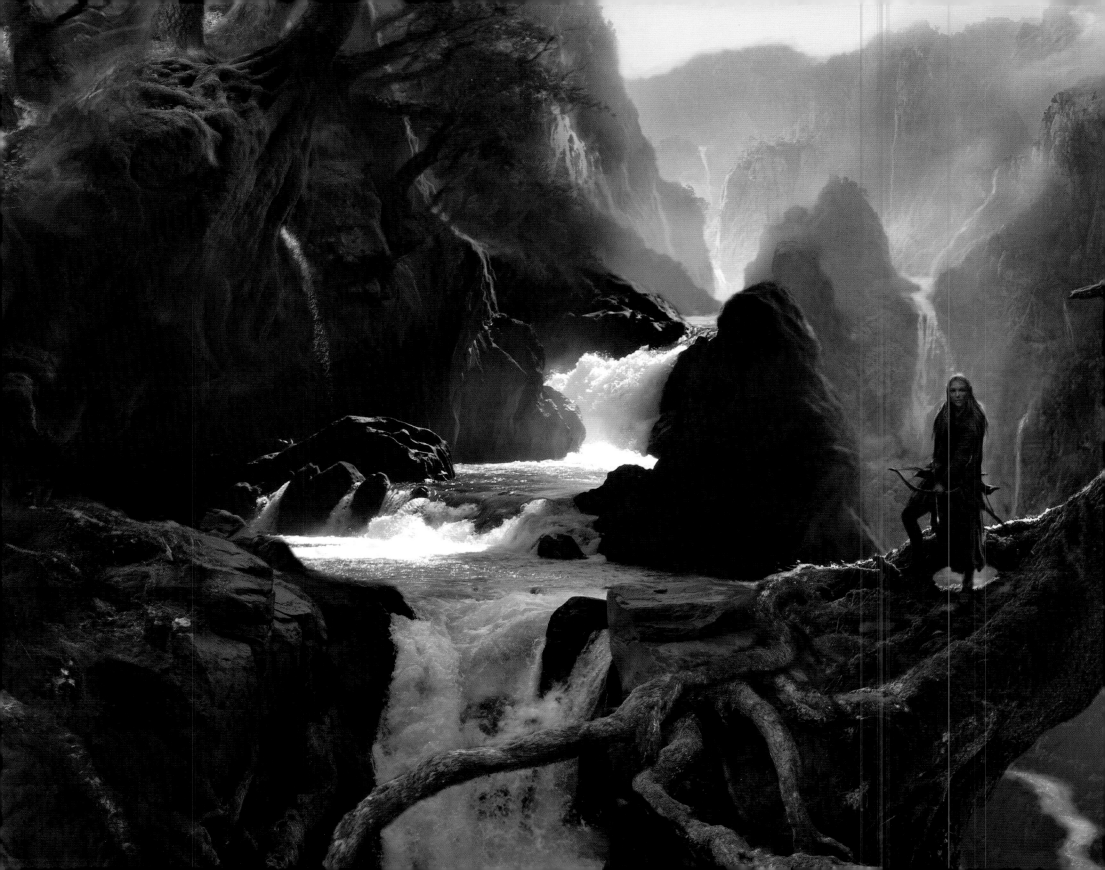

# BARRELS
## OUT OF BOND

### FLIGHT DOWN THE RIVER

Bilbo hatches a daring plan to free the Dwarves from Thranduil's dungeon, the enacting of which sees them fleeing in barrels down the underground river which the Elves use in their commerce with the people of Lake-town where the water course terminates. What ensues is a chase and a running battle when their actions are discovered.

Designing subterranean dungeons and a practical, working cellar that looked obviously Elven in design would present an interesting brief, while conceiving the elaborately modified natural waterway that the barrels would plummet down was its own huge task.

Elves are great craftsmen and have the ability to gently guide the natural elements with which they coexist to grow in their favour. An Elven aqueduct system could be very beautiful and enchanting and quite unlike anything humans would build, and of course a fantastic place to set a chase. The Art Department would work on this sequence throughout the entire time they were on the films, designing and then fulfilling the ambitious potential of the scene with elaborate practical water-courses that they could control, modify and reset to shoot the sequence, which also had to match location photography that would book-end the chase.

As many of the Dwarves would spend quite a large amount of time in the water, the grace and good humour of the project's actors and stuntmen were both depended upon and greatly appreciated.

JH
WD

# WOODLAND CELLS

The premise of the Woodland Realm was that this is a limestone cave system beneath a huge forest. The stone has been carved and shaped over centuries by water running through it and is threaded by massive roots from the trees above. The cunning Elves have employed these tree roots to cross the yawning fissures in the rock and have burrowed into the cliff faces to create spaces to live, among them the prison cells where the Dwarves end up being sent.

Being Elvish, it can't just be a miserable prison. They have an aesthetic so we designed Elven cell doors made out of bronze, heavy and functional, but embracing that distinctly Elven look and carrying on the theme of an underground forest that runs through Thranduil's realm.

The entire environment has been shaped to be like a subterranean forest. The Elves have even collected amber and used it almost the way we might use glass, shaping it to

their needs, hollowing it to make lanterns containing oil and framed with intricate metal tracery, casting a beautiful golden light. This mingles with filtered light coming from cracks far above and the ever-present dripping of water finding its way down to the underground river far below.

**Dan Hennah, Production Designer**

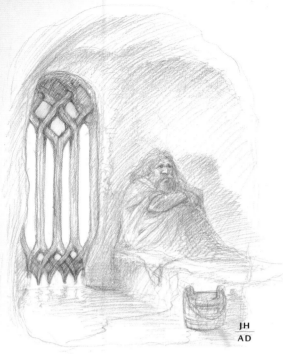

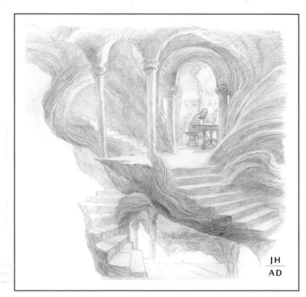

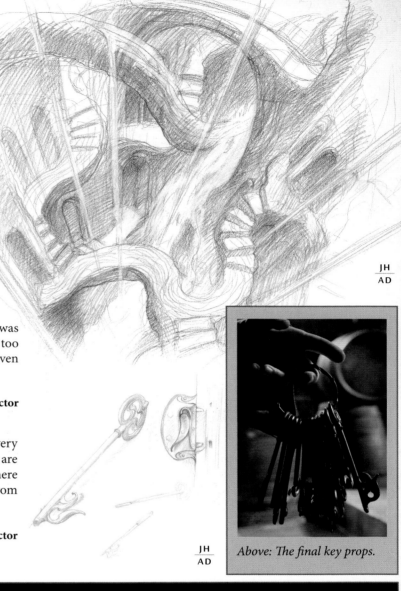

The poor Dwarves of Thorin & Co. spend an inordinate amount of time underground, often locked up to boot. But Thranduil's halls are hardly just a dark cavern. They are a subterranean forest of stone, with elegantly sculpted columns and architraves echoing tree branches, the whole transversed by the gigantic roots forming natural staircases and walkways. Imagine a forest cathedral, bathed in light, with no symmetry, grown from the living stone, where you could follow twisting pathways high in midair through the nave.

**John Howe, Concept Art Director**

One thing Peter wanted to get across was that this place was a prison. Even being Elf-made, he didn't want it to look too elegant so we had to find the right balance between Elven craftsmanship and Elven intractability.

**Alan Lee, Concept Art Director**

The prison cells, while distinctly Elven, are in the very deepest and darkest recess of the Woodland Realm. These are the last places, the dead-end spot at the very bottom, where the Dwarves are imprisoned, below the cellars and far from the airy halls above.

**John Howe, Concept Art Director**

*Above: The final key props.*

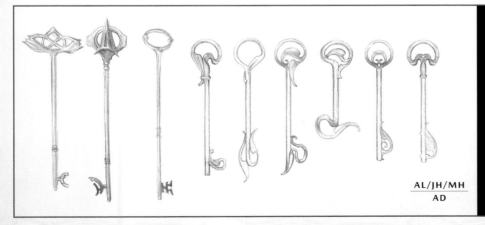

# RUNE-STONE

Kili had an engraved rune-stone that we had the chance to offer some suggestions for. There was an exchange over the stone in the cells between him and Tauriel, part of the building of the relationship between those characters. Some I based on crystalline shapes, others on raw stones, while my favourites were inspired by Maori adze-heads in which a beautifully carved edge was polished out of a raw stone. Powerful, masculine shapes, they are a valued gift in New Zealand, something you give to someone special, and I thought that was an appropriate association. I thought it would be really cool if perhaps the runes were hard to see cut into the dark, glassy stone, but when held up to a light they shone.

**Paul Tobin, Weta Workshop Designer**

AL / AD

PT / WW

*Above: The final rune-stone prop.*

# THRANDUIL'S CELLAR

## ENVIRONMENT

The wine cellar in Thranduil's realm was one of those lovely design challenges because it is full of potential contradictions. It's an Elven space, and those tend to be open and airy, but this had to be an enclosed, practical space. Upstairs is ethereal, but down here they are manually dealing with barrels, bottles and cheeses. Finding that uniquely Elven blend of practicality and elegance was our design task.

**Dan Hennah, Production Designer**

JH / AD

AL / AD

AL / AD

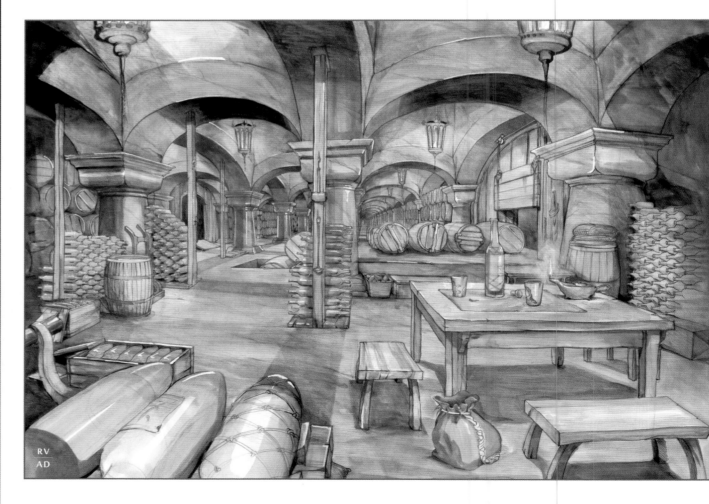

RV / AD

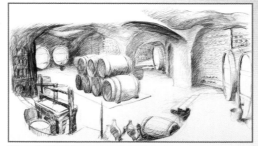

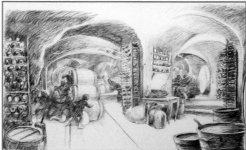

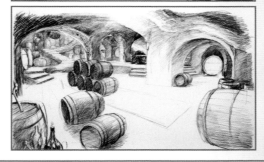

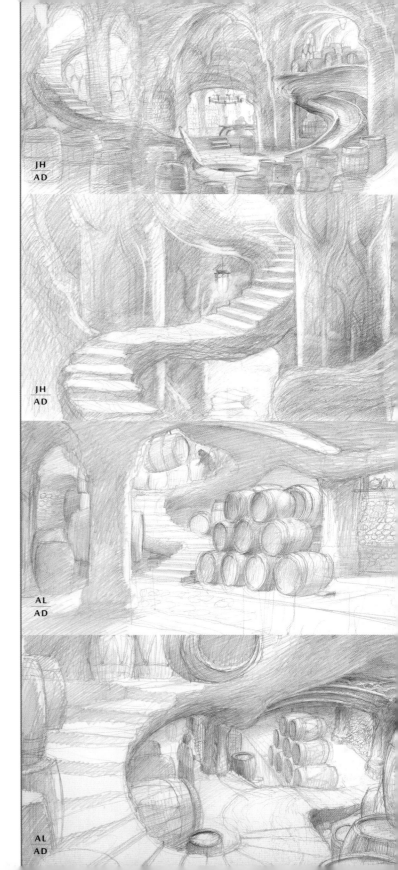

Our cellar changed a bit over the years we were thinking about it, but Peter always felt it should feel like a real, working cellar with lots of barrels, bottles and arches. One of the questions was the trapdoor. How many barrels would go down it and how? Would the barrels be on a trolley, be in piles or be rolled into a kind of spiral trough made of roots? Eventually we arrived at the simple idea of having them stacked on a sea-sawing trapdoor to tumble down all together when released, which worked brilliantly as a practical effect.

**Alan Lee, Concept Art Director**

The cellar set was a big organic structure and took a while to find its form. We had to fill that set with a huge amount of dressing, including hundreds of barrels and bottles, furniture, racks and other details, so we actually began designing and building that stuff long before the set design was locked down or built.

**Ra Vincent, Set Decorator**

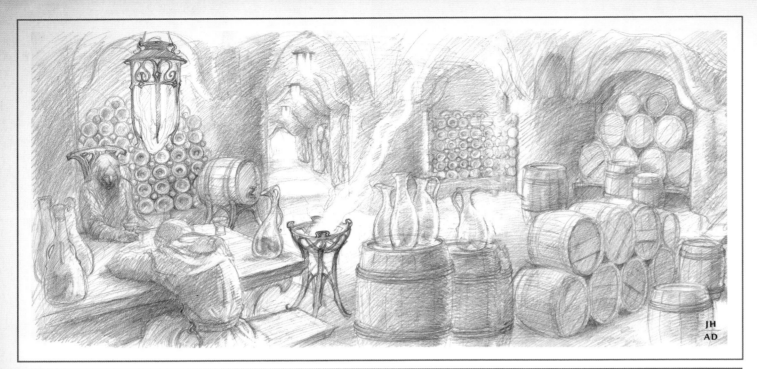

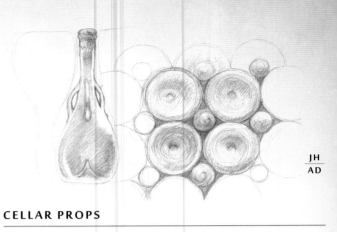

JH
AD

## CELLAR PROPS

There were some beautiful wood and amber glasses and a table in the cellar set. They're an example of a basic item that we made very Elven just by how they were approached and the materials of which they are made.

**Nick Weir, Prop Master**

We could have gone crazy with barrel designs, but in the end we worked on the premise that a fifty-gallon wine barrel is a barrel – no design embellishments, that's what a barrel is. We would be dealing with scaling issues for our Dwarves, so across the board you have a small barrel and big barrel, but a barrel is a barrel.

**Dan Hennah, Production Designer**

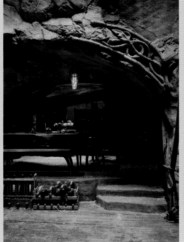
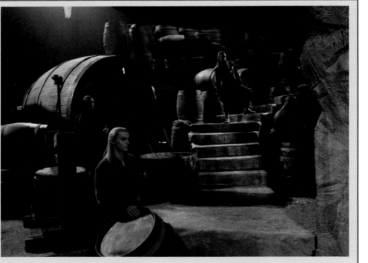

*Above: The final barrel cellar set, dressed with hundreds of barrels and bottles.*

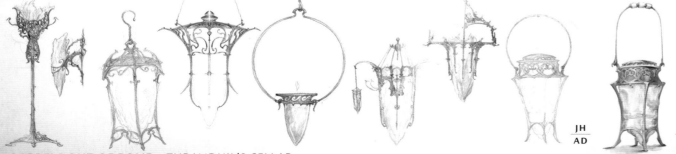

MH
AD

JH
AD

RV
AD

LC
AD

MS
AD

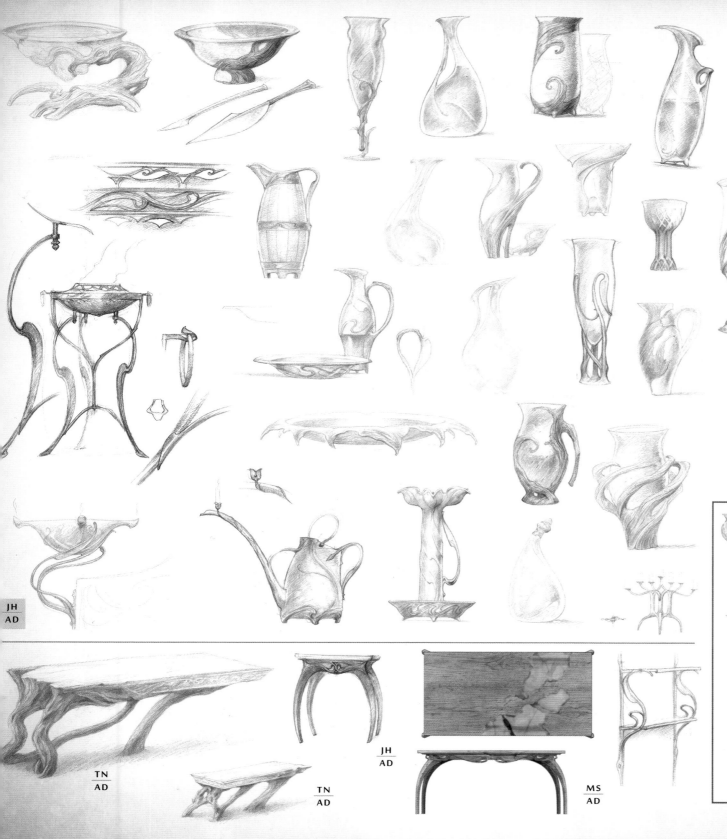

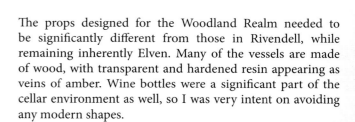

The props designed for the Woodland Realm needed to be significantly different from those in Rivendell, while remaining inherently Elven. Many of the vessels are made of wood, with transparent and hardened resin appearing as veins of amber. Wine bottles were a significant part of the cellar environment as well, so I was very intent on avoiding any modern shapes.

**John Howe, Concept Art Director**

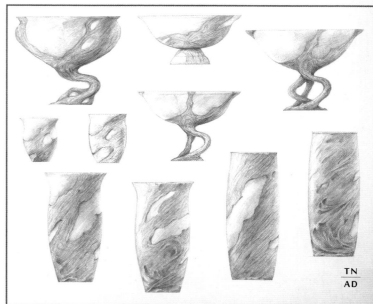

JH
AD

TN
AD

TN
AD

JH
AD

MS
AD

TN
AD

# BARREL CHASE

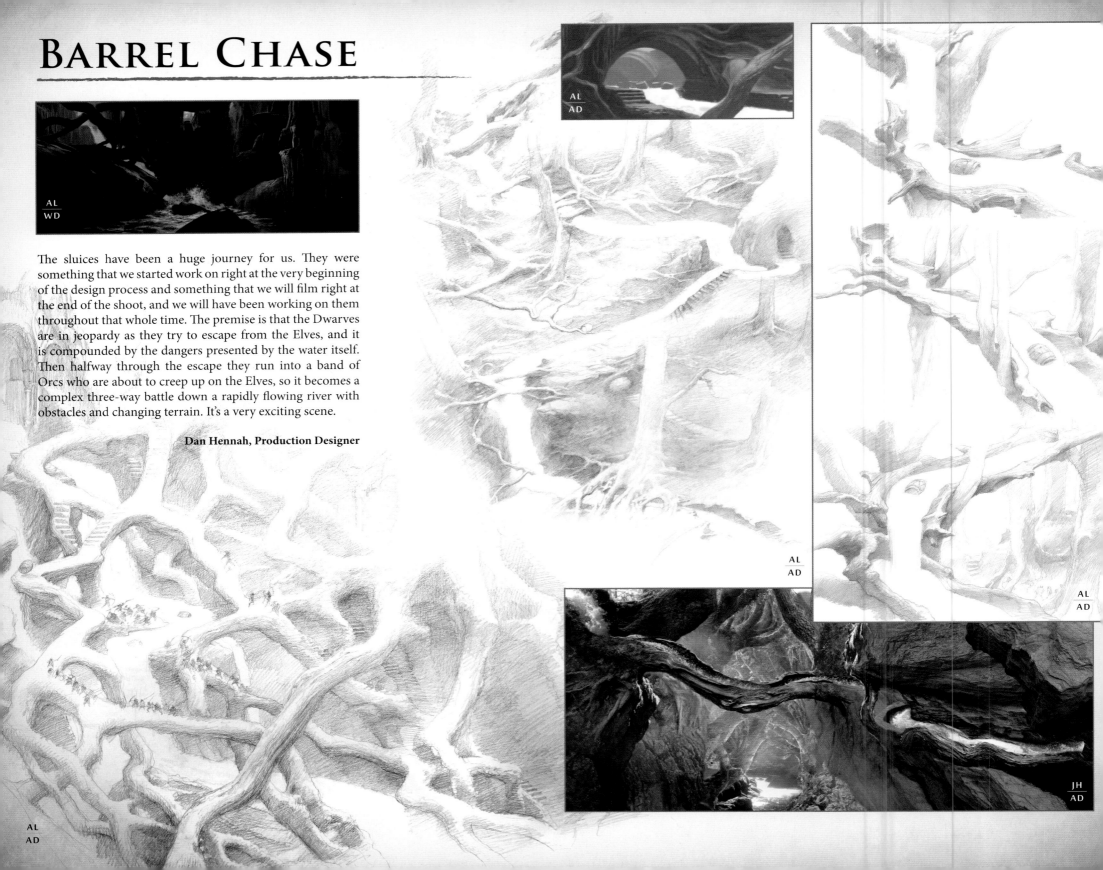

The sluices have been a huge journey for us. They were something that we started work on right at the very beginning of the design process and something that we will film right at the end of the shoot, and we will have been working on them throughout that whole time. The premise is that the Dwarves are in jeopardy as they try to escape from the Elves, and it is compounded by the dangers presented by the water itself. Then halfway through the escape they run into a band of Orcs who are about to creep up on the Elves, so it becomes a complex three-way battle down a rapidly flowing river with obstacles and changing terrain. It's a very exciting scene.

**Dan Hennah, Production Designer**

AL
WD

AL
AD

AL
AD

AL
AD

AL
AD

JH
AD

AL
AD

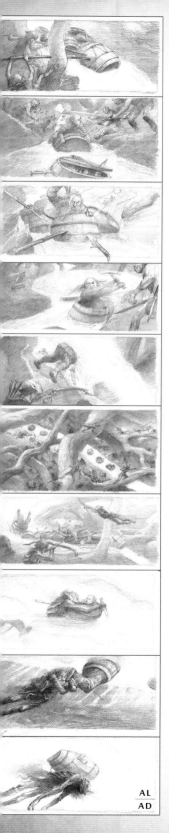

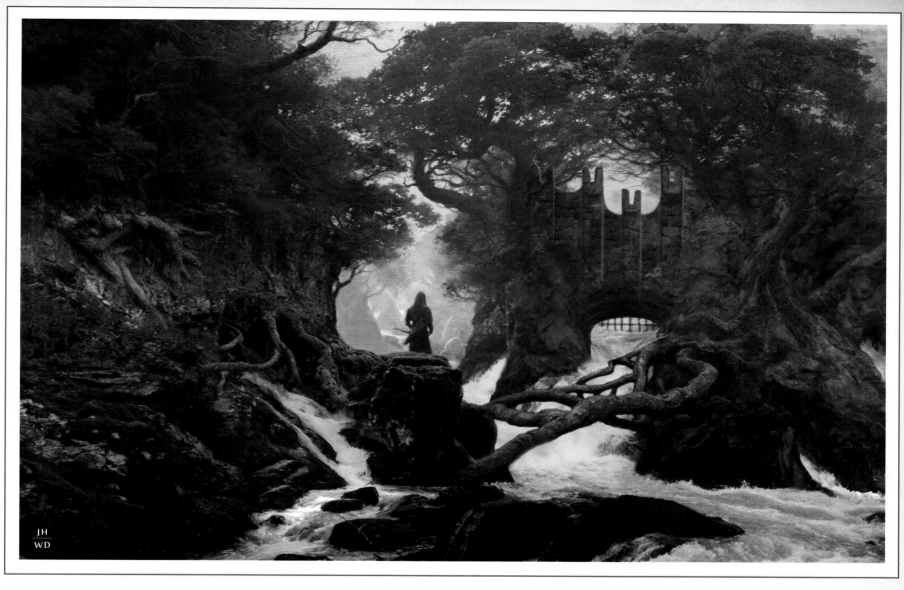

In the book, the Dwarves float in their barrels out of the caverns and down the river. Their escape in the film isn't so easily achieved; the Elven sluiceways are hardly a tranquil watercourse. In getting away the Dwarves race along channels carved into cliff faces, plunge down vertiginous waterfalls, go through hollow trees and tunnels and all kinds of danger. Not only are they pursued by the angered Elves, invading Orc warbands are there as well.

**John Howe, Concept Art Director**

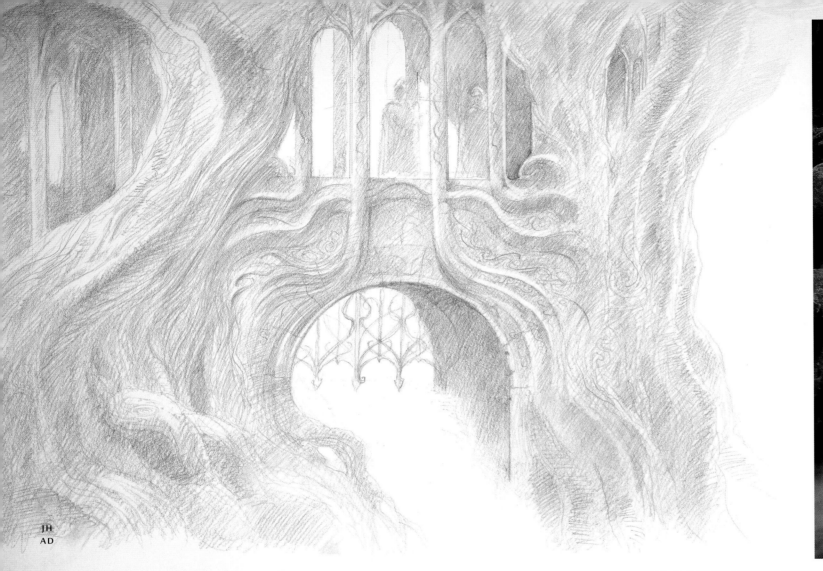

The Elves have devised this amazing network of sluices and waterways. It's like an elaborate aqueduct system with roots and bridges so that they can control where the water flows. I tried to envision how it might start off underground and then perhaps become part of a natural stream on a mossy cliff face, then maybe go back into the carved roots of trees again, in and out and all over the place. Alan Lee and John Howe had done drawings of this as well. Sometimes it's a natural waterway and sometimes it's something they've created.

**Gus Hunter, Weta Workshop Designer**

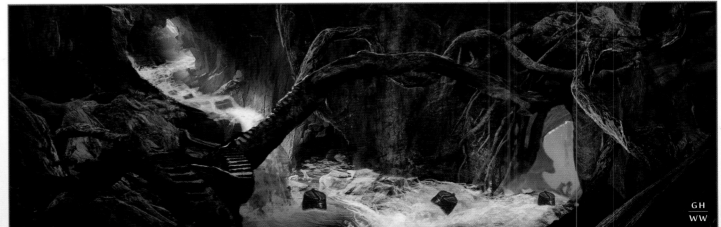

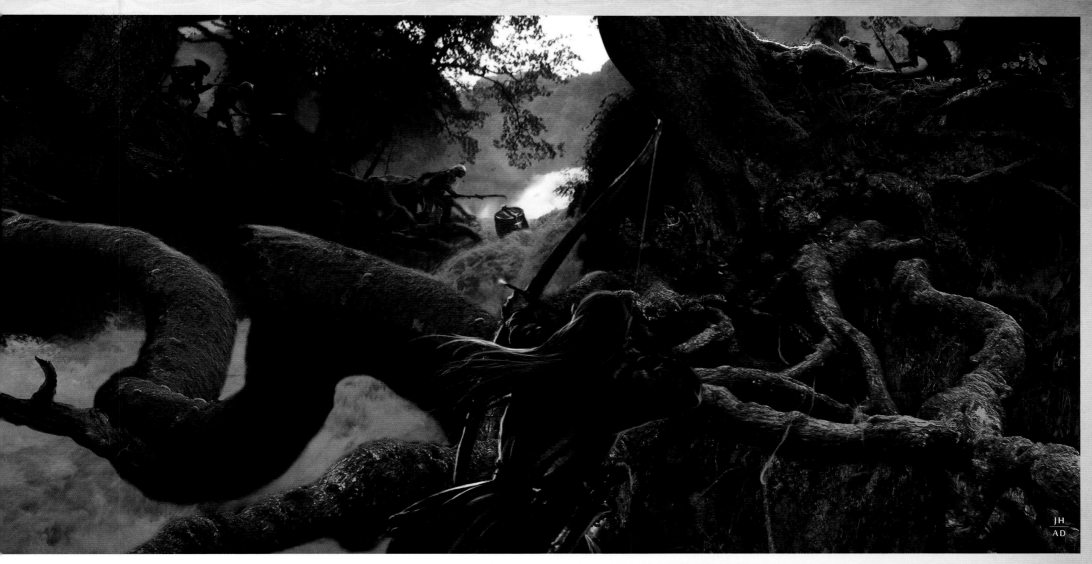

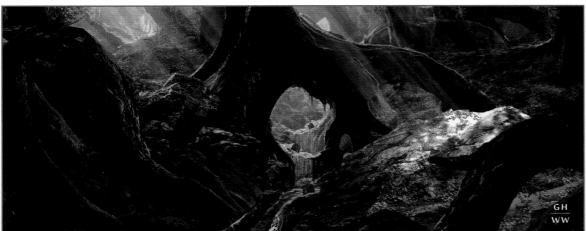

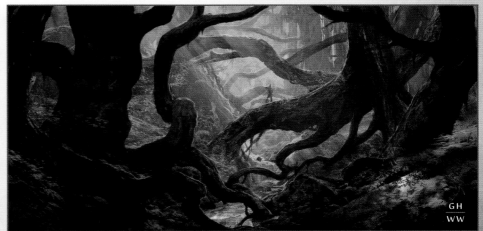

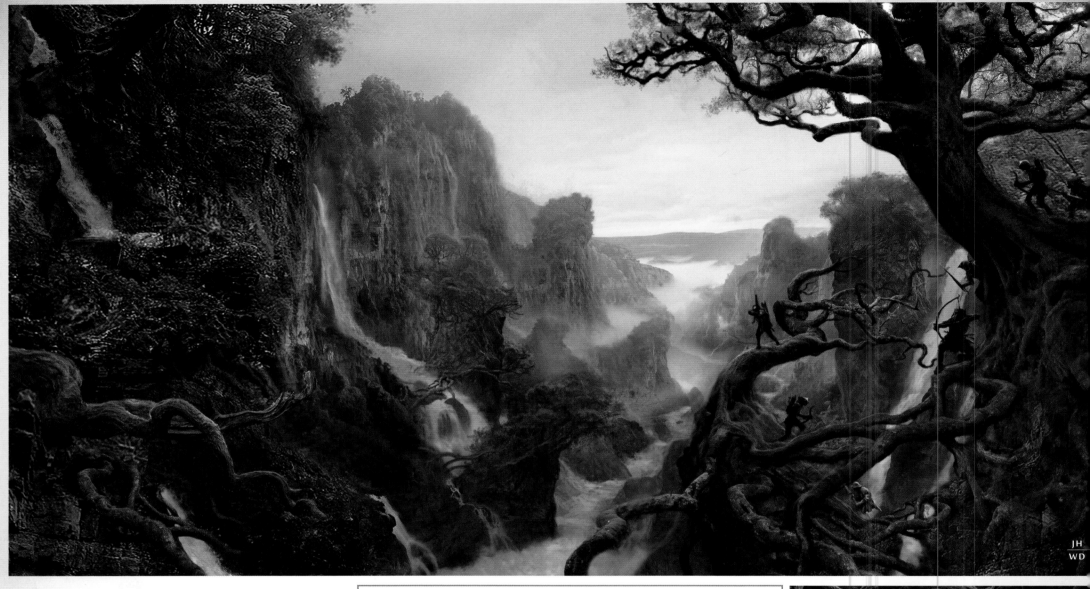

The landscape of the Dwarves' exit from the Woodland Realm is the sort of thing you could almost expect to find in New Zealand, tucked away in some unexplored valley in Fiordland: a karst landscape of pinnacles and wild waterways, vertical cliffs with great windswept trees leaning precariously over precipices. Twisted roots provide walkways over deep chasms, with the waterways running like the 18th-century Alpine *suonen* carved along impossible cliff faces.

**John Howe, Concept Art Director**

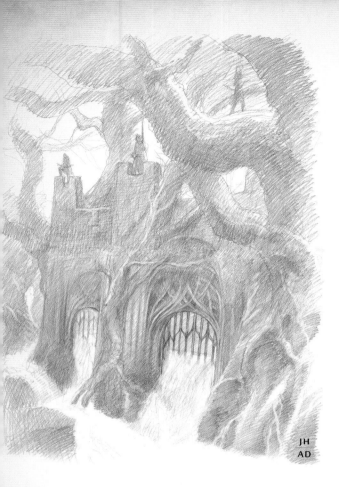

The barrel ride down the river and out of the Woodland Realm was something that demanded a huge number of drawings. We designed the entire route, right from the cellar to where they end up in the main river and you could trace the course from one drawing to the next.

The course of our imagined journey began below the cellar in an underground river, in which we saw some of the staircases and paths where the Elves might pursue them. It then opens out and they go down fast-flowing canyons before the watercourse cuts its way along a canal dug into the side of a cliff, which the Elves have cut to control the river's course. It would go into a tunnel and then along a series of wooden parts of trees, descending from one to another, through a wild environment of waterfalls and rapids and then to a section where one of the barrels would be ejected from the river and rattle downhill, banging into trees and over roots before falling back into the river again, all with plenty of opportunities for drama.

**Alan Lee, Concept Art Director**

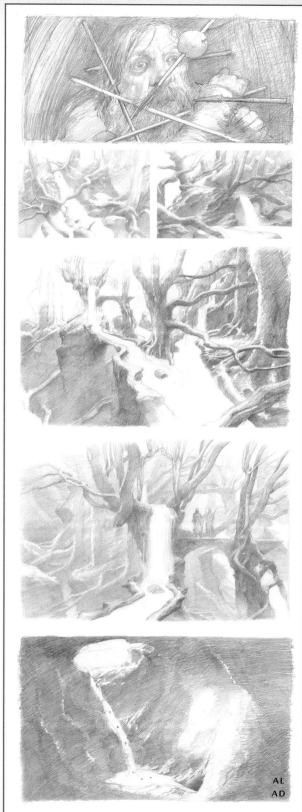

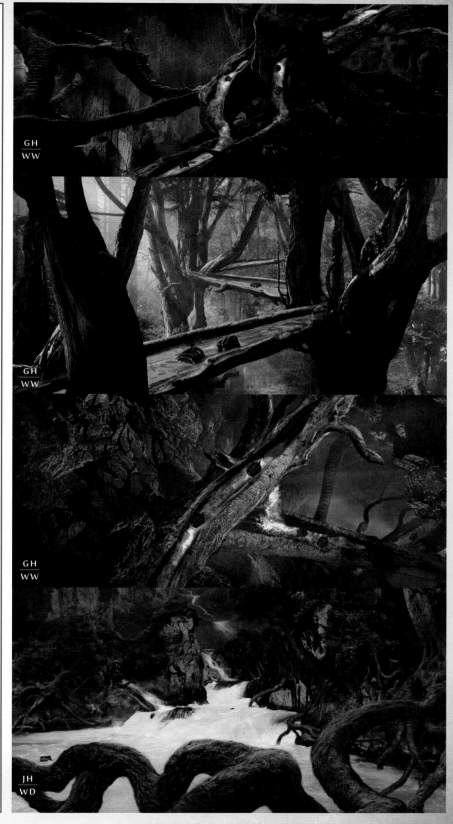

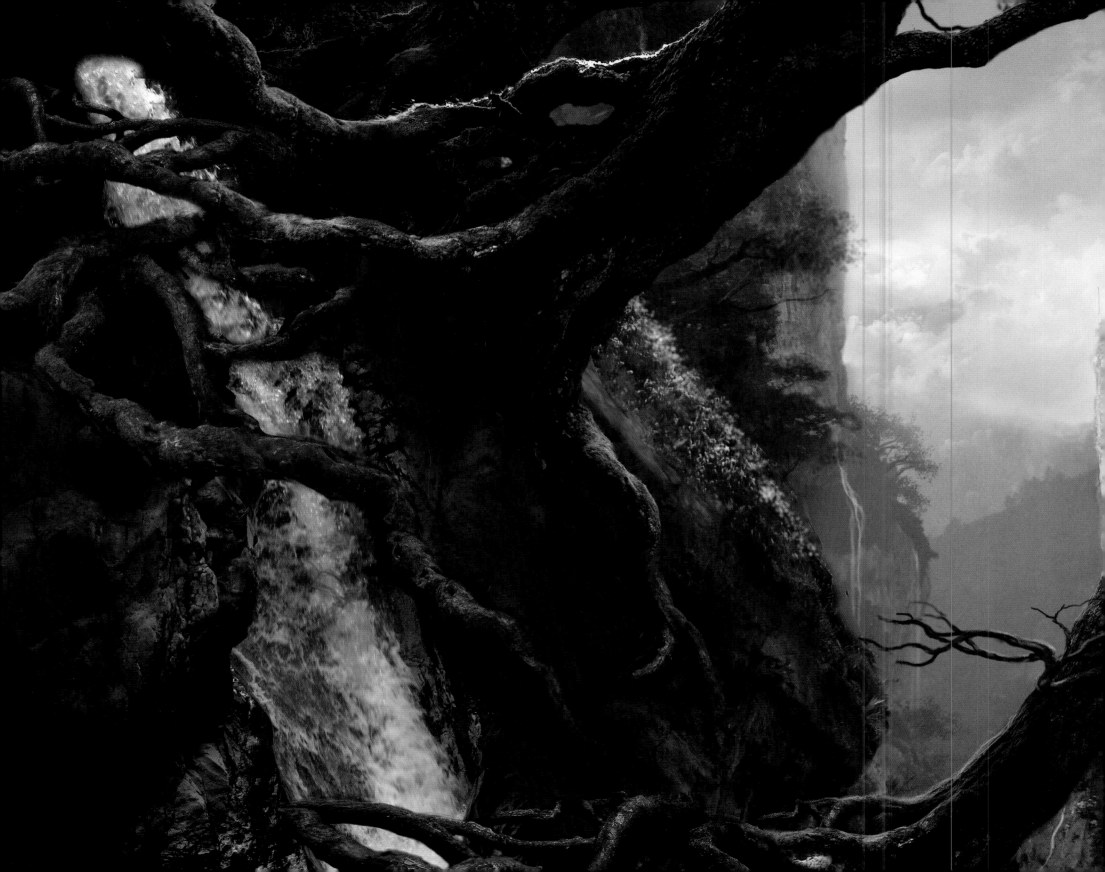

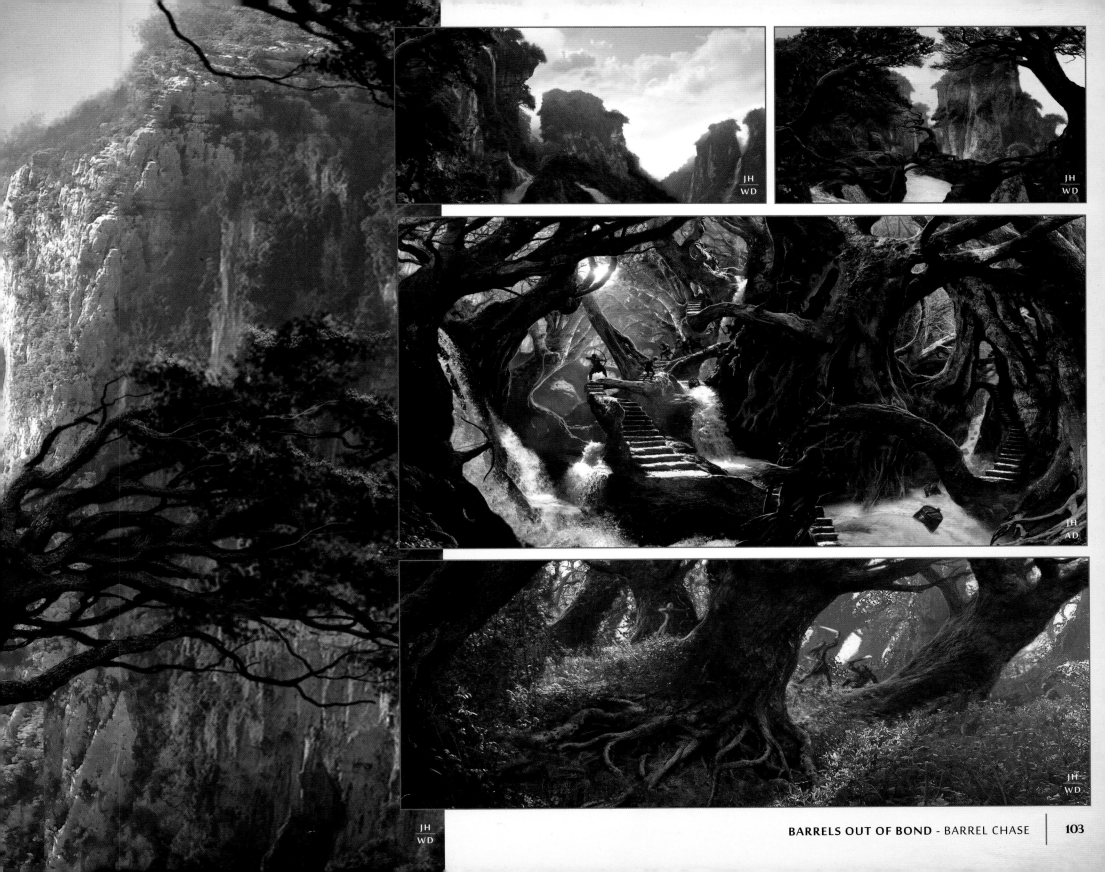

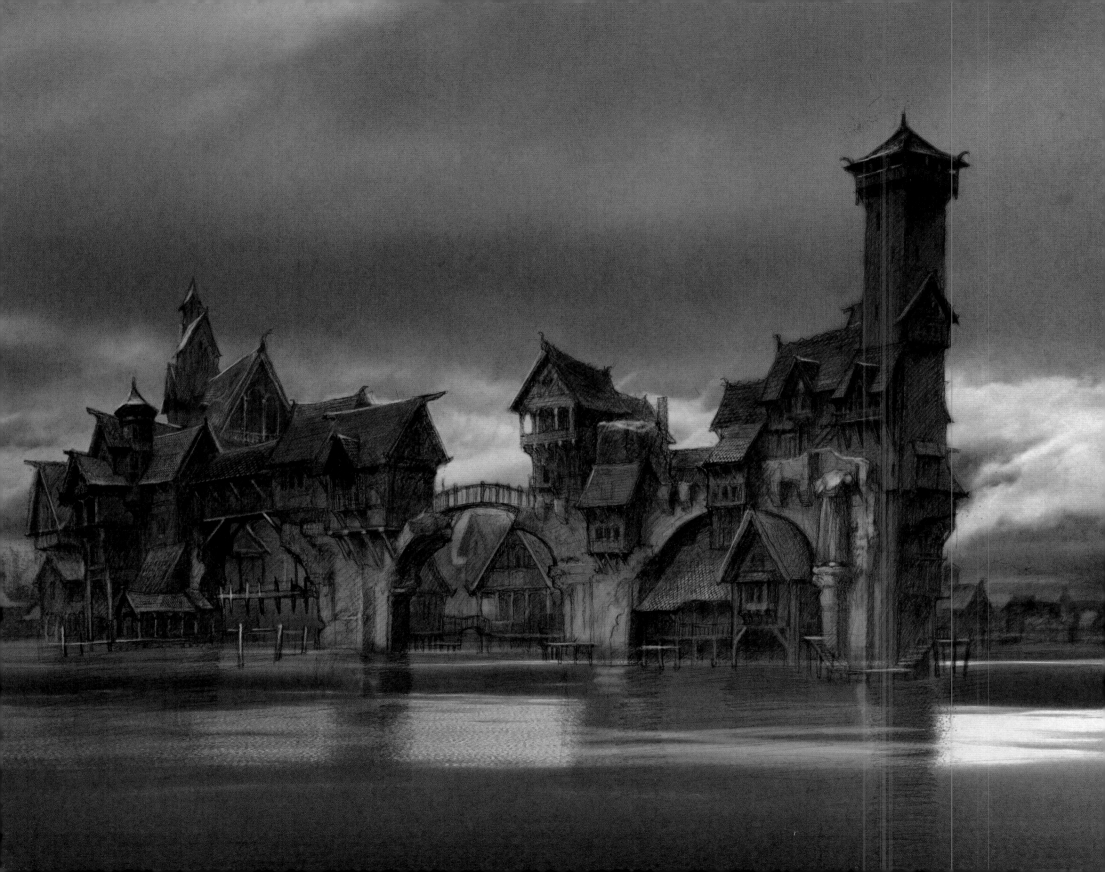

# A WARM WELCOME

## LAKE-TOWN AND ITS PEOPLE

Sodden, miserable and bedraggled, Thorin's Company finds itself scrambling ashore, freshly escaped from the dungeons of the Elven-king, but badly in need of rest and resupply. Fortunately they are found by Bard, an honourable, if not sympathetic, boatman of Lake-town, a settlement of men perched on rotting piles a short distance from shore in the Long Lake.

Also called Esgaroth, the town was once a trading hub for the entire region with close ties to the prosperous town of Dale and the neighbouring mountain kingdom of Erebor, but that was in happier times, before the coming of Smaug. Now Lake-town is in a state of slow decay. Its buildings rot and its people dwindle and despair, scratching what living they can off the lake and its surrounding lands while their leader, British actor Stephen Fry's

greasy Master of Lake-town, grows fat and wealthy. And all the while, the threat of the legendary Dragon slumbering beneath the looming bald peak of the Lonely Mountain casts a worrisome shadow over all.

Bard himself, played by Luke Evans, descends from the high born refugees of ancient Dale. A hard working man of simple values and integrity, he makes a living as a bargeman while raising three children alone. Bard helps the Dwarves enter Lake-town, but is deeply concerned once he begins to comprehend their true intentions, as Thorin's increasingly blind ambition to reclaim the Mountain, the Arkenstone, and his lost legacy threatens to engulf all of them in fire and death.

# BARD

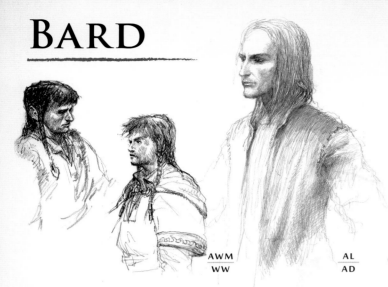

AWM / WW

AL / AD

Lake-town is a sort of controlled state, run by a dictator who has his hands on the town purse. It is a stilted community but it's rotting away from underneath, which is symbolic of what is going on among its people as well. There is nothing to sustain them and in time the town will drown, held under by the greed of its corrupt leadership, the Master and his complicit assistant Alfrid.

Doing his best as a single father and working man in these times is Bard. While it isn't expressed in the films, I had my own thoughts about what happened to his wife. I imagined she died in childbirth delivering the youngest of Bard's three children, his daughter Tilda, who is around the age of seven. The situation created by having Bard raising three children on his own works very well and makes him a very interesting hero. He cares deeply for his three wonderful children and struggles as best he can to provide for them, which makes him vulnerable and quick to warm to as an audience.

When he first meets the unruly Dwarves and the hobbit his only thought is that he might be able to make some money by getting them into town. He is thinking and surviving hand to mouth, which is the state that Lake-town is in. That changes when he comes to appreciate who they really are and what Thorin has in mind.

**Luke Evans, Actor, Bard**

We had been looking at reference material of nomadic tribesmen with enormous arrows on their backs. It created such a striking silhouette that we pushed the idea of Bard having arrows like that.

**Nick Keller, Weta Workshop Designer**

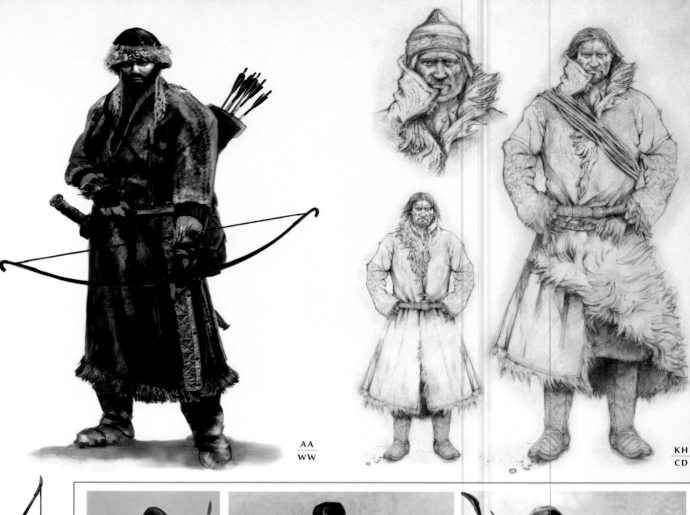

AA / WW

KH / CD

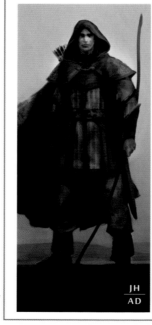

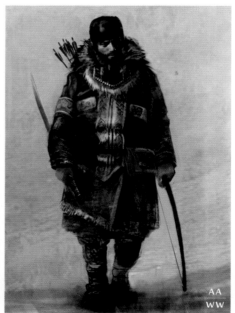

FV / WW

JH / AD

AA / WW

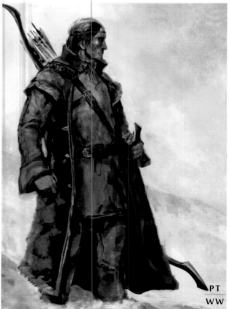

PT / WW

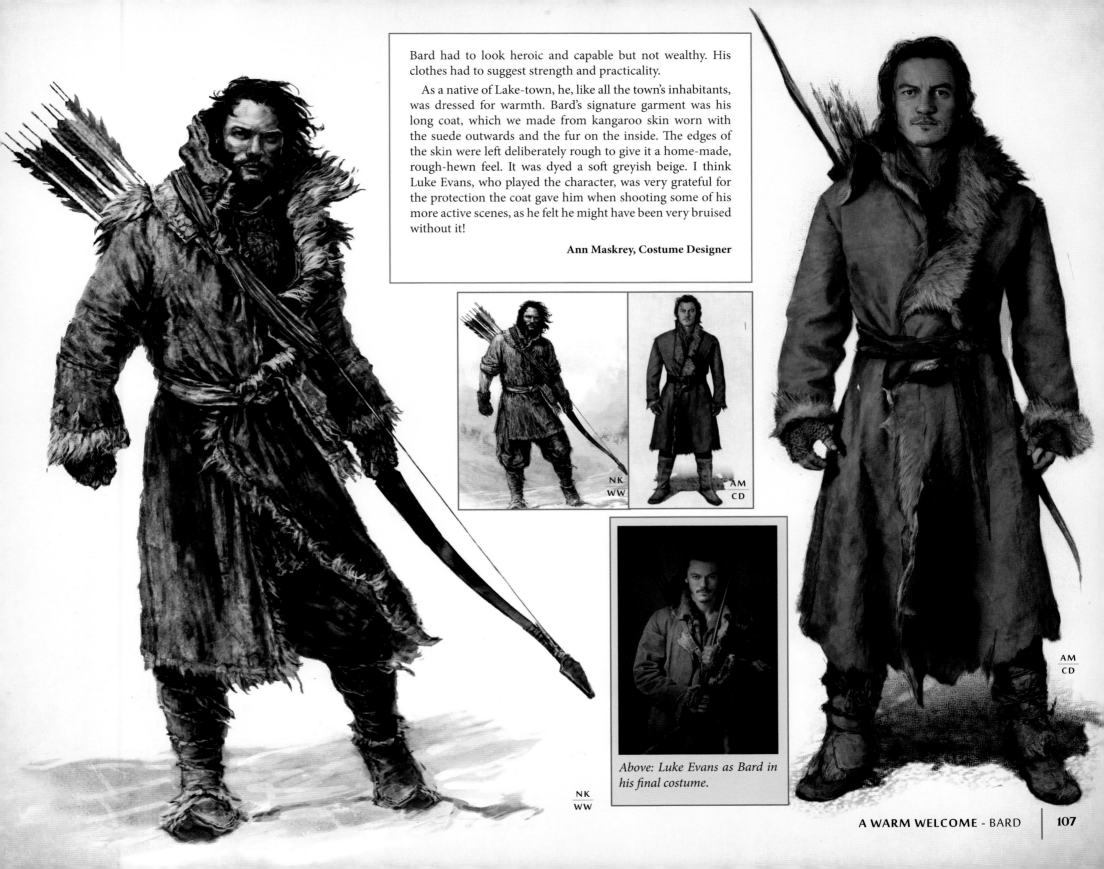

Bard had to look heroic and capable but not wealthy. His clothes had to suggest strength and practicality.

As a native of Lake-town, he, like all the town's inhabitants, was dressed for warmth. Bard's signature garment was his long coat, which we made from kangaroo skin worn with the suede outwards and the fur on the inside. The edges of the skin were left deliberately rough to give it a home-made, rough-hewn feel. It was dyed a soft greyish beige. I think Luke Evans, who played the character, was very grateful for the protection the coat gave him when shooting some of his more active scenes, as he felt he might have been very bruised without it!

**Ann Maskrey, Costume Designer**

*Above: Luke Evans as Bard in his final costume.*

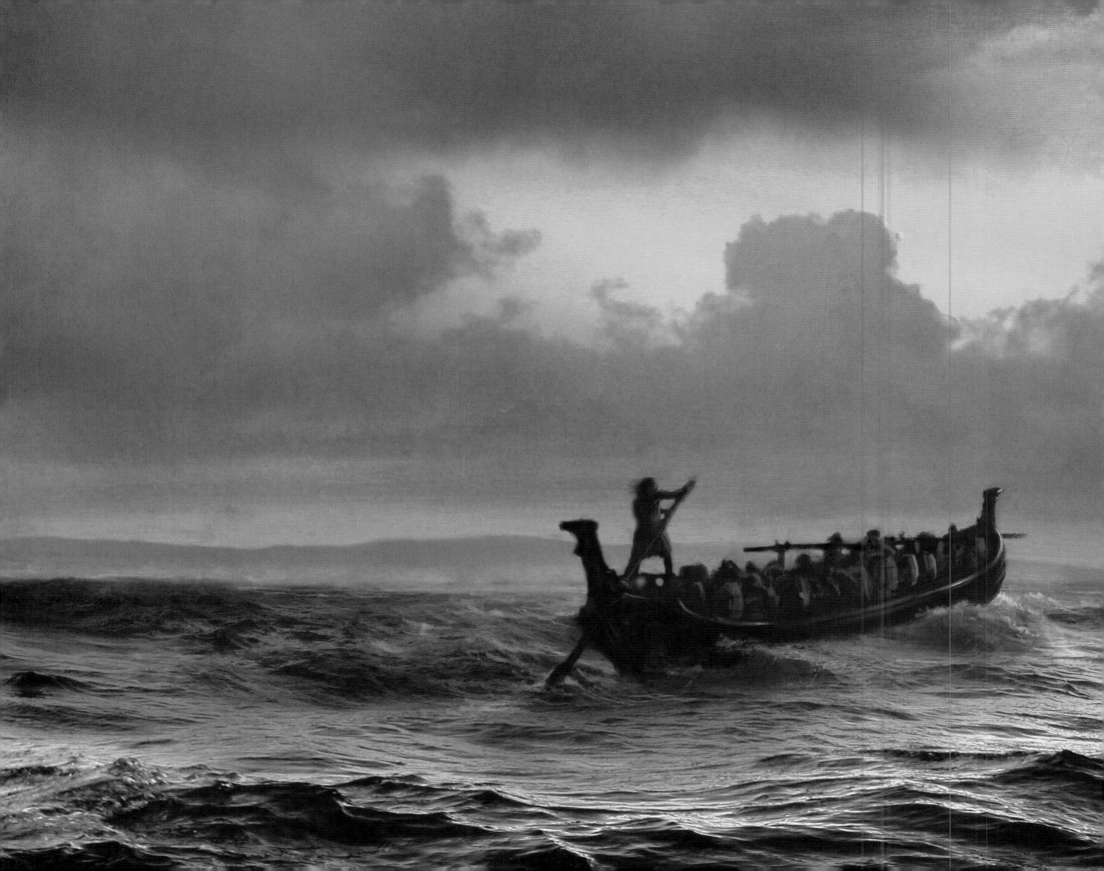

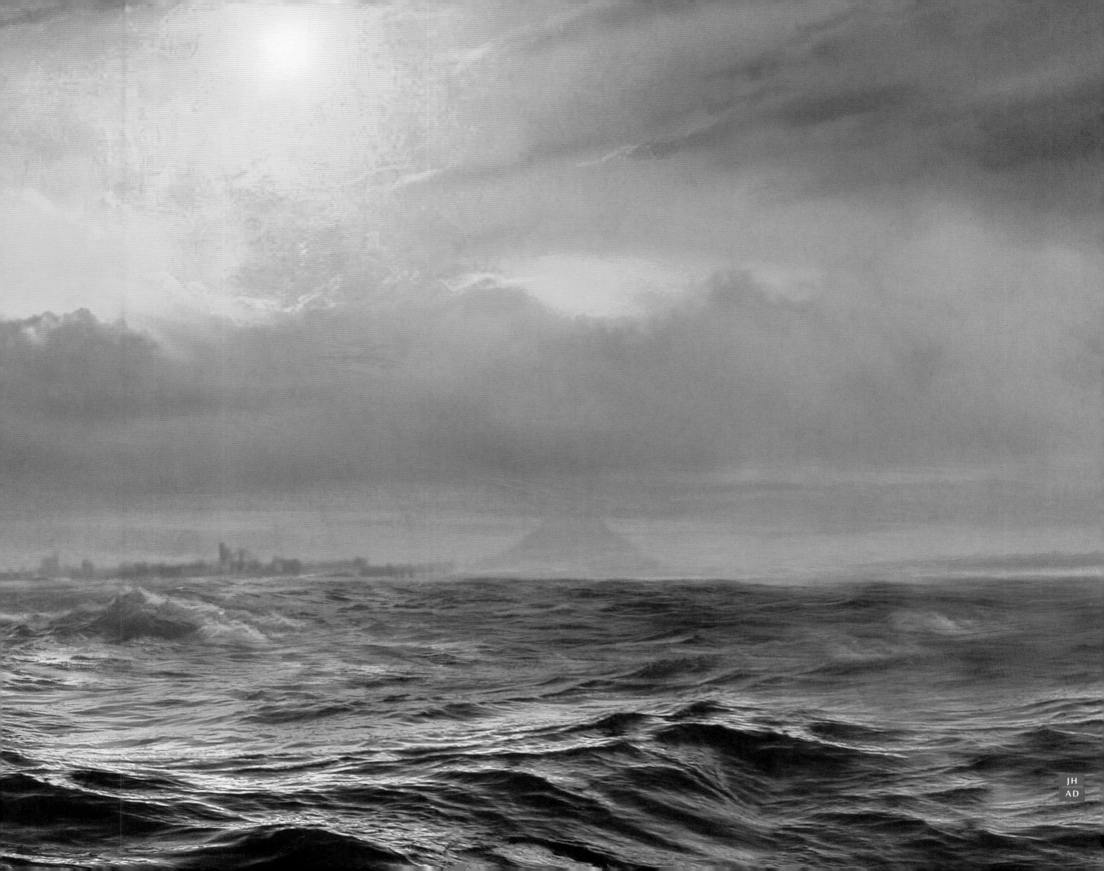

# LAKE-TOWN

AL
AD

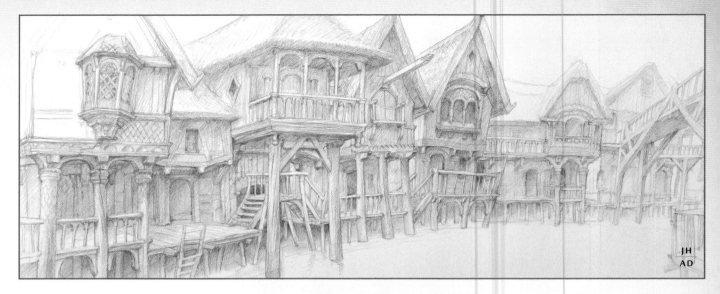

JH
AD

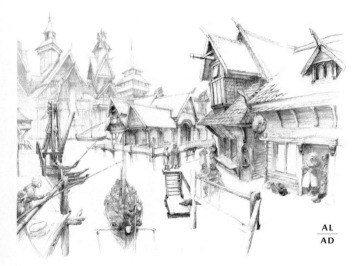

AL
AD

Much of the influence in our design of Lake-town's architecture comes from the East. There's a Tibetan influence but, that said, also a hint of Scandinavia. They're little touches such as can be seen in the finials and peaks of the roofs, but it was important that Lake-town feel different to anywhere we had been before in Middle-earth. Just as in Rohan we made use of horse iconography in the carved wooden architecture, in Lake-town there is a pervasion of fish – a fish head here, an eel there, tiles that resemble fish scales, and a lot of fish shapes in the props and set dressing.

The town is built mostly of wood, but there is also some clay and glass. There is a certain mastery of glass in Middle-earth that is implied in Tolkien's writing and which we have embraced. The people of Lake-town aren't rolling sheets of plate glass, but they have the ability to make basic glass and to blow it, to make brick or clay ovens; they can also forge metal tools and weaponry.

When Lake-town was first built there would have been a feeling of security, comfort and stability for its people, but that has changed. As the piles of the buildings have gradually sunk into the mud of the lake-bed, so too the town's culture has decayed. The Lake-towners can see that things are literally going downhill. Life in general could be better than it is and there is a sense of insecurity and dissatisfaction. The people are becoming desperate. Each day they struggle to feed their families and sift a living from what the lake can give them. The town was once a great trading post, but there's very little trade going on there now. They send wine made from grapes grown near the lake to the Elves and probably further afield, but the Master holds the proceeds of that trade fairly close, so not much is getting to the townsfolk. They are looking for someone to blame and for something to hope for, and into this ripe scenario tumbles Thorin and his Quest to reclaim the Mountain.

**Dan Hennah, Production Designer**

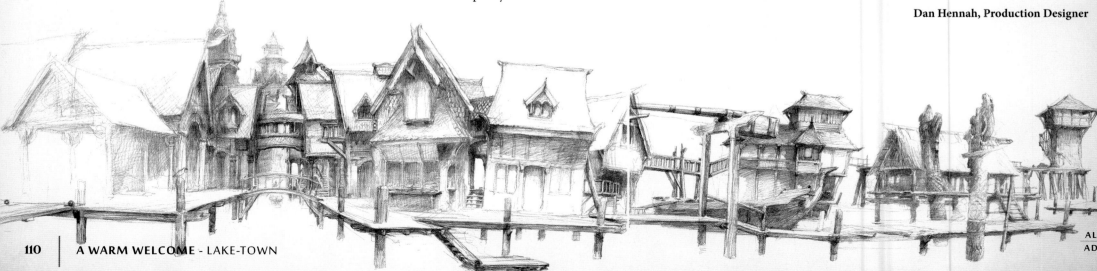

AL
AD

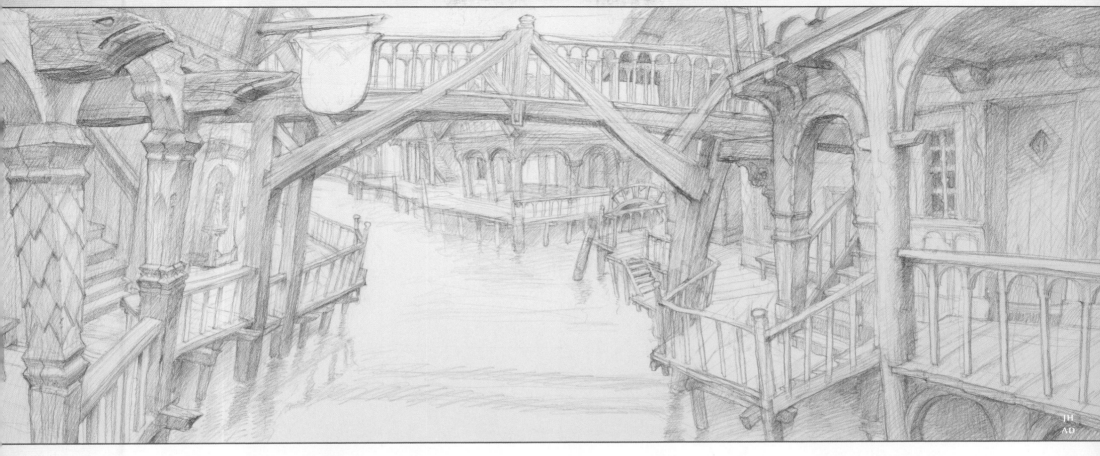

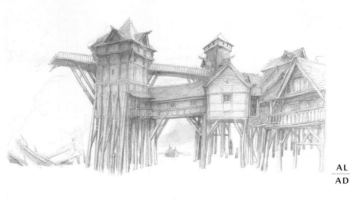

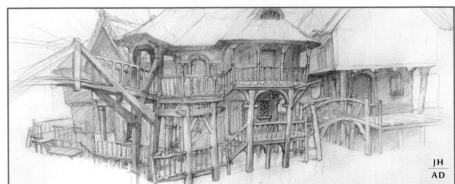

Tolkien's original inspiration for Lake-town was very likely taken from the Swiss Lake Dwellers, the Celtic people who were thought to have built villages on the many Swiss lakes, on platforms out over the water. While we know now that the lacustrine culture was an invention of well-meaning but over-zealous historians, eager to find a primitive and noble culture unique to Switzerland, Tolkien's drawings of Lake-town are nearly identical to turn-of-the-century artists' renderings of the civilization. In a sense, one fantasy has created another. The bottom of the Lake of Neuchâtel, where my family and I live, is still dotted with posts put there in Celtic times. La Tène is just a few miles away.

**John Howe, Concept Art Director**

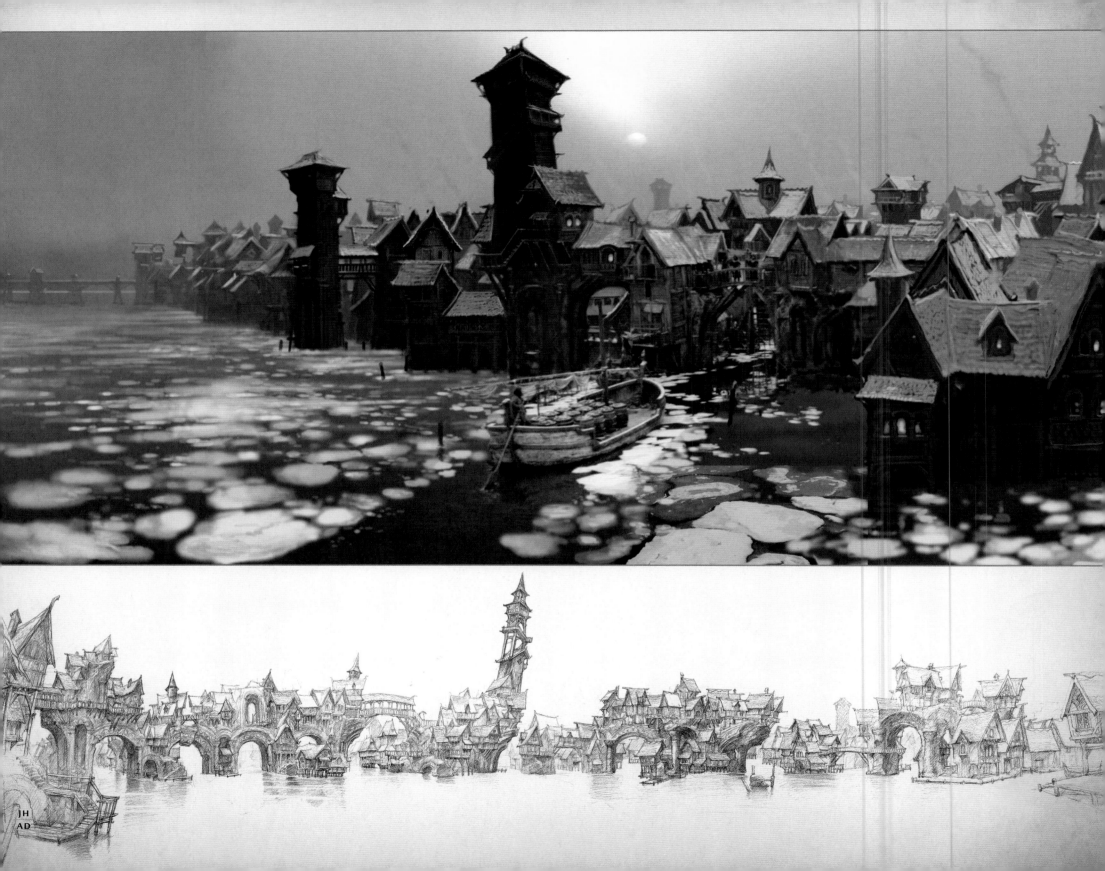

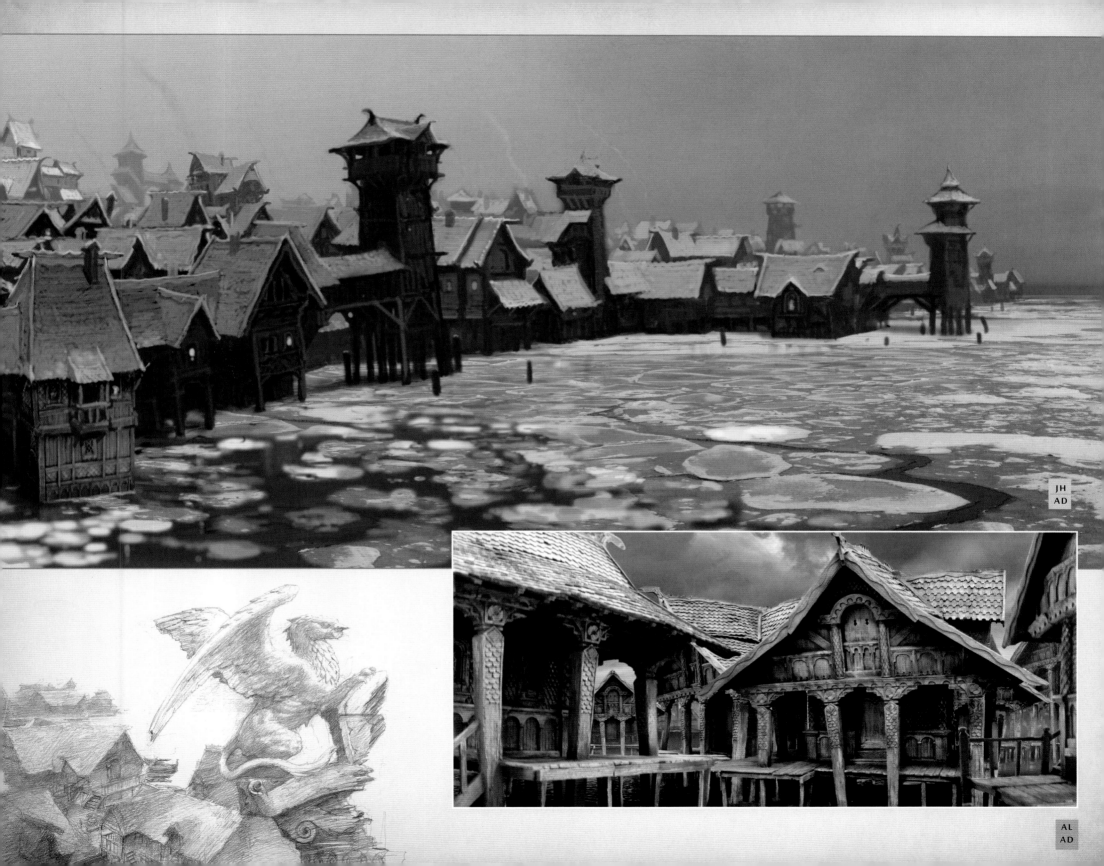

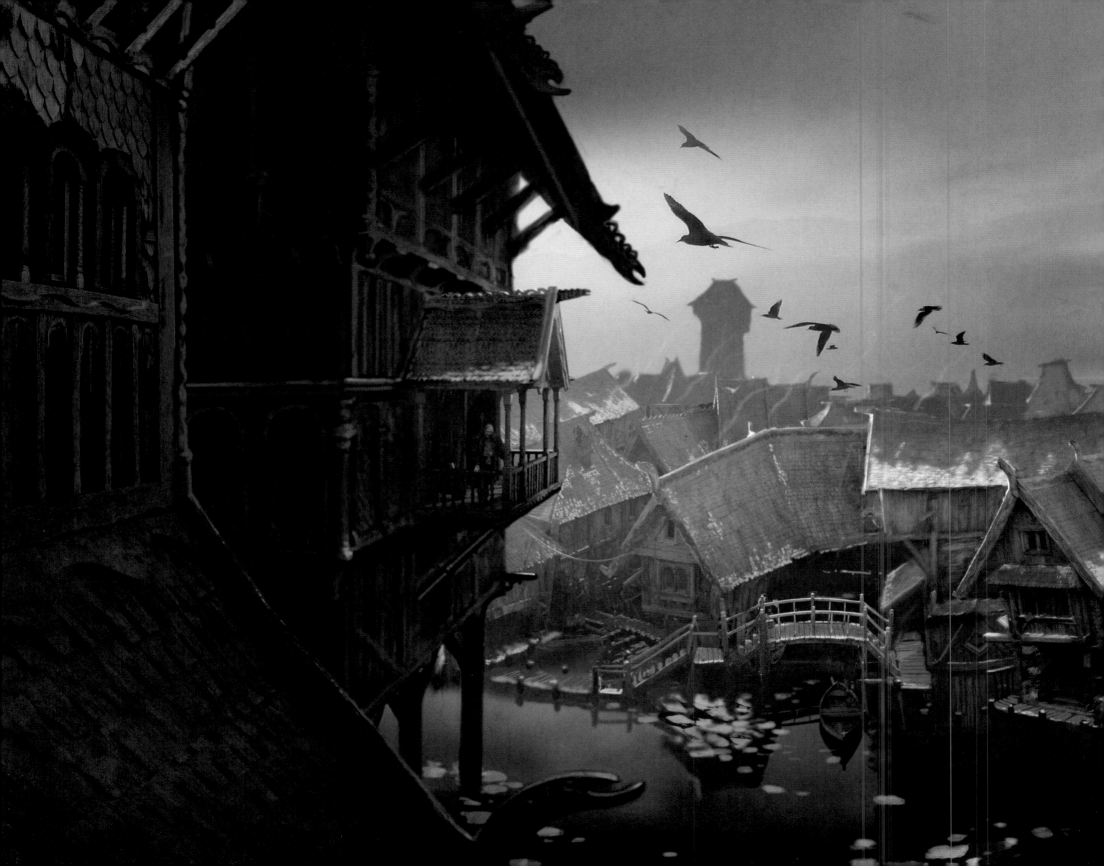

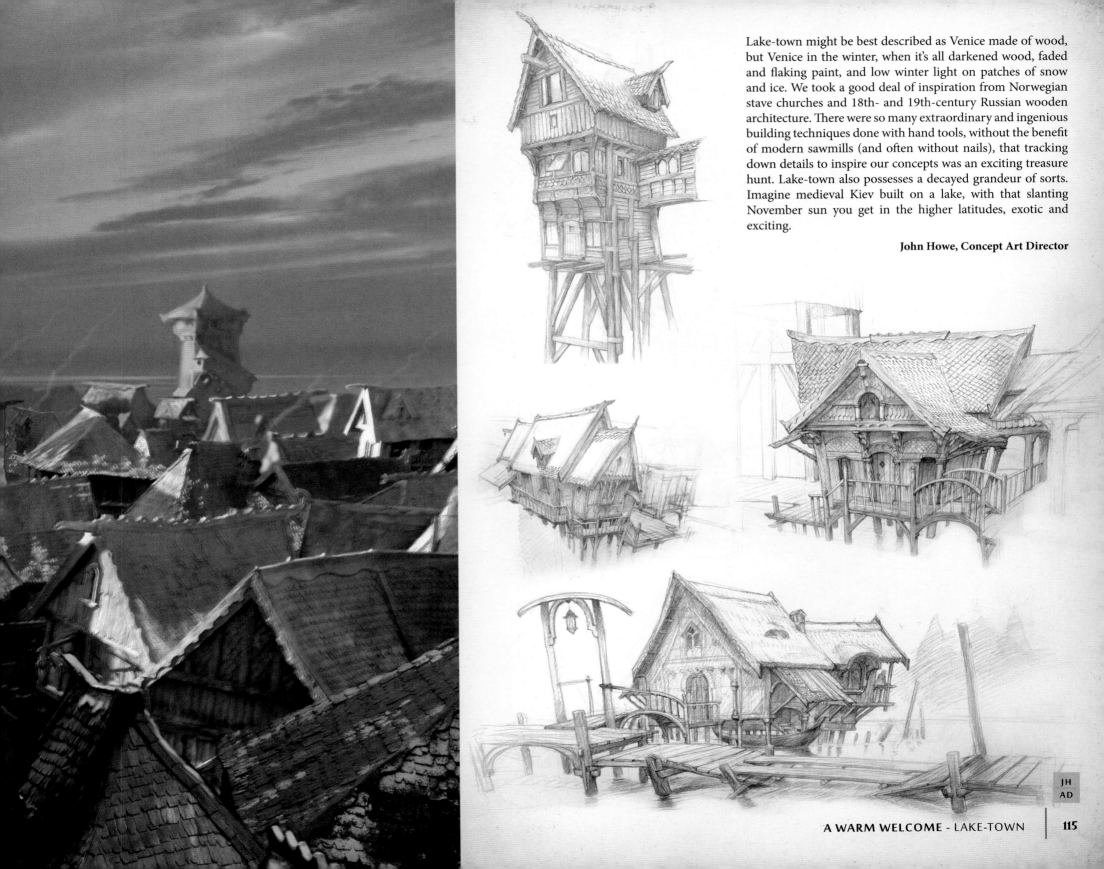

Lake-town might be best described as Venice made of wood, but Venice in the winter, when it's all darkened wood, faded and flaking paint, and low winter light on patches of snow and ice. We took a good deal of inspiration from Norwegian stave churches and 18th- and 19th-century Russian wooden architecture. There were so many extraordinary and ingenious building techniques done with hand tools, without the benefit of modern sawmills (and often without nails), that tracking down details to inspire our concepts was an exciting treasure hunt. Lake-town also possesses a decayed grandeur of sorts. Imagine medieval Kiev built on a lake, with that slanting November sun you get in the higher latitudes, exotic and exciting.

**John Howe, Concept Art Director**

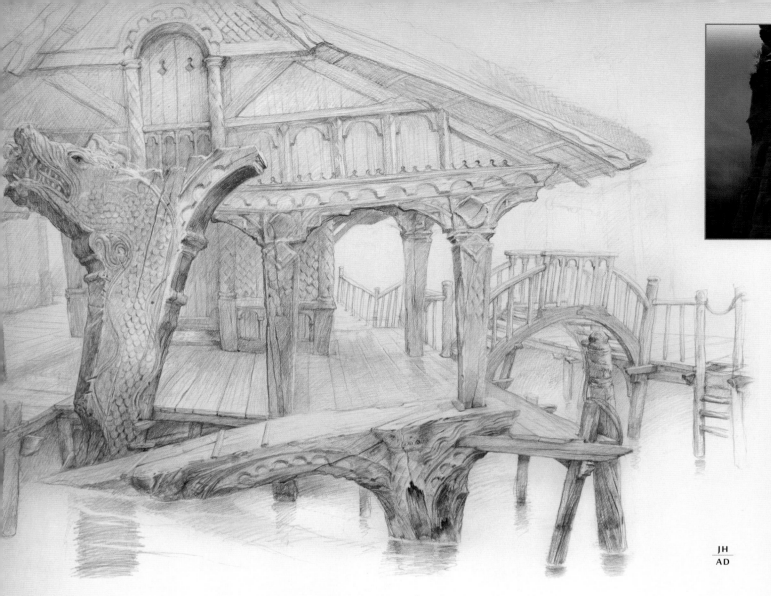

With each of the civilizations that we have explored in Middle-earth we have tried to find some appropriate culture in our own world and history as a kind of keystone upon which to elaborate. From the very beginning with Lake-town we were looking east towards the architecture of Kiev and Moscow, but also into Scandinavia, at Finland, and further east as well for some of the elements. We wanted it to feel like a medieval European town, but with slightly outlandish or exotic elements. By the time they reached Lake-town, Thorin's Company had travelled a considerable distance, so we wanted a clear sense of them having arrived at a foreign place.

We saw certain decorative devices, all carved in wood, which is something we also see in Russia or eastern Europe, but essentially the design was intended to convey a once-splendorous city in a state of decay, slowly sinking into the lake on rotting piles.

Amongst the sinking buildings and streets are stone ruins, relics of an older city, which Tolkien had mentioned, although it was Peter's idea that they be stone rather than wooden piles, so we had huge lumps of stone archways rising out of the lake, around which Lake-town's wooden architecture clusters and from which it precariously hangs. Bard's boat passes some of these stone ruins as it eases through the mist, approaching the town, and we get the impression of a much greater city that once occupied this place.

What wealth there is in Lake-town is concentrated in the hands of the Master, and the ice helps to convey another level of visual hardship. It is very much a place of work. People fish, sell things in the market, trade and scrape by, so we have filled the town with a lot of practical things like cranes on the wharves, fishing paraphernalia and merchants' wares and stalls.

**Alan Lee, Concept Art Director**

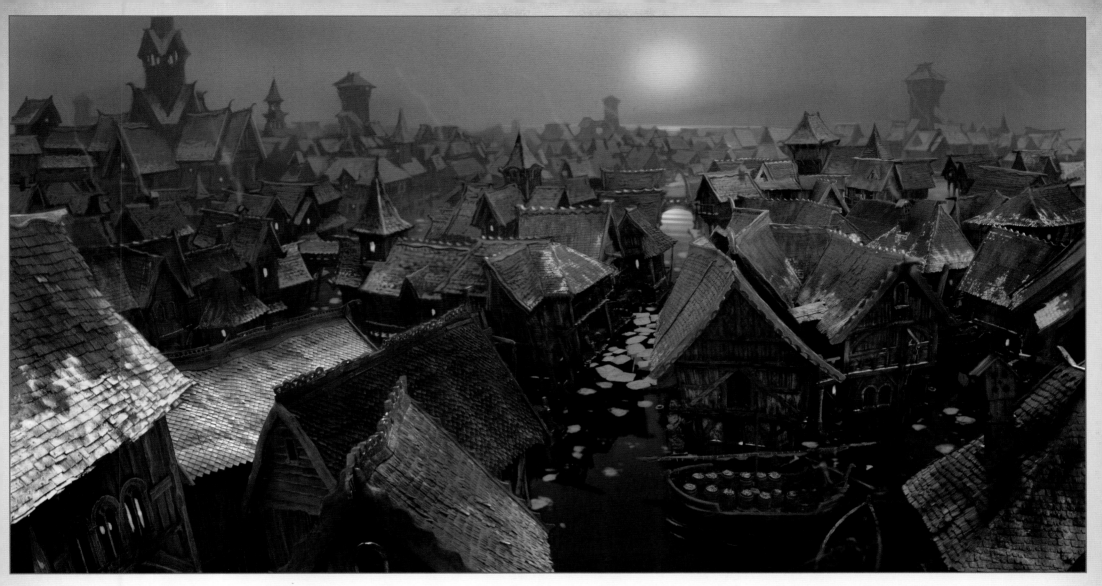

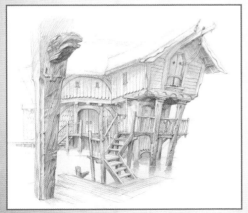

Part of our concept of Lake-town from day one was the notion that the town's foundations were erected on mud and that over the years this once-rich town had begun to sink. It's a metaphor for the hard times that its people have fallen on. We imagined there were probably five-thousand people living there, once upon a time. The more we developed Lake-town, the wonkier it became. We designed dormer windows and high pitched roofs to shed snow and ice. The general feeling was of a town that was once beautiful, and still is in a way, but now it's a shabby, rustic beauty.

**Dan Hennah, Production Designer**

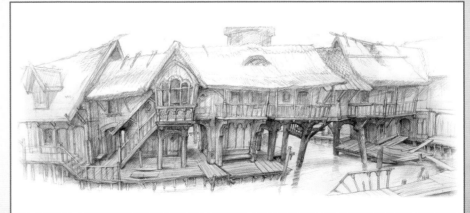

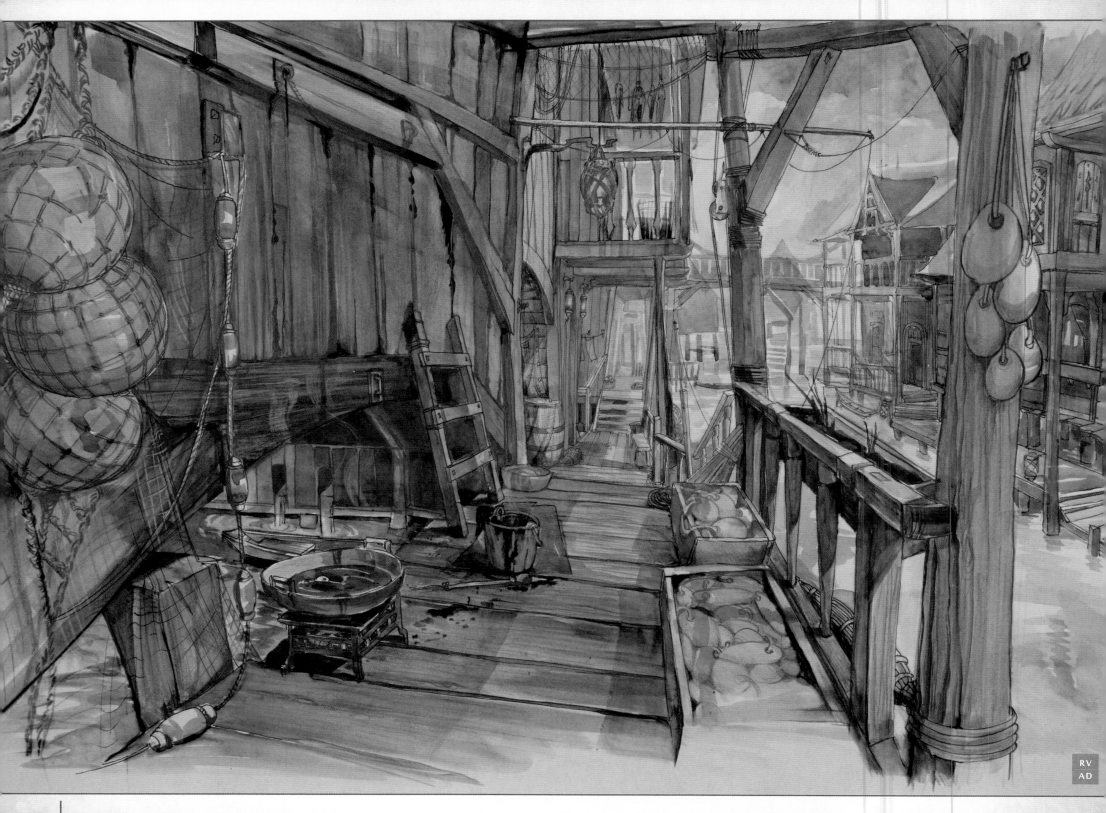

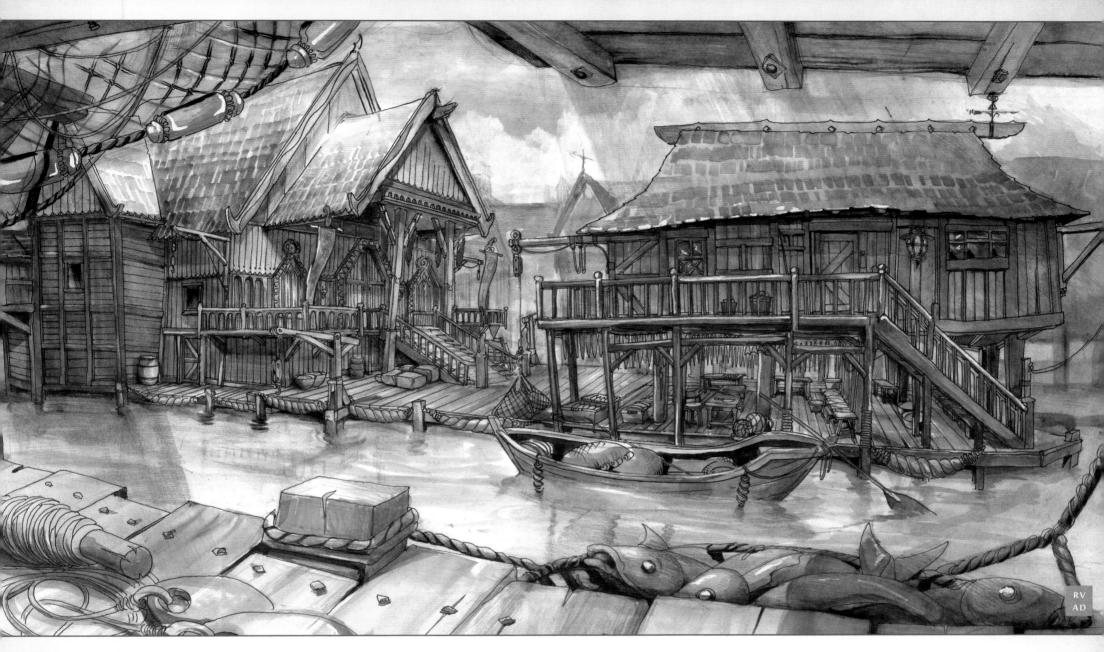

The assignment of colours in Lake-town was crucial to spelling out the character and age of the place. We had wonderful ramshackle buildings presented in the beautiful drawings, and we translated them into models, but it wasn't until we saw the three-dimensional shapes and their positions together in a maquette that we realized that they needed to be punctuated with colour. We came up with characters for each of the buildings which naturally informed our colour and dressing choices. It was once a wealthy, amazing city but it had deteriorated, so we had gold paint on bathhouses or once-opulent fabric stores and buildings with painted friezes and gilt highlights on them, but heavily aged to suggest hundreds of years of water-blasting from the elements. We imagined there hadn't been any upkeep apart from the occasional smattering of tar to waterproof old rotting buildings. The assignment of colour was important to not only individualize the buildings, but to help with the sense of depth, because it is hard to read a monochromatic environment. Colour could be used to bring certain elements forward or make others recede, giving us things to focus on. If there was a particularly beautiful building that needed more presence we put gold and warm yellows into it to lift it forward. We put cold colours in the highlights and extremities of the buildings where the snow would catch and remain, with warm tones around all the windows and doors.

**Ra Vincent, Set Decorator**

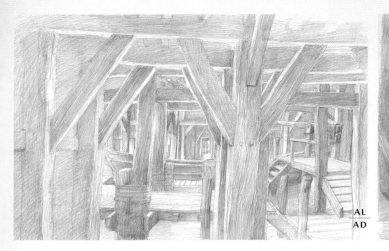

## LAKE-TOWN AT THE WATERLINE

In the course of our story we go beneath Lake-town, into the under-storey. It was always in our premise that there was an under-level that existed amid the foundations of the bigger buildings, beneath where the public walked. This would be a place where people kept their old boats and personal debris, or threw their fishing nets.

**Dan Hennah, Production Designer**

Lake-town is perched on pilings driven deep into the Long Lake, linked to the shore by a fortified causeway. Spanning the canals and waterways are a myriad of foot bridges of all shapes and sizes, allowing the boat traffic to slip by beneath.

**John Howe, Concept Art Director**

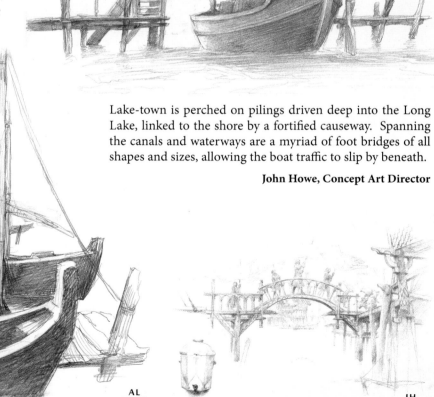

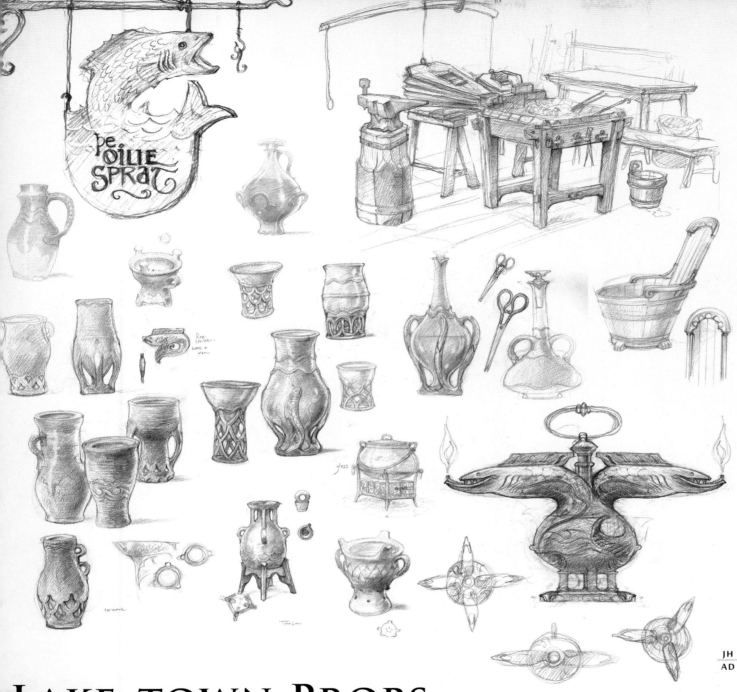

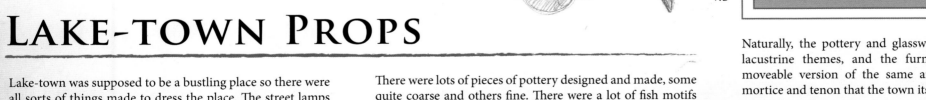

*Above: Final hanging lamp props.*

# LAKE-TOWN PROPS

Lake-town was supposed to be a bustling place so there were all sorts of things made to dress the place. The street lamps were beautiful – glass blown into wire cages. They had a very old-fashioned feel to them, very authentic.

There were lots of pieces of pottery designed and made, some quite coarse and others fine. There were a lot of fish motifs going on in the designs of the pottery and glassware.

**Nick Weir, Prop Master**

Naturally, the pottery and glassware of Lake-town echoes lacustrine themes, and the furniture is a reduced and moveable version of the same architectural principles of mortice and tenon that the town itself is built to.

**John Howe, Concept Art Director**

# PERCY

Percy originally had a much smarter costume than that which he eventually ended up with. Being that he was an official of Lake-town under the employment of the Master, I had originally designed him a wealthier looking costume *(below, left)*, albeit faded and worn. Peter decided to make him more akin to the general folk of the town and chose a design I had done for a Lake-town bargeman *(below, right)*. The coat he wore ended up being an inspiration for Bilbo's Lake-town look.

Nick Blake, the actor playing Percy, was a little sad to lose his first costume, but the second look was much better and suited him.

**Ann Maskrey, Costume Designer**

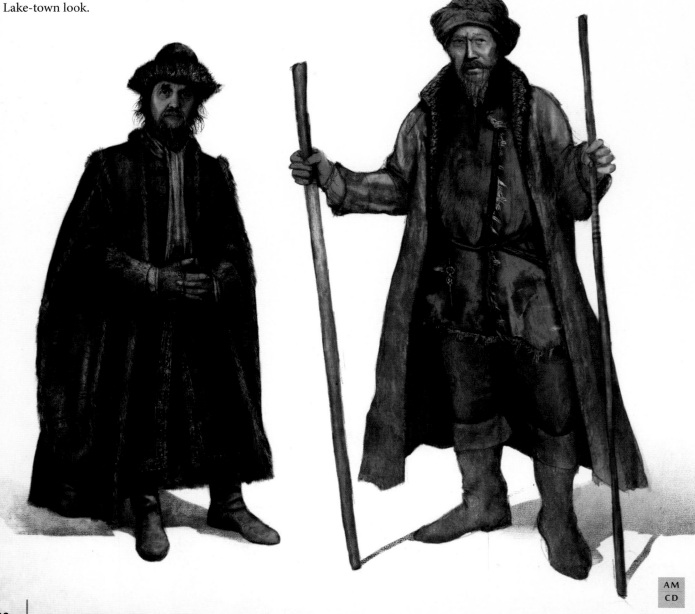

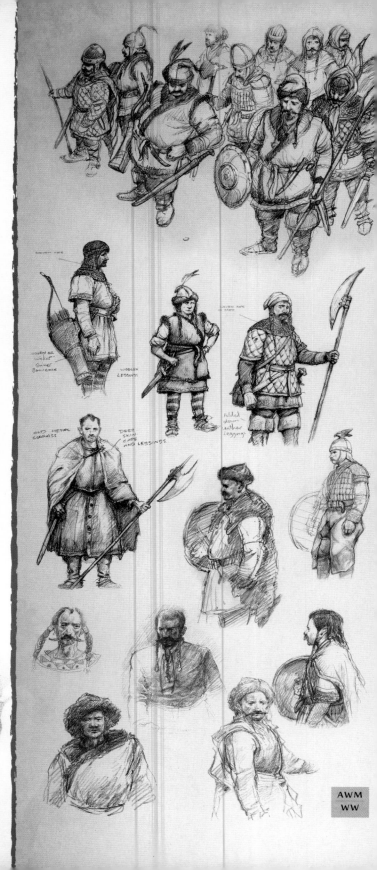

AM
CD

AWM
WW

# Lake-town Citizens

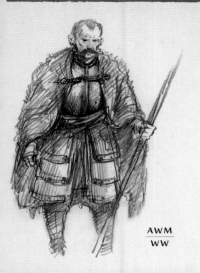

## COSTUME DESIGN

It helps to have real-world cultural references when designing new races for films. We'll usually hit the books to educate and inspire ourselves before putting pencil to paper. The cultural references for Lake-town were wide open when we began, so I offered up a wide range of suggestions. We looked at a variety of sources in our search for interesting elements that we could develop into something new. I explored concepts with a Mongolian-Chinese influence and some really colourful stuff drawn from an American colonial or French Canadian trapper influence *(left, below and facing page)*.

**Andrew Moyes, Weta Workshop Designer**

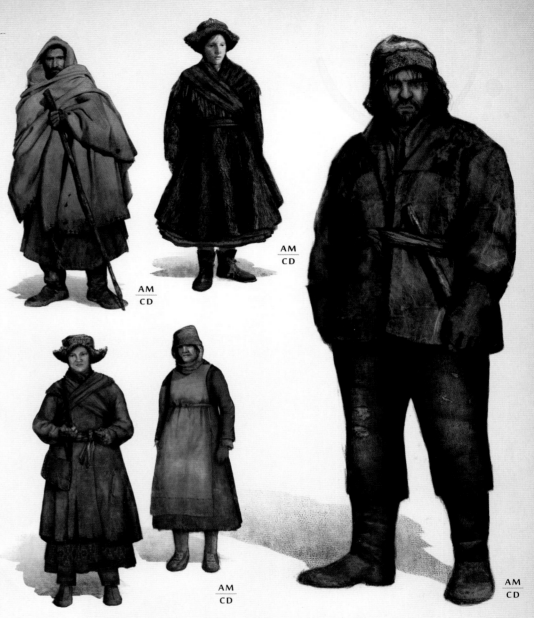

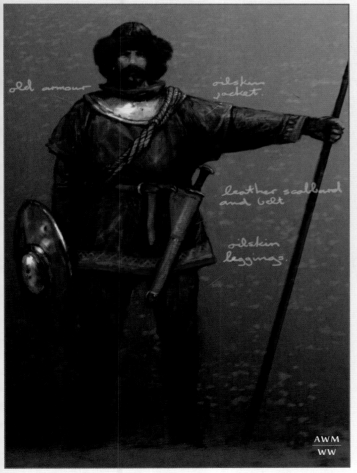

old armour

oilskin jacket.

leather scabbard and belt

oilskin leggings.

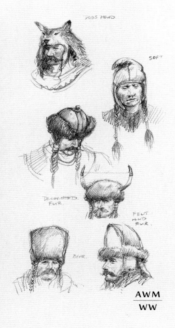

Peter's vision of Lake-town was of a cold place full of folk who had hit hard times, but also a group comprised of a mixture of peoples of different cultural ancestries. It is the only completely human group in the book. I drew upon all kinds of references from our world: Tibet, India, Mongolia, Afghanistan, Russia, Inuit, the Balkans, and many more. The Costume team did a fantastic job producing an enormous quantity of costumes from scratch and I had great fun creating the various looks with them.

The Lake-town set was my absolute favourite and I took a lot of time choosing a colour palette for the costumes to blend with it.

There is an absence of green in the Lake-town clothes because it is not a verdant place, like Hobbiton, and because there is a lot of green on the Mirkwood Elves. I felt it helps a lot to suggest a change of place and mood with a shift in colour.

**Ann Maskrey, Costume Designer**

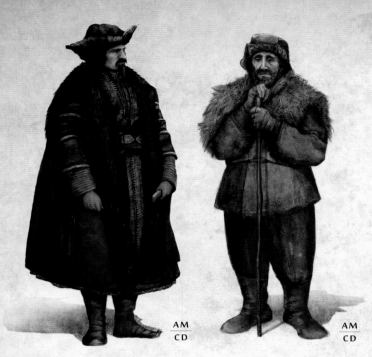

AM
CD

AM
CD

In spite of their hardship, the people of Lake-town have a strong sense of loyalty to each other and Bard has strong bonds in his community. There are many who talk about the old days when the town flourished as a trading centre and when gold and riches flowed from the Mountain and from Dale, where Bard's ancestors come from.

**Luke Evans, Actor, Bard**

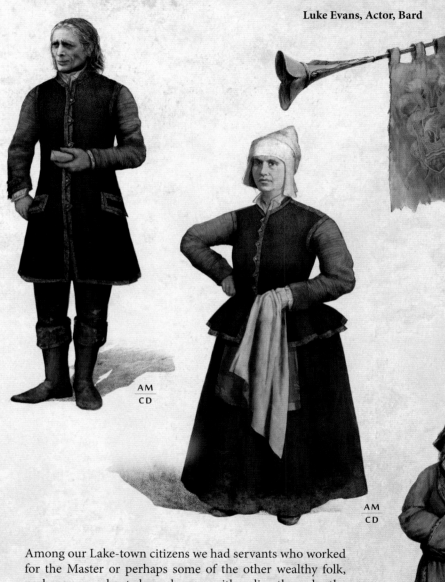

AM
CD

AM
CD

BB
CD

We wanted our Lake-town extras' costumes to be suggestive of a class system, but the town has fallen on hard times across the board and everyone is feeling it so their clothes are well worn across the spectrum. The Master has siphoned off as much as he can and everyone is living precariously. Lake-town is in the grip of winter when Bilbo and the Dwarves visit so everyone is rugged up for warmth.

**Bob Buck, Costume Designer**

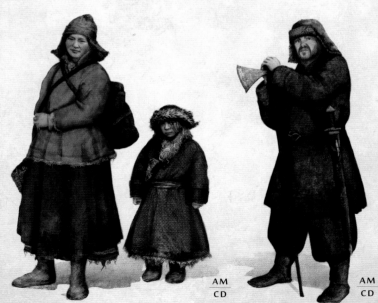

AM
CD

AM
CD

Among our Lake-town citizens we had servants who worked for the Master or perhaps some of the other wealthy folk, perhaps a merchant class who were either directly under the Master's employ or at least part of his network and putting money under the table to him. The Master also had his own little cadre of musicians, whom he made dress in the same pomp as his guards.

**Bob Buck, Costume Designer**

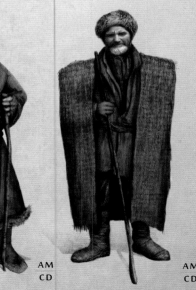

AM
CD

AM
CD

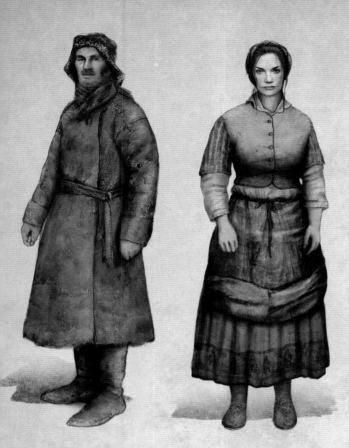

From a casting point of view, which was also something we reflected in our costumes, Lake-town represented a bit of an ethnic melting pot. Given it was once a trading hub, people from diverse groups would have come through the town and some would have stayed. Consequently, while the overall flavour of the citizens' costumes was middle European, there were some exotic influences that crept in, usually through fabrics, to greater or lesser degrees, so there was some variety.

Amid our various professions evident in the throng we had fisher folk, people who run markets, stall holders, even some colourful ladies for a while, though they were deemed perhaps a bit too racy in the end.

**Bob Buck, Costume Designer**

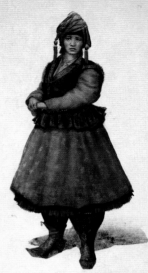

Peter also asked to see some evidence of religion in Lake-town. It's not something we have seen much of in Middle-earth before but it's undoubtedly something which pervades human culture and, given the way the people of Lake-town live beneath the shadow of the Mountain and the Dragon, it made sense that some belief systems had taken hold. There are prophesies and songs regarding the Mountain and their future. While the film doesn't spend any screen time exploring them, the presence of these groups among the Lake-town peasants adds texture and depth to the background. There were a couple of different cults holding divergent views who, it was theorized, might compete for supporters within the town.

Our blue-robed sect were perhaps a little Buddhist inspired, with a faith devoted to water, the lake and the life it provides them. The yin to their yang, the blue sect was complemented by a fire cult who adopted a more fatalistic outlook and preached about the end times coming when the Mountain would rain fire and death upon everyone, melting the town beneath a fountain of lava and flame.

**Bob Buck, Costume Designer**

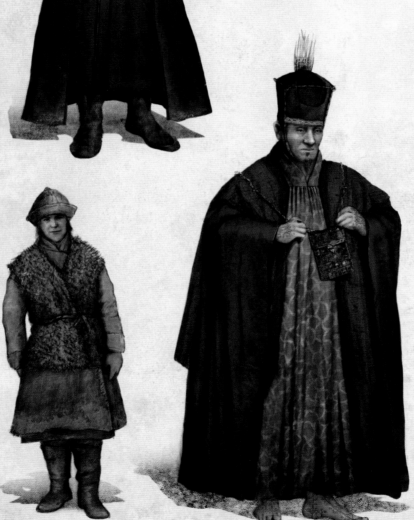

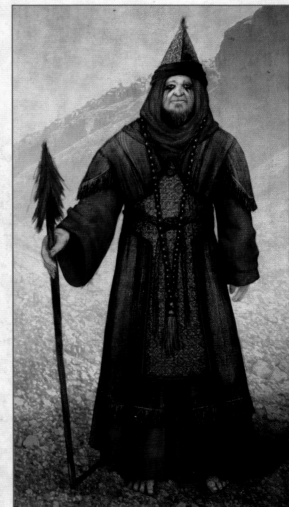

AM
CD

# BARD'S HOME

Bard's home is humble. The descendant of Girion and the refugees of Dale, he has regal blood but he doesn't live like a lord in Lake-town. He's a working man. He gets paid to run a barge, so he lives comfortably enough, but it's a hand-to-mouth existence. There's nothing left over, so he makes the most of everything he has. His home is probably typical of a larger, family-sized Lake-town dwelling, larger than some, but not as palatial as others.

**Dan Hennah, Production Designer**

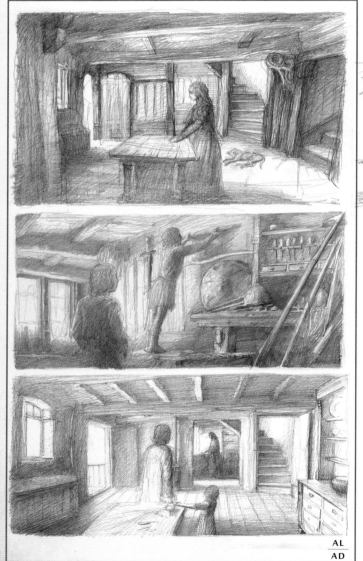

AL
AD

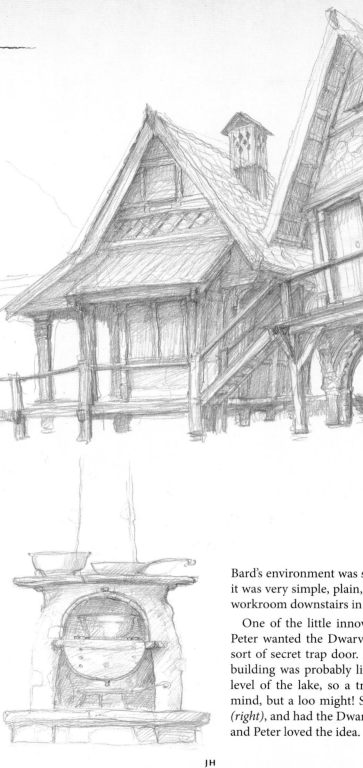

AL
AD

Bard's environment was set up in contrast to the Master's, so it was very simple, plain, quite small and practical. He had a workroom downstairs in which he had a lot of his tools.

One of the little innovations that came about was when Peter wanted the Dwarves to enter Bard's home through a sort of secret trap door. As designed, the lower floor of the building was probably little more than a few feet from the level of the lake, so a trap door didn't really work, to my mind, but a loo might! So, I did this drawing of the dunny *(right)*, and had the Dwarves kind of popping out through it, and Peter loved the idea.

**Alan Lee, Concept Art Director**

JH
AD

AL
AD

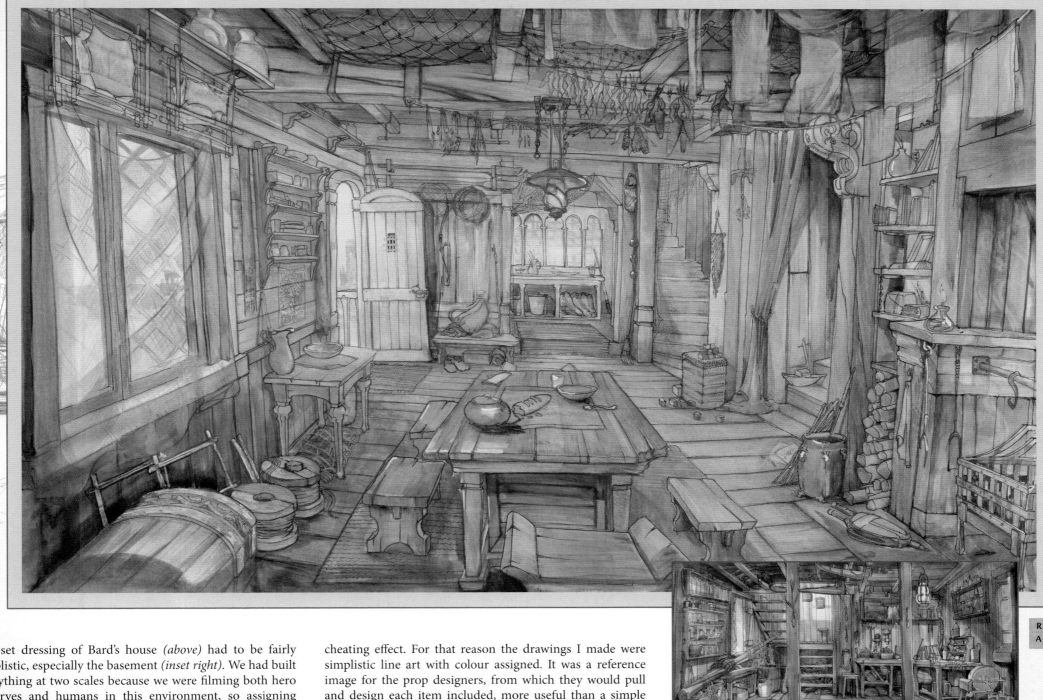

The set dressing of Bard's house *(above)* had to be fairly simplistic, especially the basement *(inset right)*. We had built everything at two scales because we were filming both hero Dwarves and humans in this environment, so assigning specific objects to a specific space became important. Even though it looked random, it was the product of a strictly designed and executed set-dressing. It was important for everybody to know what objects they had to design and where they were to be placed, because everything had to be produced identically in two scales to achieve the size-

cheating effect. For that reason the drawings I made were simplistic line art with colour assigned. It was a reference image for the prop designers, from which they would pull and design each item included, more useful than a simple list, but offering room for individual interpretations. The wonderful thing about set dressing and decoration is you rely a lot on the talents of your crew to put the life into stuff that you are encouraging them to make.

**Ra Vincent, Set Decorator**

# BAIN, SIGRID AND TILDA

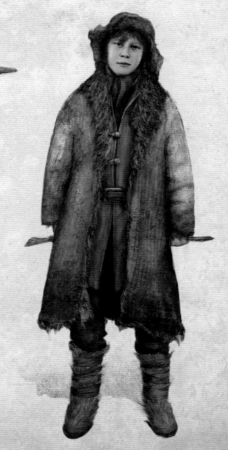

Bard's second child and only son, Bain, needed a costume that reflected his father's. He had a coat not entirely unlike Bard's with a fur collar. Where Bard's was kangaroo skin, Bain's was constructed from a fabric we manufactured in our textile department and very broken down. To help distinguish him and emphasize his youth, I put more colour in his costume than that of his father's.

Bain's boots were also similar to Bard's in that they were made from Thar (goatskin) but they lacked upturned toes. They were based on Inuit boots with suede ties criss-crossing around the leg.

Bain wore a waistcoat of rust calf-skin with toggle fastenings at the front. One of my favourite things was the hat we made for him which was segmented, dyed barracuda skin, trimmed with possum fur.

**Ann Maskrey, Costume Designer**

In early versions of the script Sigrid was Bard's wife and the mother of his children, but the writers revised the role as they developed their scripts and changed the character to be his eldest daughter instead, making her younger and consequently leaving Bard as a single parent of three kids. It works well, and in many ways Sigrid tries to assume the role of mother in the household, looking after her younger siblings.

**Luke Evans, Actor, Bard**

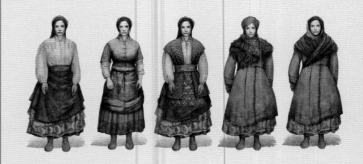

Sigrid and Tilda are the two sisters of Bain and daughters to Bard. They are first seen in Bard's house when the Dwarves arrive in Lake-town and help Tauriel take care of the wounded Kili.

Sigrid, the eldest, had some lovely fabrics within her costume, most of which were vintage pieces. Her blouse fabric came from Turkey and had some beautiful, fine embroidery on it. Her waistcoat fabric came from the same region, although the pattern was suitably washed out. I had to abandon one of my favourite pieces of fabric which I had chosen for her because we couldn't replicate it for the scale double's versions needed to shoot the scenes with the Dwarves. Instead, we used it on her hat, which was based on a common Tibetan style.

I had been stockpiling fabrics for both girls for a long time before we began their costumes. Both Sigrid's top skirt and Tilda's pinafore dress were made from a blue patterned linen that came from Romania. They also had clothes made with fabric bought in the UK. I liked the fact that the fabrics came from all over the place as it complemented Peter's desire to make Lake-town a melting pot of different cultures.

**Ann Maskrey, Costume Designer**

AM
CD

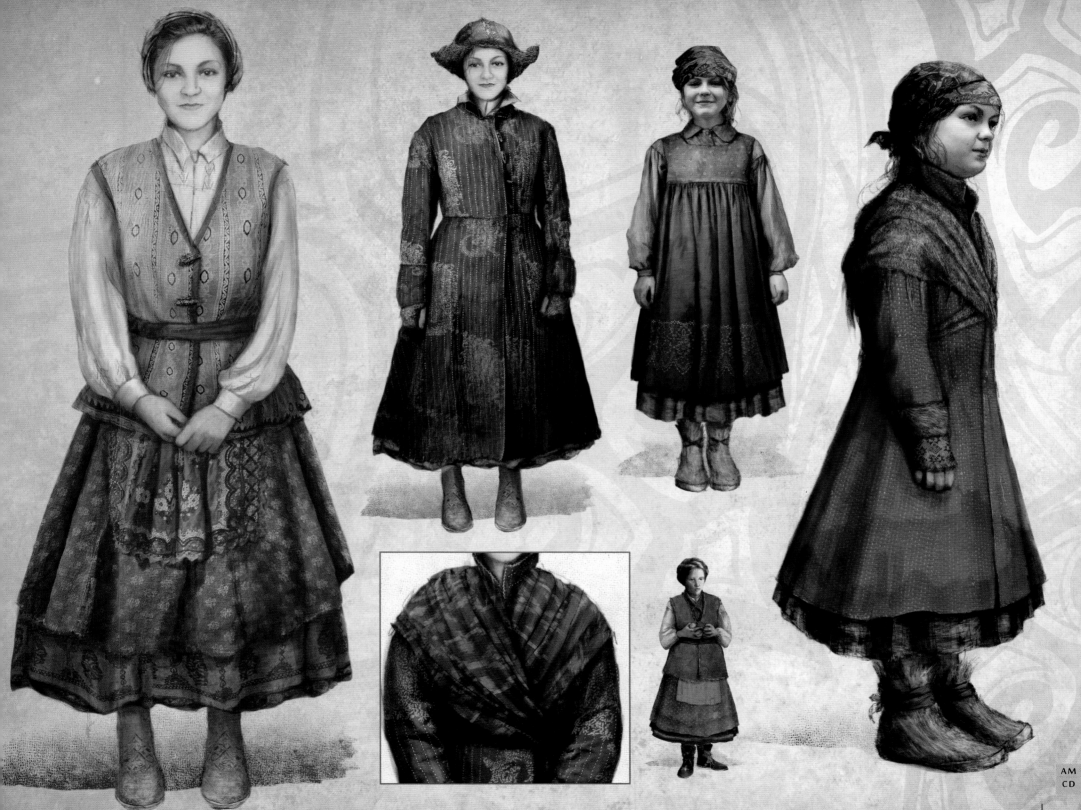

AM
CD

# LAKE-TOWN MARKET PLACES

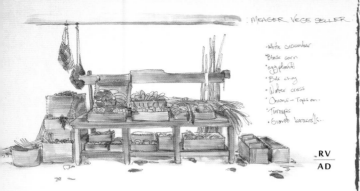

: MEAGER VEGE SELLER

- White cucumber
- Black corn
- egg plant
- Bok choy
- Water cress
- Onions - Tops on.
- Turnips
- Giant barrels.

RV
AD

# LAKE-TOWN GUARDS

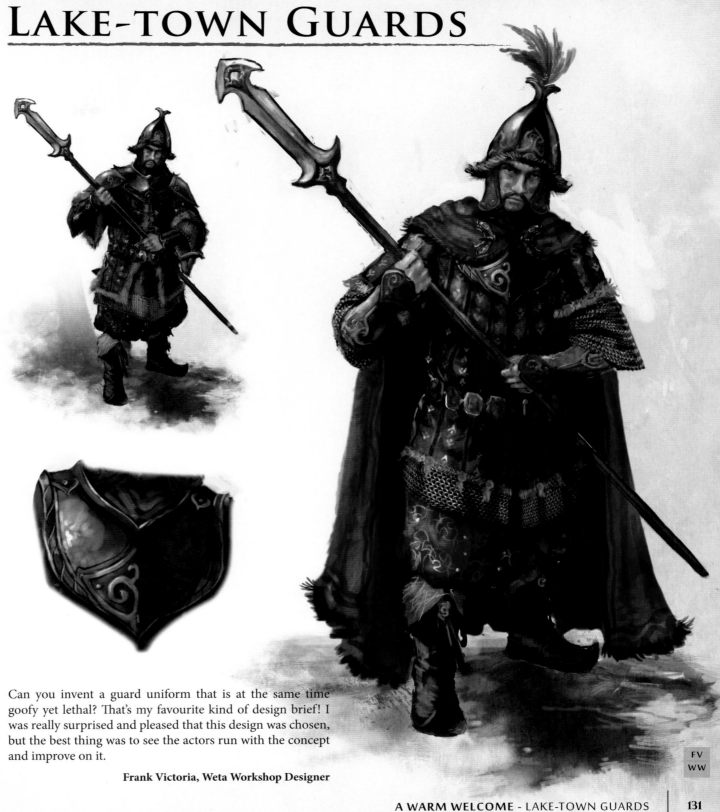

Markets were something we dotted throughout Lake-town. Within the narrow streets and open areas the people had co-opted places to trade their goods and wares – fish for bread, wine for butter or coin. At one point we looked at an indoor market *(facing page, inset)*, but it worked better to have them outside. We had seen markets in Dale and Hobbiton, but the markets of Lake-town are probably the most like Asian bazaars. Lake-town wouldn't have an abundance of outdoor space, but people find ways and places of earning their livings and obtaining their daily essentials. They would all know each other, having grown up together and we imagined the markets were well established. It was our intention to make them feel chaotic, but at the same time everyone would be watching over their neighbours' shoulders. Someone might get away with stealing an apple once, but not twice, and like all of societies that seem chaotic to an outsider, there would be an order to it understood by the locals. Everyone would be aware of who has come in at one end and gone out the other, what they bought, how much they paid for it, whether they could be bargained up or down, and if they are not worth talking to next time. An easy mark would be noticed right away, and while they mightn't get taken for a ride at the first stall, by the time they were at the third or fourth someone would definitely have taken advantage of them.

**Dan Hennah, Production Designer**

Can you invent a guard uniform that is at the same time goofy yet lethal? That's my favourite kind of design brief! I was really surprised and pleased that this design was chosen, but the best thing was to see the actors run with the concept and improve on it.

**Frank Victoria, Weta Workshop Designer**

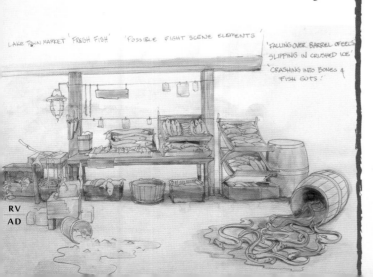

LAKE-TOWN MARKET 'FRESH FISH'    'POSSIBLE FIGHT SCENE ELEMENTS'

'FALLING OVER BARREL OF EELS'
'SLIPPING IN CRUSHED ICE'
'CRASHING INTO BONES &
FISH GUTS!'

RV
AD

FV
WW

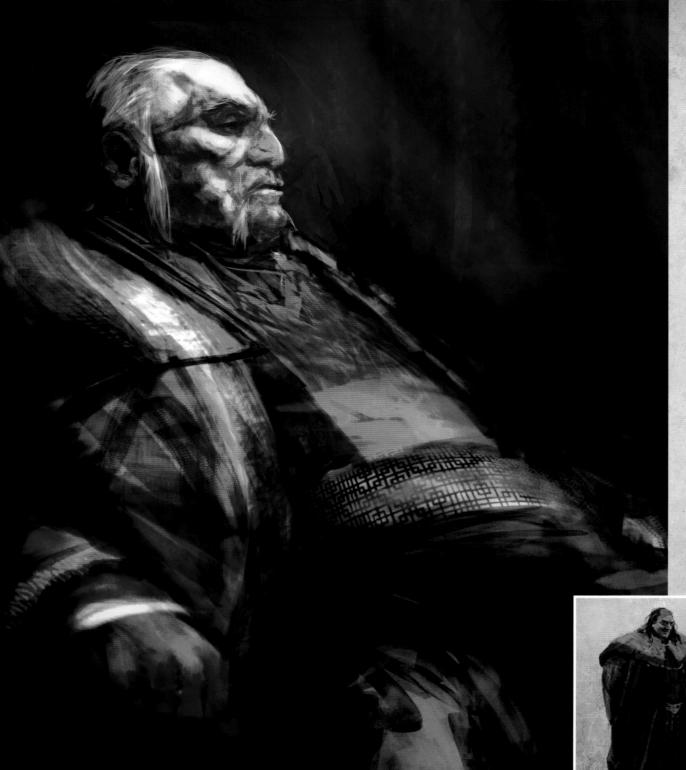

# THE MASTER

The Master's costumes were intended to be gaudy and suggest that he had hoarded what wealth remained in Lake-town. Though Stephen Fry is a lovely man, his character was a greasy popinjay and a grotesque. I wanted him to look as if he was wearing his wealth in a vulgar and deliberate display, so we gave him an abundance of jewellery and accessories, and his fabrics clashed in both colour and texture. The overall effect was one of ugliness and unpleasantness – too many rings, colours, textures and accessories – intentionally far too much going on.

To achieve this I drew upon elements of the Elizabethan and Stuart periods such as padded doublets, quilting, excessive buttons and button holes, lace, knee-breeches etc. Though they may not have made it into the films, we made an extremely over-the-top pair of bucket-top boots in purple leather which were an exaggerated version of a 17th-century pair, and his other footwear was similarly very fancy. Despite Stephen's height, he also always had heels. Through history wealthy people have often worn heels to appear taller and more important, and to suggest they didn't need to do any practical work or labour. It seemed an essential affectation to give the Master.

The cut of his clothing wasn't exactly period in any true sense, but borrowed elements from many. The main thing was to make him look garish, uncomfortable and silly, and to fill out his stomach and widen his breeches to make his legs looked thinner, like an over-stuffed parrot.

**Ann Maskrey, Costume Designer**

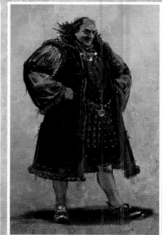

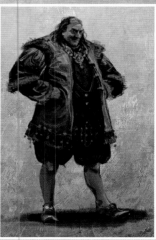

PT
WW

GH
WW

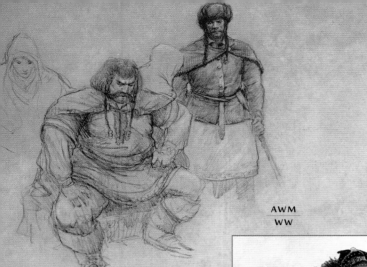

AWM
WW

The Master of Lake-town was very pompous so I tried to emulate that character in my costume suggestions, offering variations on a theme as we tried to find his signature silhouette. There was certainly a renaissance influence in there. Everything was exaggerated because he was an overblown sort of person. Primarily we were looking for a silhouette, his key shape, and then looked at enhancing that with tassels and buttons, embroidery and other adornment that all served to reinforce his puffed up, self-important personality. The overall effect was buffoonish, but I don't think the Master realizes he looks like that. He thinks he looks important.

**Gus Hunter, Weta Workshop Designer**

There was a danger with the Master's costumes that he would be wearing 'everything but the kitchen sink'. His clothes had to be the richest in Lake-town and also the most gaudy and the worst taste. He has all the wealth but not a shred of elegance or style.

I loved putting his fabrics together. Some of the patterned leathers came from Italy, many of the fabrics from London, which I bought when we were shooting in the UK. I first fitted actor Stephen Fry in London before he came out to Wellington, so that by the time he arrived we already had a good fit on all his costumes.

**Ann Maskrey, Costume Designer**

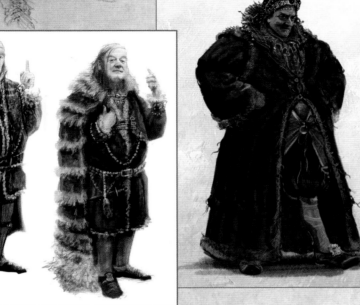

CG
WW

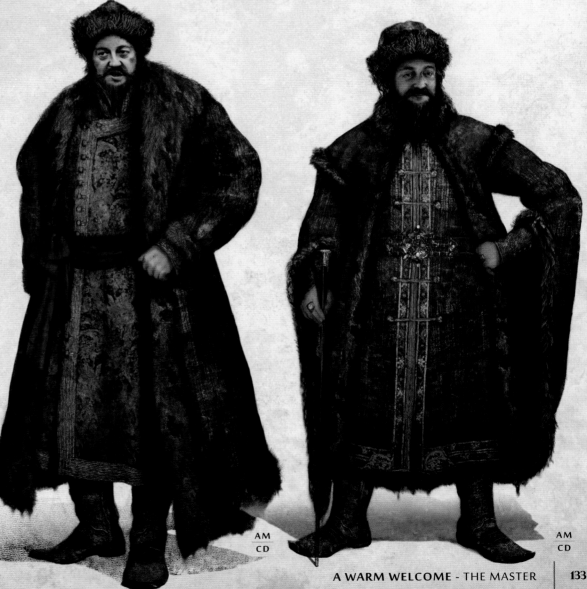

GH
WW

AM
CD

AM
CD

GH
WW

**A WARM WELCOME - THE MASTER** | 133

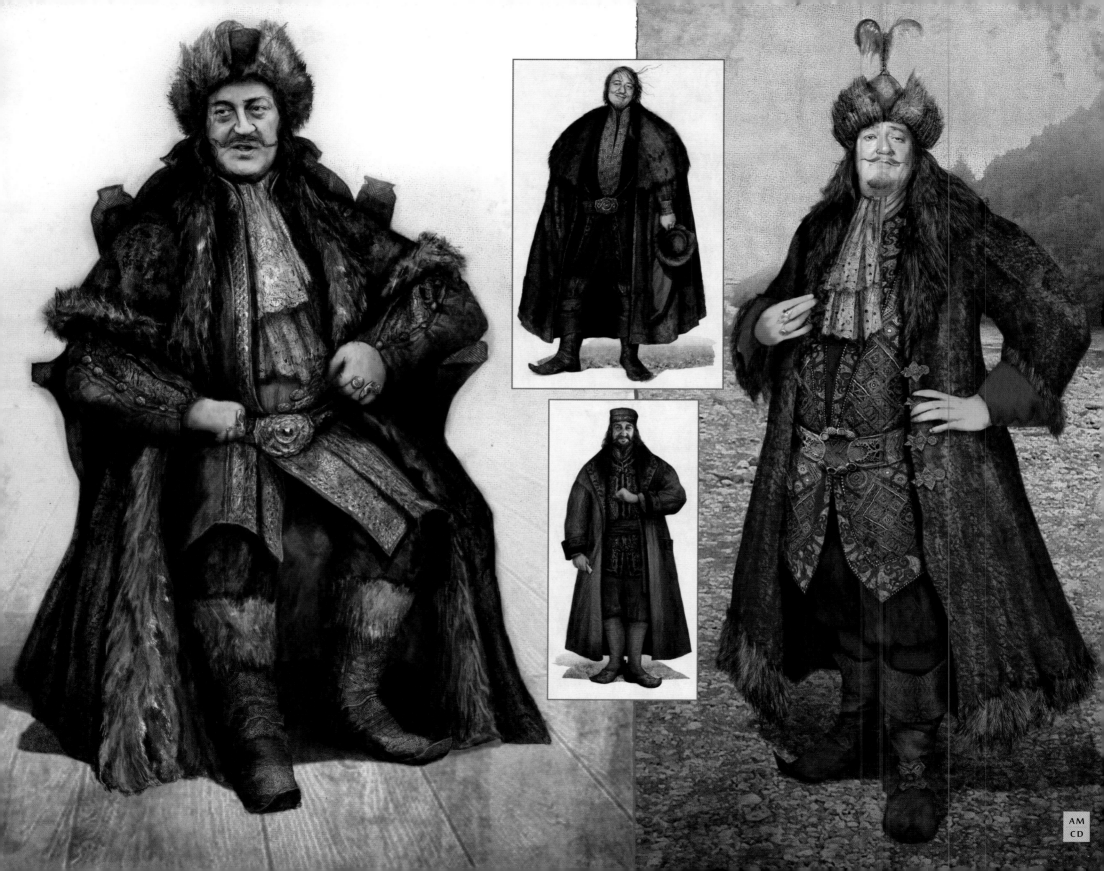

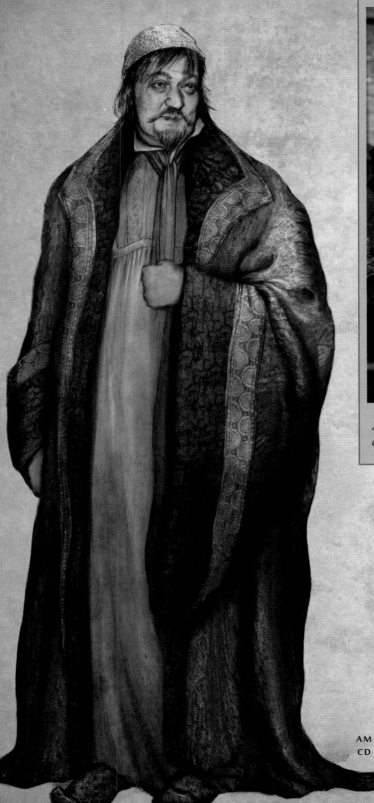

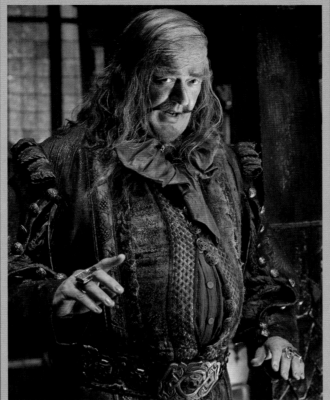

*Above: Stephen Fry as the Lake-town Master in his final costume.*

The first scenes we shot with Stephen Fry as the Master were in the character's bedroom. He wears a floor-length, grimy, beige linen nightshirt and a nightcap. The linen nightshirt had a detailed yoke with several vertical pin tucks and a small collar. Full sleeves were bound off in a cuff.

His night cap was made from a Turkish metal-embroidered child's waistcoat and managed to look ostentatious and silly at the same time, which is exactly what was required. His dressing-gown was a dark red and gold Indian damask silk with huge sleeves and large turned back cuffs made from quilted, two-tone blood-red velvet. The large shawl collar was also made from this velvet which had a wiggly pattern like a brain.

**Ann Maskrey, Costume Designer**

AM
CD

# ALFRID

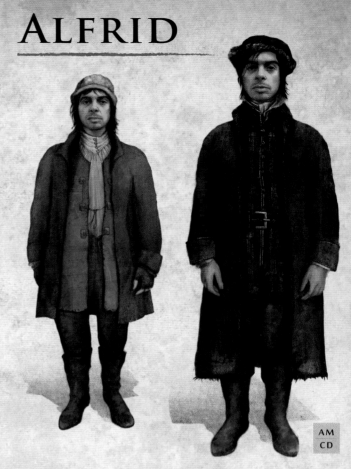

AM
CD

Alfrid is a Uriah Heep-type servant to the Master of Lake-town, a greasy, shifty, unpleasant individual with bad teeth and bad habits. In addition to being enlivened through a wonderful comic turn by Ryan Gage, he has one of my favourite costumes, which turned out to be one of the quickest designs to be approved and made. Alfrid's fabrics were all black but each very different in texture.

His main outfit was a tattered grey and black striped shirt, worn under a herringbone-weave coat with sleeves of horizontally striped fabric featuring raised sections of chenille.

I had a selection of hats which Ryan tried on. The one that was the winner was everyone's outright favourite. It looked like an upturned cooking pan with ear flaps. Ryan developed a great way of slouching and then moving his head like an owl, which seemed to start when he first put on that hat. There was a lot of laughter in the fitting room on that day.

**Ann Maskrey, Costume Designer**

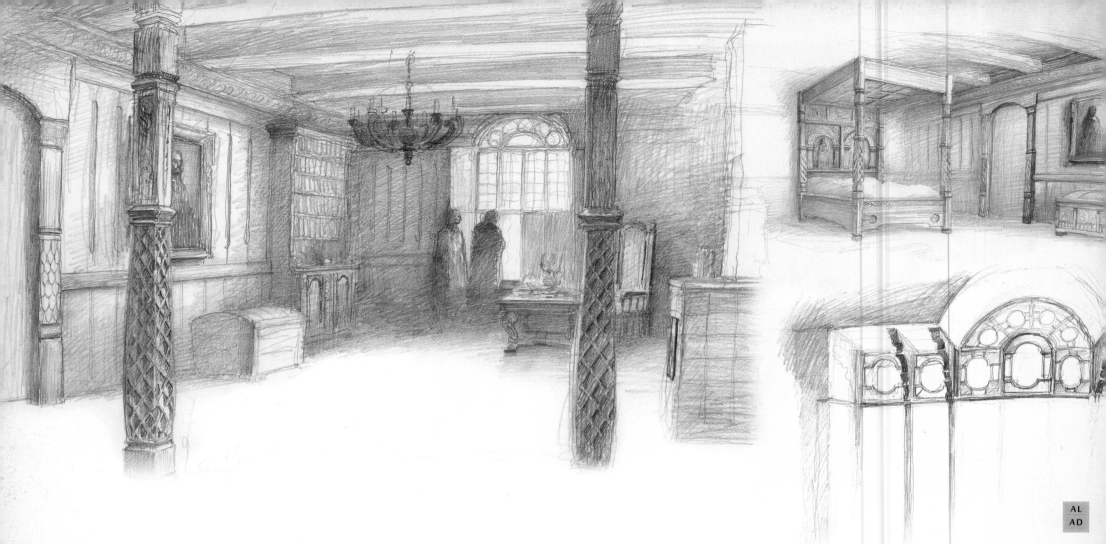

AL
AD

# THE MASTER'S BED CHAMBER

The Master's bed chamber was a fun set to build. Alan had the lovely idea that his bed might have carvings of a former Master and his wife, a hint at former decadence and glory, whereas the current Master has let things go. While he has a lot of valuable stuff, everything is a bit neglected, mouldy and threadbare. There's the sense of a hoard that has more to do with acquisition than appreciation. The Master isn't house-proud – he would never dust and his servant flings the contents of his chamber pot out the window each morning.

**Dan Hennah, Production Designer**

Among his many piled possessions in the Master's bed chamber were a stack of beautiful paintings in gilded frames and a few random instruments which I seriously doubt he played, given how awkwardly they were propped up, but he obviously coveted them. It was all suggestive of how he was squeezing his people and hoarding wealth for himself, sucking the city dry, though the true extent of that would only be revealed later in the story.

Bearing in mind his character, we chose to layer all his acquisitions with a certain level of decay or wear, so his fabrics, for example, while beautiful were also broken down. His lovely mink bed spread was balding in patches, the pile was falling out in his velvet curtains, and the goblets and things that he drinks from were chipped or scratched, little touches that add up and help with the storytelling.

**Ra Vincent, Set Decorator**

136    **A WARM WELCOME** - THE MASTER'S BED CHAMBER

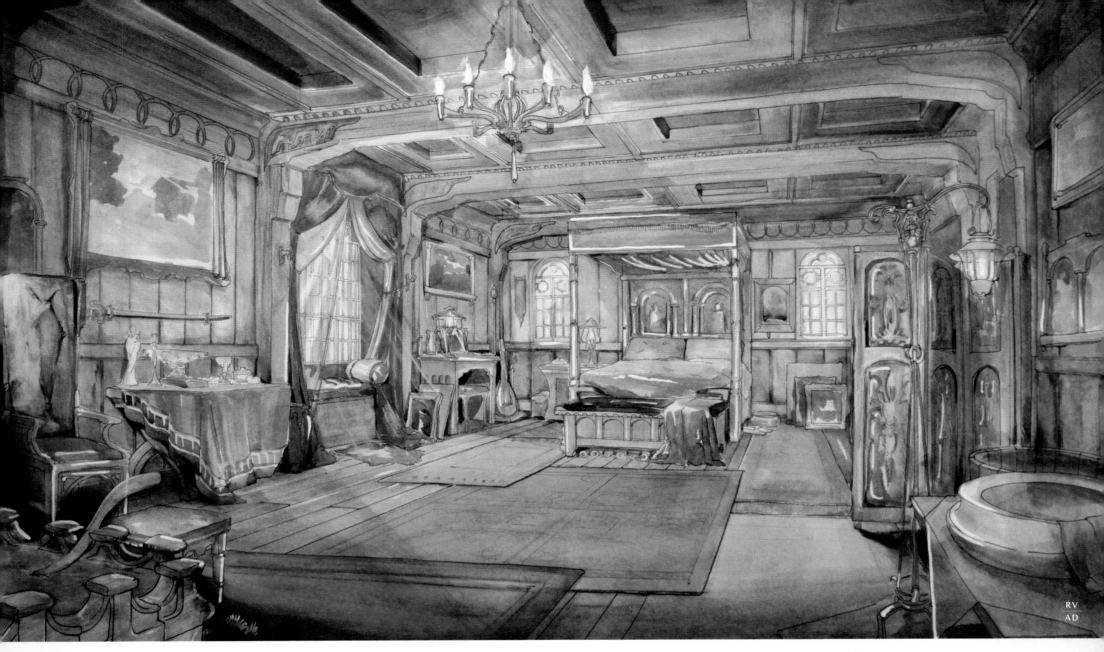

Walking on to the set of the Master's bed chamber it was immediately apparent that we needed something above the door. That space looked so big and blank and demanded some kind of ornamentation, given how baroque everything surrounding the Master is, so I came up with a kind of merchant's guild heraldry to cap the door frame *(far left)*.

He also has a very ornate ceramic stove that I was very happy with *(near left)*.

**John Howe, Concept Art Director**

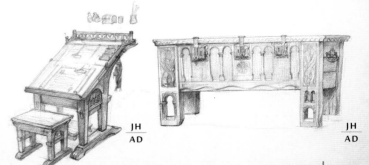

**A WARM WELCOME - THE MASTER'S BED CHAMBER** | **137**

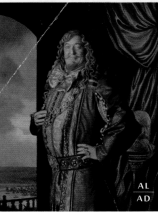

# LAKE-TOWN TOWN HALL

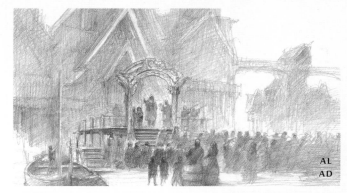

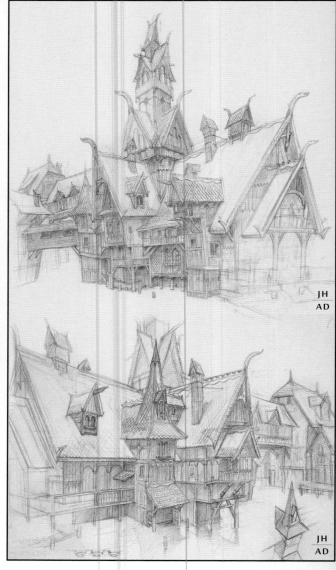

I had put a little framed portrait in my sketches of the Master's bed chamber because I imagined that would be something he would have. Once something is in a sketch it ensures that it will be thought about, and it wasn't too long before the request came back for a design of that painting. I sketched a rather self-important looking official portrait that I imagine the Master would have commissioned for himself *(above, left)*. Peter loved the idea and so when Stephen Fry, who played the character, came in for one of his fittings, I took the opportunity to photograph him. Director of Photography Andrew Lesnie set up lighting for us and we tried various arrangements with and without hats or cloaks, but the pose was always very much what I thought of as a default self-satisfied, smug one.

I worked over the best picture in Photoshop, painting the Master into what I thought was something more akin to how he liked to imagine himself, as opposed to the real tousled and grubby character who wakes up in the morning and has his night soil ejected out of the window by his servant. There was a little bust that I put in the frame with him, but not wanting to share the attention he has elbowed in front of it, while behind him was a window out of which he could overlook Lake-town from an elevated position.

We had the artwork printed onto a five-foot tall canvas and then, working with Kathryn Lim, who was the set finisher, we had it coated in a kind of gel that sets hard and is very textural, so any brush-marks that are made remain. The eye would read the variations in the brush-marks, giving the illusion that the printed canvas had actually been painted with thick oil paint. It looked great but still looked too much like a photograph, so we worked back into it with acrylics and then gave it one final coat of varnish. The result was amazing and very funny *(above, right)*. Mounted in a lavish gold frame it really looked like an oil painting.

**Alan Lee, Concept Art Director**

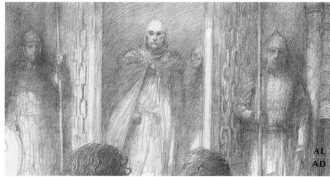

We explored a number of incarnations of the Town Hall, trying to find something that would give Peter everything he needed. A big confrontation would occur outside, so we created a wide platform upon which the commoners could stand and listen, but inside the hall needed its own character and this had to reflect the nature of the Master's administration. It would be a place where business was done, where the town's highest echelon traders would meet with their Master, but, like everything, it would also be a rundown place.

**Dan Hennah, Production Designer**

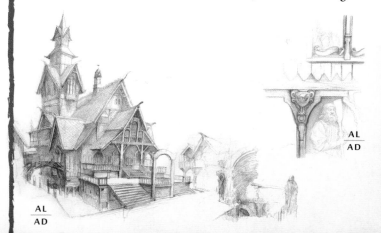

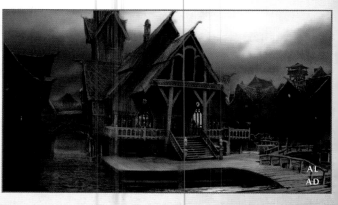

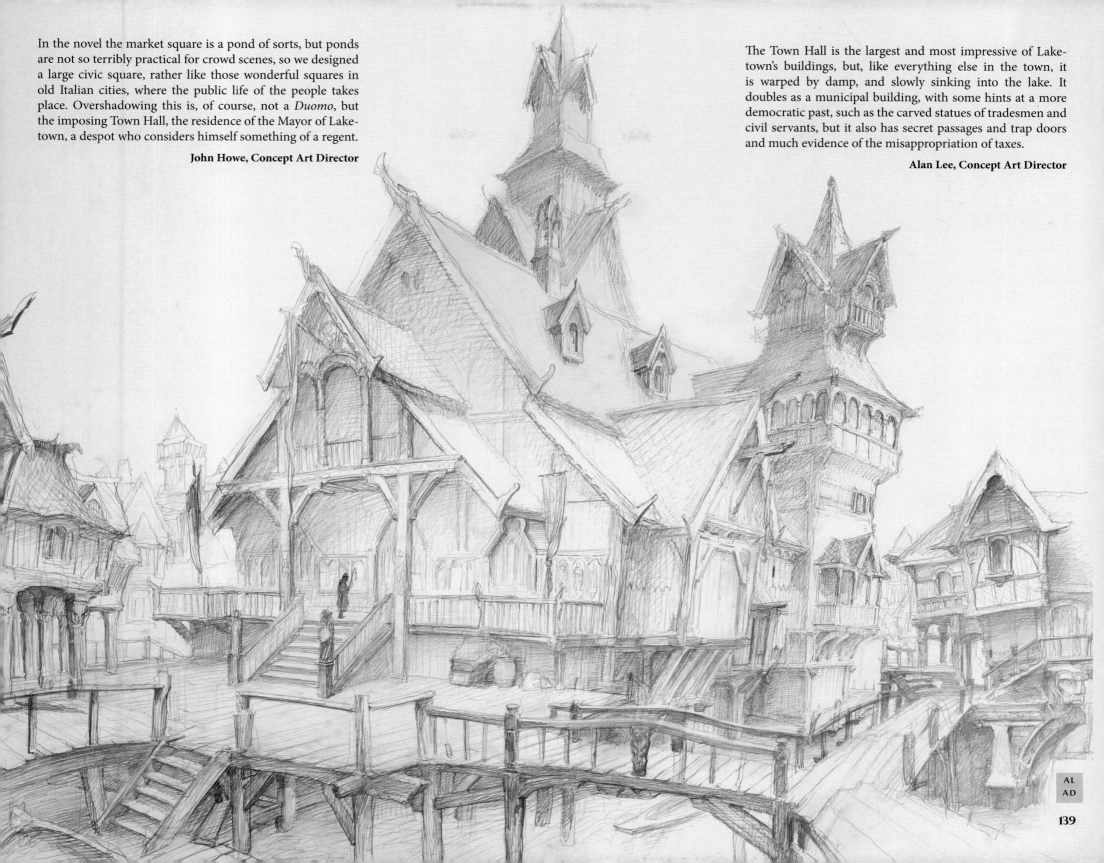

In the novel the market square is a pond of sorts, but ponds are not so terribly practical for crowd scenes, so we designed a large civic square, rather like those wonderful squares in old Italian cities, where the public life of the people takes place. Overshadowing this is, of course, not a *Duomo*, but the imposing Town Hall, the residence of the Mayor of Lake-town, a despot who considers himself something of a regent.

**John Howe, Concept Art Director**

The Town Hall is the largest and most impressive of Lake-town's buildings, but, like everything else in the town, it is warped by damp, and slowly sinking into the lake. It doubles as a municipal building, with some hints at a more democratic past, such as the carved statues of tradesmen and civil servants, but it also has secret passages and trap doors and much evidence of the misappropriation of taxes.

**Alan Lee, Concept Art Director**

AL
AD

# THE MASTER'S CHAMBER

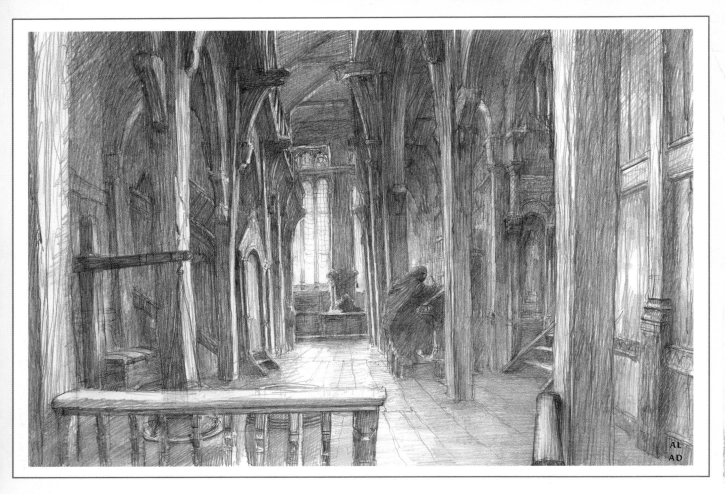

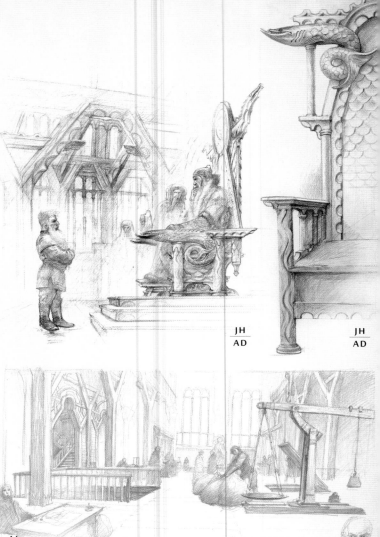

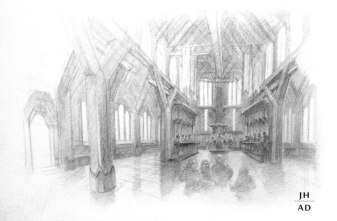

For the interior of the town hall where the Master held court we settled upon a design that was very long and tall, with high columns that, thanks to the height and depth of the space, were able to be layered beautifully, each leaning at a different angle to emphasize the crookedness of the entire structure. The space was crammed with rubbish that the Master had collected. At the far end, behind his throne, was a tall stained-glass window which cast a superb backlight. The verticality of the space was inspired by cathedrals, only rather than uplifting, the effect of this space is claustrophobic, with looming sides, little doorways and stairways leading off to precarious, narrow balconies. Once it would have been a wide, open trading hall, but the timber has darkened and now it feels close and oppressive.

**Dan Hennah, Production Designer**

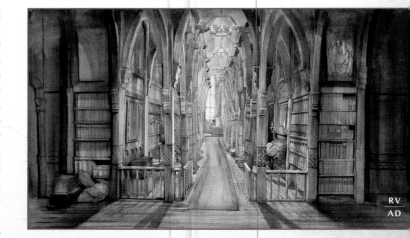

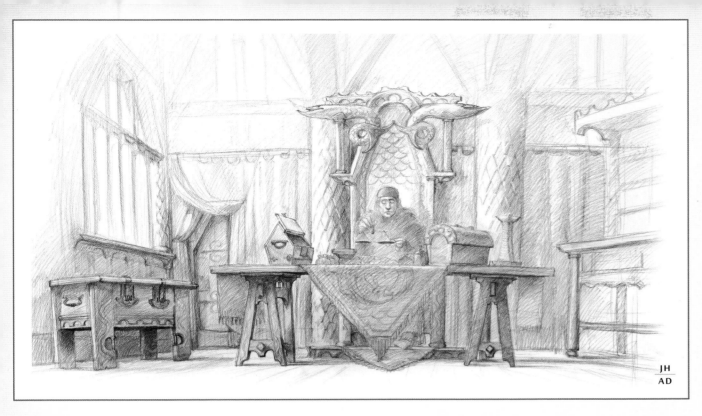

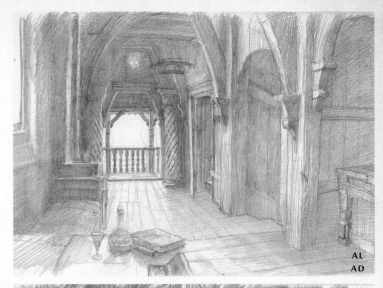

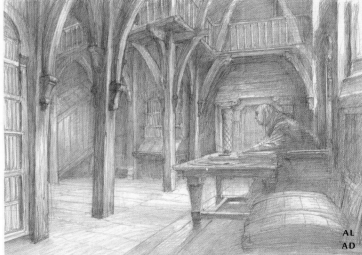

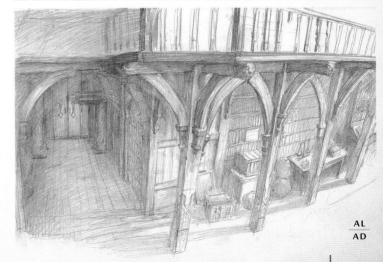

The Master's ornate throne once again employs the fish motif that is evident throughout Lake-town. Much of the town's original riches were derived from the bounty of the lake, and the throne, hand carved out of a beautiful piece of timber, reflects this. This was once a place that supplied fish to many mouths, now it's really about just one.

**Dan Hennah, Production Designer**

We explored some different ideas for what kind of environment the Master might inhabit when at work – was it an office, a huge hall or a smaller affair? We ended up with a kind of office that was a long corridor, stacked with bureaucratic paraphernalia, books, ledgers, and boxes and chests full of taxes he has levied, with the Master's desk and chair at its head, the chair being a kind of throne. Rather than a vast hall, sometimes it's better to have a smaller space in which everything is carefully considered with attention to detail that can be applied thoroughly instead of expending energy and resource on a huge space that is harder to fill and doesn't ultimately provide as much pay-off. I was very pleased with the way the Master's chambers ended up looking, and so was Stephen Fry, who took obvious delight in working in that space.

**Alan Lee, Concept Art Director**

The Master's chair is something of a throne, ostentatious and oversized, reflecting, through the pike motif, his somewhat predatory nature.

**John Howe, Concept Art Director**

We discussed with the set designers the purpose of the Master's room. This was reflected in the inclusion of scribes working at easels, which we then dressed with a layer of tithes, the idea being that people who couldn't pay taxes in currency would do so in goods so there would be a cluttered layer of all this stuff that was being amassed by his administration. On top of that was the residue of the Master's own untidy habits.

There are stages involved in dressing a set and the Master's chamber demonstrates this with all its various layers, building to achieve a look. We imagined that he would have all of his precious objects up the end of his room, near his desk. He had his scales for weighing grain and gold, and he had a chicken in a cage so he could have an egg for breakfast, and his brandy or whatever was in the drinks cabinet just within arm's reach. It was all designed under the rationale of how the Master would have crafted his immediate environment to suit him. Here he can sit, his gold next to him, surveying his minions and acquisitions with an egg or a drink no more than an arm's length away from his grandiose chair.

**Ra Vincent, Set Decorator**

## PROPS

The Master's beautiful blue decanter and glasses had the fish motif on them that had emerged as one of the main themes of Lake-town. They were very nice pieces of glasswork.

**Nick Weir, Prop Master**

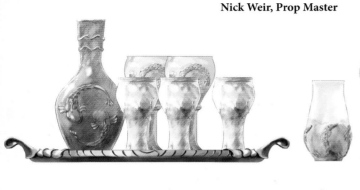

Amongst the Master's accumulations is a small place for his clerk, Alfrid, with a little stand-up writing desk. It stood alongside many beautiful pieces of furniture designed and built for Lake-town – beautiful, but inherently wonky and a bit uncared for.

**Dan Hennah, Production Designer**

I think sometimes what we design as props or furniture are things that we'd quite like to own ourselves. I would love a little scriptorium like Alfrid's *(right)*, with a shelf for writing equipment, lit by an elegant lamp and crowned with strong boxes for ledgers and paperwork.

All the furniture we came up with for the Master's chambers was inspired by a mix of medieval shapes with a baroque level of detail and ornamentation.

**John Howe, Concept Art Director**

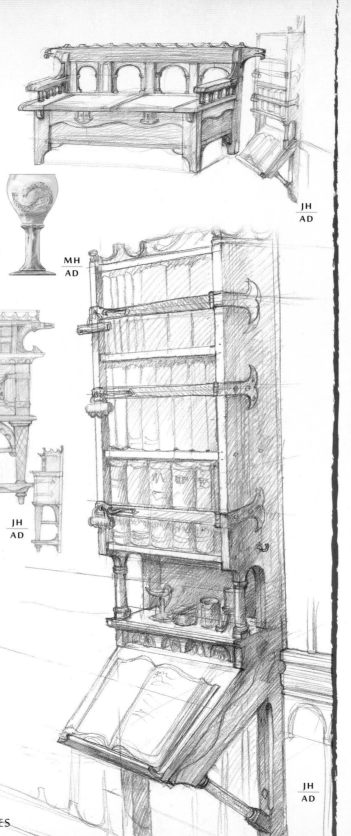

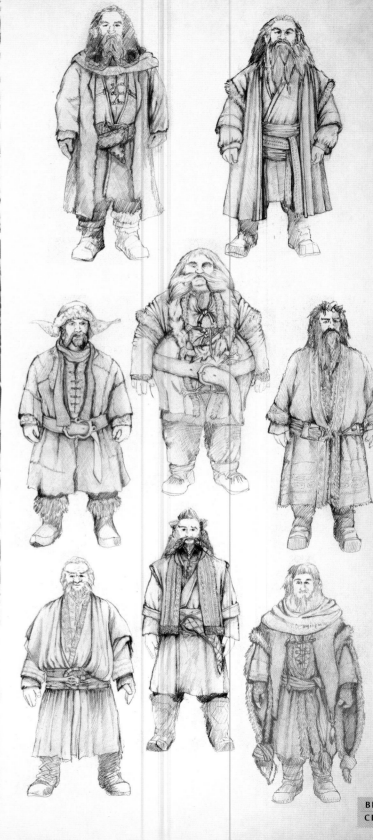

# LAKE-TOWN DWARF COSTUMES

In costume making we are often drawing and making at the very same time. Costumes don't necessarily get drawn first and then those drawings get made – instead we might draw in response to what is coming together on the mannequins or in fittings, suggesting revisions, or we might collect ideas in a drawing. This was the case with the Dwarves' Lake-town garments.

The characters had just emerged dripping from their barrels, stripped down to little more than their trousers and underwear, having lost almost everything, and this was how they appeared in Lake-town. When they make it to Bard's home they, in theory, get new clothes to throw over themselves from his daughters, but of course these are human clothes so they are oversized. Each Dwarf had started out from Bag End with a strong individual colour signature and we were sympathetic to those established associations, but at this point the colour rules were broken up a bit. Dwalin is still big, rough and ready, for example, so he wears a big, rough and ready coat, but it would have seemed forced if the Dwarves all picked their favourite colours again. When we shared the costumes with Peter on stands he would swap things around and remove or add pieces as suited him to achieve what he felt was appropriate for each character, irrespective of their original colour signatures. Bifur and Thorin's outer garments, for example, were swapped.

Thorin had started with a leather coat, while Bifur was wearing rough, heavy silk, but these were exchanged. The rougher clothing suited Thorin's gradual crumbling at this point in the story as he gets closer and closer to the Mountain and his all-consuming goal.

With all that in mind, at no point could the costumes appear art directed. These were supposed to be makeshift solutions, pulled together hastily by the characters based on what they could find to vaguely fit, even if in fact they were truly carefully considered designs.

There was a second layer to all of this which comes in the story when the Master decides to adopt the Dwarves and outfit them with his heraldic garb *(inset, right)*. He has a staff of musicians and guards who all wear his clumsy, buffoonish uniform and he starts throwing all this stuff at Thorin's Company. There's a degree of humiliation that goes with it, and a number of the Dwarves are quick to shrug off their clownish extra layers as soon as they've made their getaway.

**Bob Buck, Costume Designer**

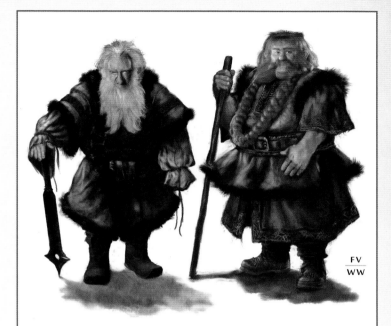

Coming up with suggestions for costumes worn by the Dwarves after their welcome in Lake-town by the Master was a lot of fun. Each Dwarf had a unique personality and look, and even with oversized clothes from another culture we tried to make sure one could still recognize each of them.

**Frank Victoria, Weta Workshop Designer**

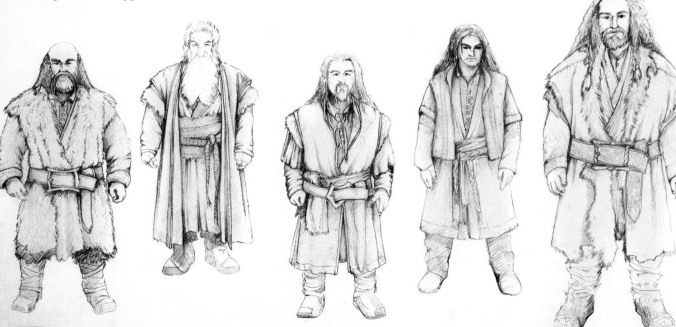

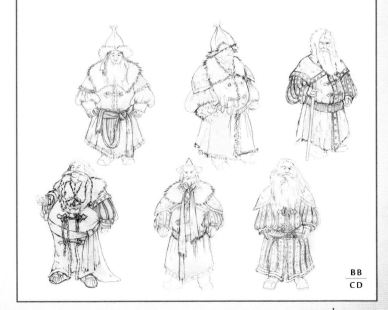

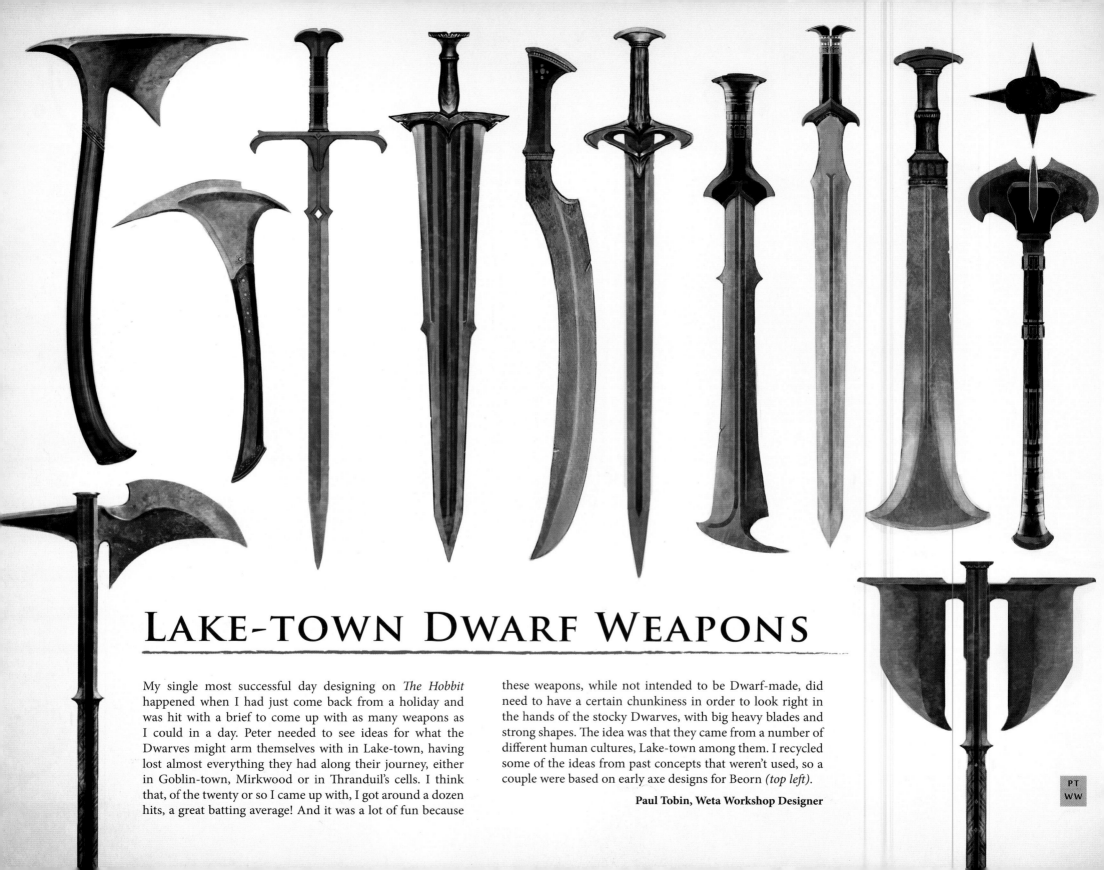

# LAKE-TOWN DWARF WEAPONS

My single most successful day designing on *The Hobbit* happened when I had just come back from a holiday and was hit with a brief to come up with as many weapons as I could in a day. Peter needed to see ideas for what the Dwarves might arm themselves with in Lake-town, having lost almost everything they had along their journey, either in Goblin-town, Mirkwood or in Thranduil's cells. I think that, of the twenty or so I came up with, I got around a dozen hits, a great batting average! And it was a lot of fun because

these weapons, while not intended to be Dwarf-made, did need to have a certain chunkiness in order to look right in the hands of the stocky Dwarves, with big heavy blades and strong shapes. The idea was that they came from a number of different human cultures, Lake-town among them. I recycled some of the ideas from past concepts that weren't used, so a couple were based on early axe designs for Beorn *(top left)*.

**Paul Tobin, Weta Workshop Designer**

PT
WW

# BILBO'S LAKE-TOWN COSTUME

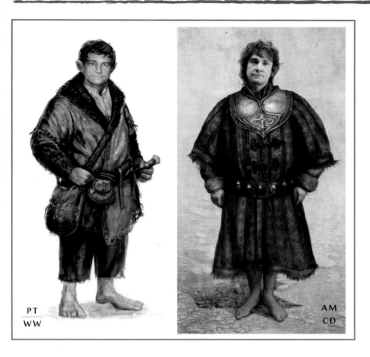

Very early on I submitted a drawing suggesting what Bilbo might be wearing once he'd been to Lake-town *(far left)*. It was quite a challenge because at the time Lake-town's costume signature hadn't been established. There were leads that had been explored in earlier concepts, and I modelled my drawing on those, which had a sheep's wool interior. There was a Nepalese influence coming through in the woven sleeves and rounded pouches. The brief was to come up with something that looked natural but definitely unhobbity.

**Paul Tobin, Weta Workshop Designer**

Bilbo's Lake-town coat came about having spent a number of weeks making costumes for the Lake-town crowd. Having made all these costumes I was able to try several different looks for Martin before settling on what we decided was the right one.

The textile team by this point had a selection of interesting swatches I had developed with them over the previous months and we were able to use a screen, which printed out already worn bald patches into the blue velvet coat prior to making the garment up.

The coat was a warm blue, in keeping with Bilbo's character, and was a colour which suited Martin very well. The lining was a bluish grey linen with a self quilt and grey fake fur-trimmed lapels which ragged up very nicely in the wash. Underneath he wore his existing waistcoat, shirt and trousers from Bag End.

The brown tooled belt was one which I had originally designed for Bard, the buckle featuring a bow design. I am glad it ended up on Martin as it was particularly pleasing, and as Bilbo and the Dwarves acquired their new clothes while at Bard's house it could have come from him.

It was of course extra long on a small hobbit!

**Ann Maskrey, Costume Designer**

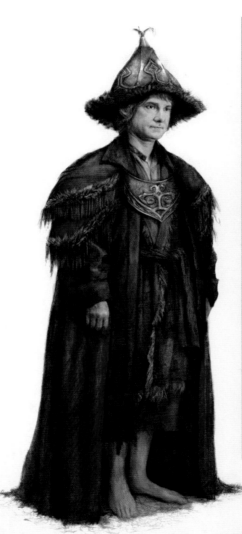

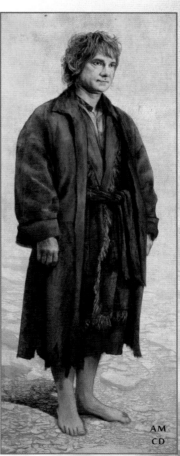

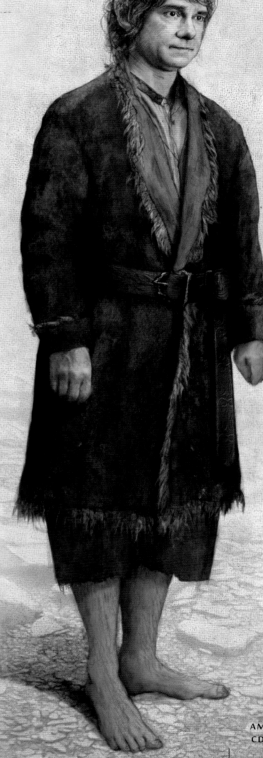

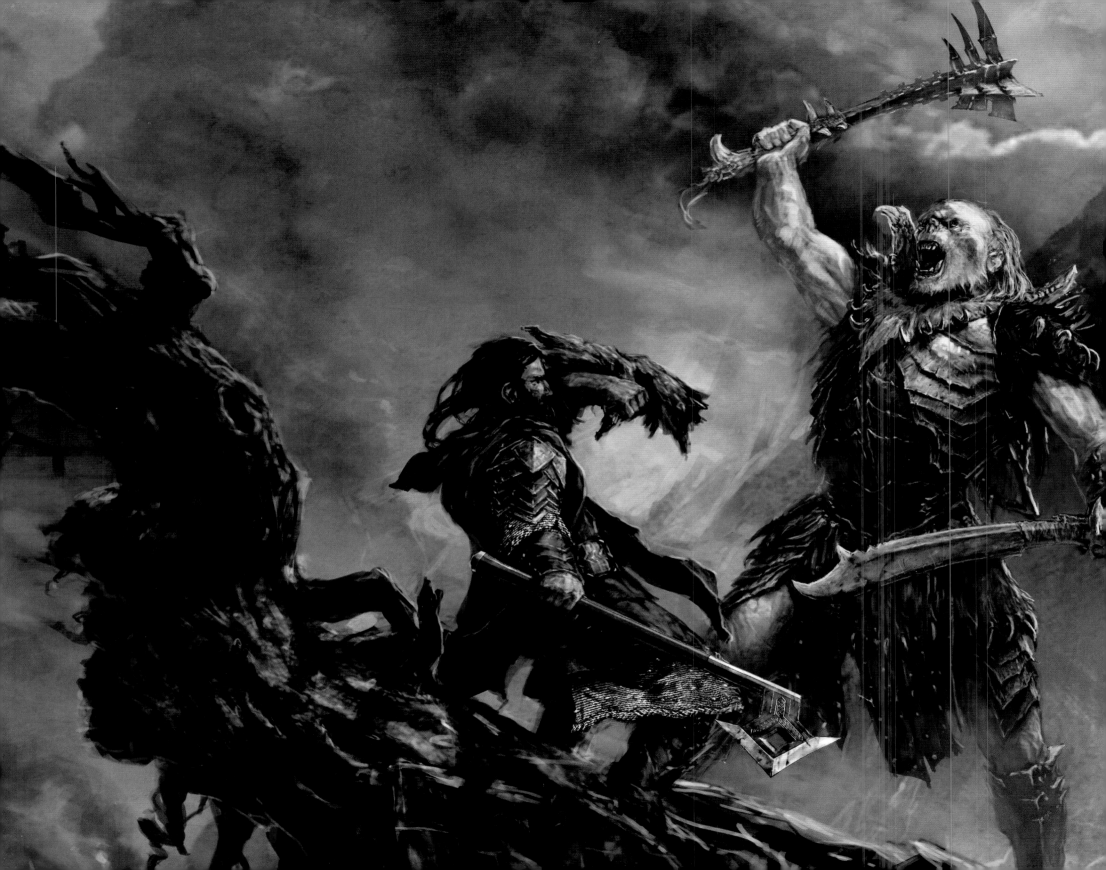

# A Ruined Form of Life

## AZOG AND THE ORCS

Led by the monstrous Azog, the giant abomination of Gundabad whom the Dwarves named the Defiler, the Orcs relentlessly pursue Thorin and his Company through the wilds of Middle-earth. In Peter Jackson's film adaptation of *The Hobbit* Azog and his Orc hunters play a crucial role, linking the Necromancer and Dwarf legacy plots and providing a dangerous, mobile villain who can threaten the heroes in all three film instalments, and who shares a deep mutual hatred with Thorin. With Wargs and Orcs snapping at their heels, the Dwarves must make eastward with all haste for the Mountain and seek shelter and supply wherever it can be found along their route.

The filmmakers employed both physical and digital technologies to make the Orcs as malevolent and threatening as possible, using computer-generated creature effects to push the designs beyond what would have been possible to achieve using practical make-up effects alone, but careful not to stray to far from what had been established in *The Lord of the Rings*. Orcs being a varied and corrupted race, there was license to conceive new varieties not yet seen before in previous films.

Azog himself had to be an Orc unlike any other, an instantly detestable and intimidating adversary. His design would go through several developmental stages before arriving at the hairless, scarred giant seen in the final films; along the way his development would spawn worthy alternative concepts that were channelled toward other Orcs in his train.

NK
WW

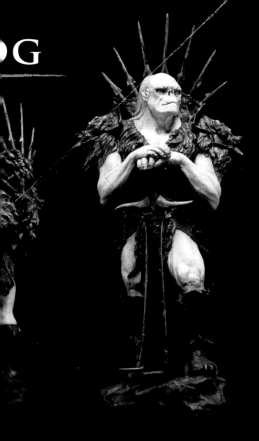

The Hobbit, we were faced with the challenge
...pecies that we had met during The Lord of
...s and developing a fresh new take on these
... also referencing what had already been seen.
...lished, the Orcs were quite a varied race, so
... of latitude to push them in new directions.
...t to repeat himself so we set about trying to
...unique and different-looking breed.

...important character in the scripts, Azog was
... Orc we began designing. Jamie Beswarick
...n amazing very first sculpture that we
...selves referring back to time and again as
...process unfolded and we explored various
... r the character.

... was the great white monster that audiences
... now, but along the way we came up with
...nd interesting alternatives, and many times
...wasn't used for Azog would inform or inspire
... e or more of our other Orc characters.

**Richard Taylor,**
**Workshop Design & Special Effects Supervisor**

The first full-body Orc maquette I sculpted was a concept
for Azog *(above, left)*. I thought it would be cool if he was
entirely white, like an albino. It distinguished him from the
rest, but it also meant he had to be someone pretty special,
because any difference would have made him a target
amongst his own kind. He would have to be very tough or
else he wouldn't have survived, so we know that much about
him right away. He would have had a nose at one point too,
but that had come off in some fight. He had a chewed ear and
long, lank, yellow hair that I thought of as a reference to his
ancient Elven heritage.

I imagined that each of the seven spikes on his back
protector represented one of the Dwarf tribes and that each
sported a corresponding braid or beard, matching seven
more he had dangling from the belt in front of his groin,
another insult to the seven Fathers of the Dwarves. On his
shoulders he might wear bear claws, declaring his personal
responsibility for wiping out most of Beorn's clan. I imagined
he'd wear these totems into battle to antagonize his enemies.

I thought that the less he wore, the scarier it might be.
Maybe he'd even disrobe before fighting Thorin, revealing
ugly, blue tattoos that almost made him look like a blue-
veined cheese. It'd be intimidating in that he simply doesn't
need armour.

Finally, I gave him a huge, curved sword because Tolkien
mentions Orcs carrying scimitars into battle. In this instance
I thought it would be cool if this sword was a more complex,
ancestral form of what the Uruk-hai would later bash out
in Saruman's factory forges years later. In my mind, this
weapon was what the Uruk-hai were referencing, a way
of suggesting that maybe Azog and the Gundabad Orcs
were the bloodline that the Uruk-hai were derived
from. They were obviously a much larger, stronger
group than most Orc breeds, and even amongst the
Gundabad Orcs, Azog was a monster, all of seven feet
tall and built like a gorilla.

We explored all kinds of other ideas and directions.
For his face, I played with widening the eyes, lowering
and sloping the brow, making the jaw bigger, and
pushing his proportions into more disturbing
directions. I even based one loosely on Movement
Coach Terry Notary, a kind of really ugly,
Orcish caricature of Terry!

**Jamie Beswarick, Weta Workshop**
**Designer & Sculptor**

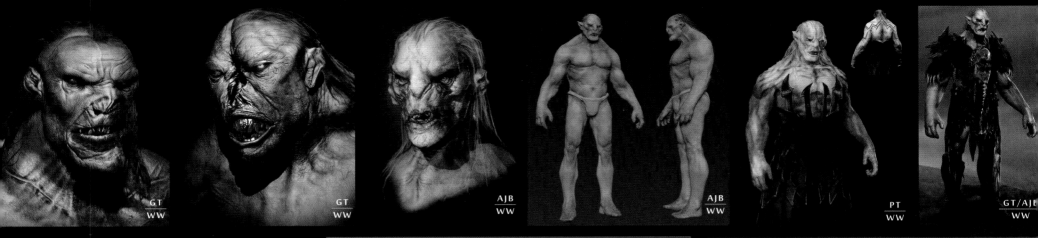

ved the idea of Azog adorning himself with totems. arves are known as craftsmen, working with their hands, one idea I presented had him wearing a collection of putated and mummified Dwarf hands *(below)*. Other cepts had him surviving horrific injuries sustained during Dwarf and Orc wars *(top)*. Azog had to be intimidating, ook like an Orc who knew he was top dog, not afraid to ow his weight around.

**Greg Tozer, Weta Workshop Designer and Sculptor**

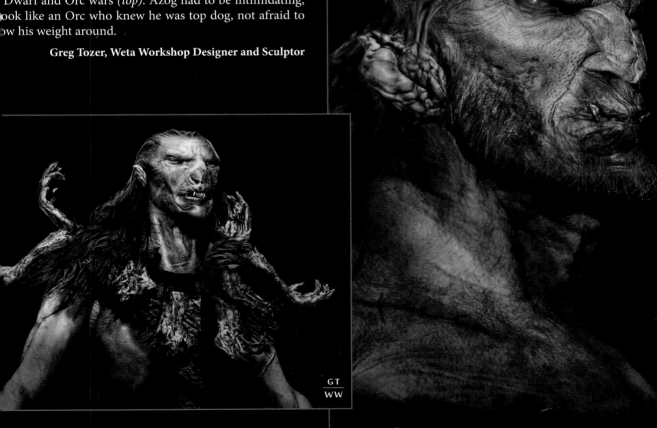

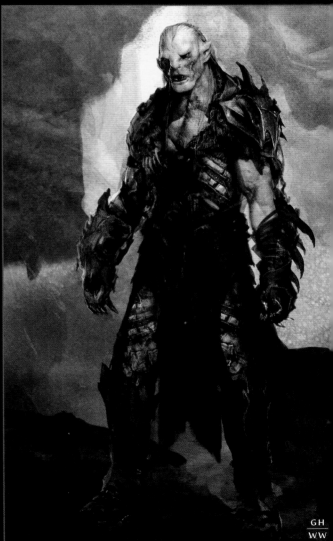

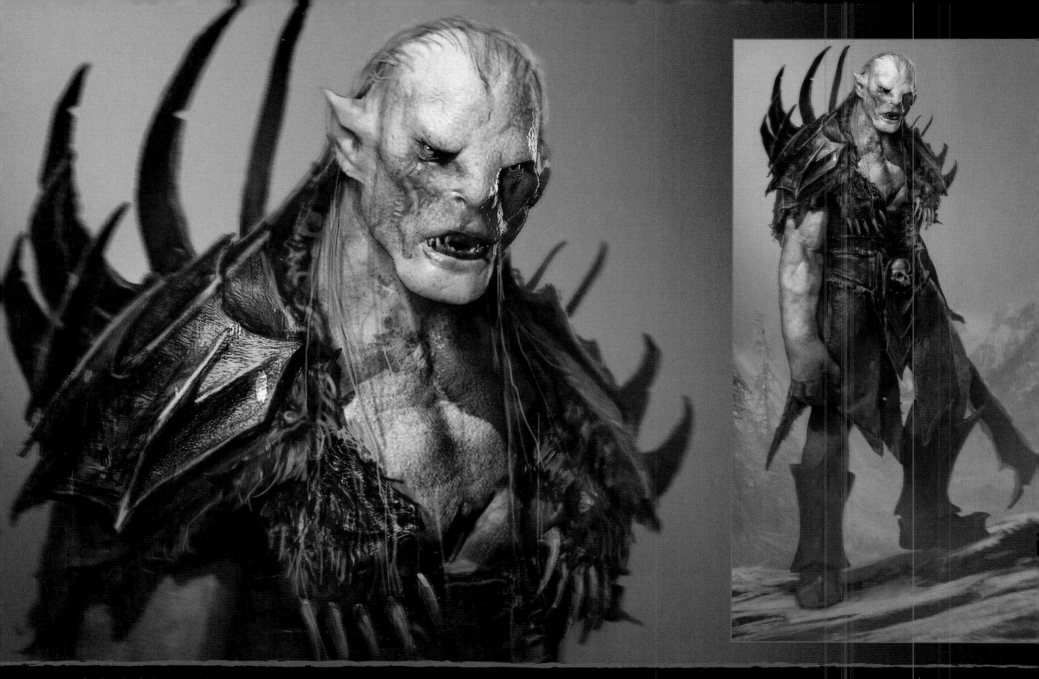

saw Azog as the kind of character that would suit some really intense scarification, so I put him in fairly minimal clothing to show as much of his scarred-up physique as possible. I saw his scars being quite dark, maybe because his blood was black or maybe it was the blood of others that he had rubbed in to them. The lines of his costume merged into the scars on his chest so it all felt integrated. I imagined some of the scars were from battles but a lot of them were things

he had added himself, like some sort of ritual he had to go through to become who he was. Peter, Fran and Philippa reacted well to it and it developed from there. Andrew Baker based a Z-Brush model on the concept and the two of us collaborated, developing it further until we had a model that was handed over to Weta Digital for their reference.

An idea that Nick had introduced in a concept drawing for an Orc that ended up being used on Yazneg was the skirt of

dried Dwarf faces. That was such a cool idea and Peter really liked it, so we brought that into Azog's costume. Peter also wanted to see options for a clawed hand, replacing the hand that we would see him lose in battle, so I was asked to come up with some cool claws. I offered three variations but they ended up going with something quite different in the final design.

**Gus Hunter, Weta Workshop Design**

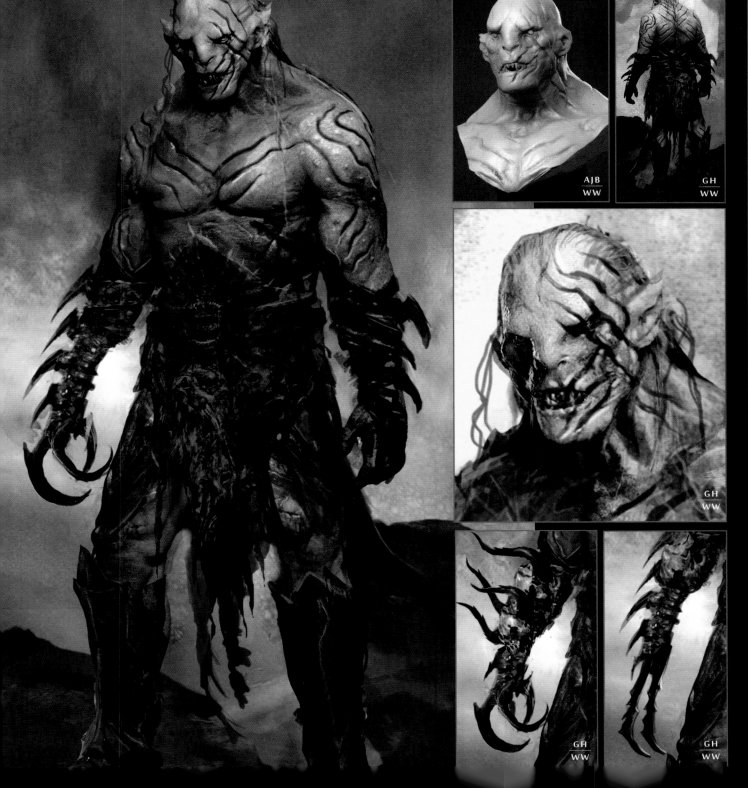

*Above: Azog, a completely digital character with performance capture by Manu Bennett, as he appeared in* The Hobbit: An Unexpected Journey.

The final design round we undertook with Azog offered a chance to include some of the elements that worked so well in that first sculpture of Jamie Beswarick's. I was very pleased with where we had got to with the character design. I think Azog had the intelligence and power that he needed. We had been responsible for finding the mood and feel of the character, but then it became the task of the guys at Weta Digital to take, refine and realize him for the final film, so was far from the end of the design process.

As finally realized in the finished films he would be hairless and more symmetrical than the early art, which I think probably helps make him feel like the idealized Orc that he is. If teenage Orcs have posters pinned to their bedroom walls they're of this guy ripping up Dwarves. I liked to think of him as maybe the last of his kind, a stand-out Orc of a level that there really aren't any more of now.

**Andrew Baker, Weta Workshop Designer**

# HUNTER ORCS

## COSTUME DESIGN

Late in the piece Peter requested that we design a specific group of Orcs that he called the Hunters, a tireless pack of creatures that would relentlessly pursue the Dwarves across Middle-earth. The brief once again was to make them iconic and dramatic. They had to be agile, fast-moving and feral, immediately frightening and plainly malicious. Our designers developed these characters in unison with a team on the Workshop floor. John Harding, Sean Foot and a large team experimented with materials while our designers drew, prototyping costume elements onto life-sized mannequins, which I approved, had photographed then shared with Peter, Fran and Philippa.

**Richard Taylor,**
**Weta Workshop Design & Special Effects Supervisor**

In pursuit of the kind of unique look Peter had in mind, we explored the idea of hoods and skins tented over bone with projecting, tooth-like barbs. Practicality saw this toned down dramatically but what we ended up with had its origins in these concepts.

**Nick Keller, Weta Workshop Designer**

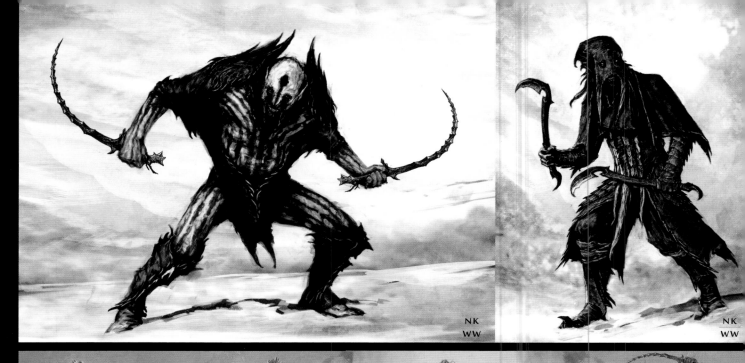

*Weta Workshop Specialty Costume Makers Alistair McDougall (left) and John Harding (right) working on Hunter Orc costumes, with Actor Ben Mitchell as Narzug.*

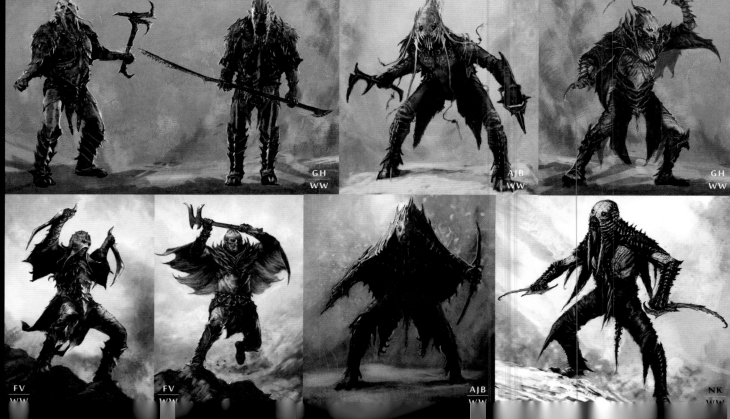

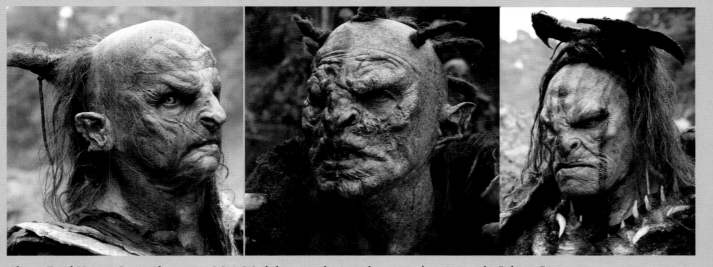

# HUNTER ORCS

## CREATURE DESIGN

Although we did a lot of conceptual illustration around the Hunter Orcs, the designs for those who were realized as physical make-ups on actors took shape as life-sized sculptural maquettes. We took human head casts and sketched over them with Plasticine. They're not finished sculptures that would be used for prosthetic casting, but fast turnaround conceptual ideas sculpted on life-size busts. The favourites we would then replicate on to working cores for moulding as prosthetics or animatronic masks.

**Richard Taylor,**
**Weta Workshop Design & Special Effects Supervisor**

At the time I was sculpting concepts for Azog's Orc hunters the design brief was for smaller, more lithe and agile creatures, so I tried to keep their features quite sharp and angular. A featured hunter, Narzug, was one of these Orcs and was a good example of this *(page 156)*. I also played with the idea of very dry skin, almost mummified and parchment-like, with bright, psychotic eyes glaring from behind a husk of a face.

**Greg Tozer, Weta Workshop Designer and Sculptor**

The challenge with Orcs at this point is to come up with something new. Approaching them with the mindset of creating very specific characters rather than simply 'another Orc', and not being afraid to mutilate them, always seemed to help. Scarring, boils and disease also worked because they evoked a disgust reaction. Peter responded very well to seeing asymmetry in the designs, which makes sense because we, as a species, are predisposed to distrust it, favouring symmetry in humans we consider beautiful.

**Steven Saunders, Weta Workshop Sculptor**

*Above: Final Hunter Orc performers in Weta Workshop prosthetic make-ups on location at the Pelorus River.*

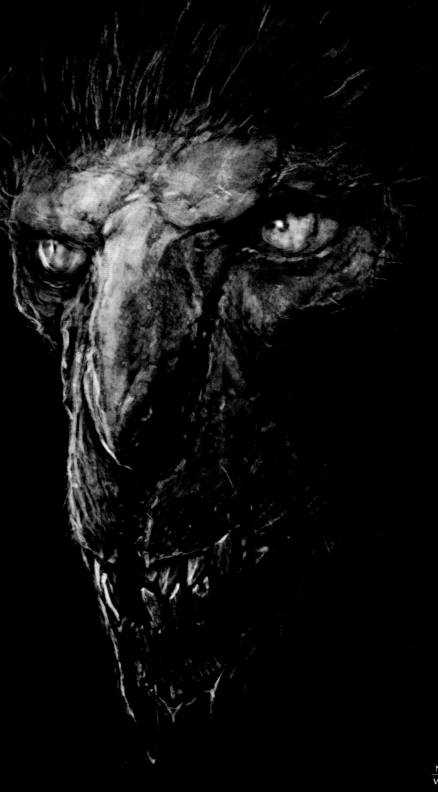

In addition to the physical prosthetic Orcs Peter was keen to make full use of modern digital effects techniques to push the variety in our Orc band to new extremes. That meant Weta Workshop's artists had the opportunity to create additional concepts that could be as grotesque as our imaginations allowed. While masks were designed to fit over live performers' features and were therefore limited to conforming to the actors' eye-width and mouth position, digital Orcs could be less human in their proportions.

**Richard Taylor,**
**Weta Workshop Design & Special Effects Supervisor**

Going digital with our Orcs kicked open all the doors for us as far as what we could offer. Whenever we embark on a new design brief my inclination is to go back to the books. Tolkien described some of his Orcs as resembling 'apes of the south', so I took that as one of my main driving cues. Peter was also looking for individuals rather than a generic base Orc. Where Elves represent a physiological pinnacle, refined and elegant, Orcs have been twisted and distorted in the opposite direction. They're broken and uncomfortable in their own skins. If they're happy it's only because they're hurting someone else.

They're a hugely varied species, so there was plenty of scope for us to push our Orcs' features around as we sought to invent memorable characters. My concepts ranged from some that were just off human, close enough to be unsettling, to others that were very extreme, with widely spaced or oversized eyes and giant maws filled with teeth.

**Greg Tozer, Weta Workshop Designer and Sculptor**

These Orcs didn't need to talk, so delving to new depths of ugly we could erode their gums and lips away to bone, with teeth projecting at all angles, creating visual icons of brutality. We shrunk foreheads and skulls while enlarging their under-slung jaws and widening mouths to the point of being gashes, maybe even torn by their own overgrown teeth. They are a very messed-up race, the cumulative result of self-mutilation, disease and bad genes that have generated anatomical anomalies. Some had missing teeth where they'd been punched in the mouth or had head-butted one too many helmeted foes.

**Andrew Baker, Weta Workshop Designer**

NK
WW

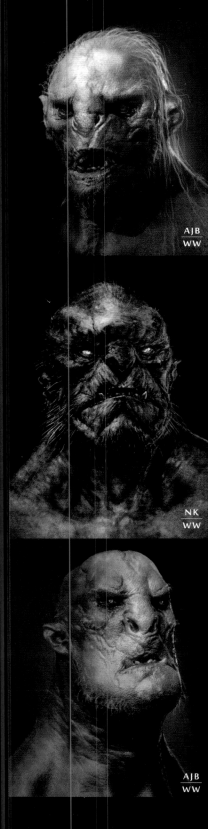

AJB
WW

NK
WW

AJB
WW

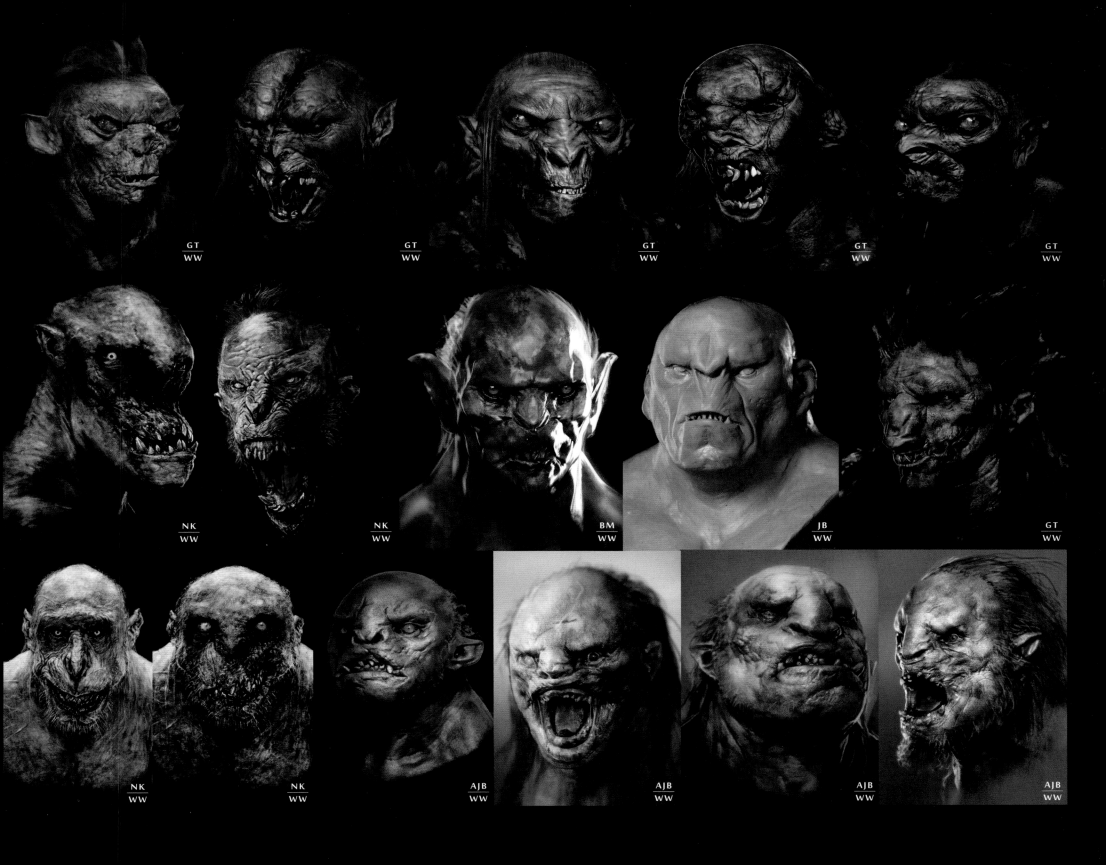

GT
WW

GT
WW

GT
WW

GT
WW

GT
WW

NK
WW

NK
WW

BM
WW

JB
WW

GT
WW

NK
WW

NK
WW

AJB
WW

AJB
WW

AJB
WW

AJB
WW

# NARZUG, FIMBUL AND YAZNEG

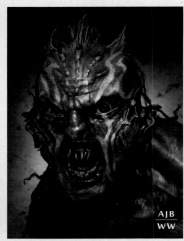

We were looking for creepy, character specific traits to help distinguish our various named Orcs. Self mutilation seemed to be a theme that was emerging. Pain, it would seem, is something they go in for, even to the point of their self-inflicted injuries being potentially disabling. Yet, instead of hindering them, I think the violent response of their robust immune systems seems to empower them somehow, like a persistent adrenalin kick. A number of our designs featured pretty extreme piercing *(above, far left)*, but one of my favourite early Narzug concepts had a split and skinned bottom lip and jaw *(above, second from left)*. The flesh below his mouth would hang from his cheeks, exposing a raw, black chin and echoing the shape of his bone and hide cowl.

**Daniel Falconer, Weta Workshop Designer**

Narzug's final prosthetic make-up design took form on a head cast of actor Ben Mitchell. We didn't have a locked down design prior to sculpting beginning, and as a quirk of scheduling, we actually needed his severed head prop to be sculpted before the prosthetic make-up was needed, so when it came to sculpting the make-up it was based on the disembodied head.

**Greg Tozer, Weta Workshop Designer and Sculptor**

Narzug had been resolved in sculpture by Greg Tozer *(above, middle)*. I came up with some ideas for his war-paint and hair, something Legolas could hold on to in the scene but feel Orc-like.

**Andrew Baker, Weta Workshop Designer**

When the opportunity to do featured Orcs came along, I was really keen to see Stephen Ure play the role of Fimbul. Stephen had given a standout performance in *The Lord of the Rings* as both Gorbag and Grishnákh, so it was fantastic to once again build prosthetics and design a character around his unique performance capabilities and physique.

**Richard Taylor,**
**Weta Workshop Design & Special Effects Supervisor**

We explored some far-out concepts for some of the Orcs in terms of what materials their costumes might be made out of. Instead of traditional steel and leather we tried sinewy, disgusting looking skins with long tufts of matted hair. I liked the striking, monochromatic look we explored for a while.

**Nick Keller, Weta Workshop Designer**

Peter loves to see us push things to extremes. He likes bold statements, so in an effort to find the design boundaries of our Orcs I went really over the top with one of my drawings, covering him in an awful, gruesome mess of meat, bone and dried flesh *(above)*. Peter loved it and it ended up being Fimbul's costume!

**Gus Hunter, Weta Workshop Designer**

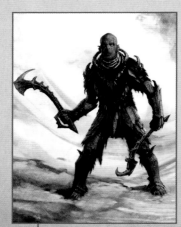

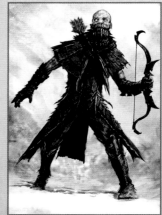

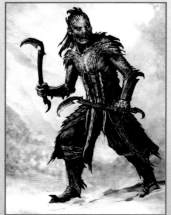

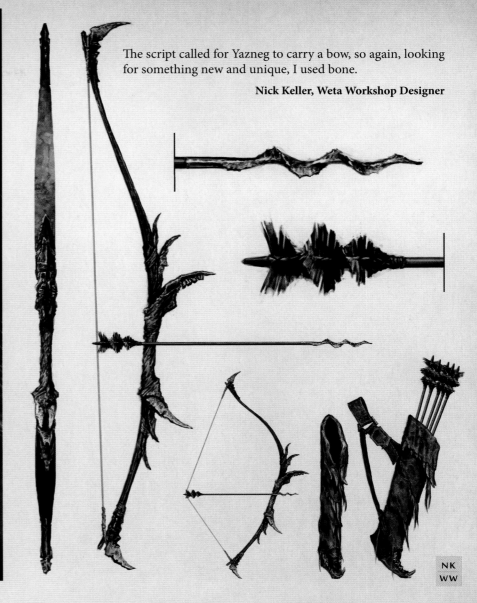

The script called for Yazneg to carry a bow, so again, looking for something new and unique, I used bone.

**Nick Keller, Weta Workshop Designer**

Originally designed as a generic Gundabad Orc long before we had heard of the character of Fimbul, there was a particular face that Peter gravitated toward. We offered alternate options as well, but essentially that original design stuck and became one of Azog's featured henchmen. His design was something I imagined as a combination of a pitbull terrier and a shark, a brutal, uncompromising and psychotically evil thing that has quite obviously been through Hell in his life but isn't quitting anytime soon. He has busted-up ears like the cauliflower ears that rugby players get, little piggy eyes and the face of a brawler.

**Greg Tozer, Weta Workshop Designer and Sculptor**

*Above: Actor Stephen Ure in Fimbul's final prosthetic make-up.*

The process of designing Orc weapons is such fun because it's all about imaging cruel shapes and the kind of movement that they suggest. It helps to get into character and embrace your inner Orc.

**Daniel Falconer, Weta Workshop Designer**

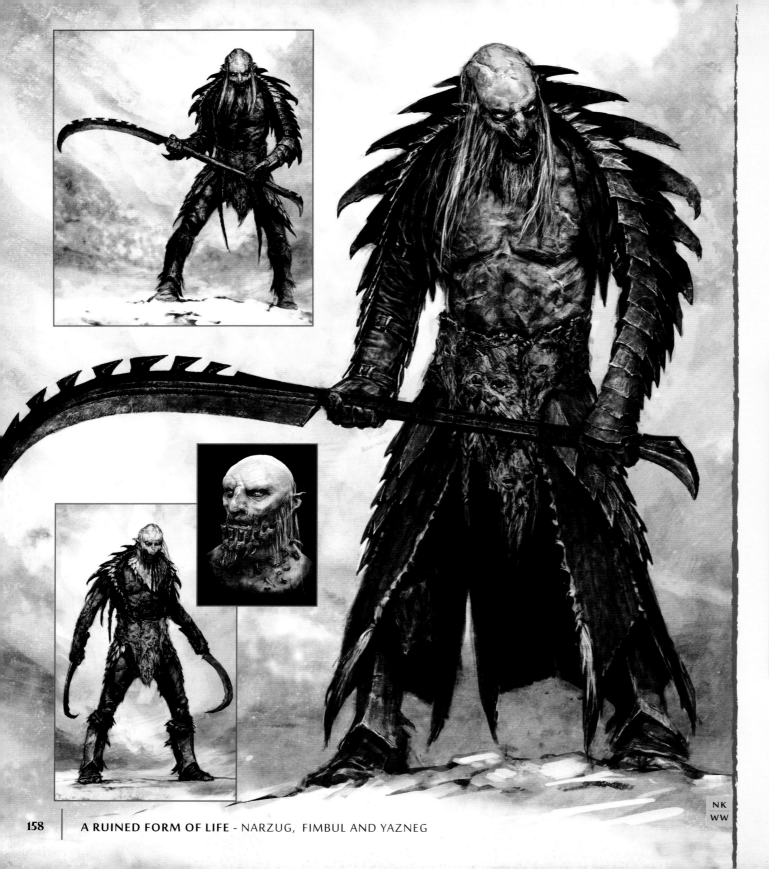

Yazneg was one of Azog's lieutenants. He met his death at Weathertop in the first film. This particular Orc's armour evolved out of some early, unused concepts for Azog. We were looking for unique silhouettes and that's where the rip-saw armour came from. I think solving how it would work drove Weta Workshop Specialty Costume Maker John Harding up the wall, but he did a great job of turning it into a very cool-looking, functional costume.

It ended up being bone on the costume, but I had imagined the armour to be metal when I drew it and had choreographed it and the weapon to match. That concept was my absolute favourites.

Another element I incorporated was a kind of trophy belt composed of stitched-together flayed Dwarf faces. The end product, I thought, ended up looking very successful. It's a layer of detail that you don't immediately notice but when you realize what you're looking at it's very creepy.

**Nick Keller, Weta Workshop Designer**

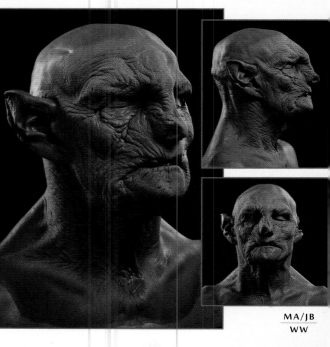

Yazneg had been created as a prosthetic make-up (*above*) and as part of our process for the practical tests we did some Photoshop colour passes over photographs of the actor in full make-up, which is where his final brown colour scheme came from (as shown in in the digital model on the facing page).

**Paul Tobin, Weta Workshop Designer**

# Azog's Warg Matriarch

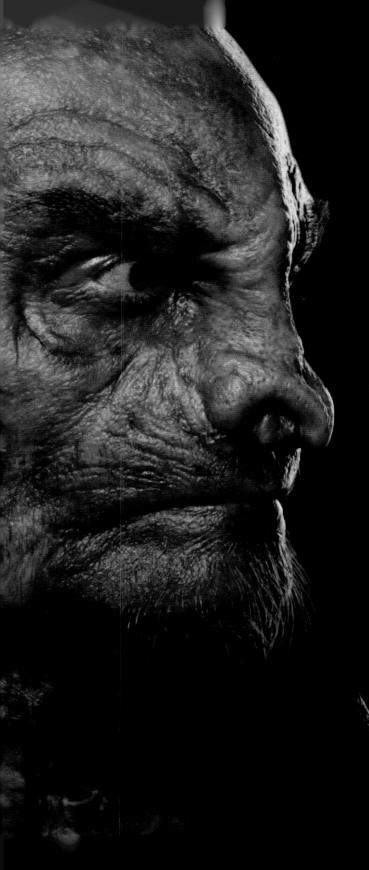

We used the 3D modelling program called Z-Brush to rapidly visualize the Wargs. Alongside Photoshop and practical sculpture, we used this software in almost all our creature design work for the films. In addition to the flexibility it permitted when designing the Wargs, it allowed us to cleanly hand off concepts to Weta Digital, without any risk of misinterpretation, where they were further refined and developed. They did an incredible job of bringing the Wargs to life in the films.

**Ben Mauro, Weta Workshop Designer**

3D modelling has become an essential part of our creature design process. It's a useful tool for conceptualizing from scratch and yields design concepts that the director can interact with in three dimensions and alter them very easily. We can take an image of our digital model and give it a cinematic or illustrative treatment using Photoshop to help sell the concept and bring it to life, but know that we have a firm foundation in a working three-dimensional idea. If the director likes what he's seeing then we have a model we can hand off to become a physical or digital creature, knowing that what we provided reflects exactly what he approved, so there's less chance of something inadvertently changing in translation from concept to problem-solving and final execution.

**Andrew Baker, Weta Workshop Designer**

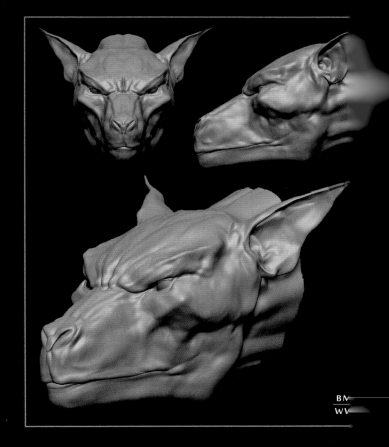

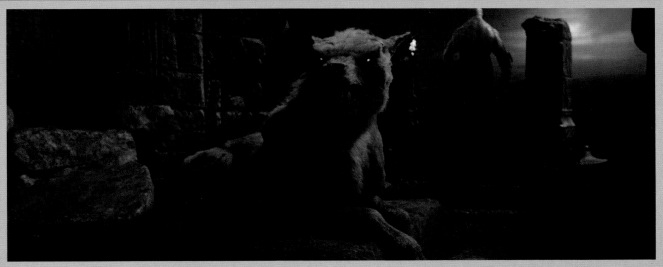

*Above: The Warg Matriarch, a fully furred digital creature, as she appeared in* The Hobbit: An Unexpected Journey.

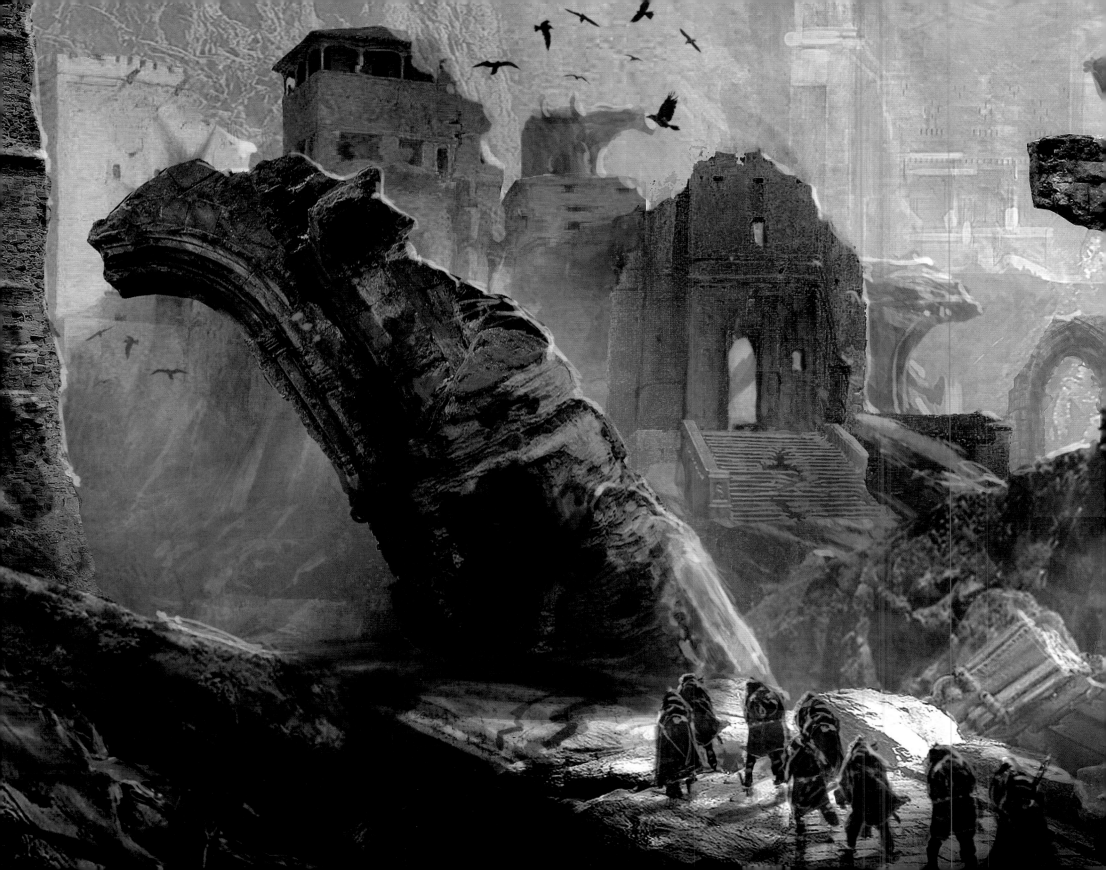

# ASHES AND GHOSTS

## DALE IN GLORY AND RUIN

Escaping the Master of Lake-town's politically motivated smothering, Thorin leads a reduced Company across the Long Lake and into the Desolation of Smaug, a barren waste where the once-thriving twin cities of Dale and Erebor prospered, fruit trees and forests grew and people wanted for nothing. Now little more than ash and snow-blanketed black skeletons of buildings and former citizens, Dale's ruins are a sobering reminder that beneath the craggy peak of the Lonely Mountain a beast of unfathomable scale and power slumbers still. Smaug is still a force with whom they must reckon before their Quest will be fulfilled.

Tucked between two out-stretched arms of the Mountain, Dale was once a sheltered and bountiful place of merry spirits, creativity and bustling commerce. Colourful and welcoming, it was a city of festivals and celebration, as described by Bilbo in his account of the history of Thorin's people. Peopled by Men, but host to traders and delegations of all peoples, including the Dwarves of nearby Erebor, the city was famous throughout Middle-earth for its toy market.

While wide shots were achieved through the use of a digital model, for the live-action shoot Dale was built as a large open air set on a hillside in Miramar, New Zealand. Initially constructed and dressed to represent the town in its pristine state, once filming of all scenes depicting Dale of yore was completed, the entire set was distressed and re-imagined as a ruin, lying beneath a blanket of snow and what little stunted regrowth had managed to take hold in the many decades since its destruction.

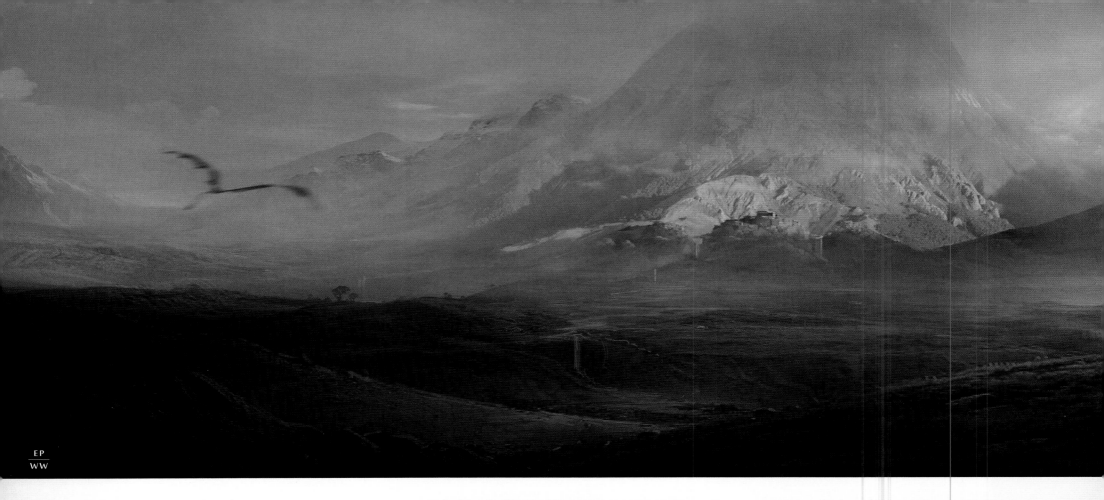

EP
WW

# ANCIENT DALE

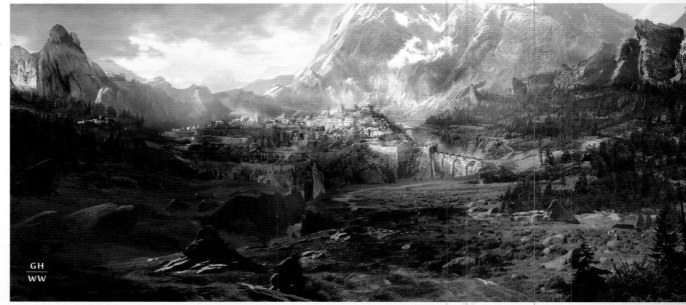

GH
WW

In flashbacks to the time before Smaug's coming, Peter provided glimpses of the cities of Dale and Erebor as they were at the height of their respective civilizations. We imagined that Dale would have been a thriving town of several thousand people at its peak. A mountain town, it was built of stone, cut from the enfolding arms of the Lonely Mountain.

The overall design carried influences from our research into the eastern hemisphere architecture of our own world. It was a conscious choice to employ similar elements and stylistic leanings in both Lake-town and Dale, given their proximity and the fact that, once Dale fell to Smaug's attack, many of the refugees fled and settled in the town on the lake. While the wooden elements most resembled Lake-town's architecture, Dale was primarily built of stone, with coloured tiles and painted surfaces, rendered walls and naïve frescoes.

**Dan Hennah, Production Designer**

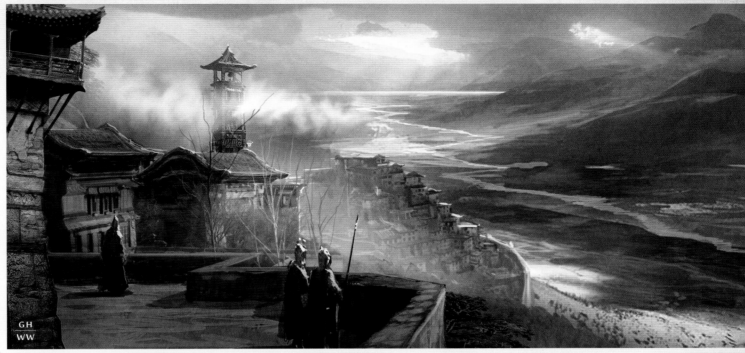

At Peter's suggestion, the architecture we were looking at for inspiration for ancient Dale was Tibetan. We were looking at how their villages were scattered around the mountainsides and how they had adapted to this very rocky, mountainous landscape. It made for some very interesting architecture and along the way we also really came to like the kind of colours that were present in their towns, quite different than any we had used elsewhere in Middle-earth.

Strong colours not only gave us something new and different, but also meant we could show some real contrast when it came to comparing old Dale before the Dragon with the burned out ruins of the city that remain when the Dwarves come back.

I took some of the ideas I was finding and placed them into a landscape dominated by the ominous Lonely Mountain in the background. I was trying some things out, looking for a good composition with opportunities for some dramatic low angle lighting on Dale with the entrance to the Dwarf city of Erebor behind.

**Gus Hunter, Weta Workshop Designer**

It's hard to express how enjoyable it is going up to each designer's desk and watching the incredible worlds that emerge from their imagination. Whenever I have the opportunity, I enjoy sitting with Gus as these environments seemingly pour from his stylus. Gus created sweeping, epic illustrations of the city of Dale, and it was amazing how specifically his vision for this part of the world evoked my memories from reading the book when I was a child.

**Richard Taylor,**
**Weta Workshop Design & Special Effects Supervisor**

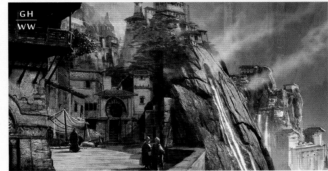

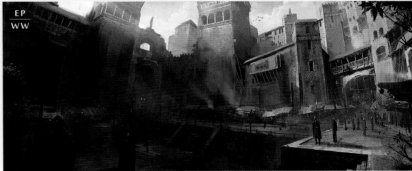

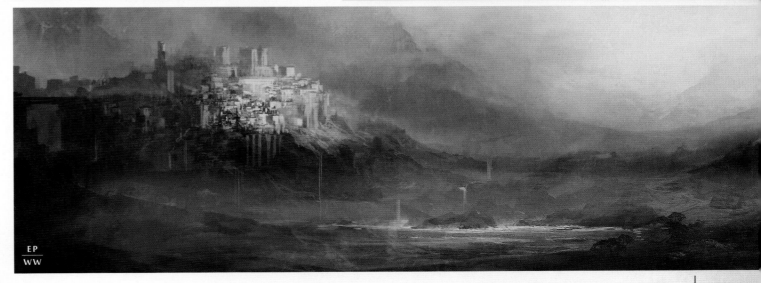

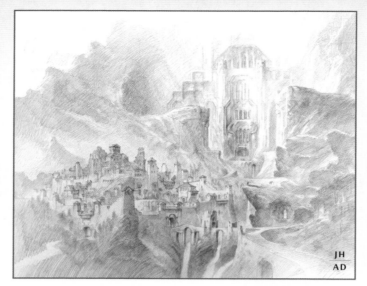

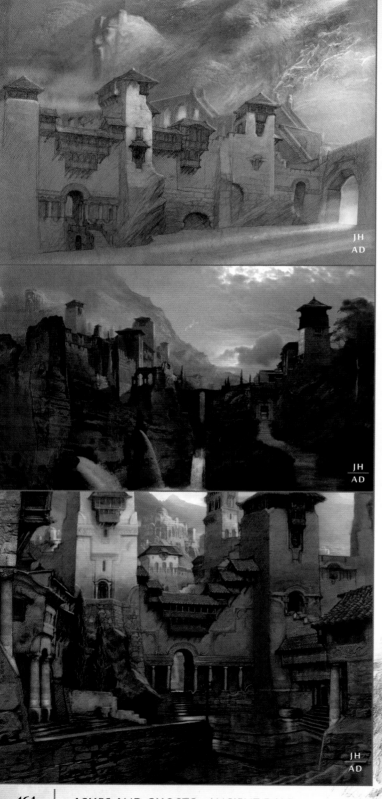

Dale was very much a mountain city, so it seemed appropriate to at least look at Tibet and Nepal for some of our inspiration, but not to go too far with that and make it look like we had directly lifted their architecture. We wouldn't want people to think that we were simply filming in some kind of real-world European or Asian environment, so instead we drew inspiration from those references and combined ideas from many sources, but using them as starting points, careful to reduce any obvious influences and bring our concepts back to Middle-earth.

There was a little Dwarven influence in the architecture of Dale, given how close it was to the Dwarf kingdom. We included some of the green marble of Erebor, but nothing too overt. Our main consideration was how the city sat in the landscape, cradled between the arms of the Lonely Mountain. Peter wanted to see water running through it, so we had waterfalls and rivers threading under the city and between the buildings.

**Alan Lee, Concept Art Director**

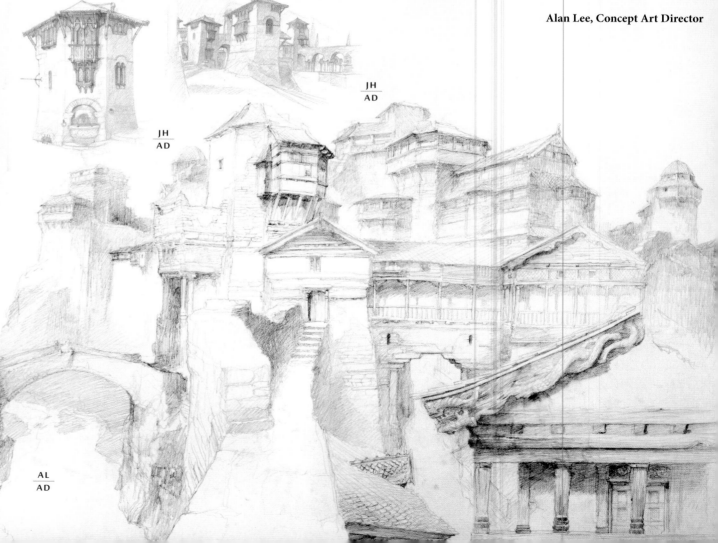

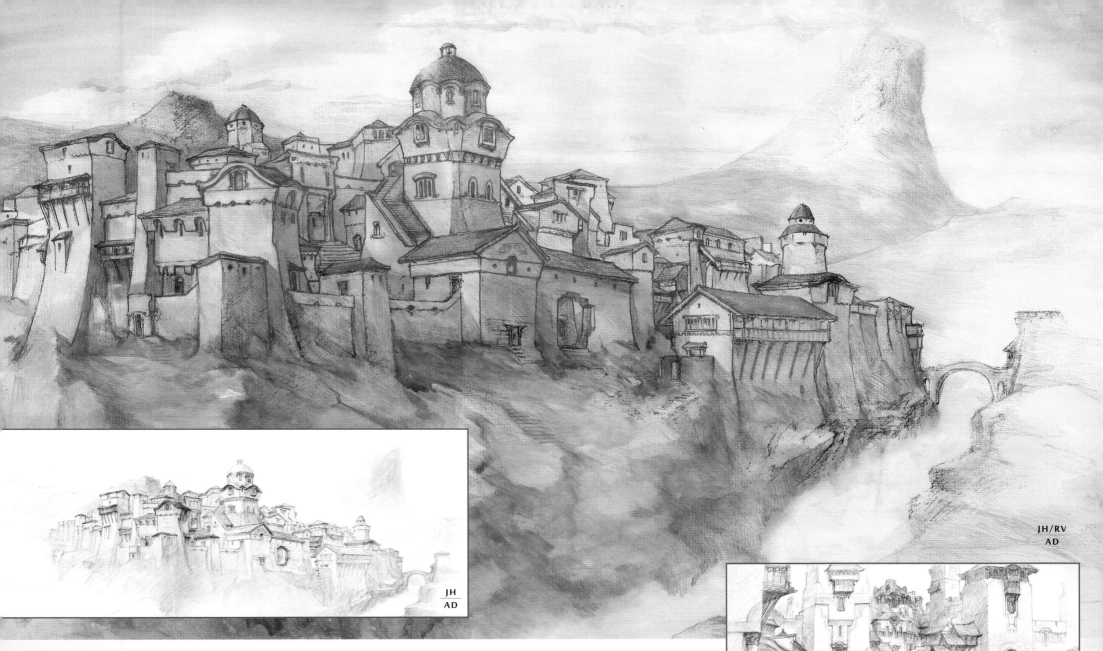

JH/RV
AD

JH
AD

JH
AD

Part of our task was to ensure we didn't repeat ourselves. Lake-town couldn't look like Edoras and Dale couldn't look like Minas Tirith. Bilbo's journey took him to a very different part of Middle-earth than Frodo and his friends, so it wouldn't do to have these places look like those we had visited in the previous trilogy. Another city of humans in the mountains, Dale risked being mistaken for Minas Tirith, which is why we sought fresh influences and palettes, and consequently ended up going east in our own world to find them.

**Dan Hennah, Production Designer**

Dale is rather like a Tibetan mountain town in the Dolomites, though I could not have told you that as we were exploring the architecture itself. Half a dozen defining elements emerged from one or two drawings and these were used as the guide for the whole of the architecture. Seeing the enormous set that was built on the outskirts of Miramar, peopled by the extras in costume, lit by a setting sun across Wellington Harbour, was like wandering about inside a 19th-century Orientalist painting.

**John Howe, Concept Art Director**

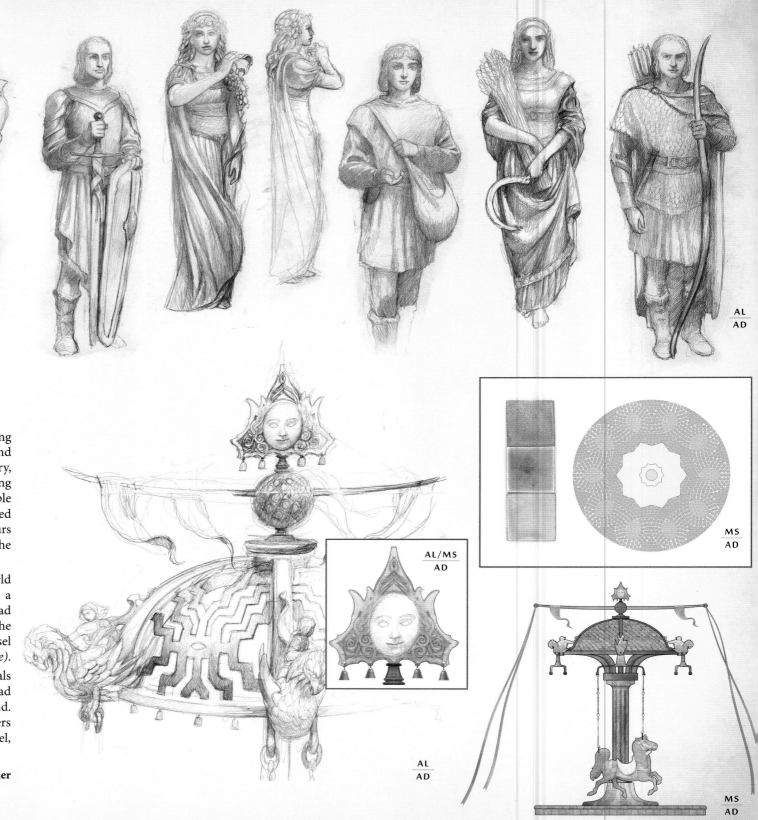

Dale was a rich city, full of orchards and gardens, bursting with produce and happy gardeners. The theme of plenty and abundance was evident in everything, including the statuary, which featured animals, grapes, wine, grain, people gathering and harvesting food, hunting and pouring from ample vessels. It was a happy place where the Dwarves held famed toy markets, something reflected in the shapes and colours we chose, but of course it was all set up for the tragedy of the Dragon's attack.

There was a photograph taken in Stalingrad during World War Two of a devastated street, and in the middle was a bronze statue of children dancing. The juxtaposition had such poignancy, it hit you in your heart and was one of the things we wanted to capture in Dale, so we created a carousel to sit in the middle of the marketplace *(right and facing page)*.

It was lovely. The design was so sweet. It had bronze animals for the children to ride upon. When we shot the scene we had half a dozen four- or five-year-olds going round and round. It was all the more heart-breaking when our characters returned to Dale later, to see it in ruin. There is the carousel, now a tangled, knocked-over mess in the snow.

**Dan Hennah, Production Designer**

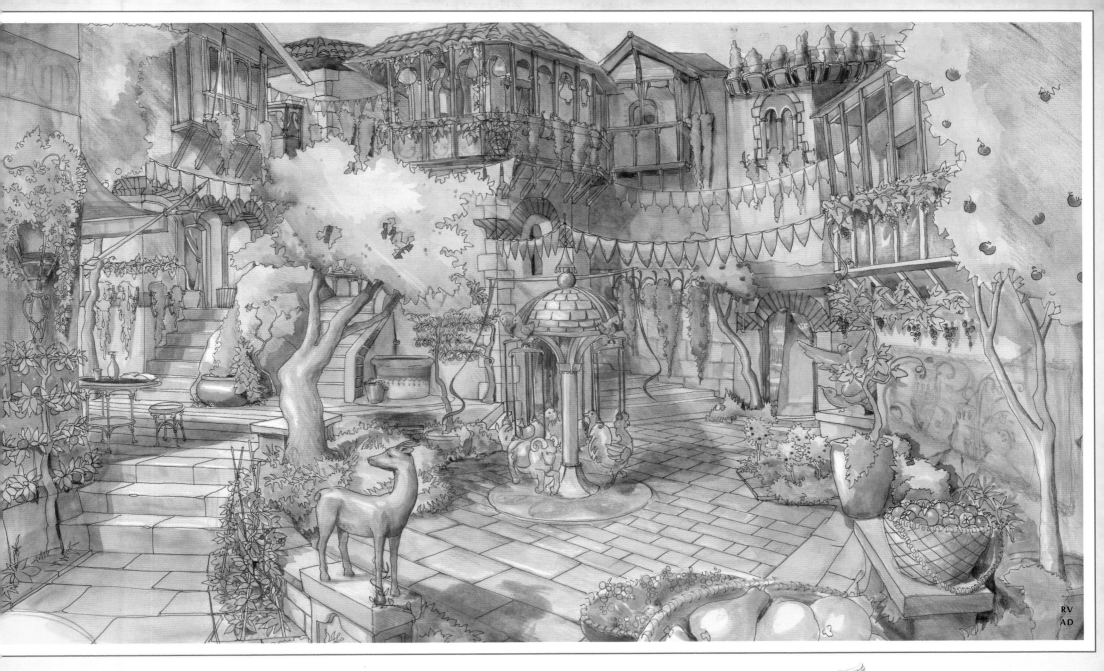

RV
AD

AL/MS
AD

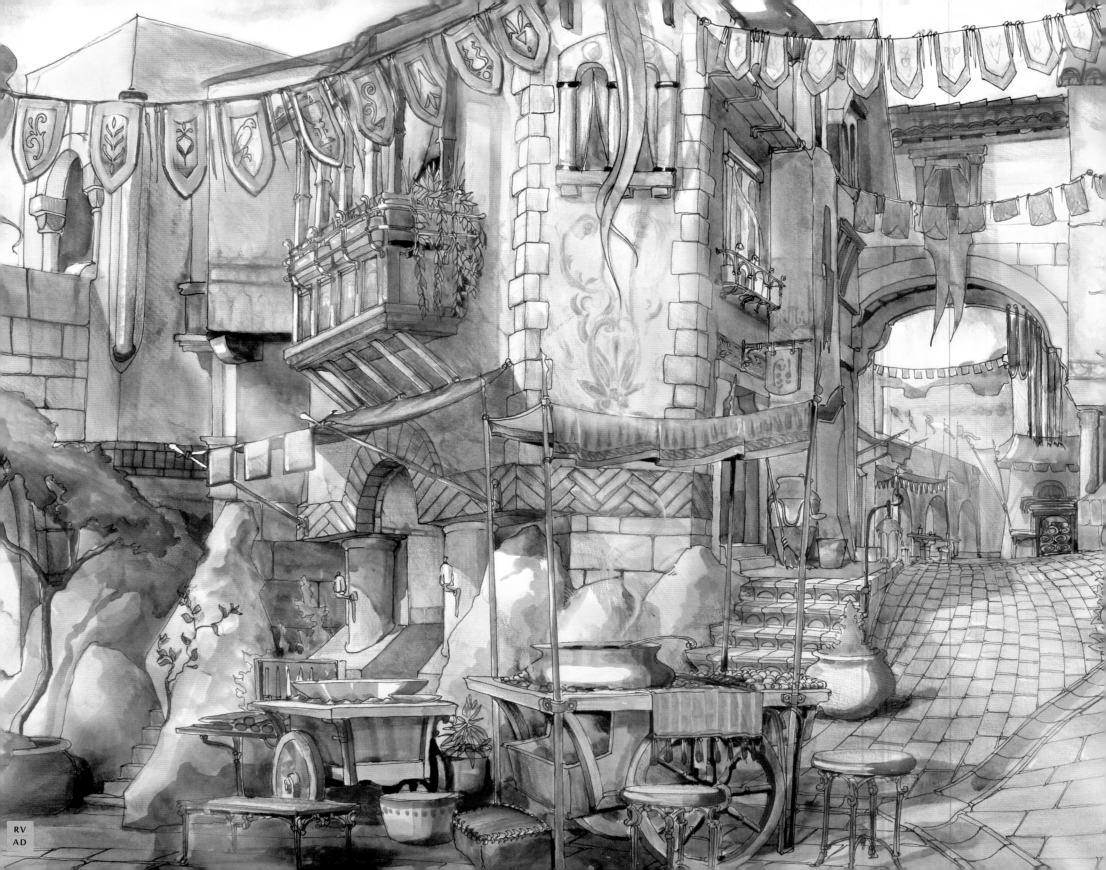

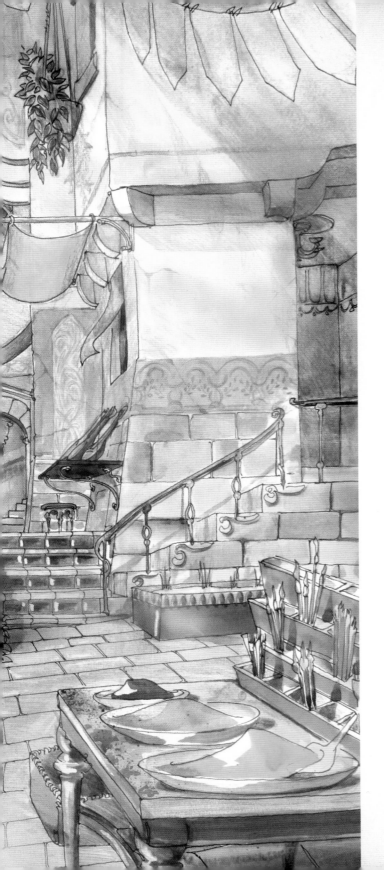

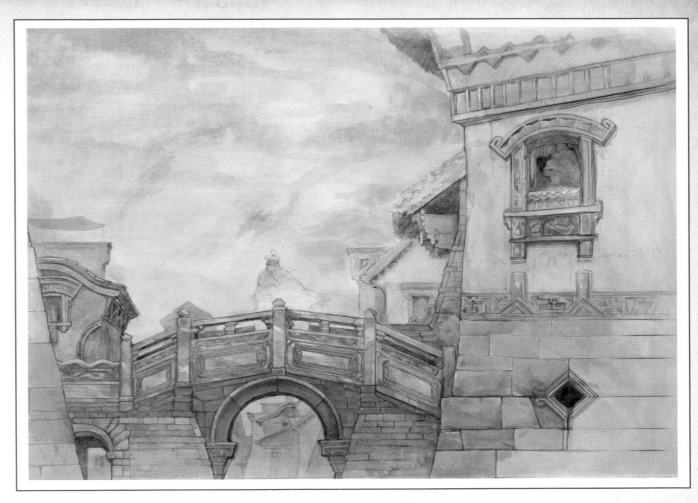

To soften the heavy stone architecture of Dale we applied renders and frescoes, looking at the decorated buildings of ancient Pompeii, probably an appropriate reference given the ultimate fate of the city. Without a finishing render there is the risk that we might end up with a whole lot of block buildings that merge together on screen into a single mass of stone, so we individualized the facades with assigned colour washes and plaster renders, the notion being that when we come back to visit Dale again after it has been left for dead for so long we can identify places in the architecture that we saw earlier. There were painted murals on the walls. Even faded and aged by fire and weather, they would tie ancient and ruined Dale together. We had paintings and bright plaster, fruit trees laden with fruit to their maximum capacity on the sunny sides of the buildings and pots growing herbs – all to show Dale was an abundant orchard town, alive and colourful, providing contrast with what it would become. We had introduced regal banners and bunting flags to give it a kind of festive mood.

**Ra Vincent, Set Decorator**

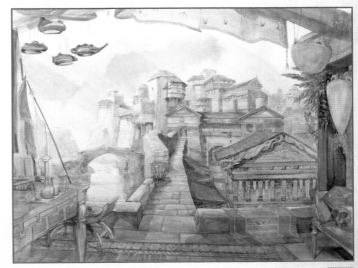

*Above: Dale as it appeared in* An Unexpected Journey, *with the Dwarf realm of Erebor in the background.*

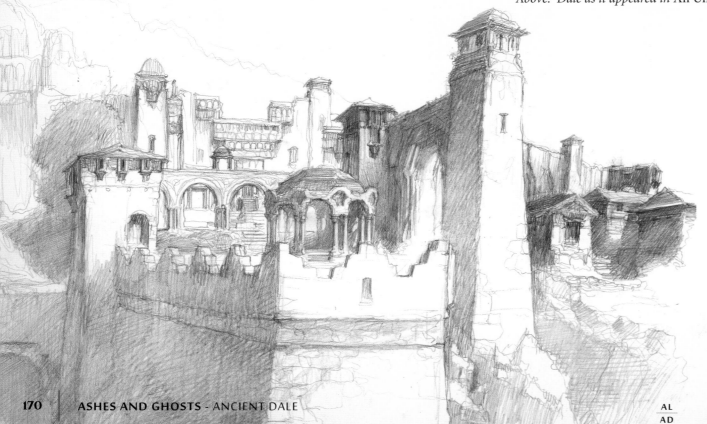

One of the first drawings I did of Dale had a kite in the foreground *(above)*, with the idea that the kite being buffeted by an unnatural wind might be the first indication of the coming attack. Peter liked the idea and it turned into a shot that appeared near the beginning of the first film. The kite was the first thing to be blasted out of the sky!

**Alan Lee, Concept Art Director**

AL
AD

# DALE PROPS

It seems that jars, pots and crates are a demand endlessly repeated by the Props Department for urban settings. How to redefine something as basic – and ubiquitous – as a wooden crate and a bit of crockery is one of the more enjoyable challenges offered by a film. Functionality is the key, enhanced by a pinch of stylistic invention. Ancient Persian pottery was the inspiration for many of the shapes.

**John Howe, Concept Art Director**

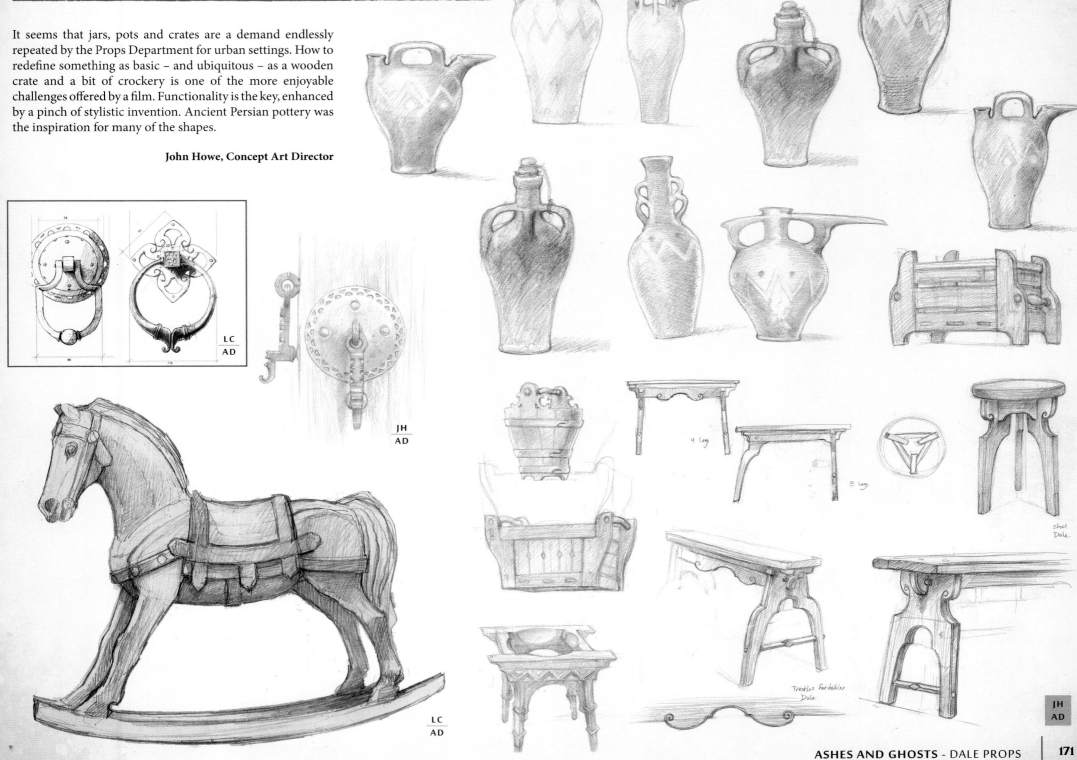

# PEOPLE OF DALE

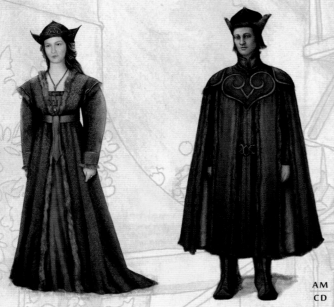

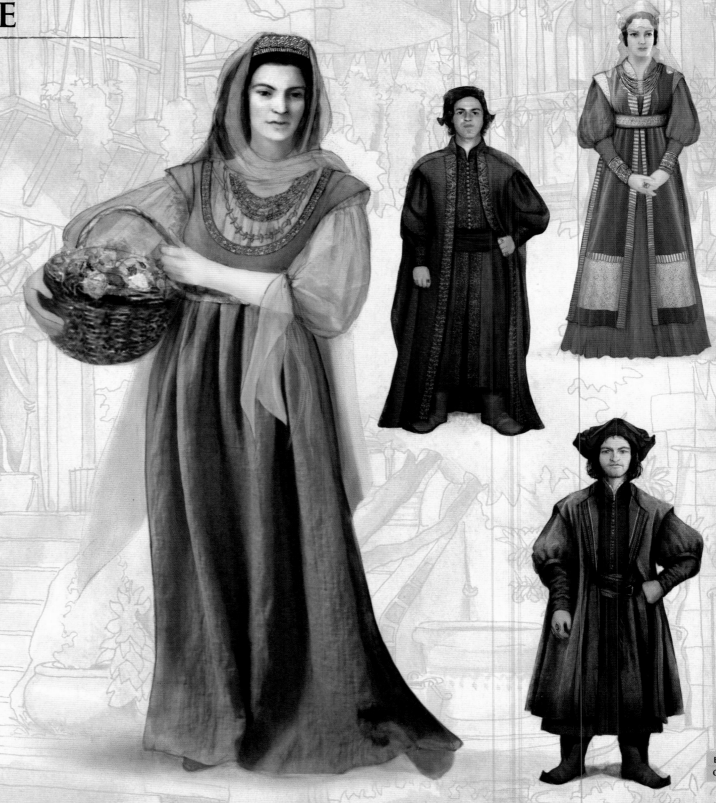

AM
CD

As we approached the people of Dale we were briefed to bring out the colours, to make it rich and jewel-like. There's a festive, positive attitude and everything needed to be bright and colourful in order to contrast with the tragedy of the Dragon ruining it all. It's a happy world of humans living in peace and friendship with the Dwarves, everyone prospering and vital.

Our references were a mix of romantic Italian, Prussian, a little Medieval and some Byzantine influences. It was quite eclectic. The jewellery was Byzantine, but we mixed that with some Tibetan shapes in the waistcoats of the ladies to include some of the eastern kicks and flicks in their silhouettes, in keeping with the architecture. It's a little bit of a mountain Shangri-la. There were even a few Renaissance elements that we brought in, the result being something familiar and real, but nothing someone could point out and identify as any single culture we might already know.

There were flowers and other decorative flourishes. For the men we had long coats, all rich, full and wealthy-looking. The Art Department had lots of sculptures of women with urns and baskets of flowers creating a kind of town-wide cornucopia with fruit trees and abundance, which we embraced in our own designs. The thought was that there was a spring festival taking place.

**Bob Buck, Costume Designer**

BB
CD

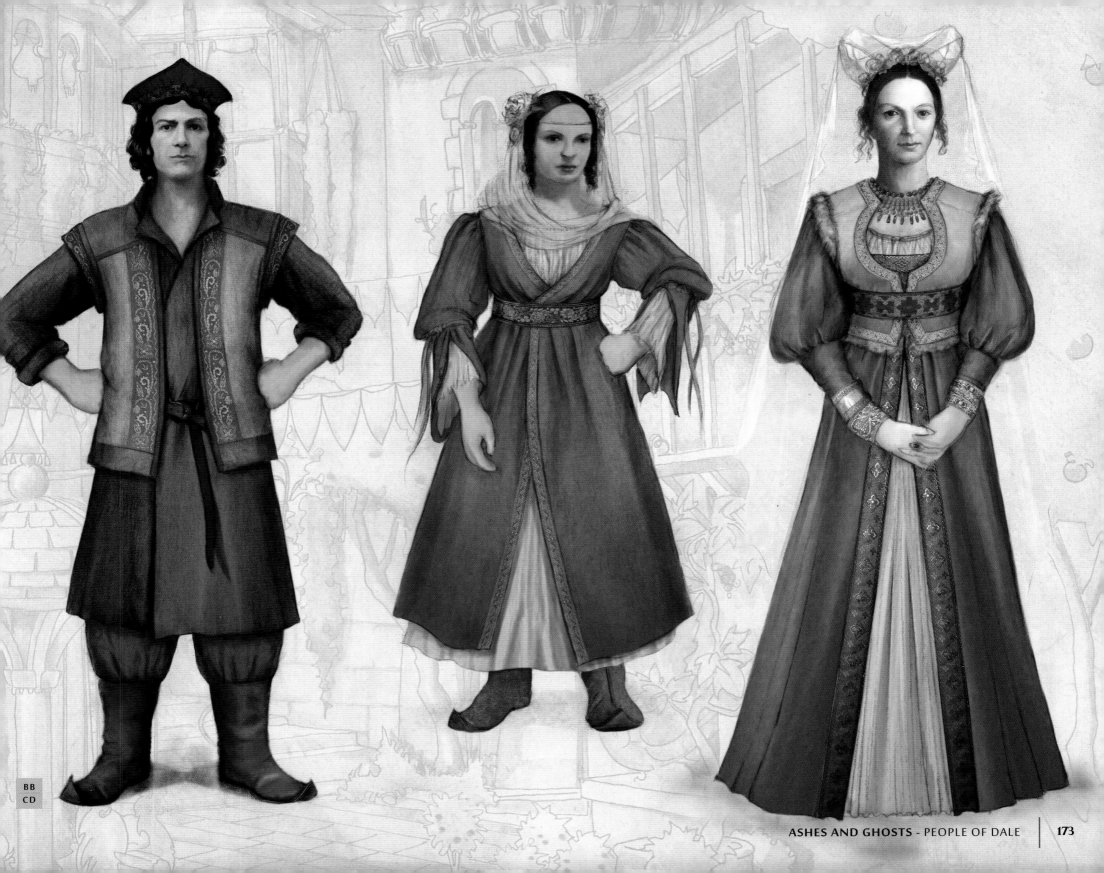

# The Coming of Smaug

Peter responds best to cinematic artwork. When he is describing design briefs to our team he is seeing moments from his film in his mind's eye, so we aspire to respond to the challenges he poses us with artwork that tells his story with as much drama and impact as possible. For the sack of Dale, Gus Hunter and Eduardo Pena complemented the artwork being created at the 3Foot7 Art Department by Alan Lee and John Howe with dramatic paintings of firestorms and ruination. Flipping through the print-outs evoked sounds of battle and mayhem with a pounding Howard Shore score in my imagination. I could envision these moments in my mind as if they were stills from the finished film!

**Richard Taylor,**
**Weta Workshop Design & Special Effects Supervisor**

When it came time to start painting ideas for Smaug's attack on Dale there wasn't a defined brief, which was great in a way because it meant I could just have fun creating cool images of Dragon mayhem. The architecture was still being designed, so I took the opportunity to explore more ideas for building shapes and towers, incorporating some of the leads that John Howe and Alan Lee had established and drawing on the Tibetan reference we had been looking at.

No one knew at the time what Smaug was going to look like, so I covered him up with effects, the idea being that when he attacks he would leave this big trail of fire and smoke that covers him up to a certain extent and create a really interesting and destructive visual.

**Gus Hunter, Weta Workshop Designer**

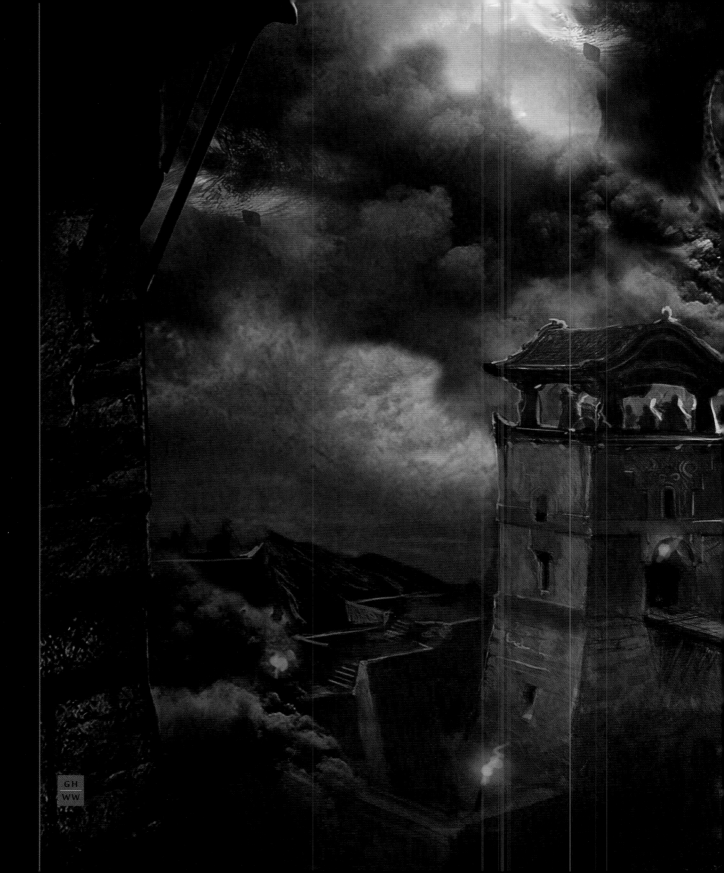

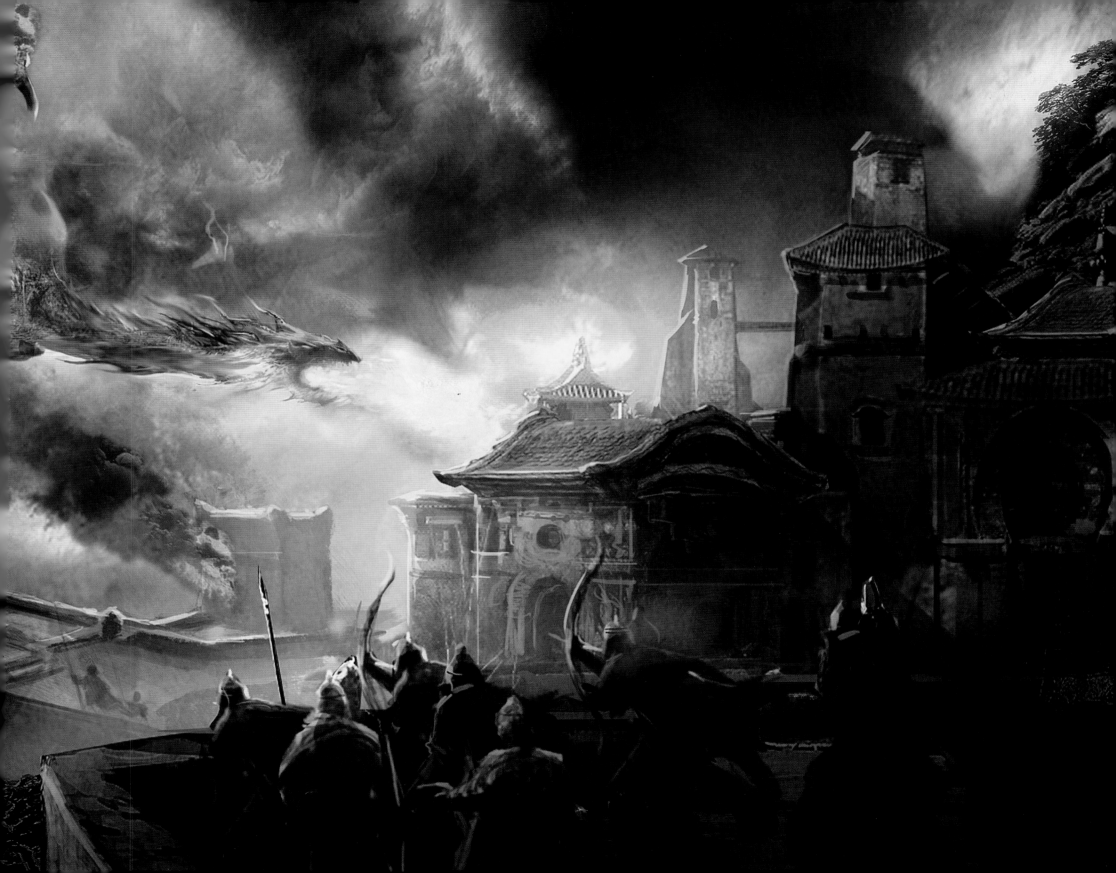

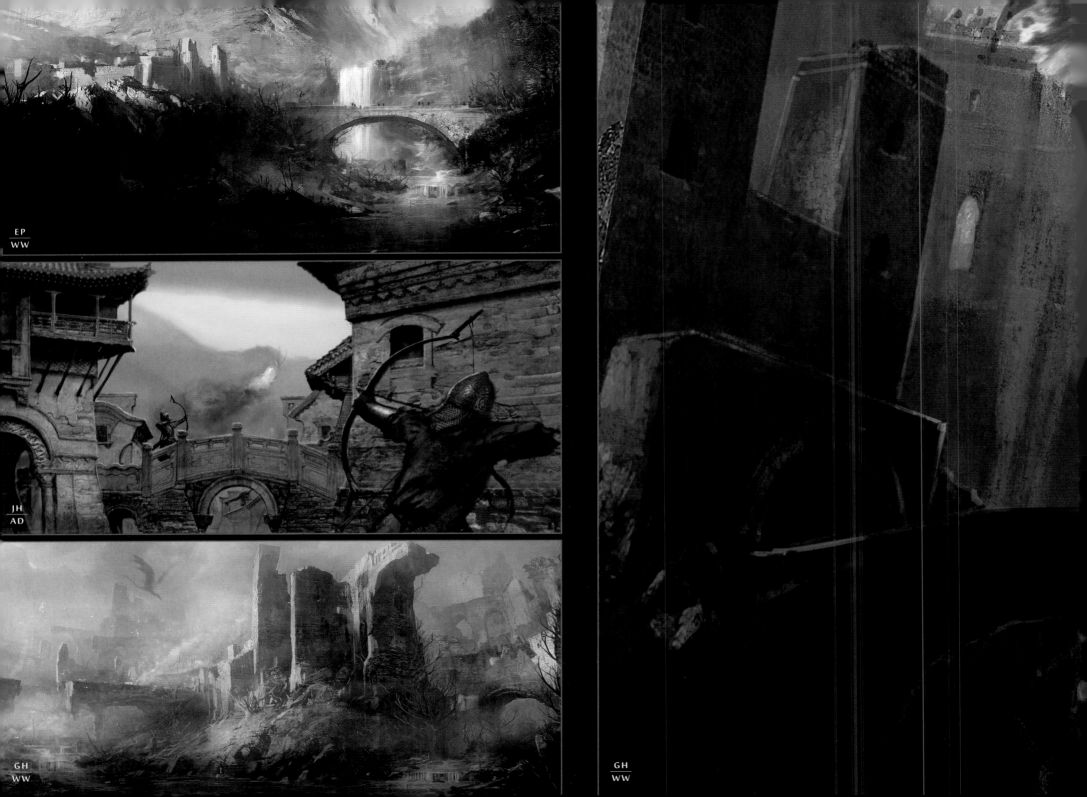

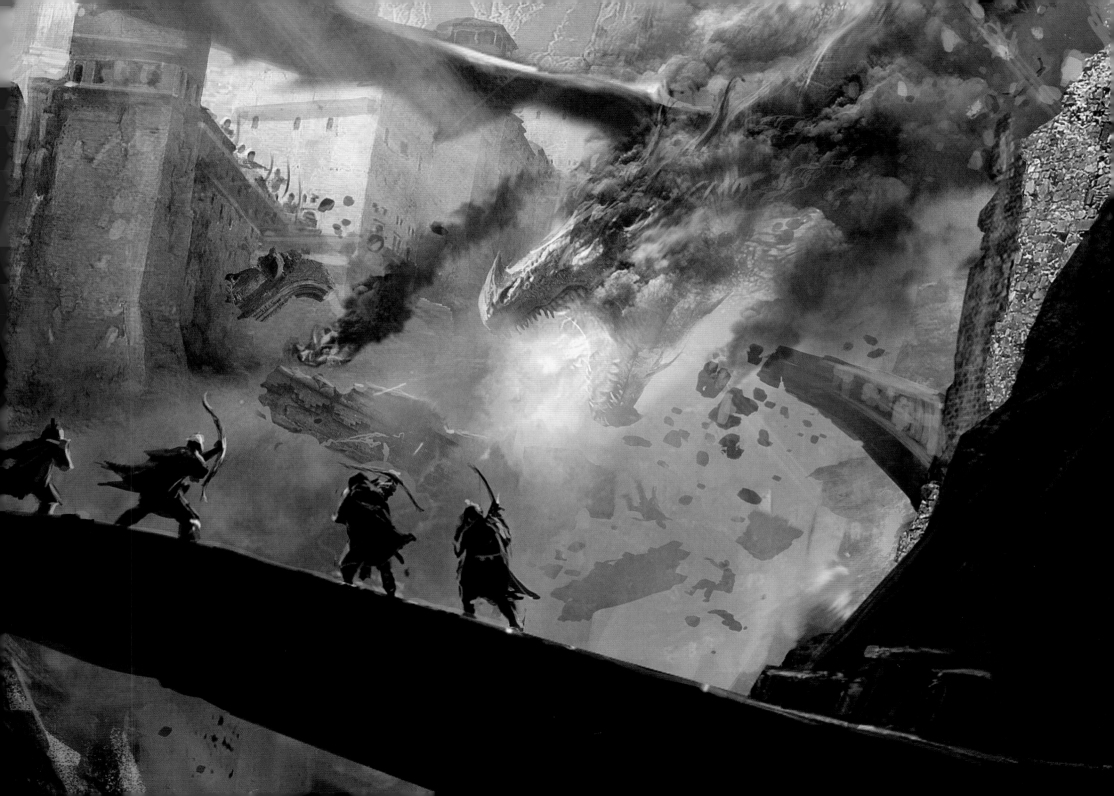

# RUINS OF DALE

Timbers are burnt, there are scorch marks on the walls, roofs have collapsed and architecture has fallen down into the streets, but until the Dwarves make their way through the ruins, no one has been in Dale since the cataclysm. What they find is harrowing, a city frozen in the moments of its destruction, lying still beneath a blanket of snow and some tentative, scrappy regrowth, but it's winter and the land is barren.

We approached the design of Dale by first conceiving it in its glory and then applying the effect of the Dragon's attack to find our ruined version. It was the smartest way to do it, and because if reflected how we intended to build and shoot the sequences as well, building Dale in its glory first, shooting those scenes, and then destroying it and shooting it in ruin. The two versions had very clear and distinct colour palettes: bright and summery for the glory days and wintery, blackened and skeletal in the aftermath of its devastation.

**Dan Hennah, Production Designer**

AL
AD

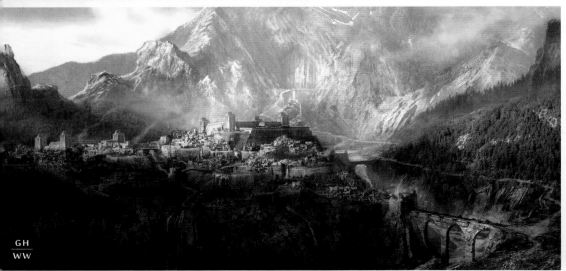

GH
WW

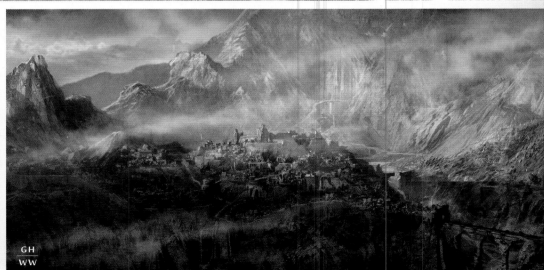

GH
WW

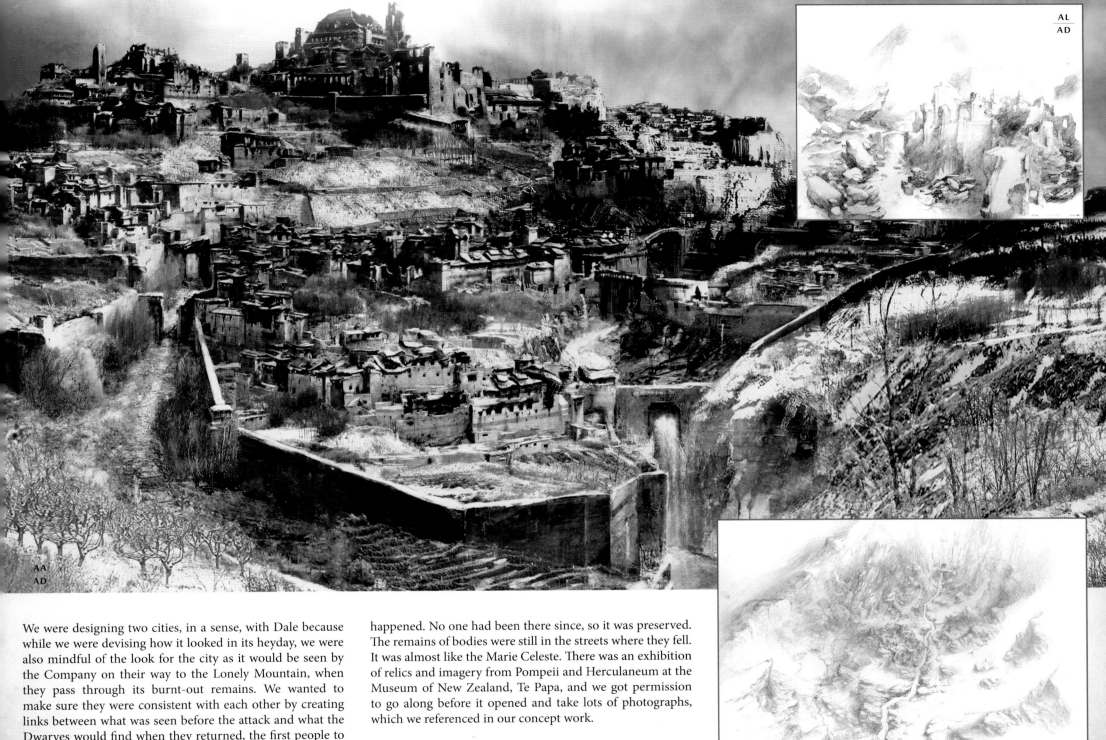

We were designing two cities, in a sense, with Dale because while we were devising how it looked in its heyday, we were also mindful of the look for the city as it would be seen by the Company on their way to the Lonely Mountain, when they pass through its burnt-out remains. We wanted to make sure they were consistent with each other by creating links between what was seen before the attack and what the Dwarves would find when they returned, the first people to go back there.

While the Dragon's fires occurred decades earlier, there was something of the feel about the ruins, as if it had just happened. No one had been there since, so it was preserved. The remains of bodies were still in the streets where they fell. It was almost like the Marie Celeste. There was an exhibition of relics and imagery from Pompeii and Herculaneum at the Museum of New Zealand, Te Papa, and we got permission to go along before it opened and take lots of photographs, which we referenced in our concept work.

**Alan Lee, Concept Art Director**

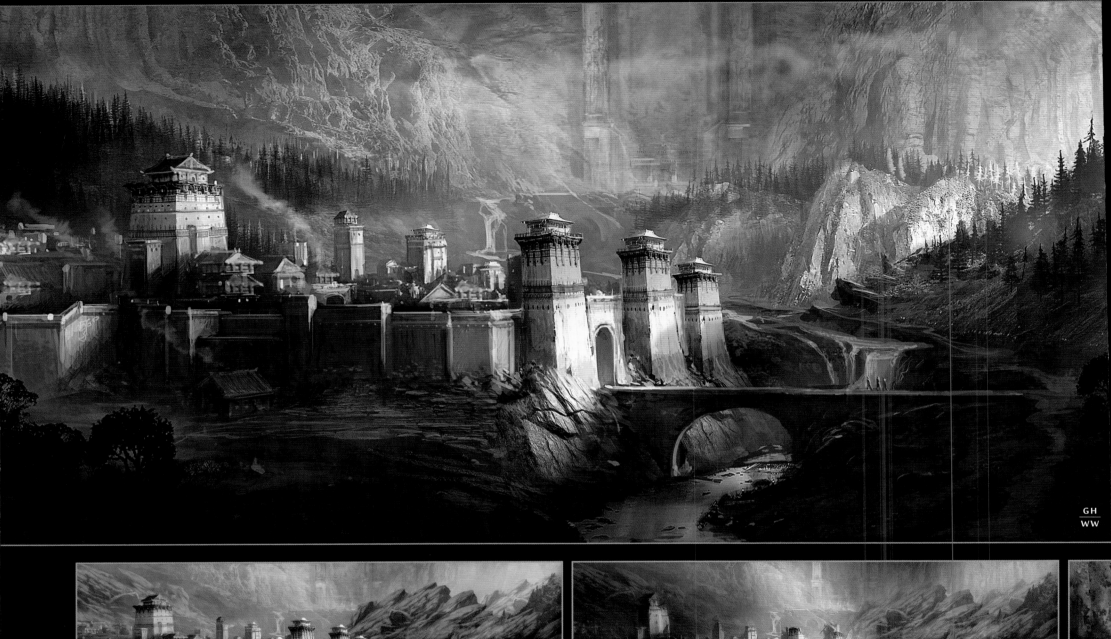
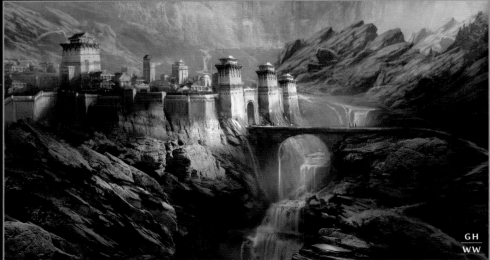
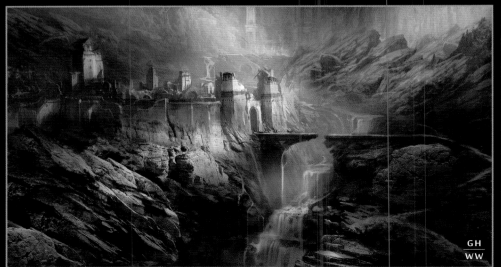

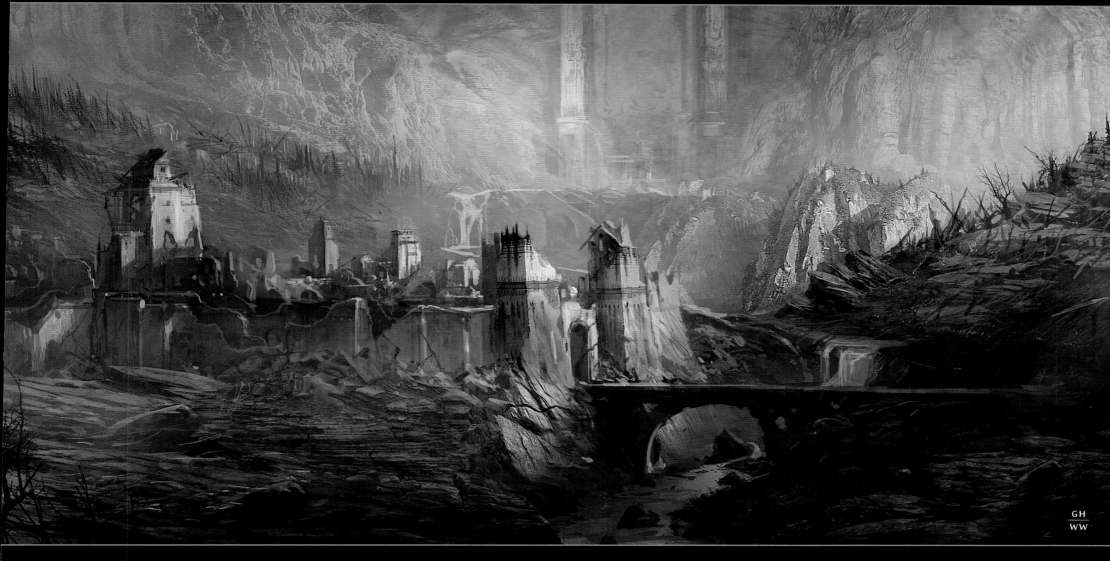

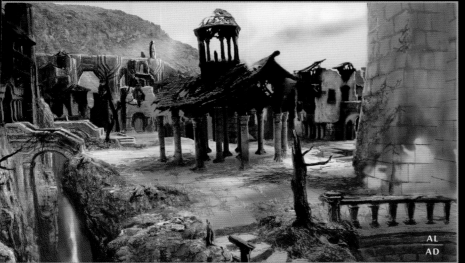

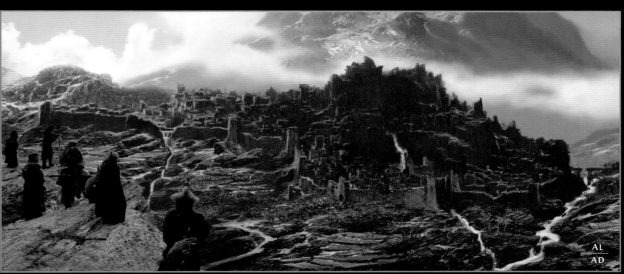

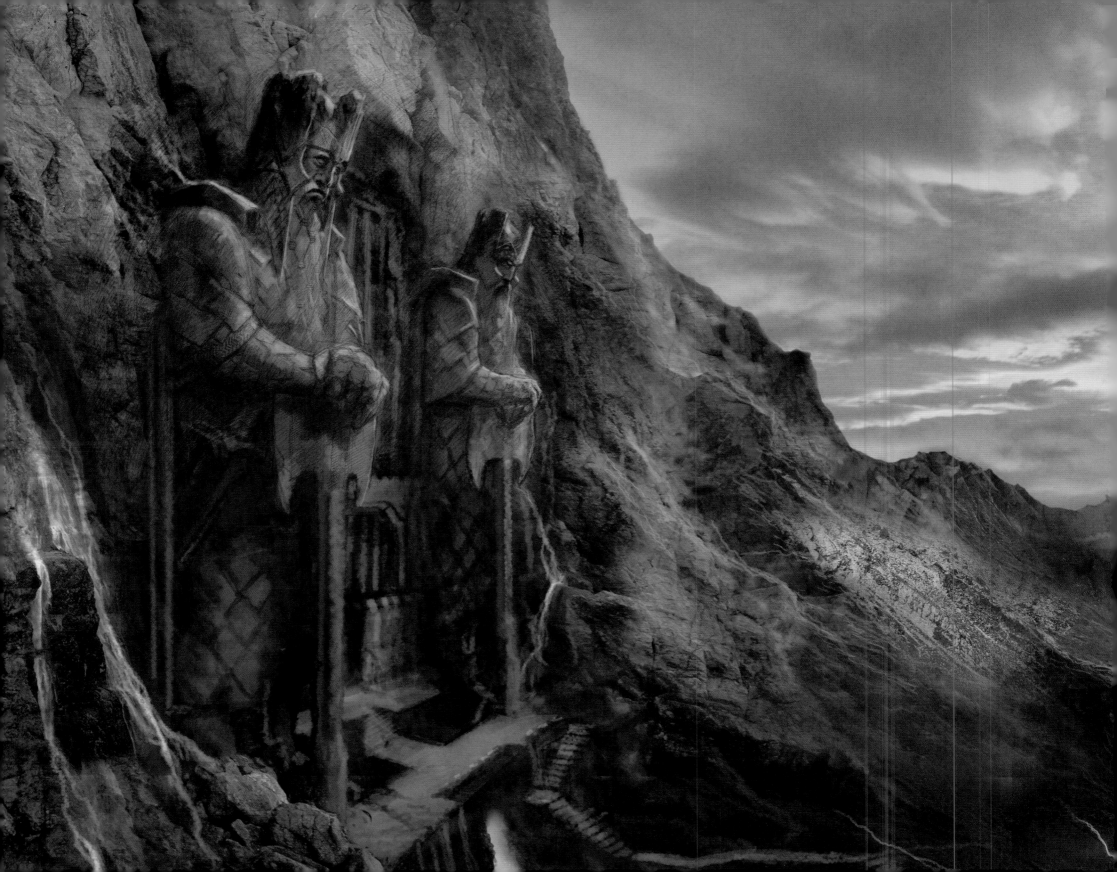

# On the Doorstep

## THE LONELY MOUNTAIN

On the eve of achieving their goal, Thorin, Bilbo and the remaining Dwarves search the barren slopes of the Lonely Mountain for the hidden back door. As Thorin's frustration threatens to overwhelm him, Bilbo's sharp eyes and calm head sees them in the right place at the right time and, in accordance with the map's secret moon rune directions, fate smiles upon the Company once again and they are admitted into the lost realm of Erebor.

Now Bilbo must live up to his promised burgling prowess, and clutching his sword, Ring and courage, he begins a dark and frightening descent into the heart of the Mountain, towards the legendary treasure of the Dwarves and into the lair of the Dragon, Smaug.

## DEVELOPMENT ART

GH
WW

An early alternative concept we toyed with grew in answer to the question of how to get light down into the interior spaces. Maybe the Mountain was riven by huge fissures? That might have given it a quite different appearance.

**Dan Hennah, Production Designer**

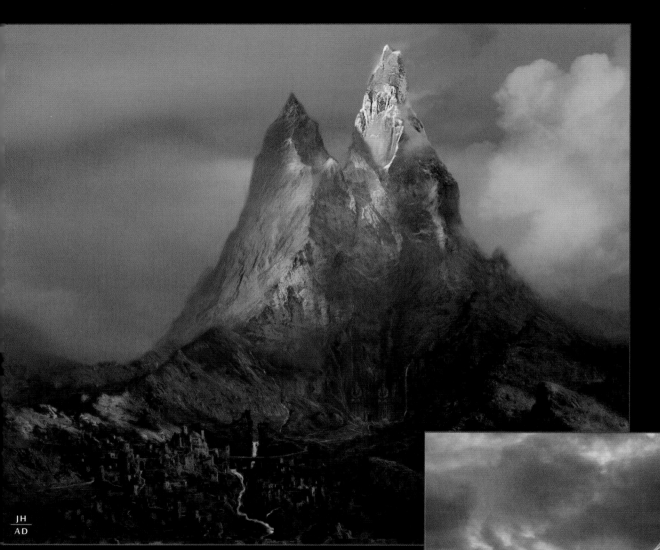

JH
AD

Following Tolkien's descriptions and drawings, the Lonely Mountain of the films is essentially conical. In all his sketches Tolkien was very influenced by Switzerland's Matterhorn, so we didn't want to stray too far from that, but nor did we want to recreate the Matterhorn and call it the Lonely Mountain. We needed something different, and yet it still had to be a jagged, conical mountain with five spurs running off it.

**Dan Hennah, Production Designer**

GH
WW

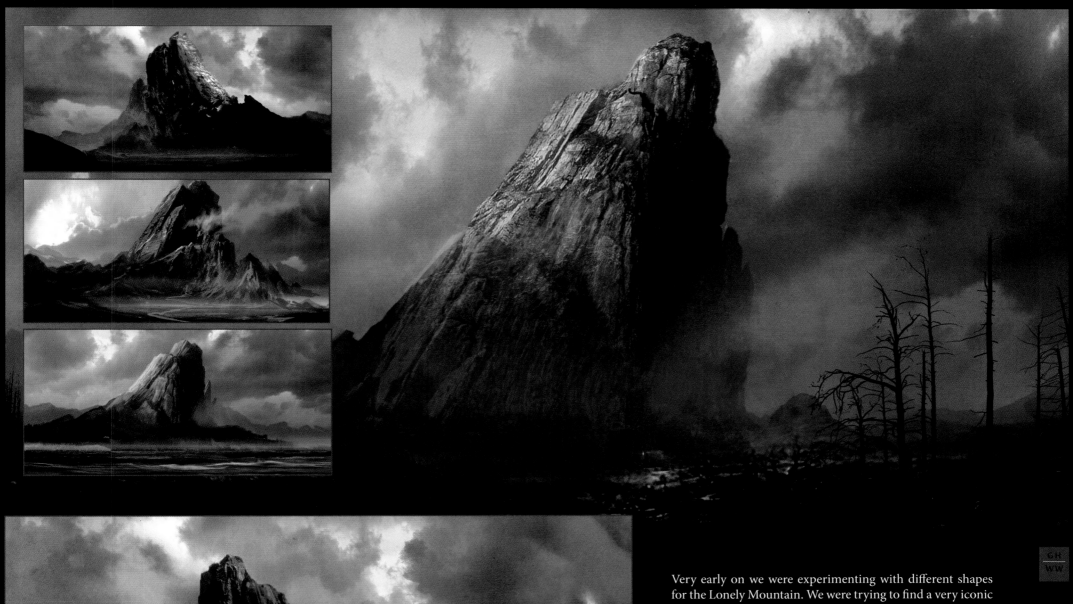

Very early on we were experimenting with different shapes for the Lonely Mountain. We were trying to find a very iconic and original shape, treating the Mountain like a character. One of the ideas even had it looking a bit like a giant crouching Dwarf warrior. It was a very experimental stage in the project and we were throwing out all kinds of concepts. We also explored how it might look in different seasons.

**Gus Hunter, Weta Workshop Designer**

AL
AD

The Lonely Mountain itself was surprisingly tough and time consuming to define. It was one of those things that is so iconic and yet so elusive. It is seen in a number of different contexts and from many different angles, and the specific geography becomes more and more important as the story progresses. Peter was very keen that it should feel massive. He pointed to Mount Hood in the United States, which he liked because it grew out of a vast uplifted landscape. It wasn't a single peak projecting from flat land, but rather when you might come to the point at which it becomes craggy you had already been climbing up a long way over broken terrain.

**Alan Lee, Concept Art Director**

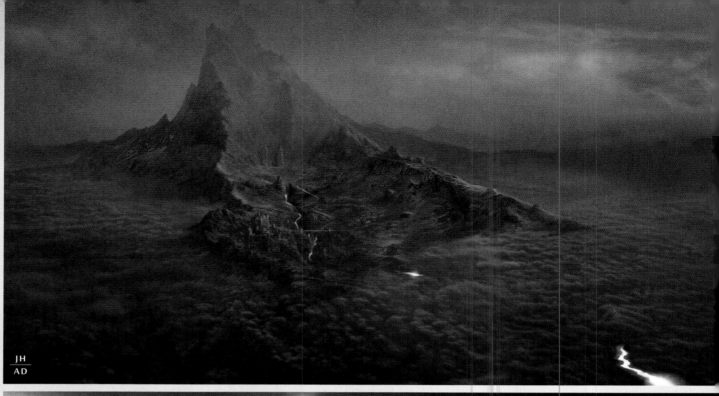

JH
AD

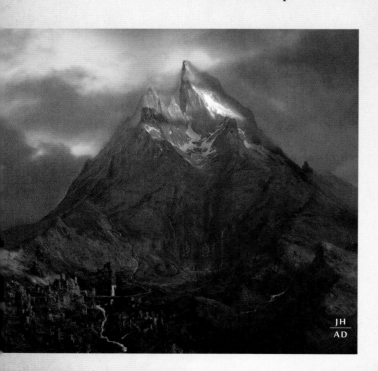

JH
AD

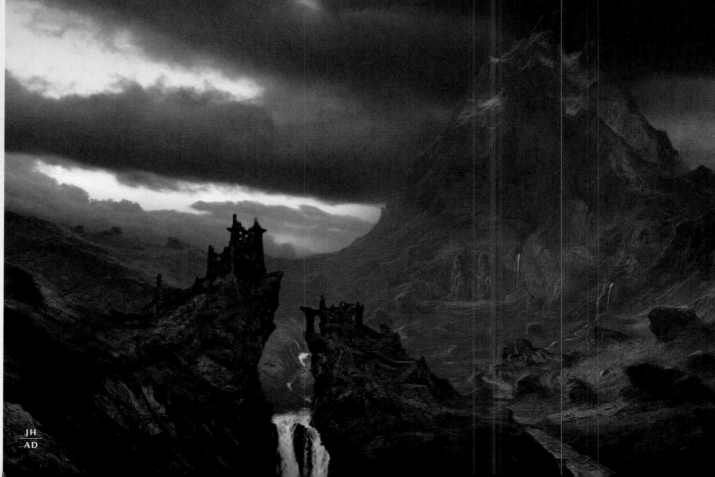

JH
AD

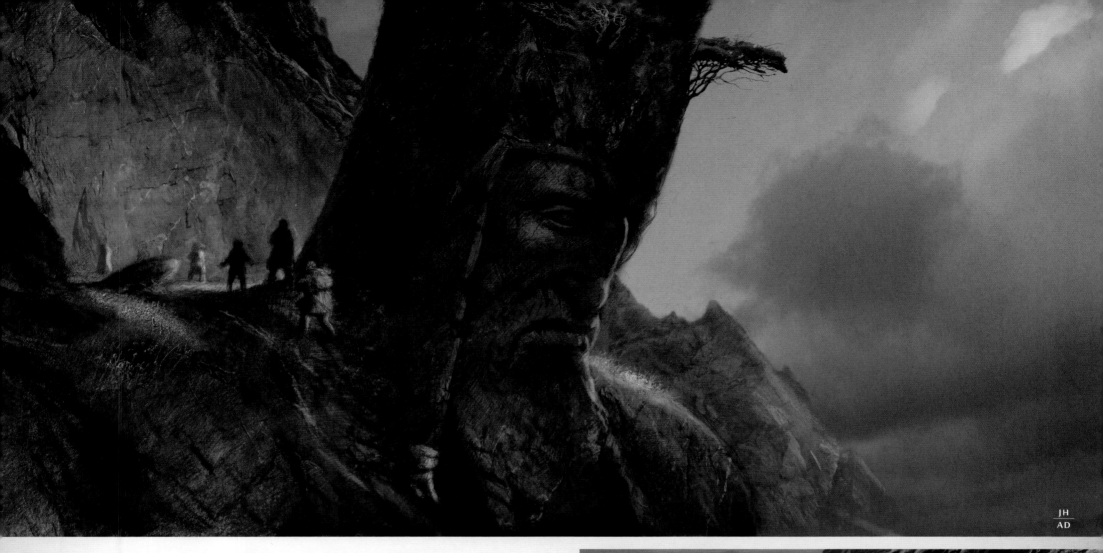

# THE BACK DOOR

Dispirited and frustrated, the Dwarves are picking around on the back side of the mountain, desperate to find the hidden stair that will lead them to the back door, the secret way into Erebor. In the end, it is Bilbo's sharp eyes that discern the stairway hidden at the foot of a great statue. They follow the stairway as it wends its way up, around and through the grand figure, eventually revealing a hidden cove where the back door itself is magically hidden by an ancient spell. As foretold on Thorin's map, it is only with the last light of the setting sun on Durin's Day that the keyhole is revealed.

**Dan Hennah, Production Designer**

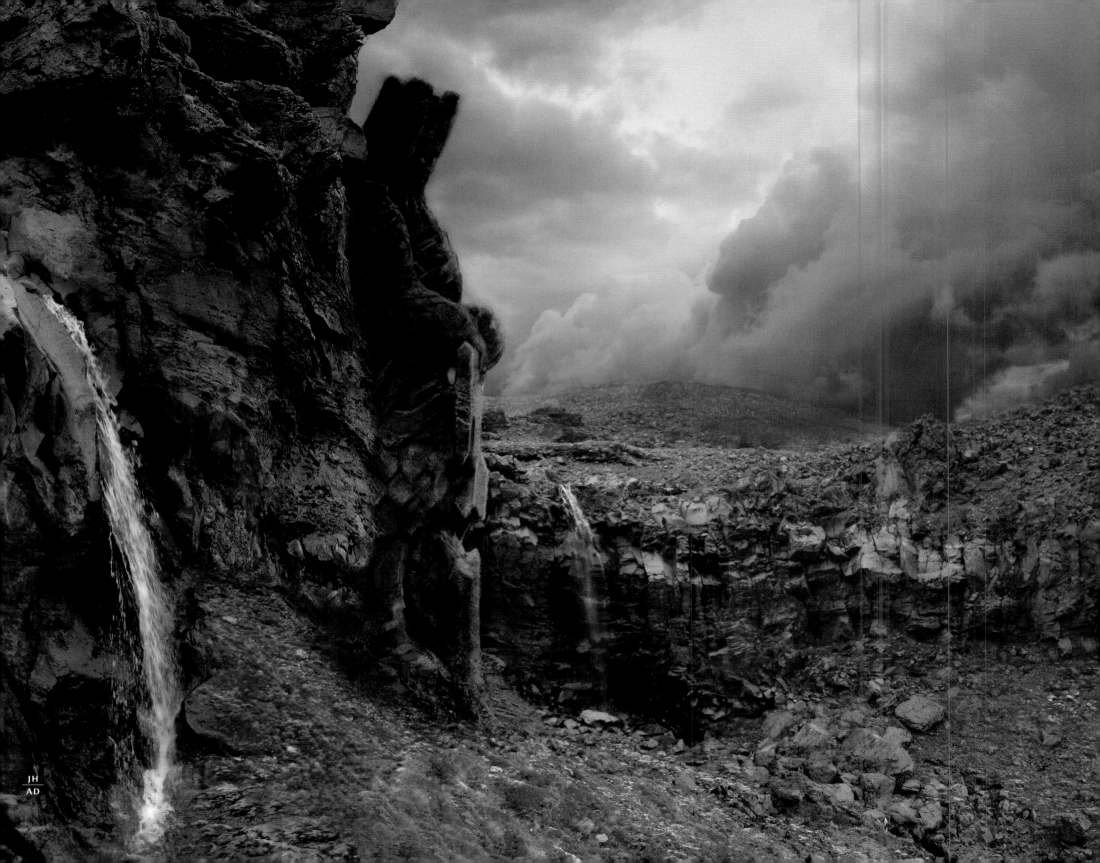

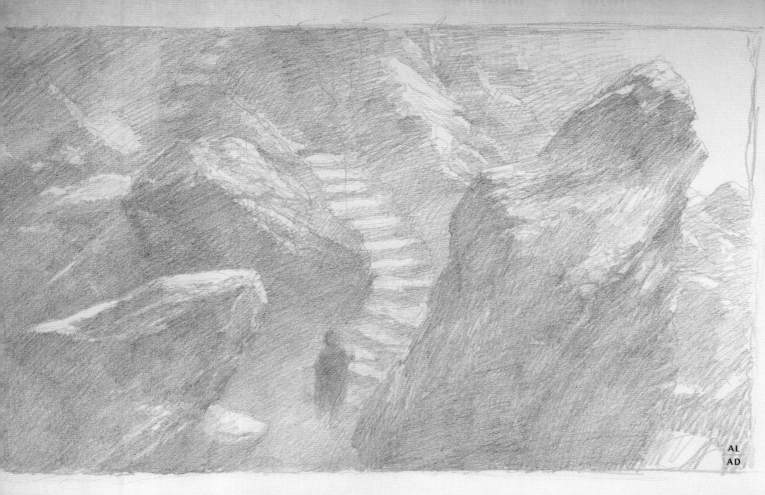

AL
AD

AL
AD

Peter's notion for the back door was to hide it in plain sight, behind one of the most visible features on the Mountain, this huge, carved statue of Thror that is emerging from the mountainside, part of a perhaps incomplete 'Valley of the Kings' between two of the Lonely Mountain's spurs. Behind it is the hidden door. It was a brilliant idea. We had been exploring fiddly stairways and secret bays, but being so anchored in the book it took Peter, who has such a mind for cinematic opportunities, to come up with something like this. The statues had emerged as a theme of sorts for Erebor, so this felt like a perfect fit, and it looks great onscreen, which is ultimately the most important thing.

That's one of the most exciting things about designing for these films – you can extrapolate within what's not said. Sometimes it's very much in sync with the book and perhaps sometimes I suspect we might go a little farther than the author might have desired. But, I think it is fair to say we have lived in this world for so long that even when we might think outside the box as defined by the book, we're still thinking within a much bigger box that the book has inspired.

A lot of thought went into the keyhole, but sometimes less is more. It could easily have been something elaborate, but it's a hidden keyhole that is exposed when the rock cracks and flakes. What is produced is an immediately recognizable keyhole, without any need for explanation or description. It's the shape of the key, basically, which is exactly what it needed to be.

**John Howe, Concept Art Director**

JH
AD

# The Hill of Sorcery

## DOL GULDUR, LAIR OF THE NECROMANCER

Knowingly walking into darkness and peril, Gandalf travels to the fortress ruin of Dol Guldur, from which his brother Wizard, Radagast, barely escaped with his beard. In search of answers, the Grey Wizard navigates the tangled, riven passages of the ancient castle, descending through shadow until he is set upon by a crazed assailant who turns out to be none other than Thrain, son of Thror. The father of Thorin and heir to the throne of Erebor, Thrain has been driven mad by grief and torture as a prisoner of the Necromancer, whom Gandalf will soon come to know by another name. In this labyrinthine dungeon he has dwelt for decades, bereft and overcome, but by Gandalf's skill he finds sense long enough to reveal a terrible truth; there is more afoot than the Wise have dared suspect, and an ancient evil stands poised to rise again in Middle-earth, this time with the power of a Dragon enlisted to its cause.

Dol Guldur was built as a large indoor set, a maze of pits, claustrophobic passages, uncomfortably narrow and steep stairways, wickedly barbed ironwork and twisting thorns. Dressed with bones and evidence of torture, it was a distinctly unpleasant place to inhabit, even knowing it was composed of plywood and polystyrene. The design was sufficiently oppressive that little imagination was required to feel unwelcome within its grim corridors.

Digital set extensions and entirely computer-generated wide shots would add more height to the space, with yawning pits, crumbling bridges and teetering towers, all strangled by a choking tangle of thorns. This was the lair of the Necromancer, and Wizard or not, Gandalf would enter at his peril.

# APPROACHING DOL GULDUR

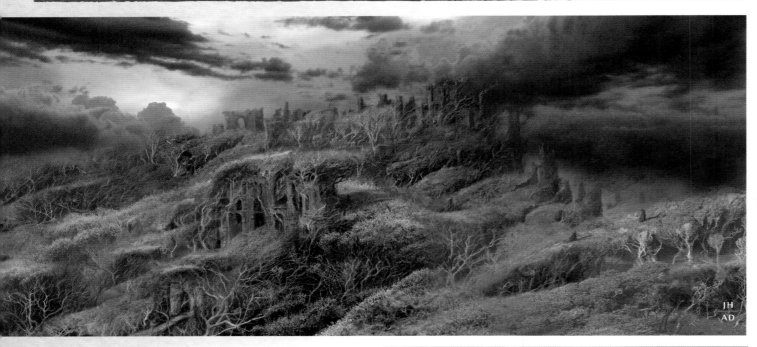

Dol Guldur is a precipitous and vile place. Everything about it was to do with sharp, dangerous angles and drops. It's a very uncomfortable place to be and, as a visitor, there is nowhere a person could relax or let their guard down. Even if Gandalf were to find somewhere to sit, it is likely there would be a vine with poisonous thorns all over it. He might even be grabbed!

Dol Guldur has a very strong directionality. All lines run toward the central castle which has been eaten away, exposing broken levels and stairways.

**Dan Hennah, Production Designer**

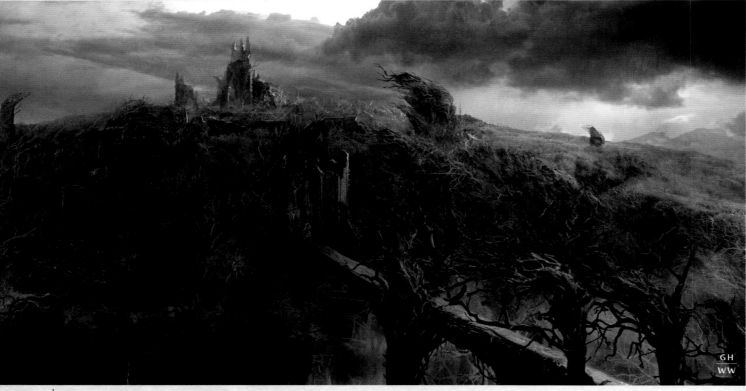

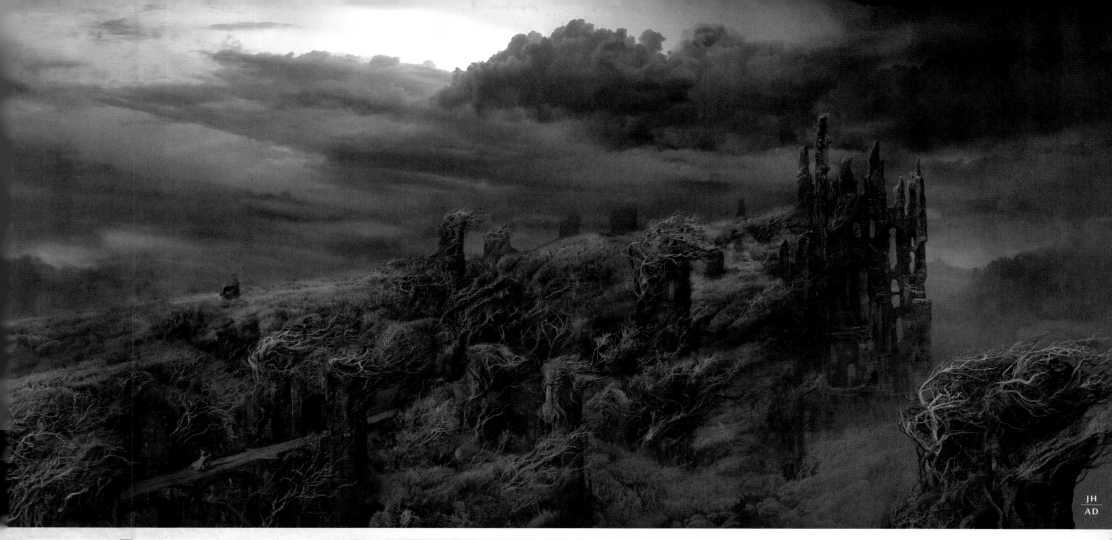

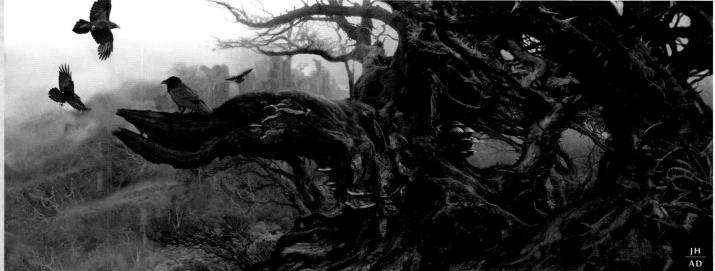

The concept of Dol Guldur was of a fortress on a hill overgrown by the sick Mirkwood forest, huge rotting trees, thorns and brambles that have twisted their way throughout the skeleton of the castle. The fortress itself and hill has, to a large extent, fallen away. It was so riddled with dungeons and underground passages that, like a termite nest that has broken open on one side, the interior has been exposed to the elements.

It was the ultimate haunted castle, really. The addition of trees helped make it unique and also blur the distinction between the forest and the fortress. Peter had the idea that as Radagast or Gandalf picked their way through the trees and thorns they would suddenly realize they had in fact entered the castle, but everything was so overgrown that the architecture wasn't immediately apparent.

**Alan Lee, Concept Art Director**

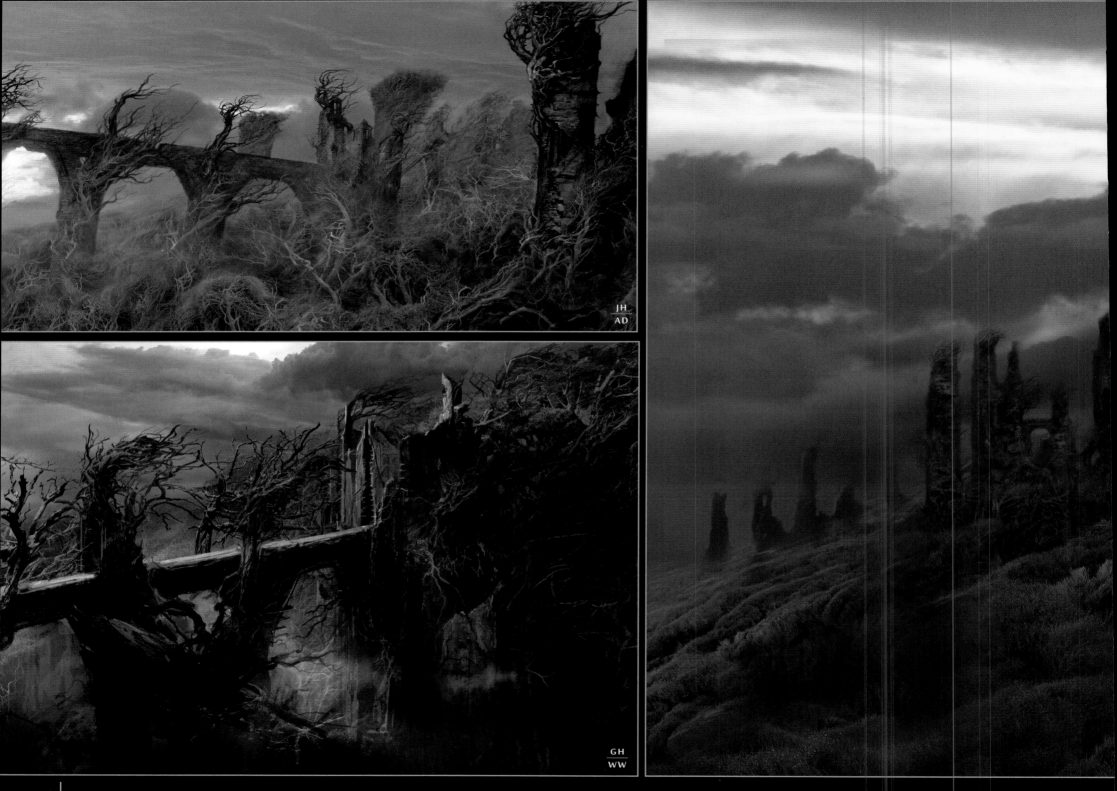

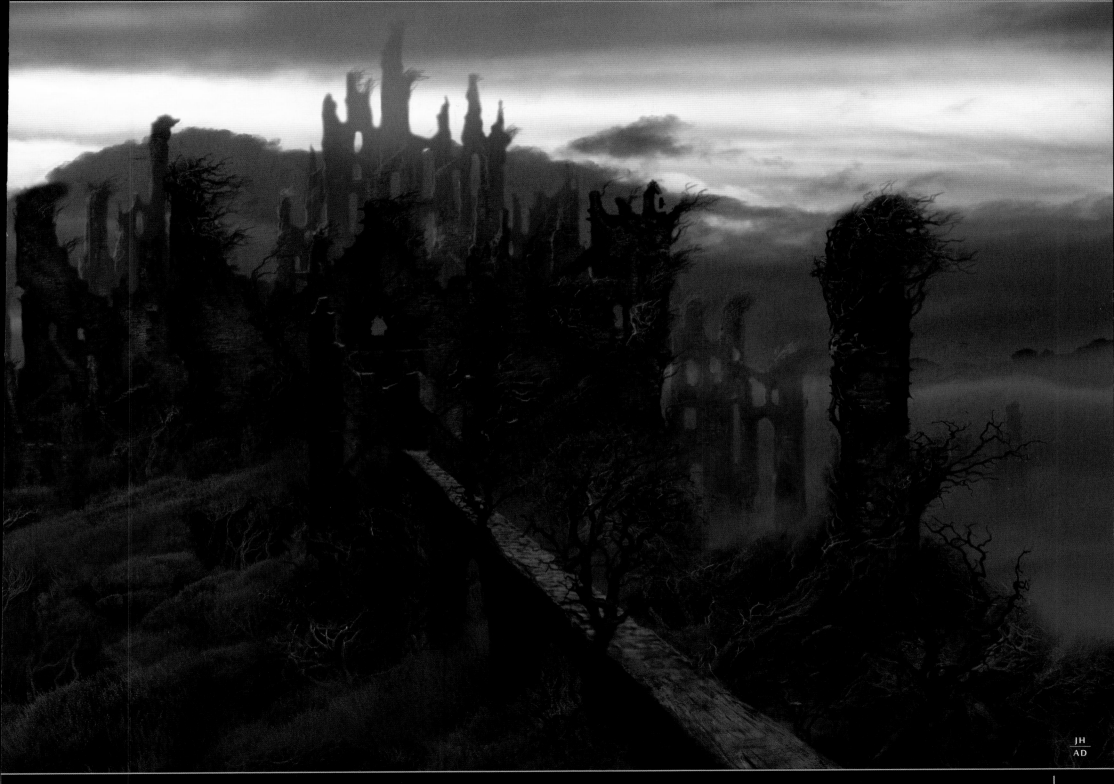

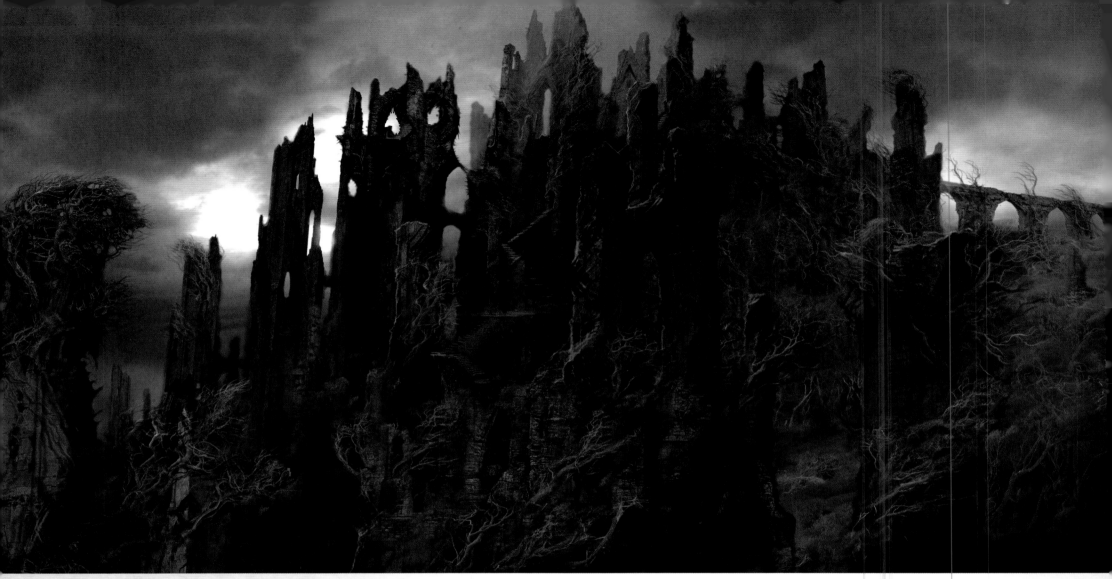

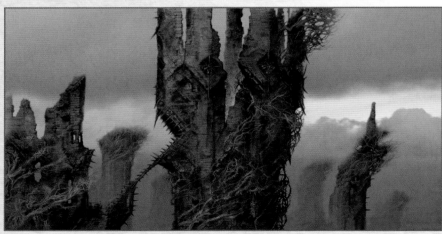

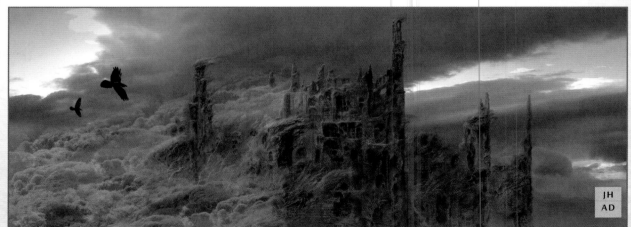

JH
AD

# INSIDE DOL GULDUR

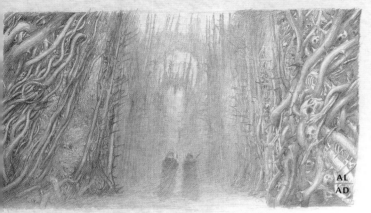

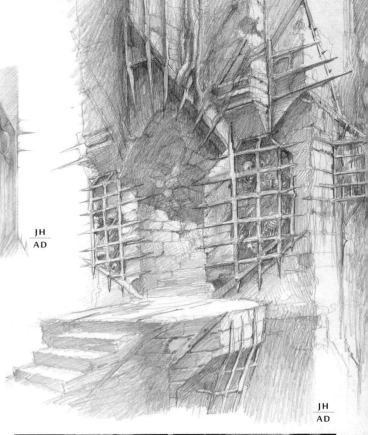

We designed the Dol Guldur sets to get as much height out of them as possible. Peter loves getting off the stage floor and creating environments that punch up or plunge down. It's so easy to walk into a set in which everything has been built on one level. People mill around on the set, but they might never step up or step down. Wherever I can I like to make our actors take a few steps – make them get natural!

**Dan Hennah, Production Designer**

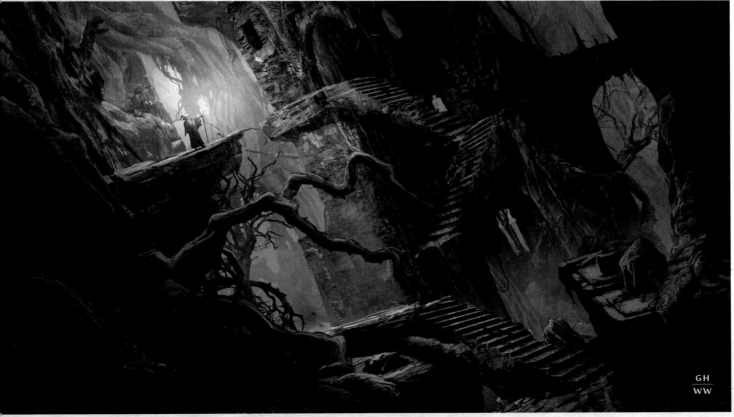

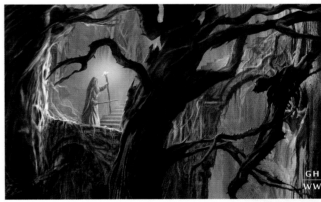

Dol Guldur is a very dead and dreary place. Peter loves to scare the living daylights out of everyone and this environment is all about that. It's overgrown with gnarly roots and trees and you know it's a dangerous place just by looking at it. Working with Alan and John to achieve that was the brief I was working to. Together we produced a lot of creepy artwork, and the final sets were amazing to walk through.

**Gus Hunter, Weta Workshop Designer**

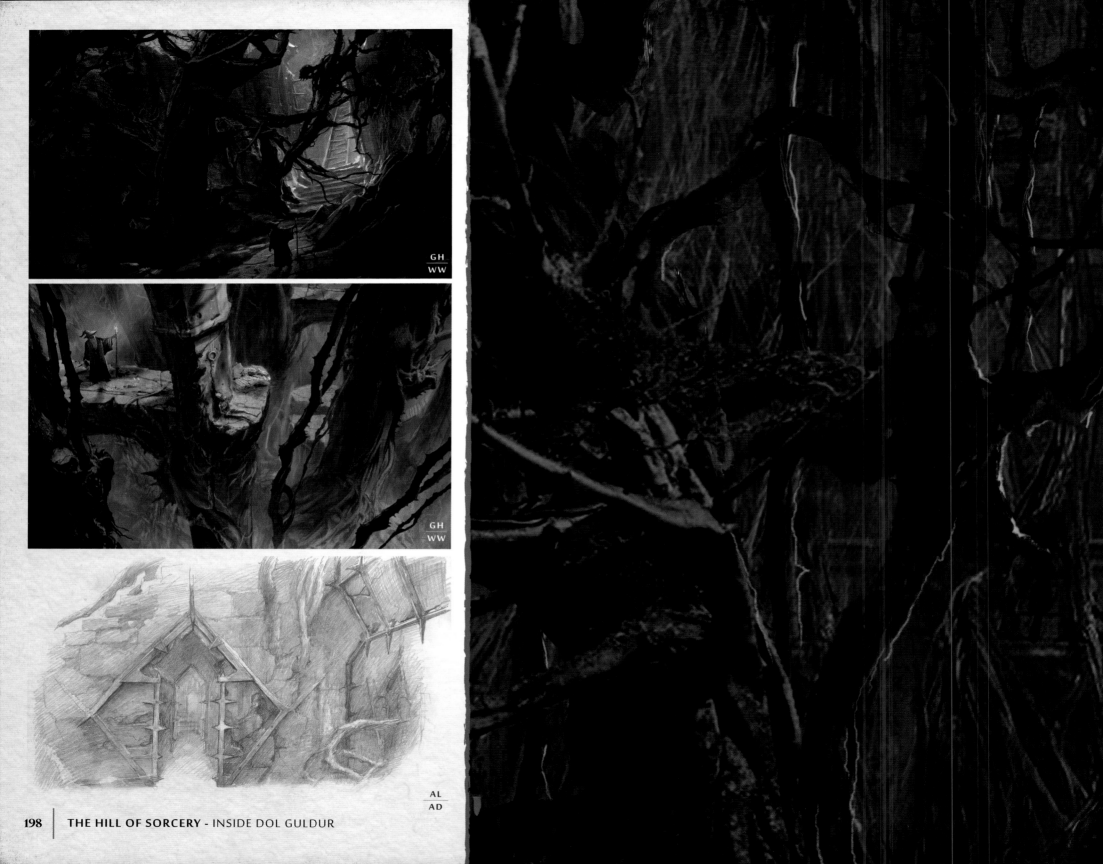

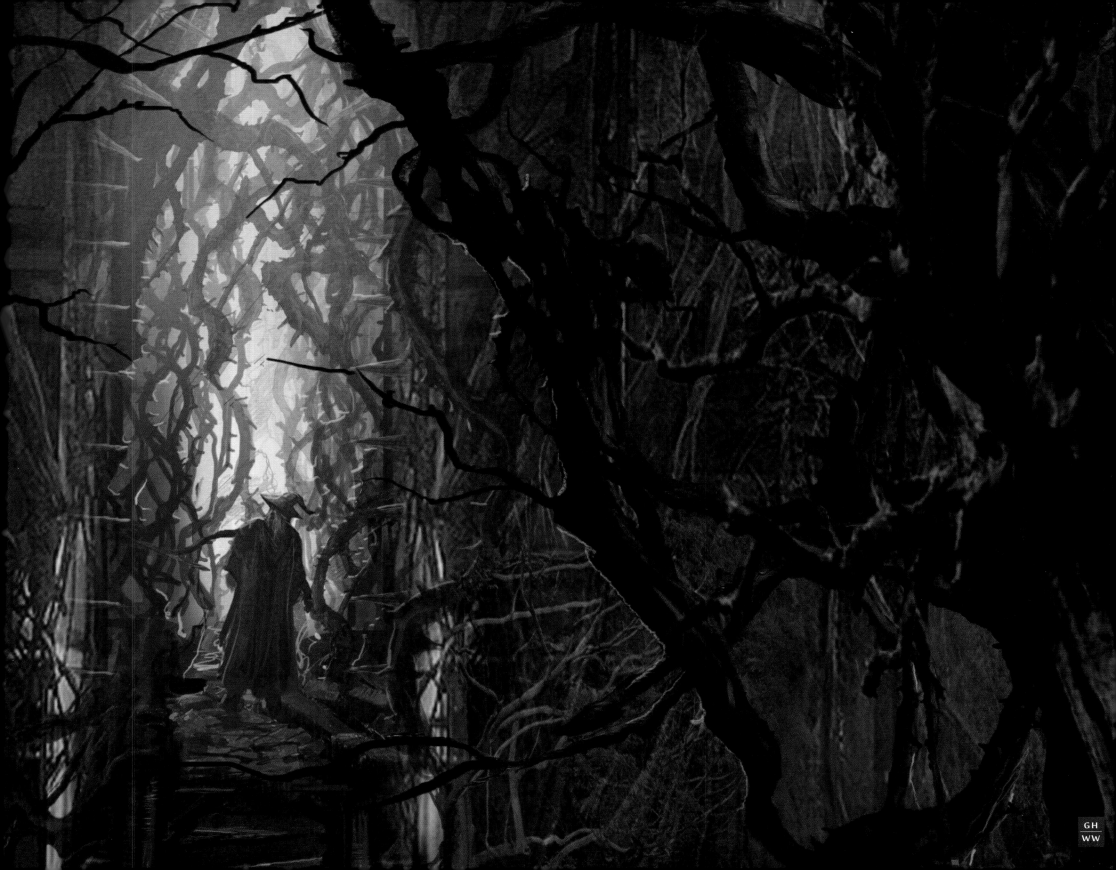

Alan and John had established a very strong lead for the design of Dol Guldur and I was asked to come in and work up some colour paintings of the interior based on their work. In some cases I worked over their drawings, colouring them up, but then Peter also gave me licence to have a play myself and come up with ideas that explored more of the environment. That was lots of fun.

**Gus Hunter, Weta Workshop Designer**

It's fun to collaborate on these kinds of briefs. I have often done sketches and had Gus Hunter take them and paint his own version of them, bringing colour and lighting to take it a step further. I have also returned the favour, taking one of his paintings of one of my sketches that was great but didn't quite match the geography we were looking at, and worked back into it myself. Gus has a beautiful way of creating very interesting spaces in which everywhere you look there is something that invites a closer look, but it is all sound and based on an understanding of architecture and physics. His paintings are very cinematic. As artists working towards a common goal we all complement each other well.

**Alan Lee, Concept Art Director**

AL
AD

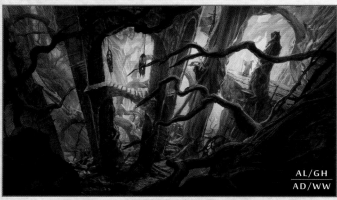

AL/GH
AD/WW

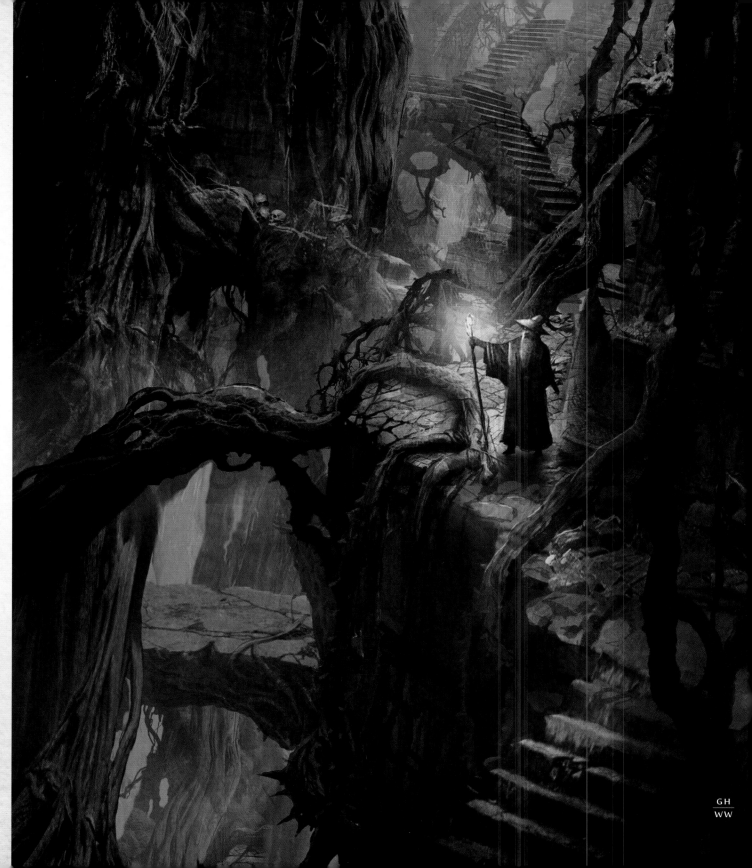

GH
WW

# THRAIN

There is an echo of Gollum in Old Thrain: a character who once was good, or at least decent, but who, through a series of circumstances and his own faults, was driven to utter madness. The challenge here was to try and make him as unkempt and dangerous as possible while keeping a bit of his former humanity, or rather 'Dwarvity'.

**Frank Victoria, Weta Workshop Designer**

FV / WW

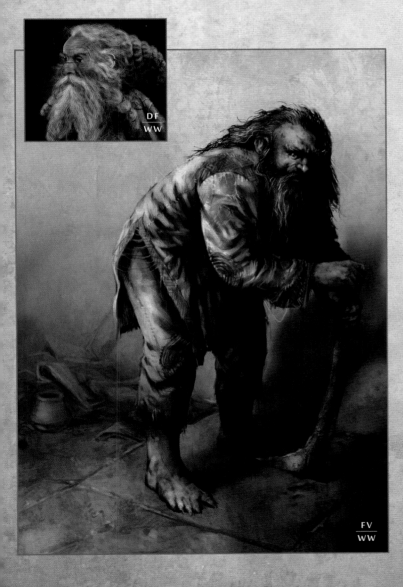

DF / WW

FV / WW

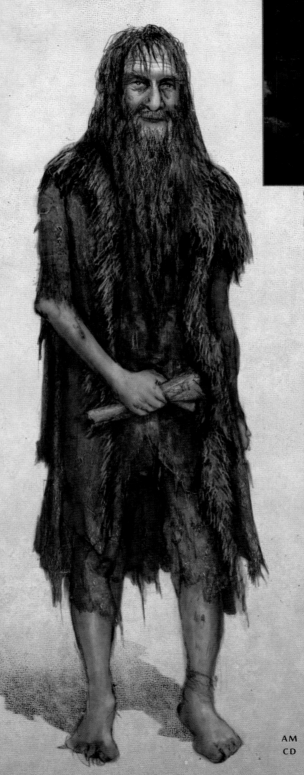

AM / CD

# BATS

Dol Guldur is haunted by giant bats which give chase to Radagast when he is caught investigating the old ruins. I tried a few different looks with different noses before Peter settled on his favourite.

**Gino Acevedo, Weta Digital Textures Supervisor/Creative Art Director**

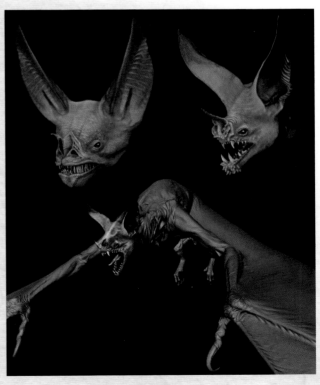

GA / WD

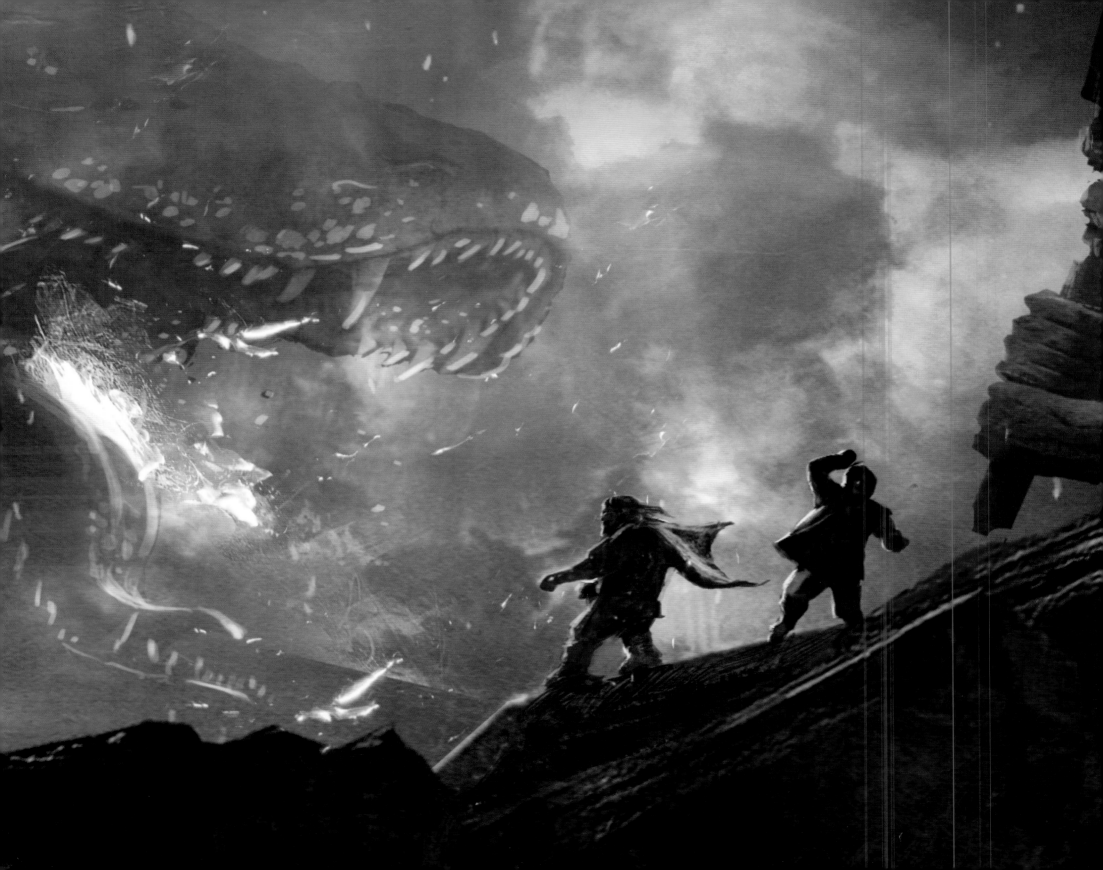

# INSIDE INFORMATION

## THE LAIR OF THE DRAGON

Having made his way gingerly down the secret passage into the heart of the Mountain, Bilbo finds himself at the climax of his long journey from Hobbiton. Here he stands, at the foot of a mountain of treasure in the halls of the ancient Dwarves, and before the baleful red stare of a being so dreadful and far beyond his gravest imaginings that it is all he can do not to bolt for Bag End.

Fortunately Bilbo is made of stronger stuff than even he ever expected, and what ensues is a delicate, high-stakes game of evasion and deflection as the hobbit draws upon all his wits to stay alive and escape the Dragon's breath. Smaug is intrigued by Bilbo, but he is no fool. He knows there can be only one reason why the strange little creature has dared to trespass in his sacred lair, and while the scent of hobbit is unfamiliar to him, he knows better than any the taste of Dwarf and can trace the lingering trail of it upon Bilbo's clothes.

Smaug presented a formidable design challenge to the team of artists at Weta Workshop, Weta Digital and the 3Foot7 Art Department charged with finding him for Peter Jackson's adaptation. Dragons are not new to the screen and, while Smaug of the book might be one of the most famous and spawned many derivatives in other properties already seen in cinemas, he would be appearing in a film that would be viewed in the context of all that had gone before and could himself be derivative if not handled carefully. Many options were thoroughly explored so that informed choices could be made.

Ultimately, once a design was chosen, the Dragon would take form as a digital creature, realized by Weta Digital, and voiced and performance driven by actor Benedict Cumberbatch.

# EREBOR

## SECRET PASSAGE

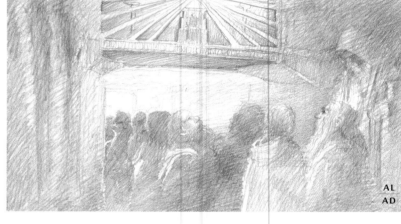

Next to the scale of Erebor's halls and balconies, the secret passage down which Bilbo must sneak into Smaug's lair was quite the contrast. That was an intentional choice. Having come through the thick doorway Bilbo found himself in a very narrow corridor, carved and polished to a smooth finish. A dado rail runs down the sloping passageway, but its modest and tight – barely room for two to walk abreast.

**Dan Hennah, Production Designer**

There was a carved bas-relief just inside the back door of the Lonely Mountain. It showed a throne topped by a stone surrounded by radiating lines, representing the Arkenstone. The sculpture was done before Thror's throne and the Arkenstone were designed, so it was a bit of a leap in the dark. I deliberately kept the design very abstract, and used it as a starting point for the design of the throne itself.

**Alan Lee, Concept Art Director**

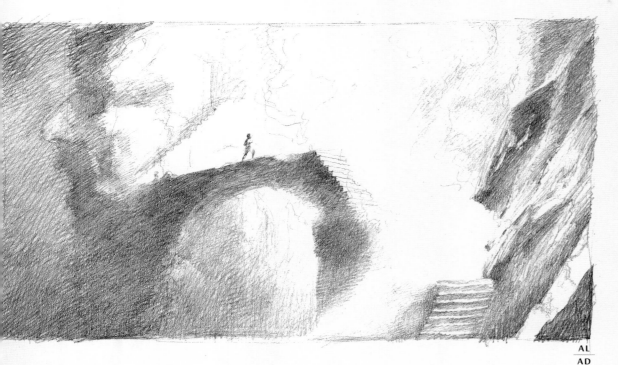

AL / AD

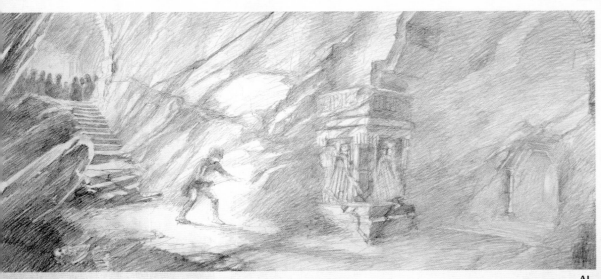

AL / AD

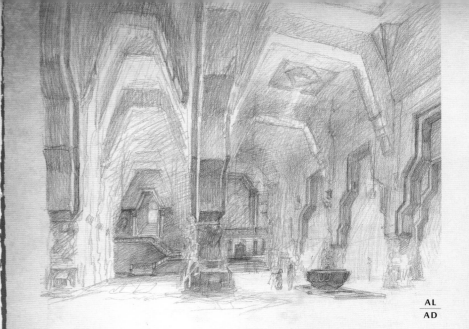

AL / AD

# EREBOR

## SMAUG'S LAIR

Smaug inhabits what was once the pride of the Dwarves, the great kingdom of Erebor. While the Dragon has made it his own, the scale and majesty of the Dwarves is everywhere and not even a hundred years or more of habitation by Smaug has undone their great work.

**Dan Hennah, Production Designer**

AL / AD

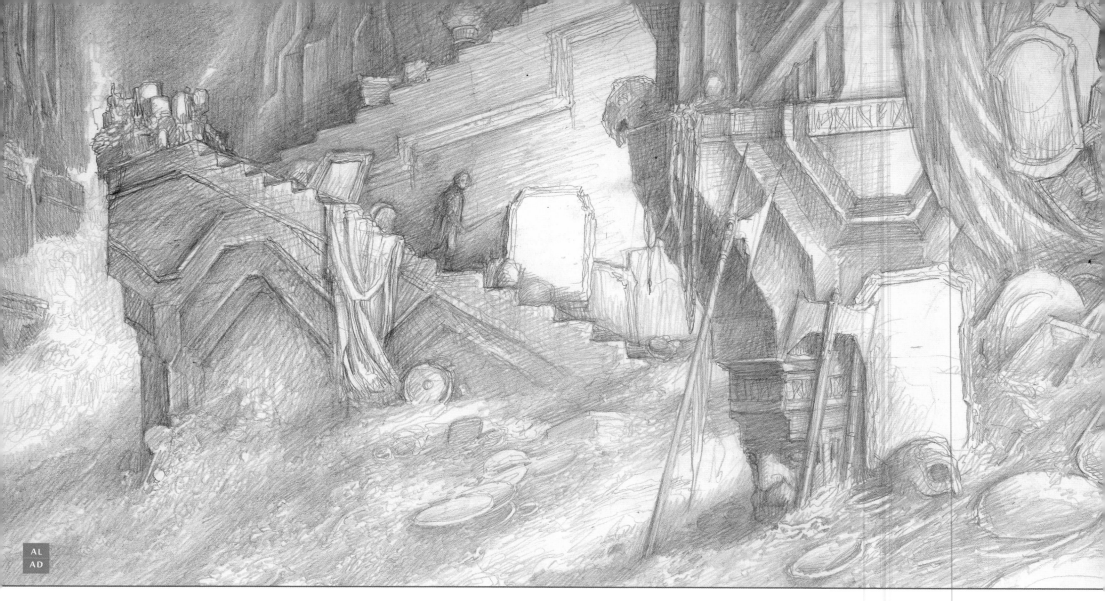

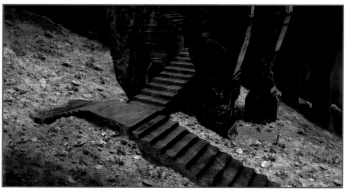

The chief influence for the unique palette of Erebor was a type of marble that comes out of a mountain in China. A beautiful dark green stone, flecked with rusty gold veins, it became the catalyst for the idea that perhaps the entire mountain core was a single chunk of jade-green marble, shot through with quartz veins. We imagined that before the true wealth of the Mountain was known the Dwarves might have explored a small cave at the base and found some quartz. Chiselling their way along, pulling the gold out of the quartz, they gradually worked their way into the Mountain, uncovering more and more of the riches it held, realization coming upon them exactly what it was they had and how special it was.

**Dan Hennah, Production Designer**

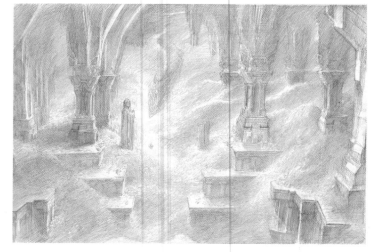

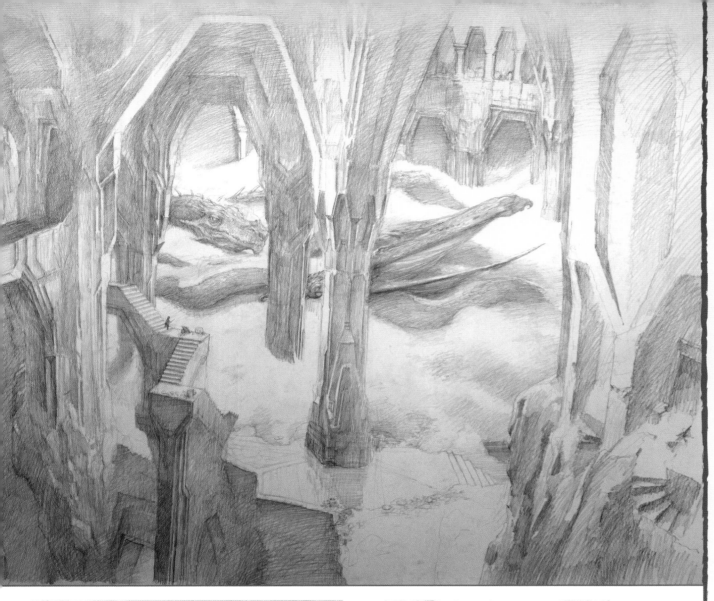

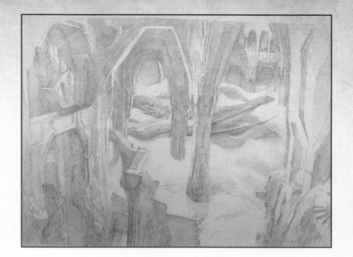

We imagined that as the early Dwarven explorers and miners had worked their way along the first veins to be exploited inside the Mountain they would chisel little nooks in which to sleep, but being Dwarves they could not help but carve their iconography into the rocks. It simply isn't in a Dwarf's nature to do things crudely, so simple structural pillars would be symmetrical and intercut with geometric patterns, bosses and capitals.

Over time, they gradually expanded this labyrinth of exploratory tunnels into cavernous halls – up, down, sideways, following the veins and creating a kingdom in which to live and thrive. As a consequence the architecture is very organic in one way, but very structured in another. It follows weird paths, carved into beautiful bridges and chiselled archways, with architraves and huge figurative pillars.

It was important that it have its own character and style when compared to the other great Dwarf kingdom that we had seen in Peter's films, Moria, from *The Fellowship of the Ring*. Partly it was in the palette, and partly it was in the detail. We used a lot more Dwarven detail in the architecture of Erebor, and set gold into the green. Where Khazad-dûm was predominantly flat, Erebor was crisscrossed with winding stairways and bridges.

Monumental statuary became a theme of Erebor. The Dwarves of Durin's line place great importance on ancestry and lineage, honouring their forebears with huge visages carved into the rock in which they live. When Smaug takes the Mountain, it's not just the gold and their home that he steals, but their heritage; their identity.

**Dan Hennah, Production Designer**

AL
AD

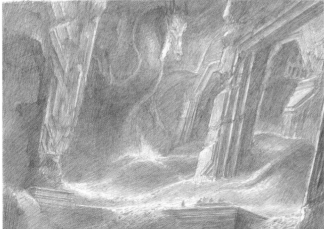

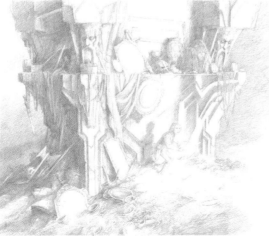

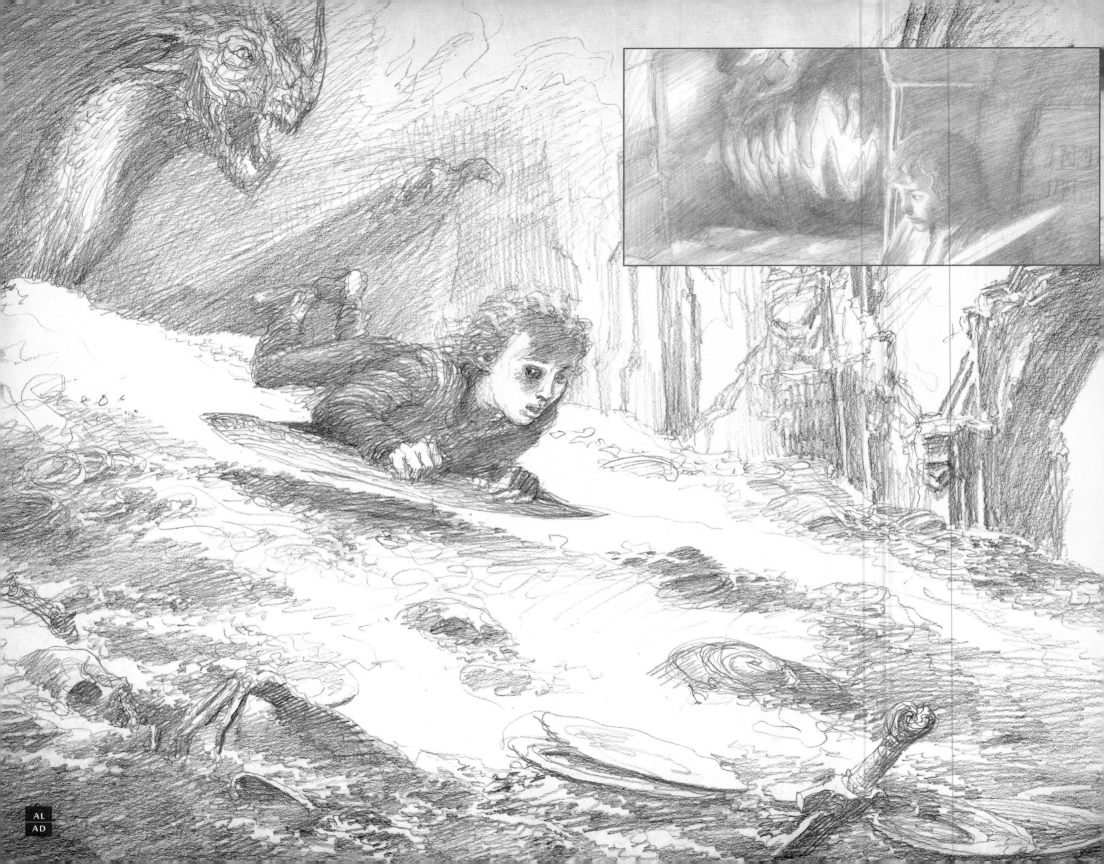

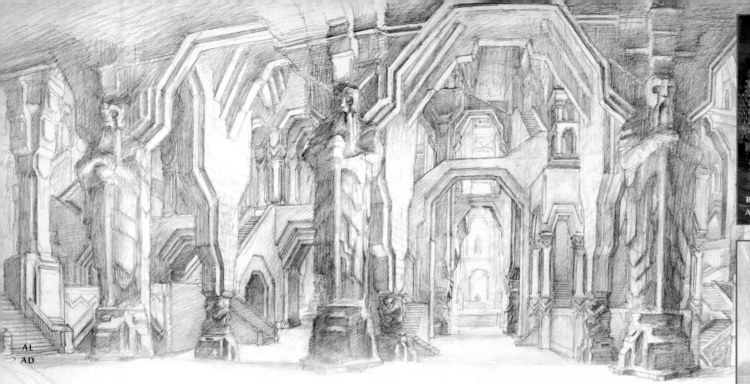

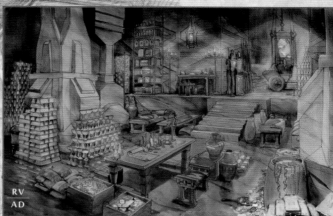

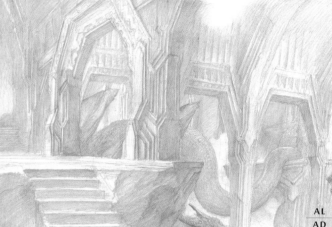

Since the Dragon moved in he has wormed his way around and gathered all the gold into a great mound in which he curls. He has trashed anything that had any value and dragged it all into his cavernous treasure chamber. We designed wear marks around pillars.

**Dan Hennah, Production Designer**

Erebor's green marble with veins of precious metals running through it was a way of explaining the wealth of the mountain kingdom, but it was also just a great colour choice. The gold and the green complemented each other beautifully.

**Ra Vincent, Set Decorator**

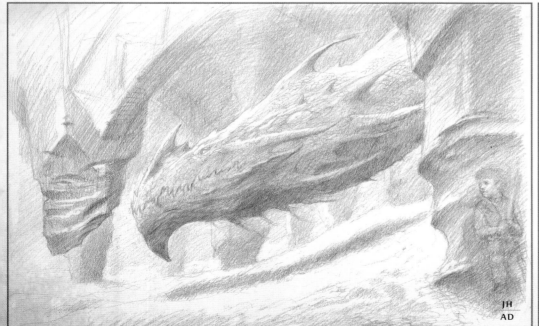

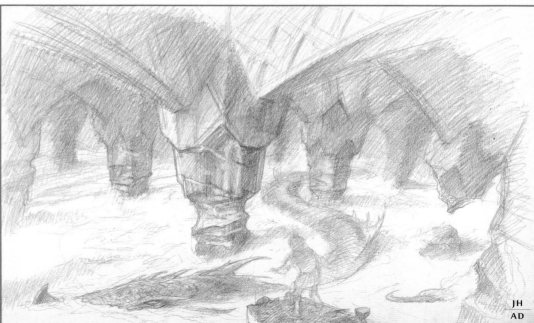

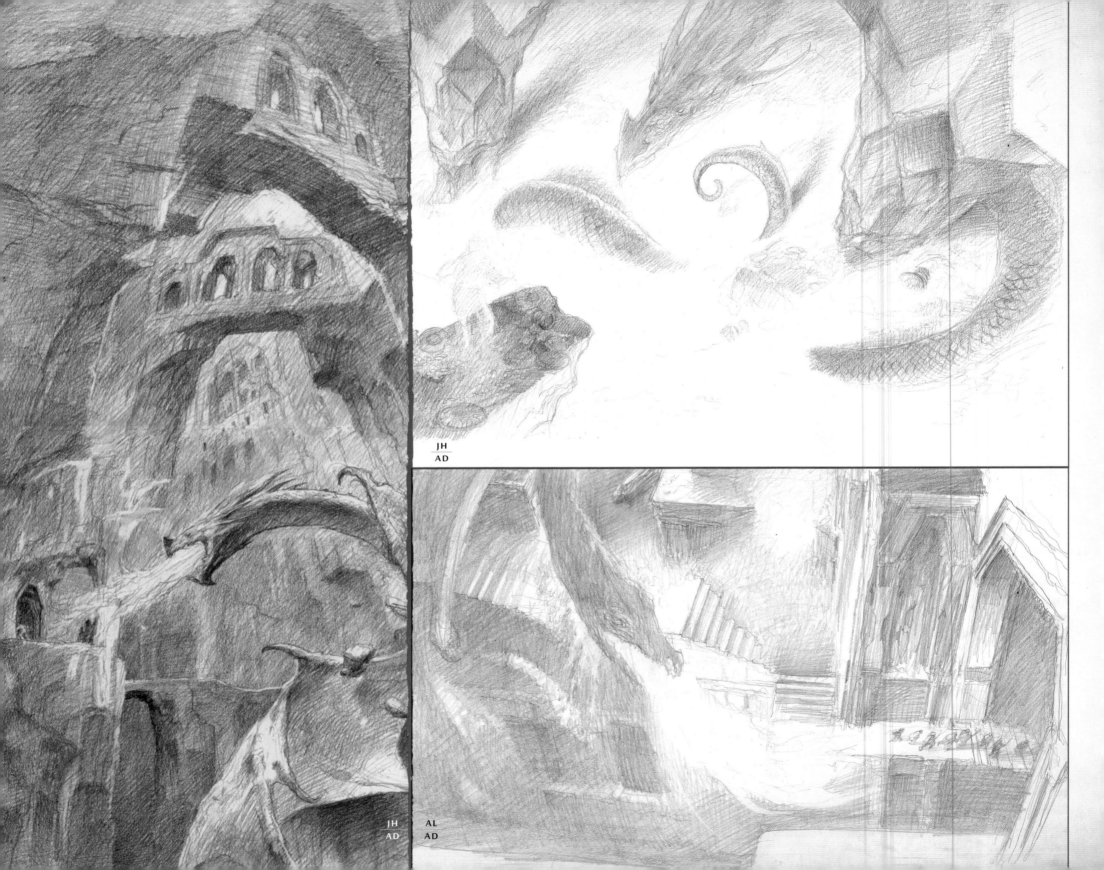

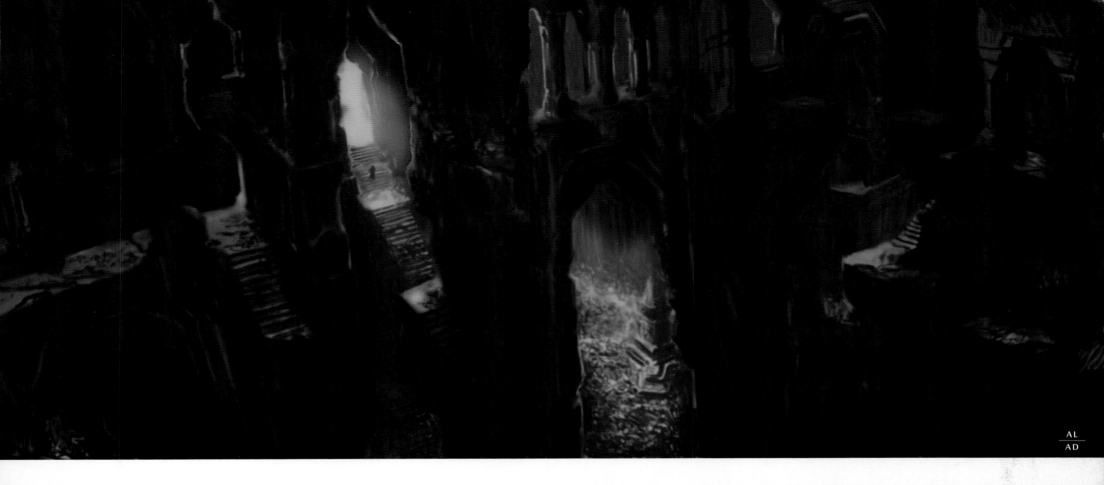

We explored a variety of different ideas for Smaug's lair in our original concept sketches. A number of set elements were constructed and the action with Bilbo was shot on the soundstage. We had some pillars and steps, some platforms and a pile of gold, and these elements were rearranged in various set ups to represent different parts of Smaug's vast home. The entire environment was far too large to ever build in its entirety, so the plan had always been to digitally extend it in post-production.

Returning to design those extensions has been an interesting challenge, because we wanted to avoid the audience seeing any reused live set elements cropping up in shots that were supposed to represent different parts of the environment. We needed an impressive design that would have a great feeling of size and drama, offering an ideal setting for a suspenseful scene, and yet also be geographically consistent between the various live-action shots we had to work with. I worked on lots of Photoshop studies, taking the plates from the live-action shoot, locating them in a digital model and painting in the backgrounds.

**Alan Lee, Concept Art Director**

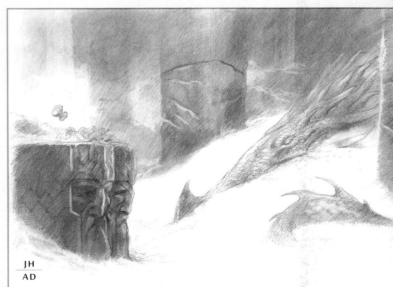

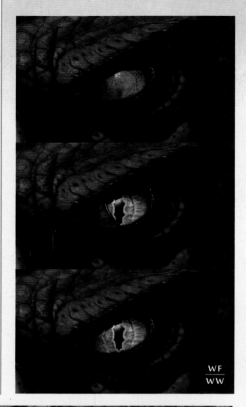

# SMAUG

## THE GLARE OF THE DRAGON

Finally we come to it; the Dragon himself, Thorin's greatest nemesis and object of so much speculation and anticipation both within the fictional film world and beyond. Bilbo and the Dwarves have reached the eastern terminus of their journey, and, as on the maps of ancient explorers from our own world, 'Here be Dragons!' Well, just one really, but that will be enough!

**Richard Taylor,**
**Weta Workshop Design & Special Effects Supervisor**

Smaug is the iconic Dragon, the first fictional Dragon to occupy the place left vacant by Fafnir or the Dragon in the saga of *Beowulf* – hoarder of gold, breather of fire, asleep or brooding upon a treasure hoard. Thus, not only is he a Dragon, in a sense he is the archetype of all modern fantasy Dragons. This notion that he not only had to be original and formidable, but somehow sum up generations of Dragons, was a guiding principle in his design.

The first film concluded with audiences teased by a glimpse of the Dragon snorting and his eye blinking awake.

The eye itself evolved from one pencil sketch. The actual shape of the iris was a small doodle next to the main drawing. Often the best ideas are like that – incidental doodles in the margin of a drawing, rather than a prolonged exploring of dozens of incrementally differing options.

**John Howe, Concept Art Director**

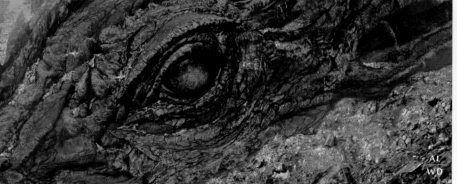

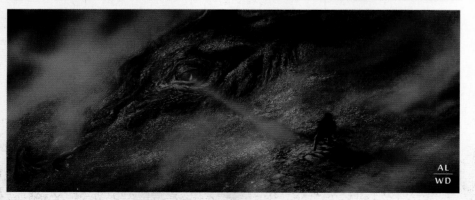

Often the artwork we present is intended to raise questions rather than answer them. In the book there's a very iconic moment when Smaug's eye opens and a thin gleam of red pierces through the darkness, illuminating the gold and narrowly missing catching Bilbo as he stealthily climbs amongst the treasure. Of course we wanted to capture that in the film, but when creating a real creature, or as real as we can get it, an eye that illuminates from within and casts a glow is a tricky thing to pull off. I wanted to present some artwork to put the idea on the table for discussion.

**Alan Lee, Concept Art Director**

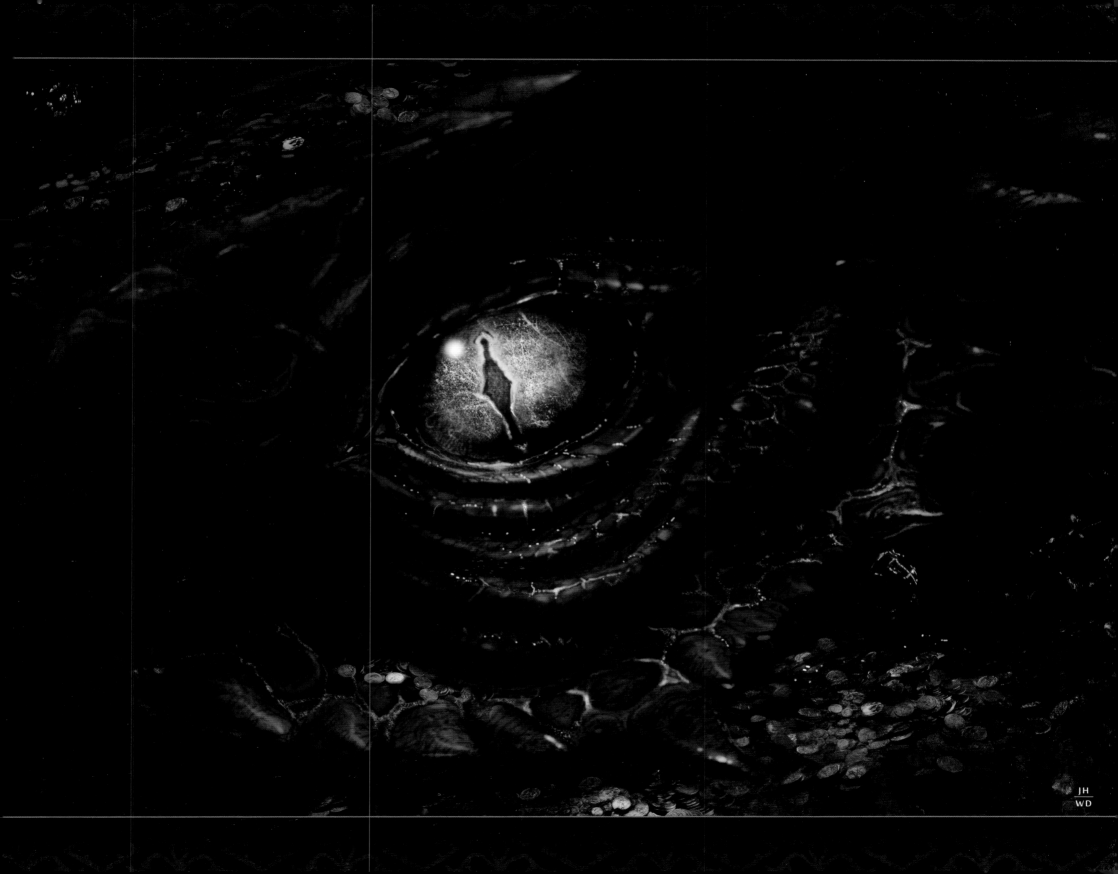

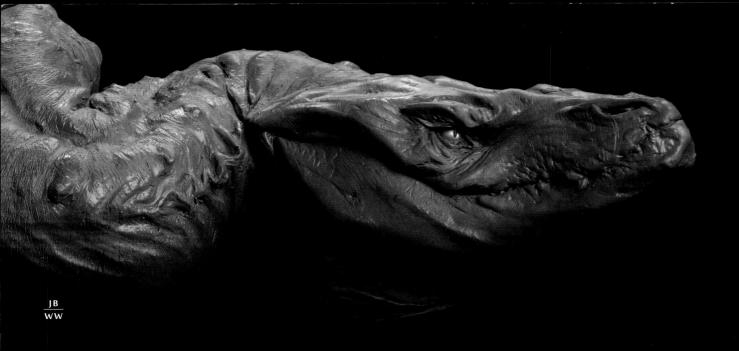

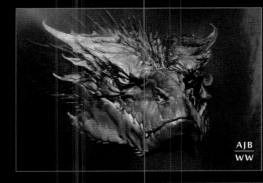

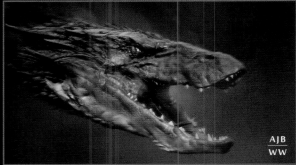

# SMAUG

## DEVELOPMENT ART

How do you follow hundreds of years of depictions of Dragons? How do you design something that stands next to so many great Dragon designs presented in illustrations, films and other media, and yet still be unmistakably *The Hobbit*'s Dragon, *the* Dragon, Smaug, with all the majesty and horror that Tolkien's text conjures. Do you embrace the archetype and create something familiar and expected, but risk being obvious or unoriginal? Do you run from the previous Smaugs in search of something totally original and surprising, but risk your design being defined by what it is not and estranging the audience? How much newness is jarring and how little is dull? Bringing Smaug to life for the screen was no small challenge. When, like Bilbo, we stared into the eye of our Dragon, how would we fare?

Fortunately our course was steered by an astute helmsman, and Peter knew from the outset that the answer to these riddles lay in those most important things of all to a film, story and character. With those as our compass and sextant, we knew we could lick this worm.

**Richard Taylor,**
**Weta Workshop Design & Special Effects Supervisor**

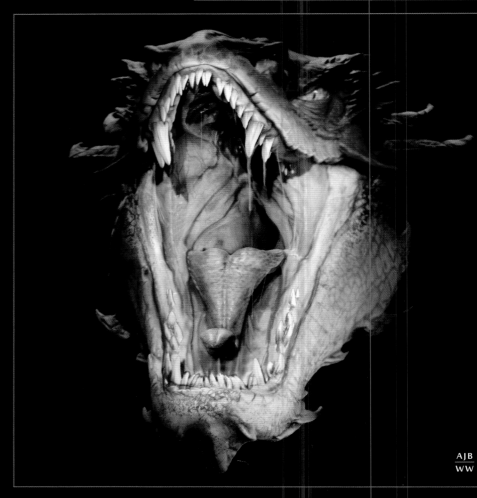

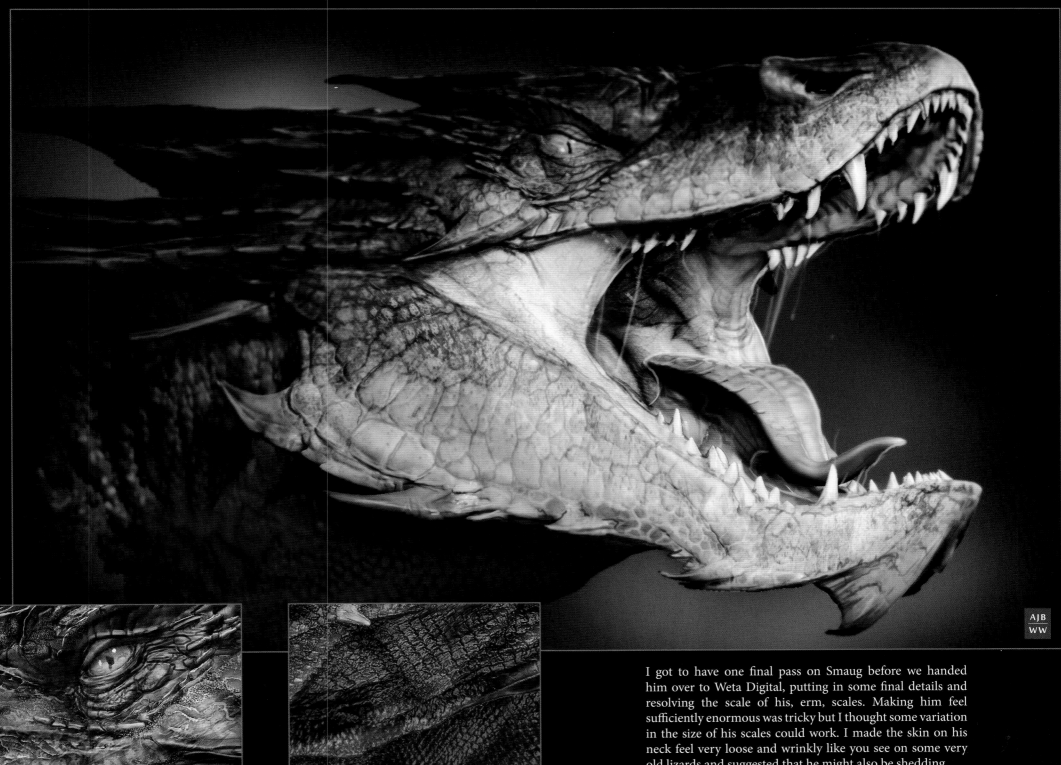

AJB
WW

I got to have one final pass on Smaug before we handed him over to Weta Digital, putting in some final details and resolving the scale of his, erm, scales. Making him feel sufficiently enormous was tricky but I thought some variation in the size of his scales could work. I made the skin on his neck feel very loose and wrinkly like you see on some very old lizards and suggested that he might also be shedding.

**Andrew Baker, Weta Workshop Designer**

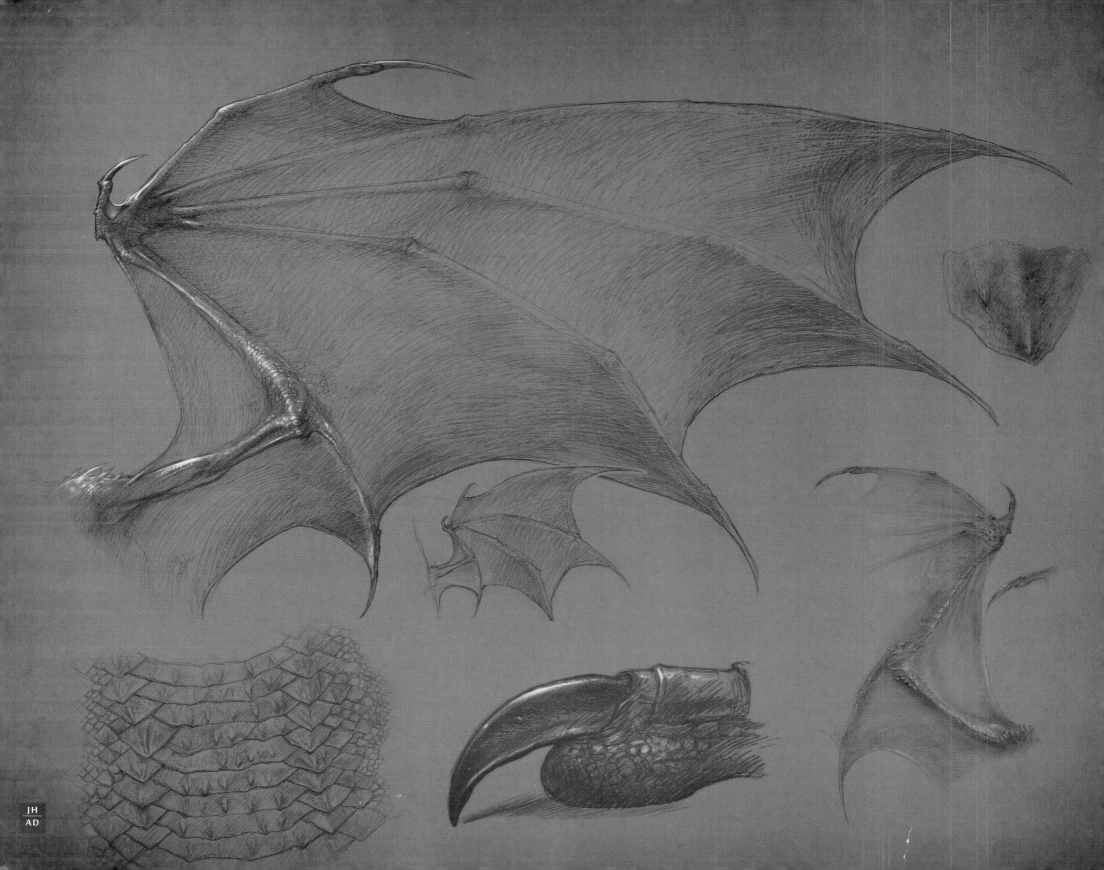

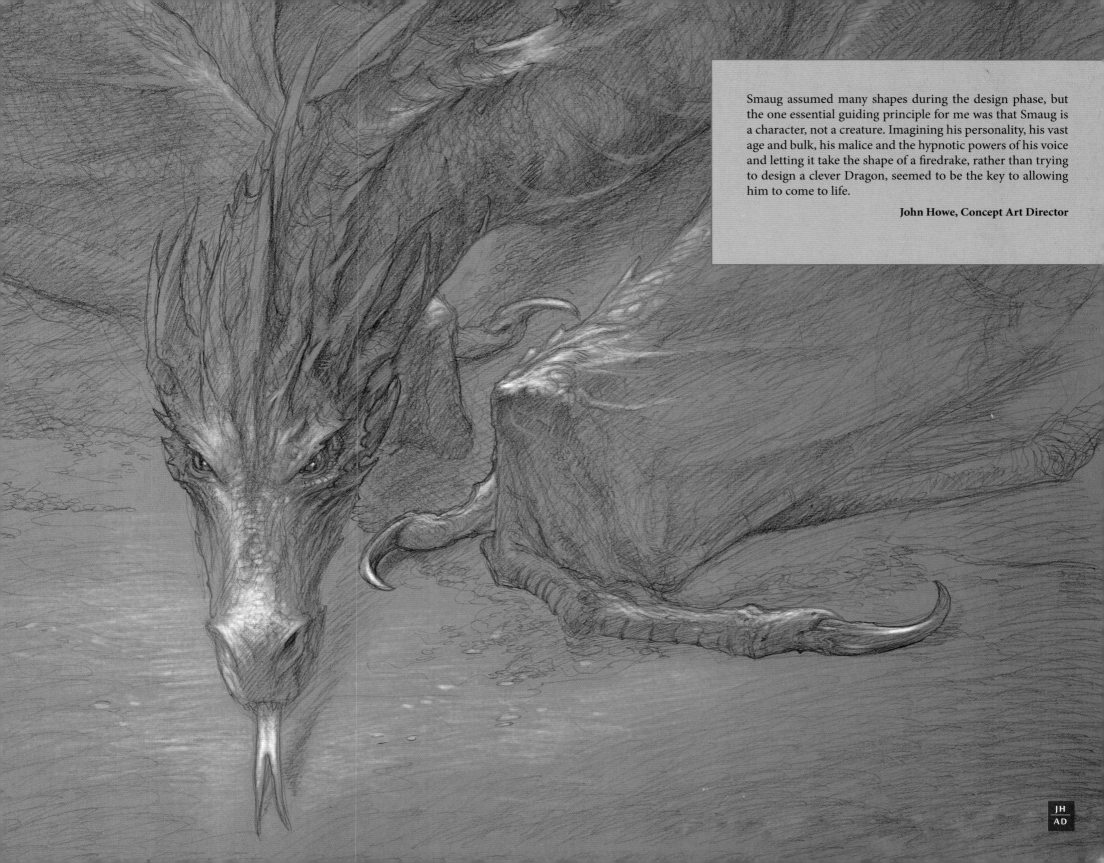

Smaug assumed many shapes during the design phase, but the one essential guiding principle for me was that Smaug is a character, not a creature. Imagining his personality, his vast age and bulk, his malice and the hypnotic powers of his voice and letting it take the shape of a firedrake, rather than trying to design a clever Dragon, seemed to be the key to allowing him to come to life.

**John Howe, Concept Art Director**

# About the Peninsula

## ART DEPARTMENT

The 3Foot7 Art Department, led by Production Designer Dan Hennah, is responsible for creating the overall look of the film, bringing the Director's vision to the screen. The Art Department is responsible for creating all of the sets, props and dressings from concepts through to the finished articles. Their job is to create an environment that is so real, the actors feel completely in character wherever that may be: in a forest, on a lake, up a tree or in a cave. To achieve a look or atmosphere for a film involves many people. The Art Department on *The Hobbit* has more than 350 artists and craftspeople in workshops throughout the Miramar Peninsula. Starting with the Director's brief, ideas go through the concept stage before being turned into working drawings. Designs then go to the various departments to be made into a physical set, prop or dressing.

## COSTUME DEPARTMENT

The Costume Department is ultimately responsible for the look worn by actors, stunt performers and body doubles in front of the camera. The department consists of 'off set' and 'on set' crew, each dealing specifically with either producing the costumes or dressing and maintaining the look and continuity during filming. 'Off set' crew are based in the workroom where designs are created, illustrations coloured, samples developed, materials sourced, patterns cut, fabric dyed, jewellery made, boots cobbled, costumes fitted and alterations completed. Finished costumes are aged to appear lived in. 'On set' crew work either in the studio or travel to location. As well as dressing the performers, they also attend to their comfort and safety by keeping them warm or cool between shots and attend to general maintenance and laundry. Continuity photos are taken and notes are written about how the costumes were worn for that particular scene. On *The Hobbit* the Costume Department consists of approximately 60 'off set' crew and 15 'on set' crew.

## MAKE-UP & HAIR DEPARTMENT

The 3Foot7 Make-up Department creates characters by designing and applying make-up, prosthetics, wigs and beards to the cast. Every cast member, including extras, wears some form of wig and all the lead actors and their various doubles wear prosthetics. Four make-up department bases manage the large number of artists and extras. All activity is coordinated through the Make-up Room based at Stone Street Studios. This is also where wigs are made and mended, and hair is prepared for inclusion in the wigs, including the dying and curling. Seven five-seater Make-up Trucks positioned on the back-lot are used for applying prosthetics, make-up and hair on principal actors, some taking three hours to complete each day, under the eye of two supervisors. Offsite is another 18-station make-up facility for extras. There are 34 permanent staff though the department swells to as many as 60 during periods that call for large numbers of extras and stunt people.

## WETA WORKSHOP

Weta Workshop is a multi-award winning conceptual design and manufacturing facility based in Wellington, New Zealand, servicing the world's creative industries. Weta Workshop draws on more than 25 years of filmmaking experience and is led by five-times Academy Award®-winner, Richard Taylor. Their crew members are expert in a diverse range of disciplines and enjoy engaging in projects, from preliminary technical analysis and conceptual design through to manufacture and final delivery of product, anywhere in the world. Weta Workshop provides design and manufacturing services on *The Hobbit*, designing creatures, armour and weapons, and building armour, weapons, prosthetics and physical creature effects.

## WETA DIGITAL

Weta Digital is one of the world's premier visual effects companies. Led by Senior Visual Effects Supervisor Joe Letteri, Weta Digital is known for uncompromising creativity and commitment to developing innovative technology. From ground-breaking performance-driven digital characters like Gollum, Kong and Caesar, to the revolutionary virtual production workflows of *Avatar* and *The Adventures of Tintin*, Weta Digital's team continues to break down barriers between live action and computer-generated imagery and expand what is possible in film. Weta Digital established its reputation for cutting edge visual effects with work on blockbusters like *The Lord of the Rings trilogy* and *King Kong*. The company began work in 1993 on co-founder Peter Jackson's film *Heavenly Creatures* and is based in a number of facilities spread around Wellington, New Zealand. Weta Digital is creating all digital visual effects on *The Hobbit* films.

You can also keep up to date on all our new releases as well as all the Weta news, including *The Hobbit: The Desolation of Smaug*, by signing up for our free email newsletter at: www.wetaNZ.com

# COLLECTIBLE ART

### DRAGON PIN

Decorative metal pin based on the line art depiction of Smaug on Thorin's Map, created by 3Foot7 Art Department Graphic Artist Daniel Reeve.

### BILBO BAGGINS™ AND BOMBUR THE DWARF™ BARREL RIDERS

Miniature polystone statues by Weta Workshop Sculptors Brigitte Wuest and Steven Saunders, respectively.

### TAURIEL™

Limited edition 1/6th scale polystone statue by Weta Workshop Sculptors Yasmin Khudari and Steven Saunders.

### DAGGERS OF TAURIEL™

Accurate prop replicas cast from the same moulds as Tauriel's dagger props, created at Weta Workshop based on designs by Paul Tobin.

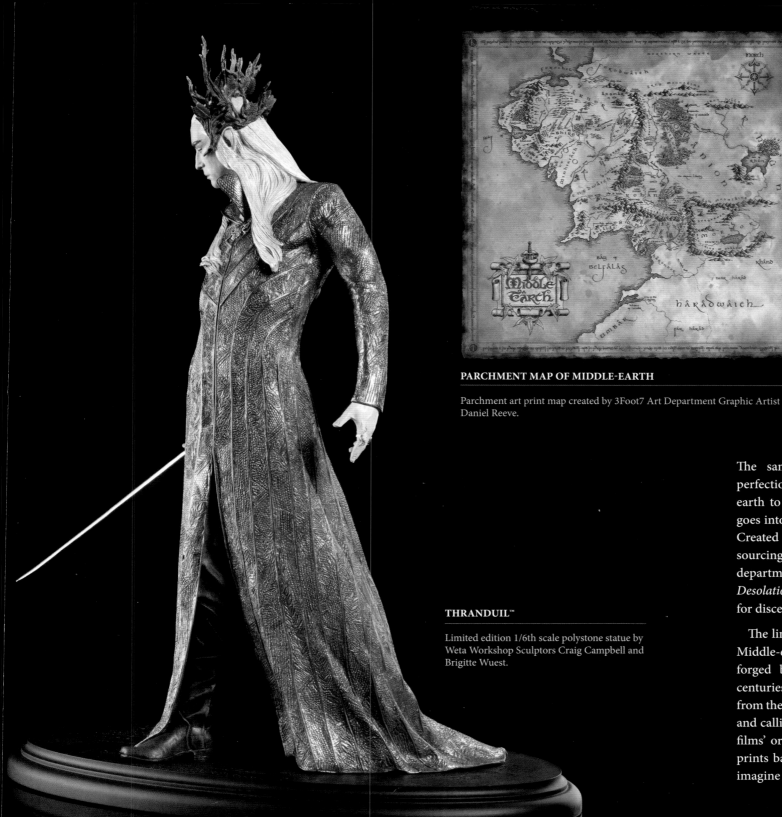

**PARCHMENT MAP OF MIDDLE-EARTH**

Parchment art print map created by 3Foot7 Art Department Graphic Artist Daniel Reeve.

**THRANDUIL™**

Limited edition 1/6th scale polystone statue by Weta Workshop Sculptors Craig Campbell and Brigitte Wuest.

The same burning passion and relentless pursuit of perfection that drives every department bringing Middle-earth to life for *The Hobbit: The Desolation of Smaug* also goes into the creation of the most authentic movie replicas. Created by the same artists working on the films, Weta is sourcing beautiful Middle-earth artefacts from across the departments and companies represented in *The Hobbit: The Desolation of Smaug*, and offering them as authentic replicas for discerning collectors.

The line represents the closest experience next to visiting Middle-earth itself. Collectors will find replica swords hand-forged by a world-renowned master swordsmith using centuries-old and cutting edge techniques and props cast from the very same moulds as those made for the films. Maps and calligraphic prop replicas have been handmade and the films' original artists have created new, limited edition art prints based on the characters and landscapes they helped imagine for the films.

# CREDITS

## BOOK CREDITS

| | |
|---|---|
| Writer and Art Director | Daniel Falconer |
| Layout Designer | Monique Hamon |
| Art Department Content Co-ordinator | Karen Flett |
| Image Retouching | Chris Guise |
| Transcribers | Fiona Ogilvie |
| | Candace Little |
| | Darinie Johnston |
| Weta Workshop Design & Special Effects Supervisor | Richard Taylor |
| Weta Workshop Manager | Tania Rodger |
| Weta Ltd General Manager | Tim Launder |
| Weta Publishing Manager | Kate Jorgensen |
| Weta Workshop Design Studio Manager | Richard Athorne |
| Weta Workshop Photographer | Steve Unwin |
| Weta Workshop Assistant Photographers | Wendy Bown |
| | Simon Godsiff |
| Contributing Photographers | Mark Pokorny |
| | Grant Maiden |
| | Nels Israelson |
| | James Fisher |
| | Todd Eyre |

**HarperCollins**_Publishers_ **UK**

| | |
|---|---|
| Series Editor | Chris Smith |
| Production Director | Charles Light |
| Design Manager | Terence Caven |

## ABOUT THE AUTHOR

Daniel Falconer has been a designer at Weta Workshop for more than fifteen years, producing conceptual art as part of the design team on many of the company's high profile projects including _The Lord of the Rings_, _King Kong_, _The Chronicles of Narnia_, _Avatar_, and now _The Hobbit_. In addition to the _Chronicles_ series, Daniel has written a number of books for Weta; _The World of Kong_, _The Crafting of Narnia_, _Weta: The Collector's Guide_ and _The Art of District 9_, each showcasing the company's creative works. He lives and works in Wellington, New Zealand with his wife Catherine and two daughters, revelling in his dream career of playing in imaginary worlds every day.

## CONTRIBUTOR CREDITS

### 3 Foot 7 Ltd Art Department  (AD)

The 3 Foot 7 Art Department, led by Production Designer Dan Hennah, is responsible for creating the overall look of the film, which helps to bring the Director's vision to the screen. The Art Department is responsible for creating all of the sets, props & dressings from concepts through to the finished articles.

| | | |
|---|---|---|
| Dan Hennah | Production Designer | DH |
| Alan Lee | Concept Art Director | AL |
| John Howe | Concept Art Director | JH |
| Nick Weir | Prop Master | |
| Ra Vincent | Set Decorator | RV |
| Anthony Allan | Prop Designer | AA |
| Link Choi | Prop Designer | LC |
| Mat Hunkin | Prop Designer | MH |
| Matt Smith | Prop Designer | MS |
| Thaw Naing | Prop Designer | TN |

### 3 Foot 7 Ltd Costume Department  (CD)

The Costume Department is ultimately responsible for the look worn by actors, stunt performers and body doubles in front of the camera. The department consists of 'off set' and 'on set' crew, each dealing specifically with either producing the costumes or dressing and maintaining the look and continuity during filming.

| | | |
|---|---|---|
| Ann Maskrey | Costume Designer | AM |
| Bob Buck | Costume Designer | BB |
| Kate Hawley | Additional Costume Designer | KH |
| Lesley Burkes Harding | Costume Designer, Legolas & Tauriel | LBH |

### 3 Foot 7 Ltd Make-up Department  (MD)

The 3 Foot 7 Make-up Department creates characters by designing and applying make-up, prosthetics, wigs and the beards to the cast. Every cast member, including extras, wear some form of wig and all the lead actors and their various doubles wear prosthetics.

| | | |
|---|---|---|
| Peter King | Make-up and Hair Designer | PK |

...acility based in Wellington, New Zealand. Best known for its Academy Award®-winning work on *The Lord of the Rings* trilogy, Weta Workshop has contributed conceptual design (creatures, characters and environments) for *The Hobbit* films along with manufacturing armour, weapons, specialty prosthetics and creatures. Weta Workshop is led by Academy Award® winner Richard Taylor.

| | | |
|---|---|---|
| Richard Taylor | Design & Special Effects Supervisor | |
| Aaron Beck | Weta Workshop Designer | AB |
| Adam Anderson | Weta Workshop Designer | ATA |
| Andrew Baker | Weta Workshop Designer | AJB |
| Andrew Moyes | Weta Workshop Designer | AWM |
| Aris Kolokontes | Weta Workshop Sculptor | AK |
| Ben Mauro | Weta Workshop Designer | BM |
| Chris Guise | Weta Workshop Designer | CG |
| Christian Pearce | Weta Workshop Sculptor | CP |
| Craig Campbell | Weta Workshop Sculptor | CC |
| Daniel Cockersell | Weta Workshop Sculptor | DC |
| Daniel Falconer | Weta Workshop Designer | DF |
| David Meng | Weta Workshop Designer | DM |
| Eduardo Pena | Weta Workshop Designer | EP |
| Frank Victoria | Weta Workshop Designer | FV |
| Gary Hunt | Weta Workshop Sculptor | GJH |
| Greg Tozer | Weta Workshop Designer | GT |
| Gus Hunter | Weta Workshop Designer | GH |
| Jamie Beswarick | Weta Workshop Designer | JB |
| Lindsey Crummett | Weta Workshop Designer | LCC |
| Matthew Rodgers | Weta Workshop Designer | MR |
| Max Patté | Weta Workshop Sculptor | MP |
| Michael Asquith | Weta Workshop Sculptor | MA |
| Nick Keller | Weta Workshop Designer | NK |
| Paul Tobin | Weta Workshop Designer | PT |
| Steve Lambert | Weta Workshop Designer | SL |
| Steven Saunders | Weta Workshop Sculptor | SSA |

Weta Digital is one of the world's premier visual effects companies. Led by Senior Visual Effects Supervisor Joe Letteri, Weta Digital is known for uncompromising creativity and commitment to developing innovative technology. Weta Digital established its reputation for cutting edge visual effects with work on blockbusters like *The Lord of the Rings* trilogy and *King Kong*. The company began work in 1993 on co-founder Peter Jackson's film *Heavenly Creatures* and is based in a number of facilities spread around Wellington, New Zealand. Weta Digital is creating all digital visual effects on *The Hobbit* films.

| | | |
|---|---|---|
| Eric Saindon | Visual Effects Supervisor | |
| Gino Acevedo | Textures Supervisor/Creative Art Director | GA |
| Alan Lee | Concept Art Director | AL |
| John Howe | Concept Art Director | JH |

Thanks to: Peter Jackson, Fran Walsh, Philippa Boyens, Zane Weiner, Caro Cunningham, Brigitte Yorke, Matt Dravitzki, Amanda Walker, Dan Hennah, Chris Hennah, Karen Flett, Natalie Crane, Cilla Leckie, Judy Alley, Melissa Booth, Ceris Price, Guy Campbell, Dave Gouge, Mahria Sangster, Amy Miller, Steven McKendry, Ri Streeter, Cathrine Mitchell and Tracey Morgan.

NB.    Film credits were not available at the time of publication.

## ARTWORK CREDIT KEY

Artist credit as indicated on top and their
department indicated beneath line

$$\frac{AL}{AD}$$

All artwork on page by indicated artist
and department

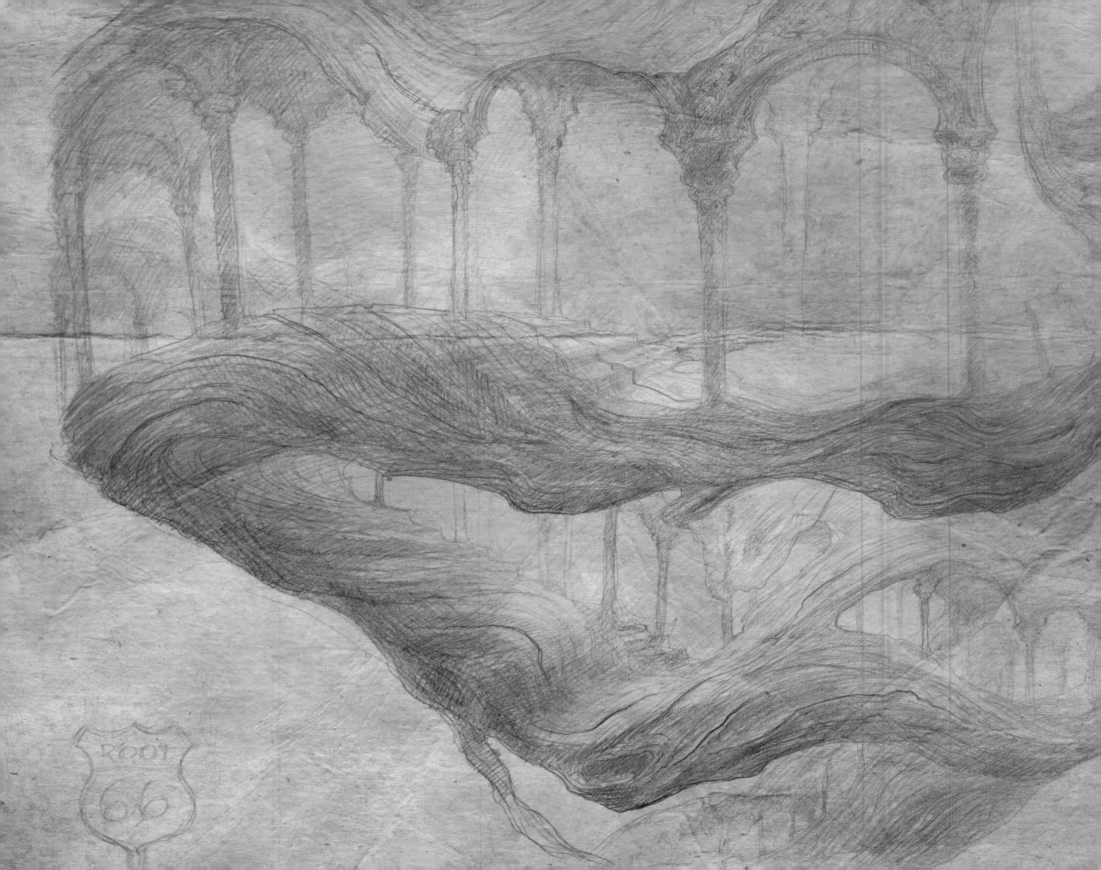

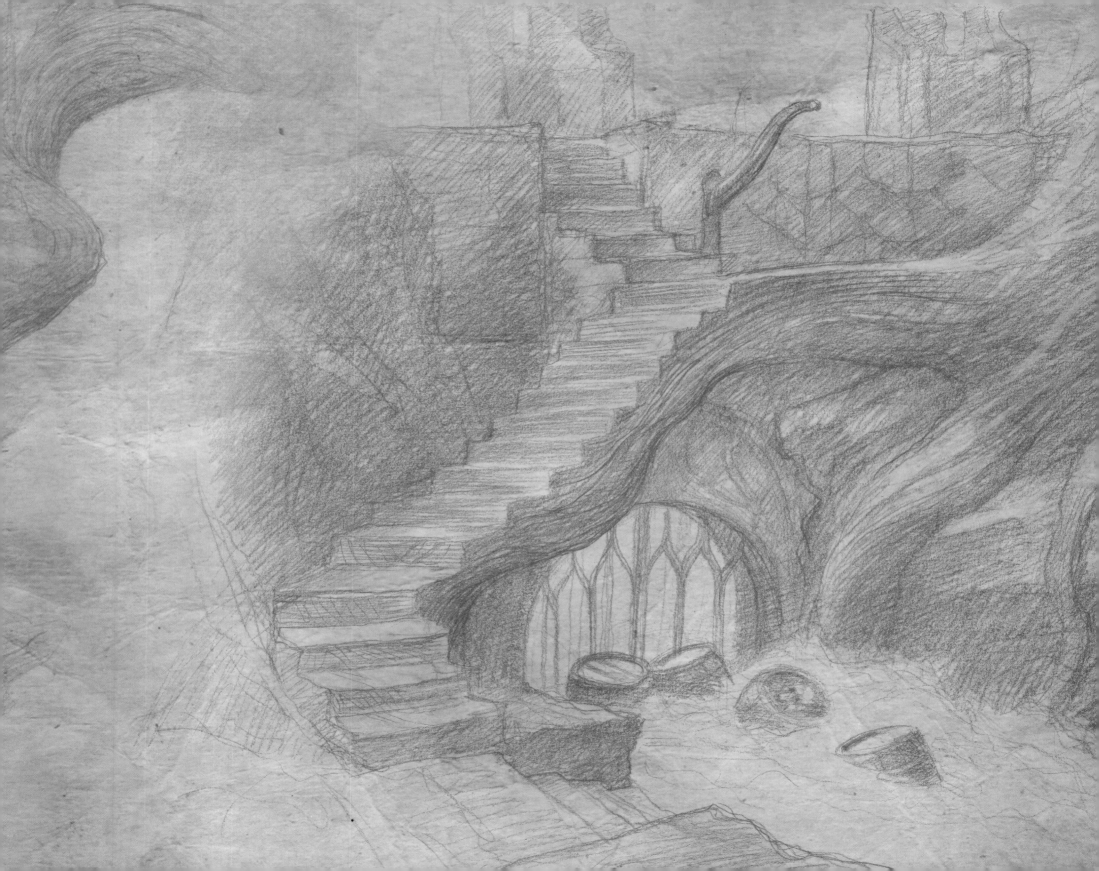